RANKIN UNFASHIONABLE

UNFASHIONABLE

30 YEARS OF
FASHION PHOTOGRAPHY

RANKIN

New York · Paris · London · Milan

First published in the United States of America in 2018 by
Rizzoli International Publications, Inc.,
300 Park Avenue South, New York, NY 10010
www.rizzoliusa.com

All photography by Rankin.
Design and art direction by Farrow.

All photography © Rankin.

No part of this publication may be reproduced, stored in a
retrieval system or transmitted in any form or by any means
electronic, mechanical, photocopying, recording or otherwise,
without the prior written permission of the publisher.

Printed in Italy.

2018 2019 2020 2021 / 10 9 8 7 6 5 4 3 2 1

ISBN 13: 978 0 8478 6217 7
ISBN 10: 0 8478 6217 8

Library of Congress Catalog Control Number:
2018954421

Foreword by Katie Grand	7
2018–2016	8
2016–2011	62
2011–2001	128
2001–1996	178
Rankin in conversation with Kate Moss	220
1995–1988	246
Afterword by Jefferson Hack	310
Index	312
Acknowledgments	320

CONTENTS

I first met Rankin in a bar called DNA in 1992. He'd photographed a friend of mine named Christine Kellogg for an exhibition at the old Katharine Hamnett shop now called the Collection Gallery, at Brompton Cross. She was tiny and he'd shot her from above in a laundry basket; she was fragile and fine, he was Scottish and brusque.

Rankin, Jefferson Hack, and a college friend named Ian Taylor had just won awards for a student union magazine called *Untitled*. They were trying to get together a magazine called *Dazed & Confused*. I hated the name—why would you ever name anything after a Led Zeppelin song?

I was on my year out from Central Saint Martins. I was bored—I was packing boxes for a knitwear company called Artwork, a job I thought was significantly beneath me, and I'd had my car clamped for the first and only time ever in Bermondsey. Did I want to go and work for them at the London School of Printing? Sure, anything was better than getting clamped and packing boxes and not getting paid.

Rankin was getting some notice around town taking Bailey-esque portraits of young London faces that he hoped would be the stars of tomorrow. I think only Peter Cunnah from the young band D:Ream went on to be famous. He also did a brilliant series of club kids at the time called 'Blow Up.' It didn't really matter that these kids weren't famous, nor would ever become famous. It's a brilliant documentation of Westwood and Pam Hogg fashion from the time, and also of the people who couldn't afford the high fashions doing their own brilliant copies.

As Rankin's confidence grew (he was always painfully arrogant in public), he wanted to change how we looked at fashion. I had a pure fashion background, but understood for him to get his head around photographing fashion he needed a reason, a concept. I think he was nervous to compete with the fashionable photographers of the early 1990s who worked on *The Face* and *i-D*: David Sims, Mario Sorrenti, Corinne Day, Juergen Teller. He needed a spin on it—it couldn't just be a photograph.

And so began a series of concept shoots: 'Ghosts,' 'Hungry?,' 'Big Girl's Blouse,' 'Sad Lad,' 'Animal Fashion'…. He was one of the first people ever to photograph plus-sized models for a fashion shoot. He wanted to turn the normal perception of what a fashion shoot was on its head. And years later he's still doing it with his magazine *Hunger*. For Rankin, it can't just be a straight fashion image: it needs a reason for being.

**FOREWORD
KATIE GRAND**

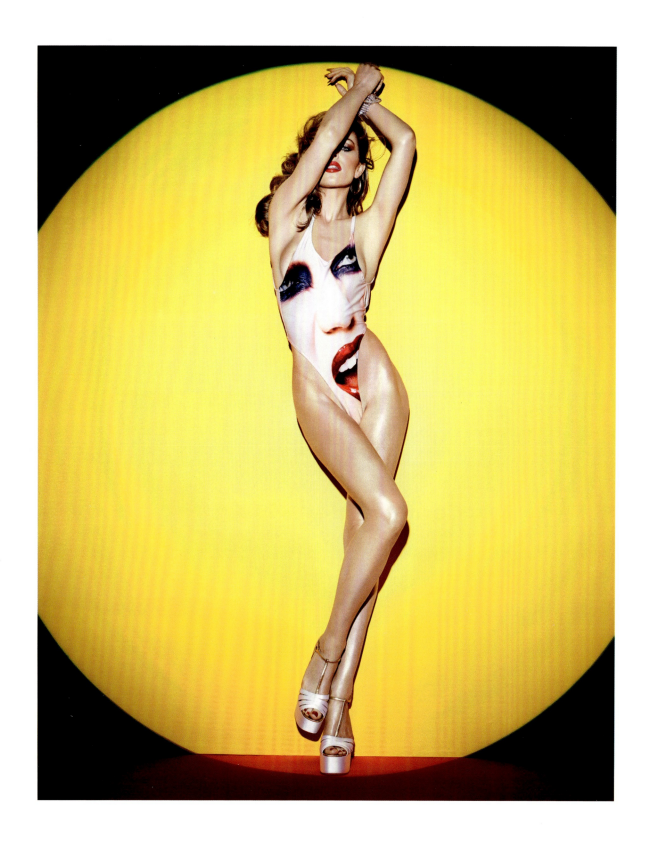

2018–2016

Slime of Passion
F**k Facetune
Casket Couture
#NoFilter
Eye Eye Abbey Clancy
Love's a Bitch
The New Law
Life in a Dream
Bella in Love
Bird Song
Jump to It
Scream
It's a Small World
Uncovered

I think my favorite memory is one which is quite indicative of how we work together. It was toward the end of an advertising job. Rankin came into the make-up room and said he liked the model, should we shoot some beauty on her? I hesitated and said I didn't have all my creative kit, extra bits with me, and he just said, "Well, go get them!" That's always stuck with me. I think it's a good representation of how he doesn't settle for second best and encourages me to bring my A-game, and thank goodness he did that day. I feel like he often makes me "go get it," and I really appreciate that.

ANDREW GALLIMORE

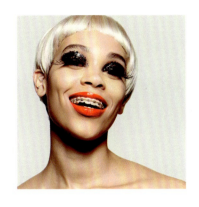 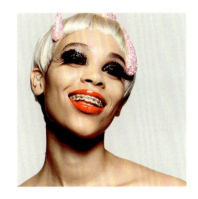 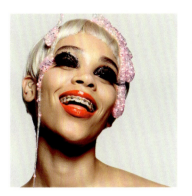 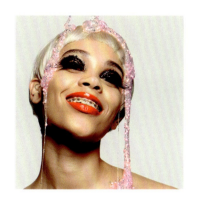
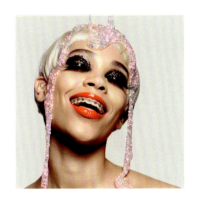 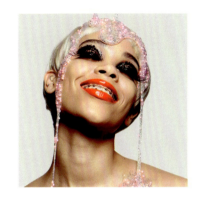 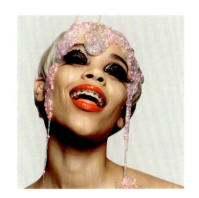 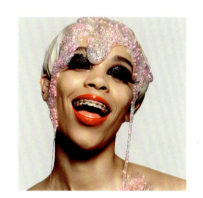
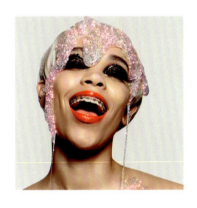 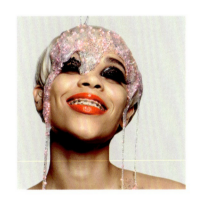 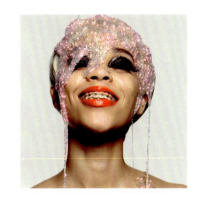 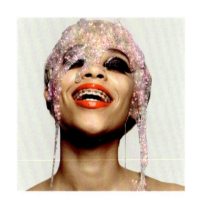
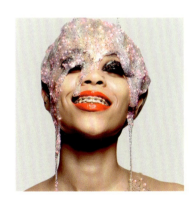 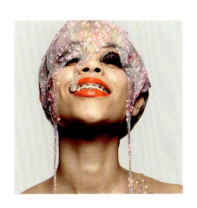 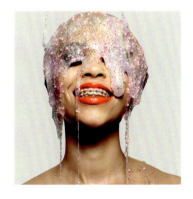 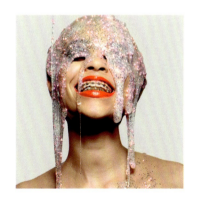

Slime of Passion | 2018

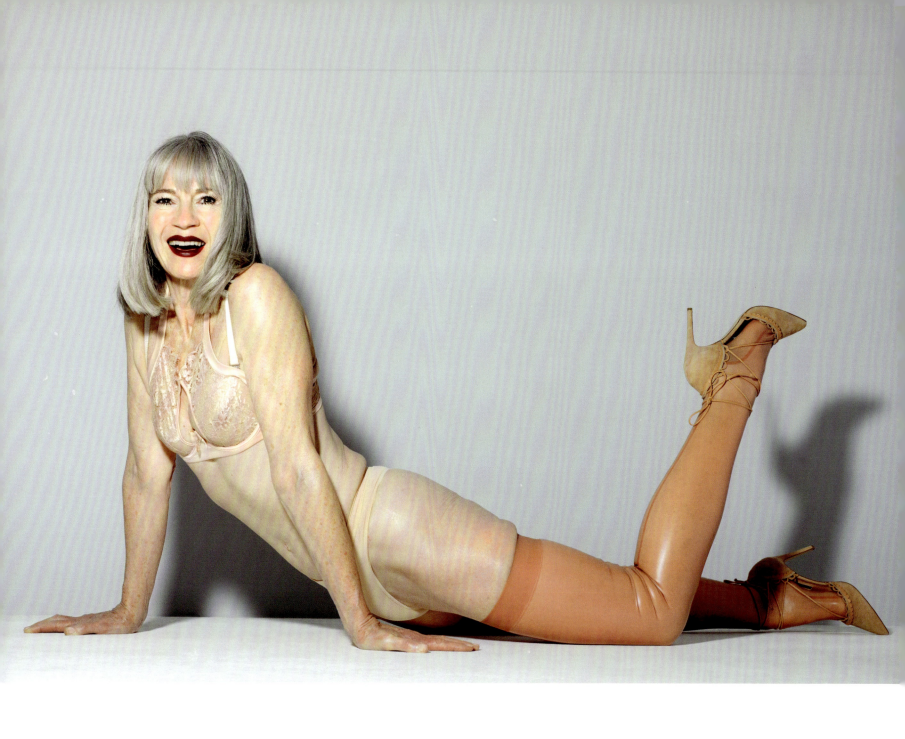

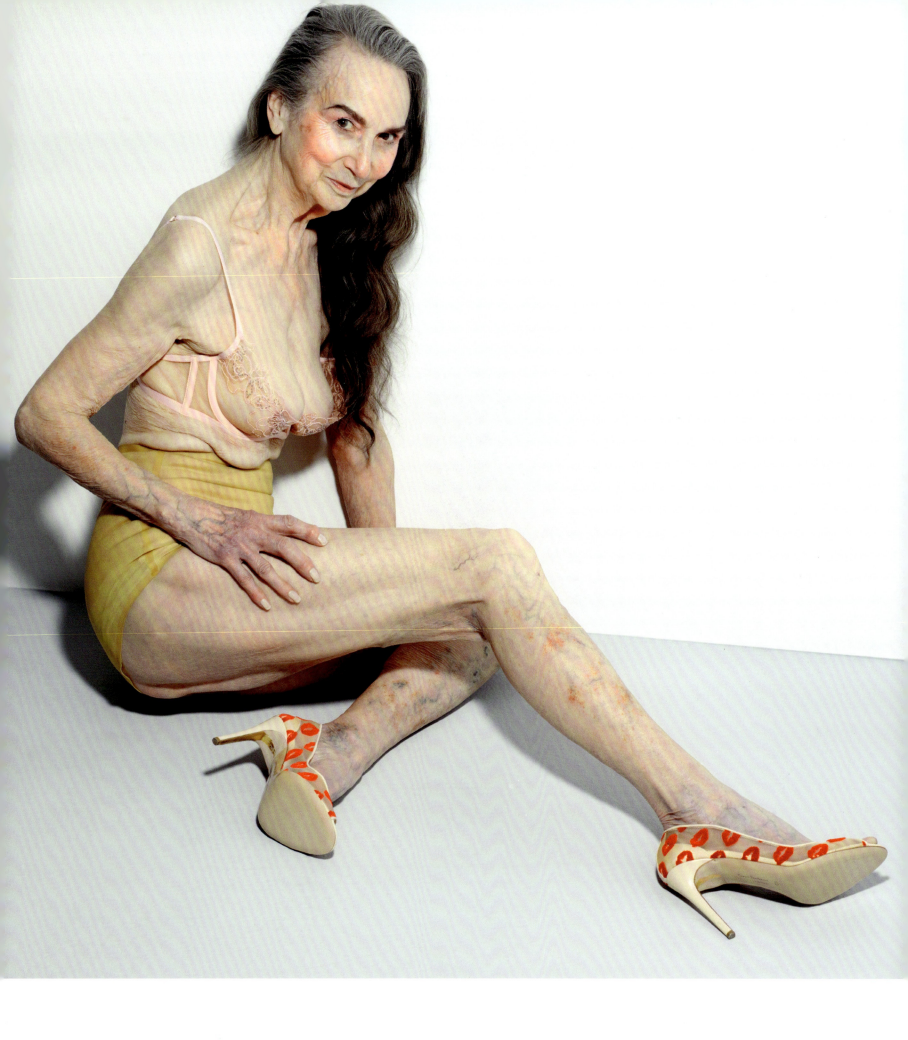

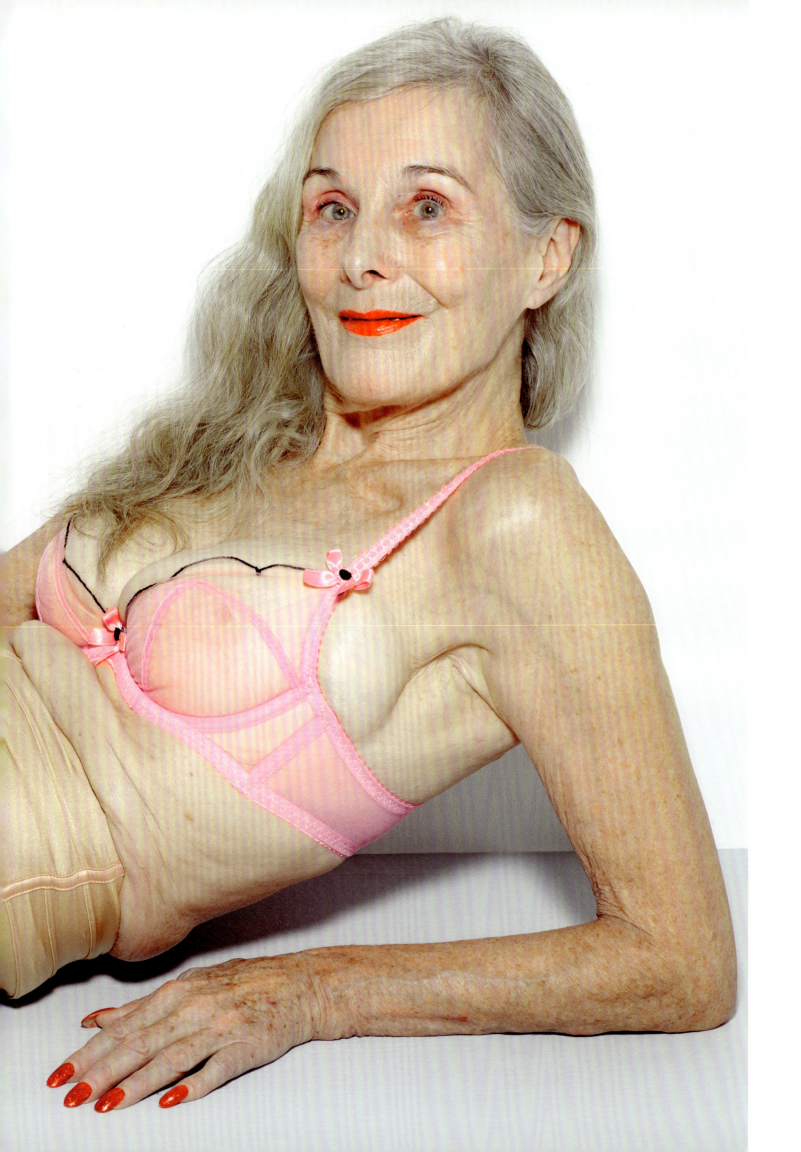

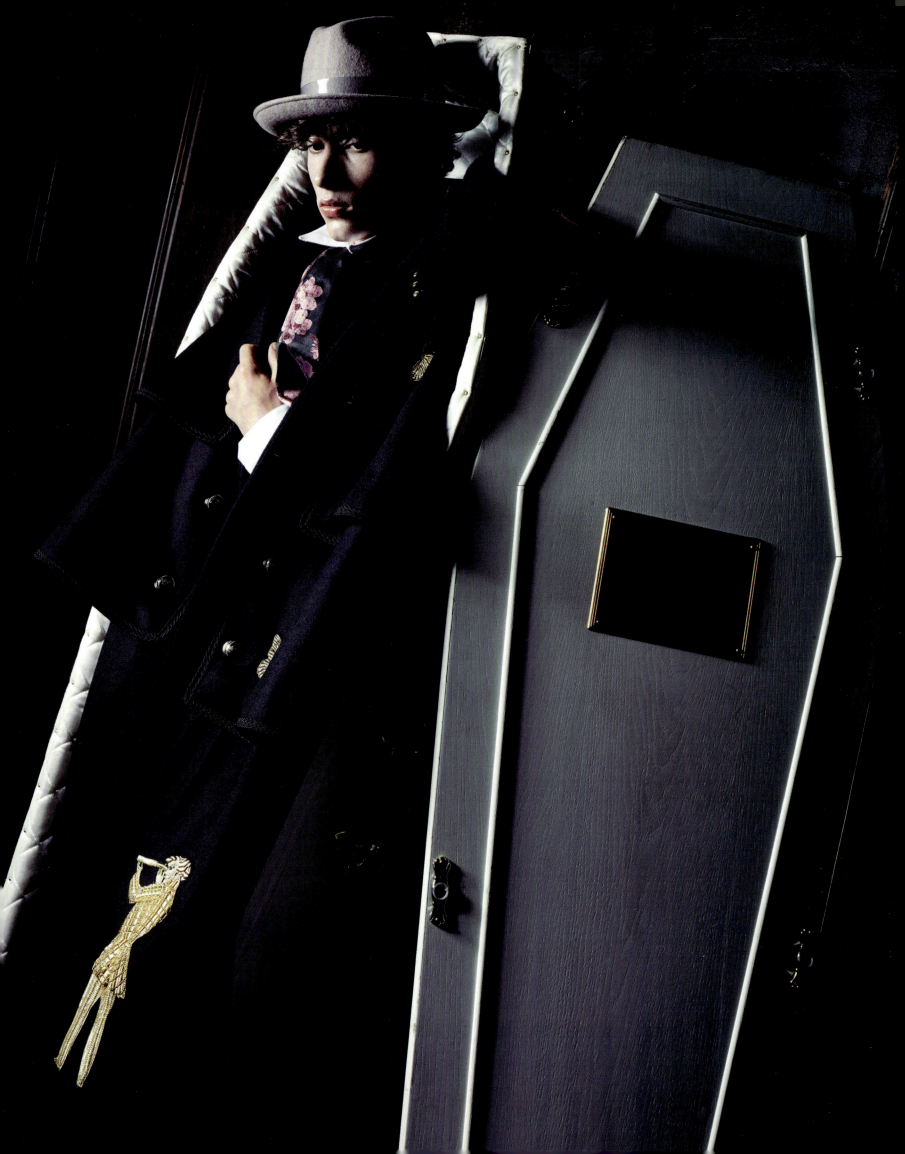

I knew it would be a 'hardcore' experience working with Rankin. 'Hardcore' meaning more of a challenge. I love being challenged and I consider myself a workaholic, so being around a photographer who is a workaholic himself was inspiring.

MARCO ANTONIO

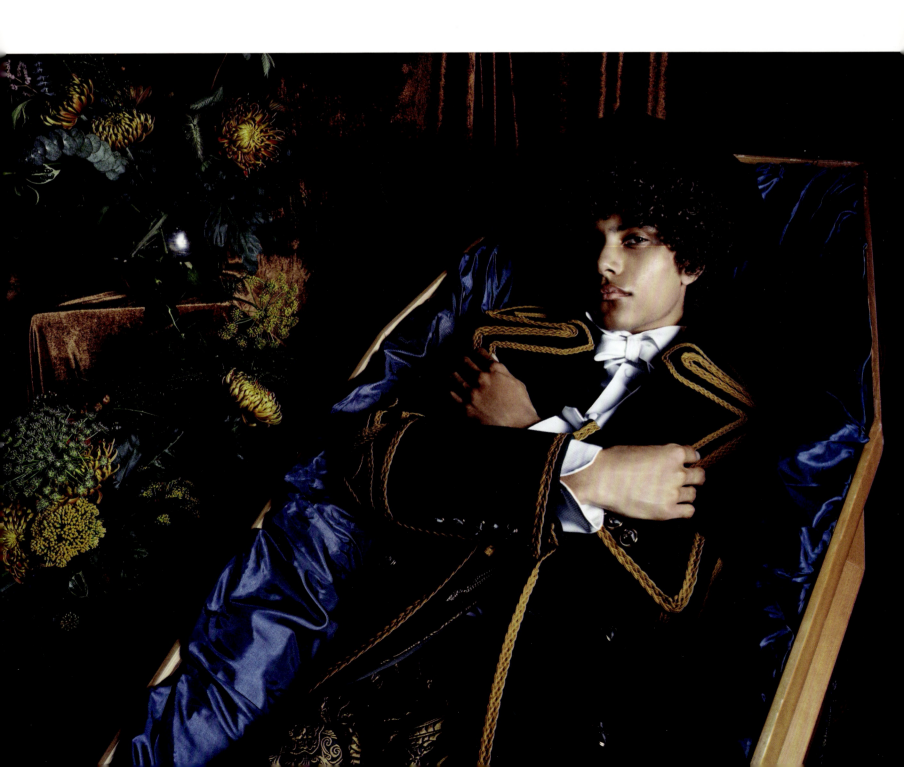

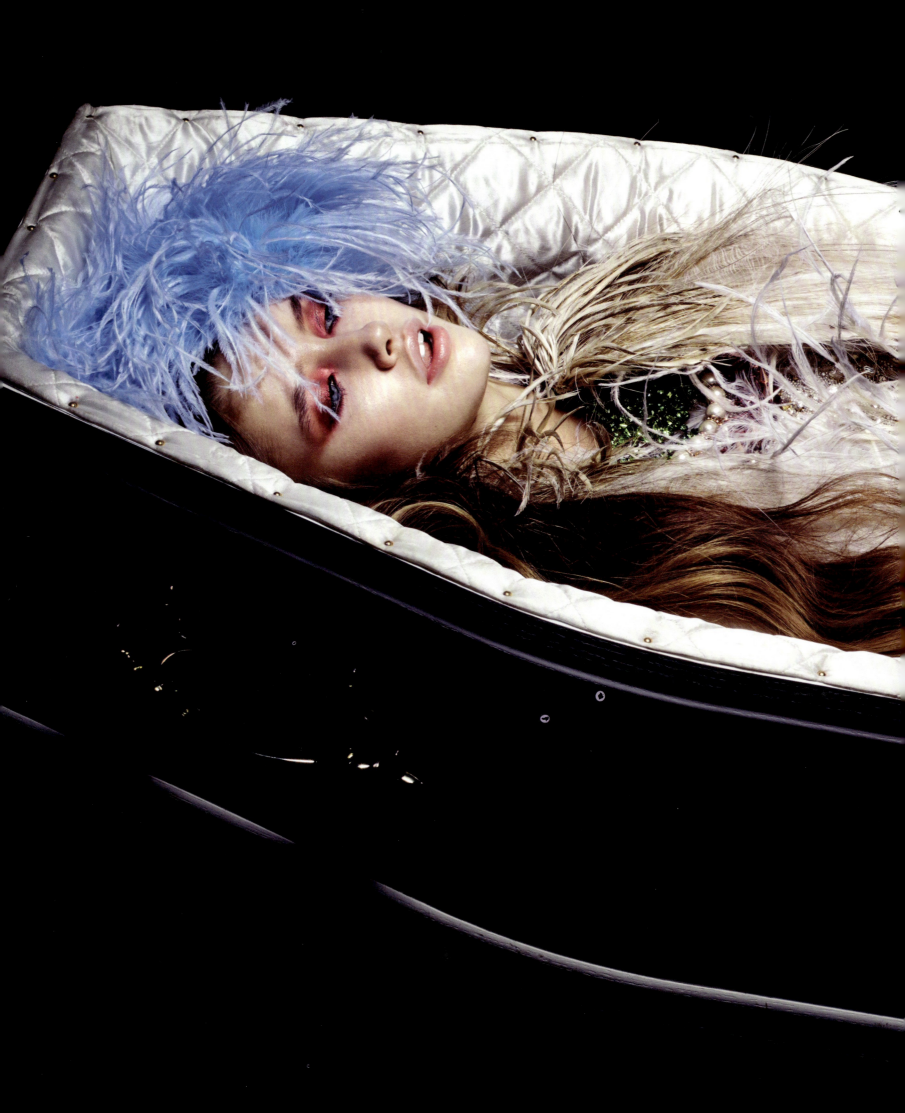

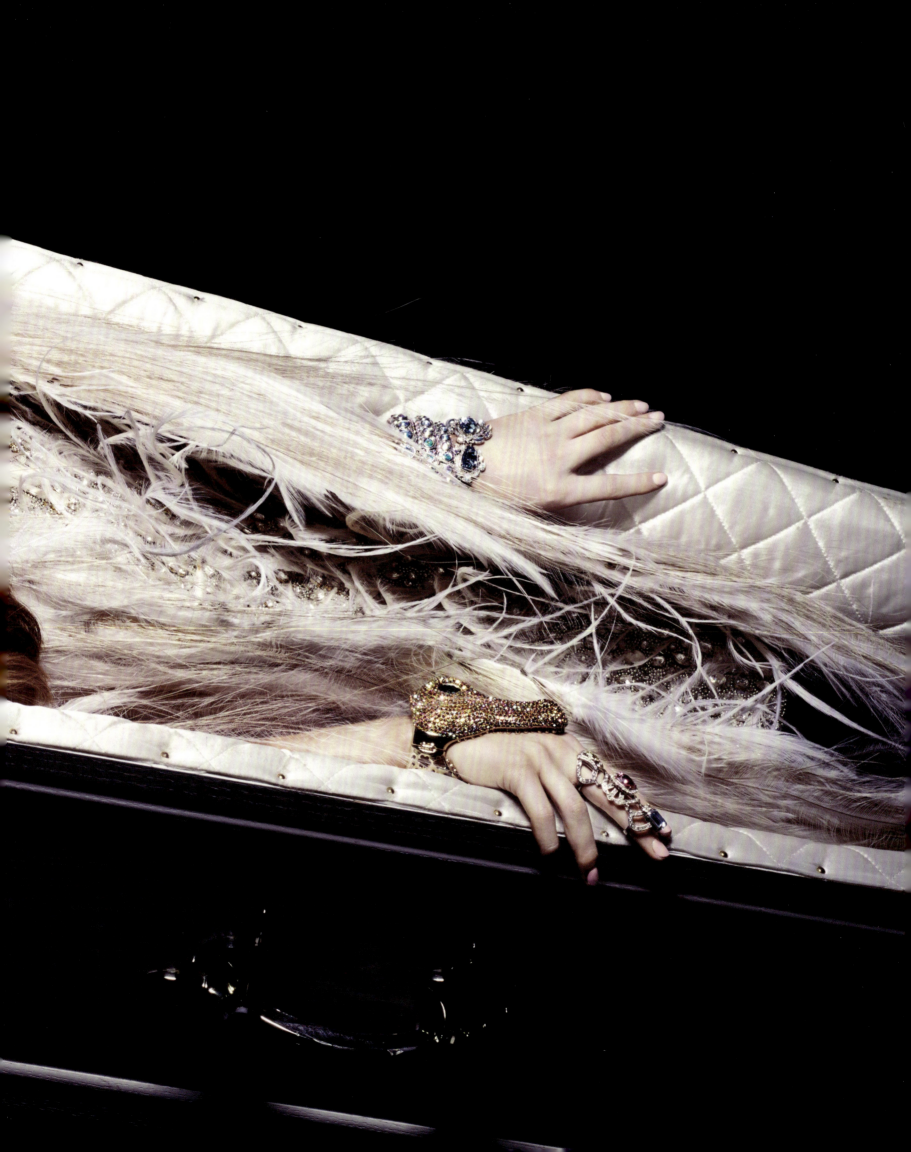

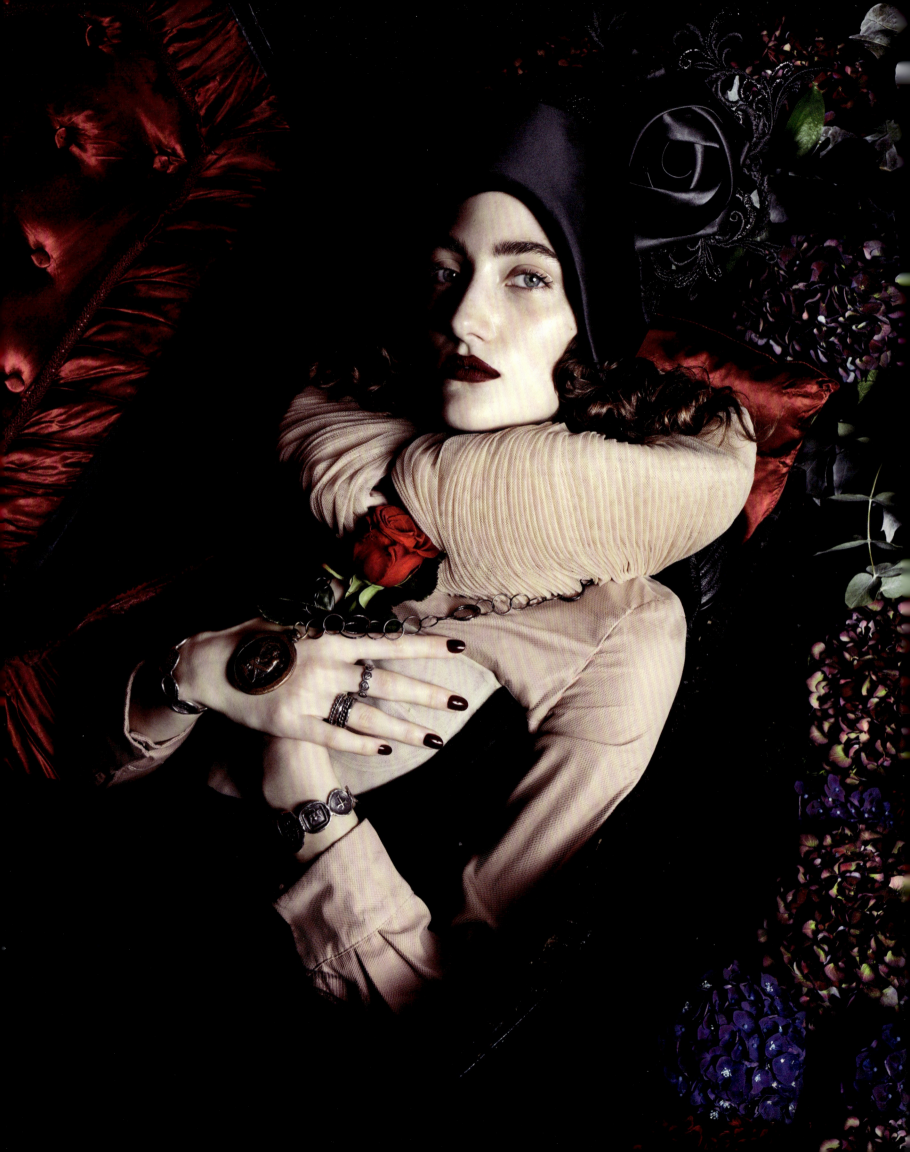

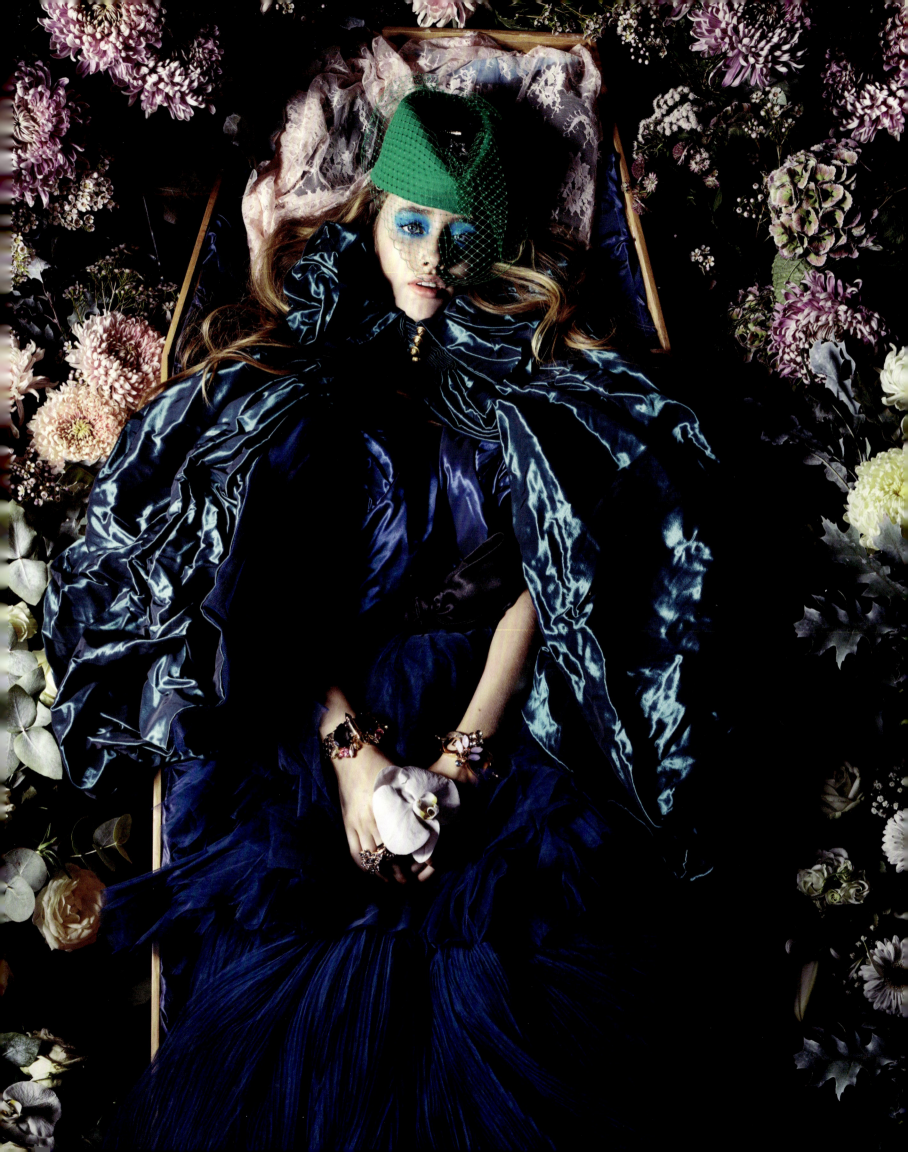

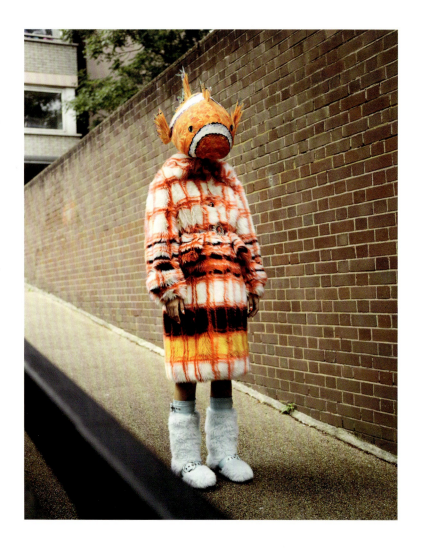
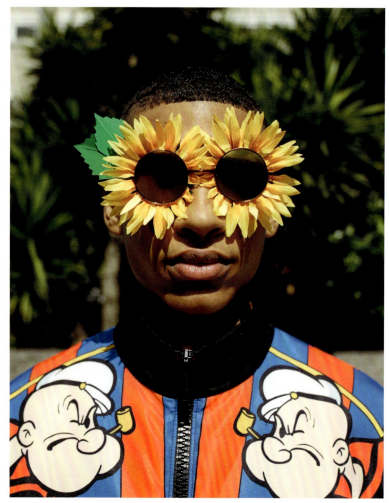
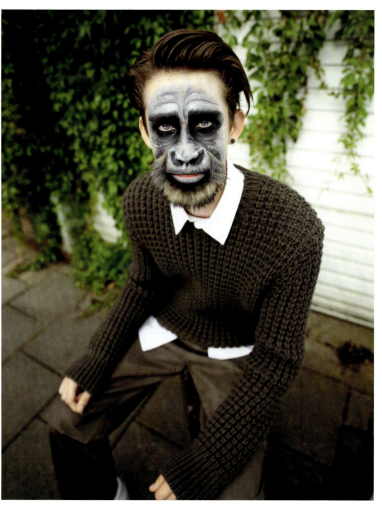

It's very clear from the first shot exactly where Rankin is taking his vision, and each image or look builds into a completed story. An important part of the process is trust—trusting completely in Rankin's vision. He sees beyond the mechanics of the moment—he sees the final tapestry as soon as he sees the thread.

MIKE ADLER

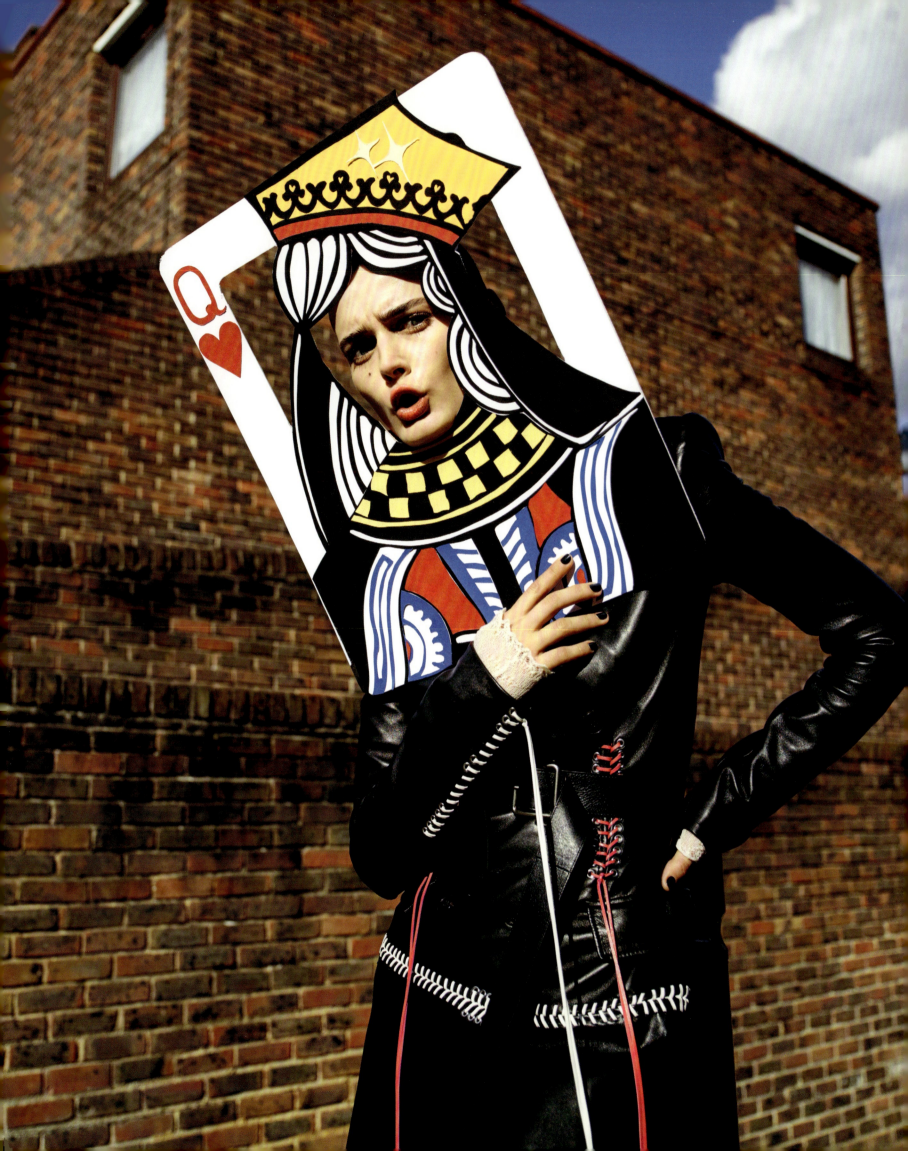

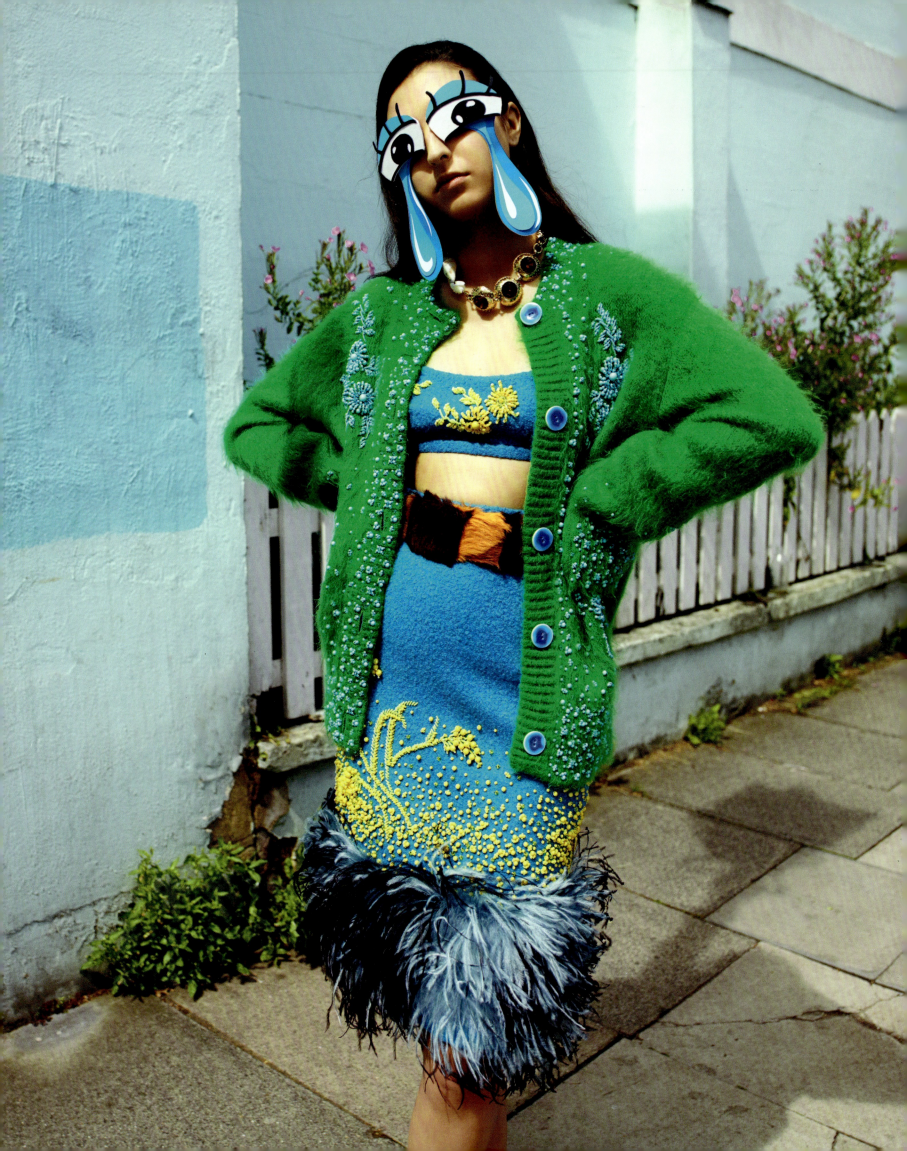

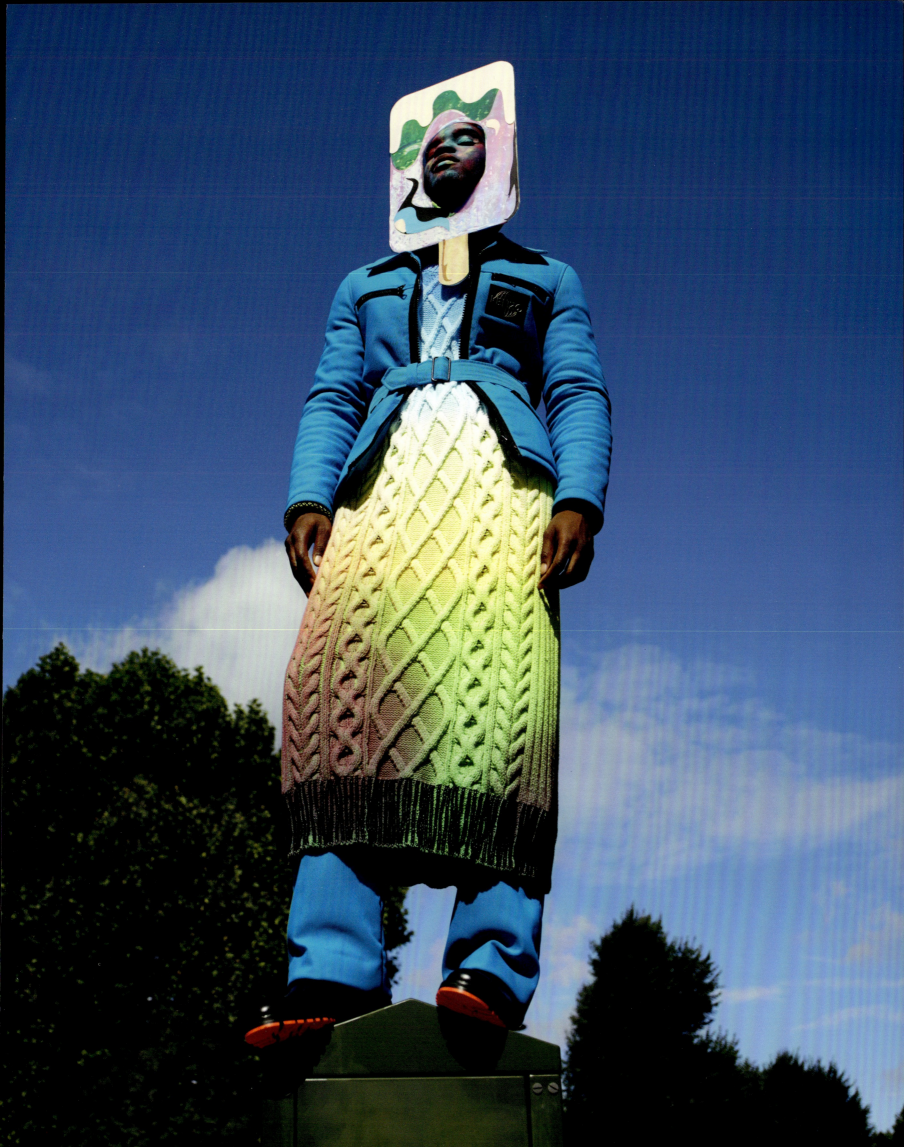

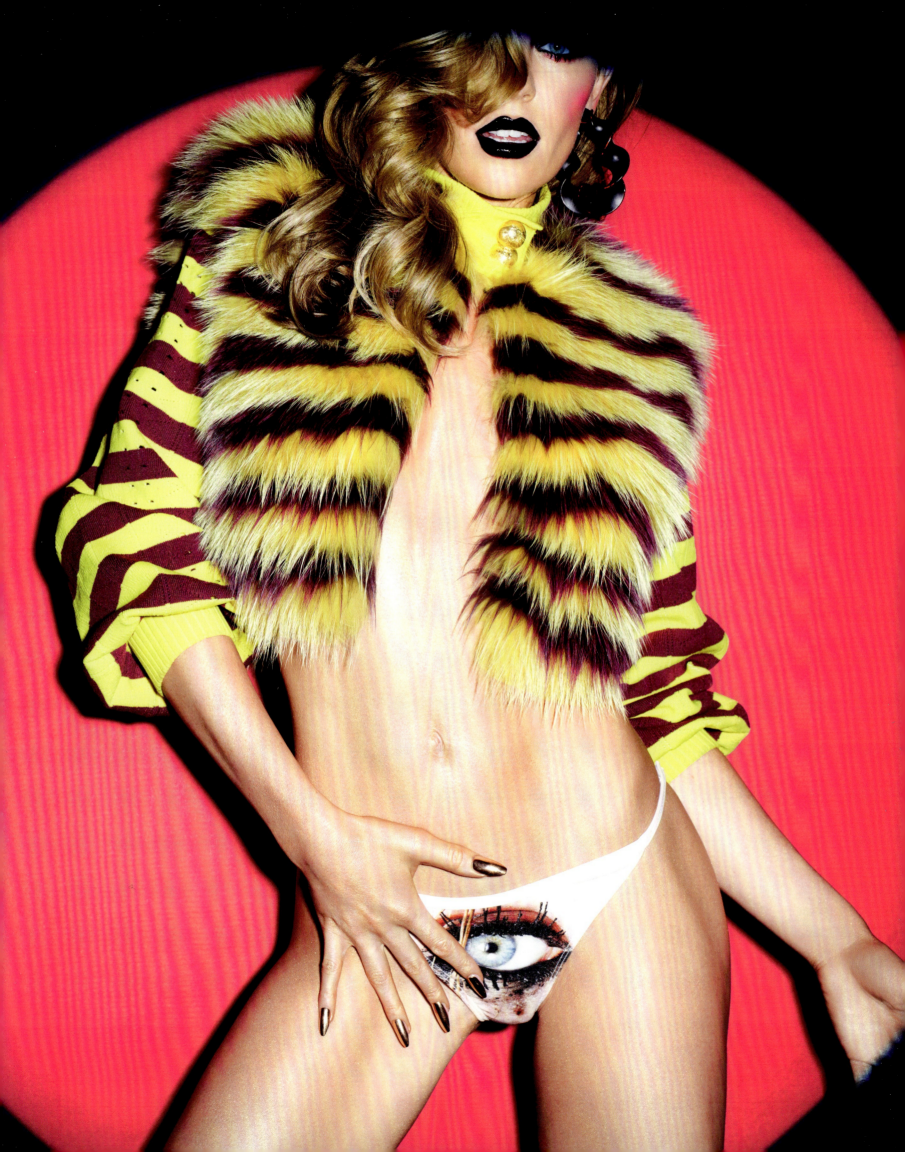

Eye Eye Abbey Clancy | 2017

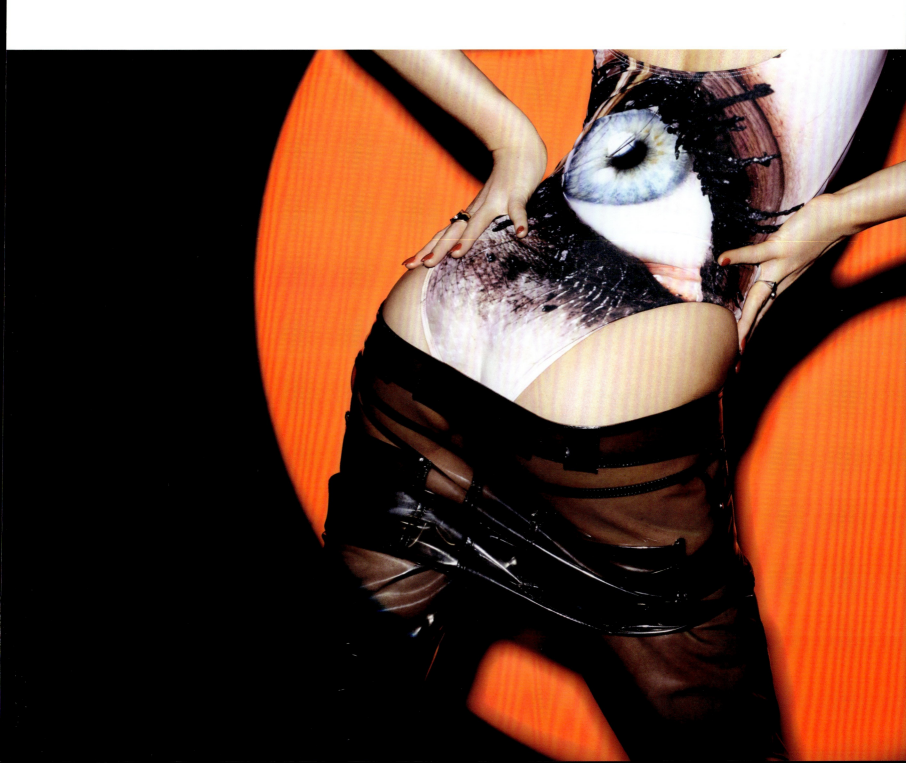

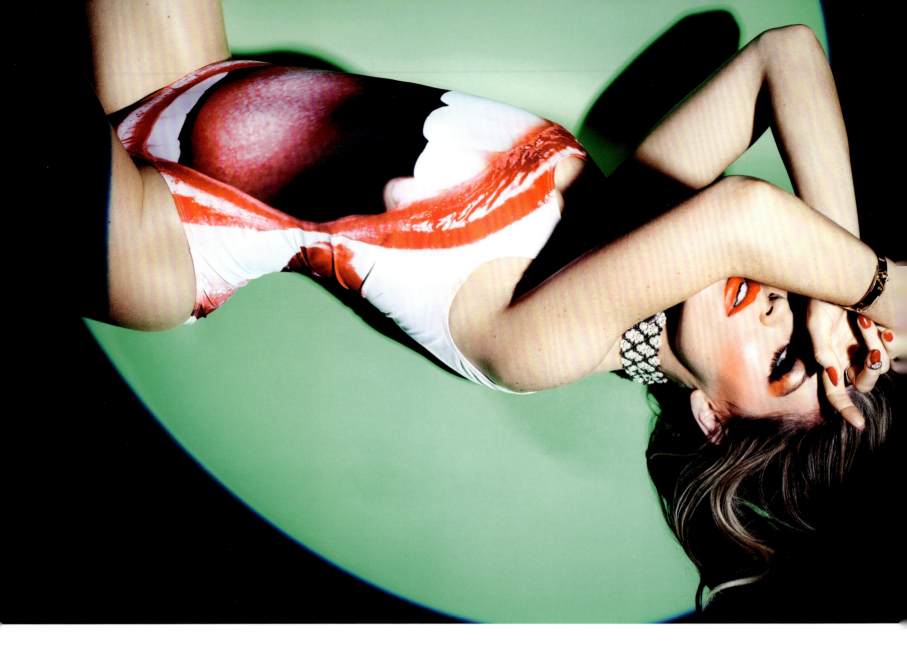

I loved the Eye Eye shoot; it was an amazing experience. It was shot over two sessions, the first being a beauty shoot with incredible, vibrant looks and mad, wacky colors on the eyes and lips. These images were then printed onto swimsuits and bikinis.

The next shoot was me wearing the pieces and posing in front of colored spotlights. Rankin came up with the idea after buying his wife a swimsuit for Christmas with their little dog on the front. It was all very clever and beautiful. I loved it.

It felt quite surreal wearing my own face. I wanted to keep the swimsuits and actually wear them, but he never sent me one!

ABBEY CLANCY

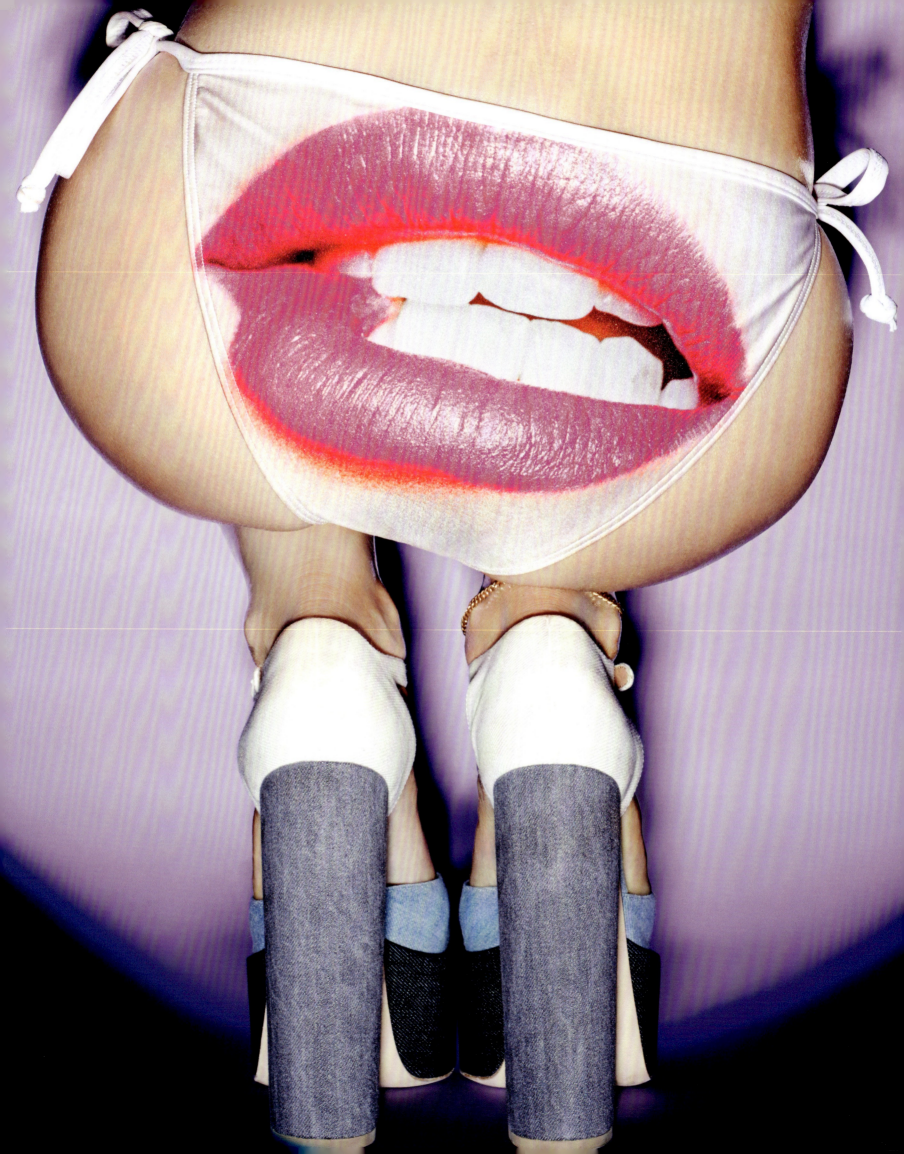

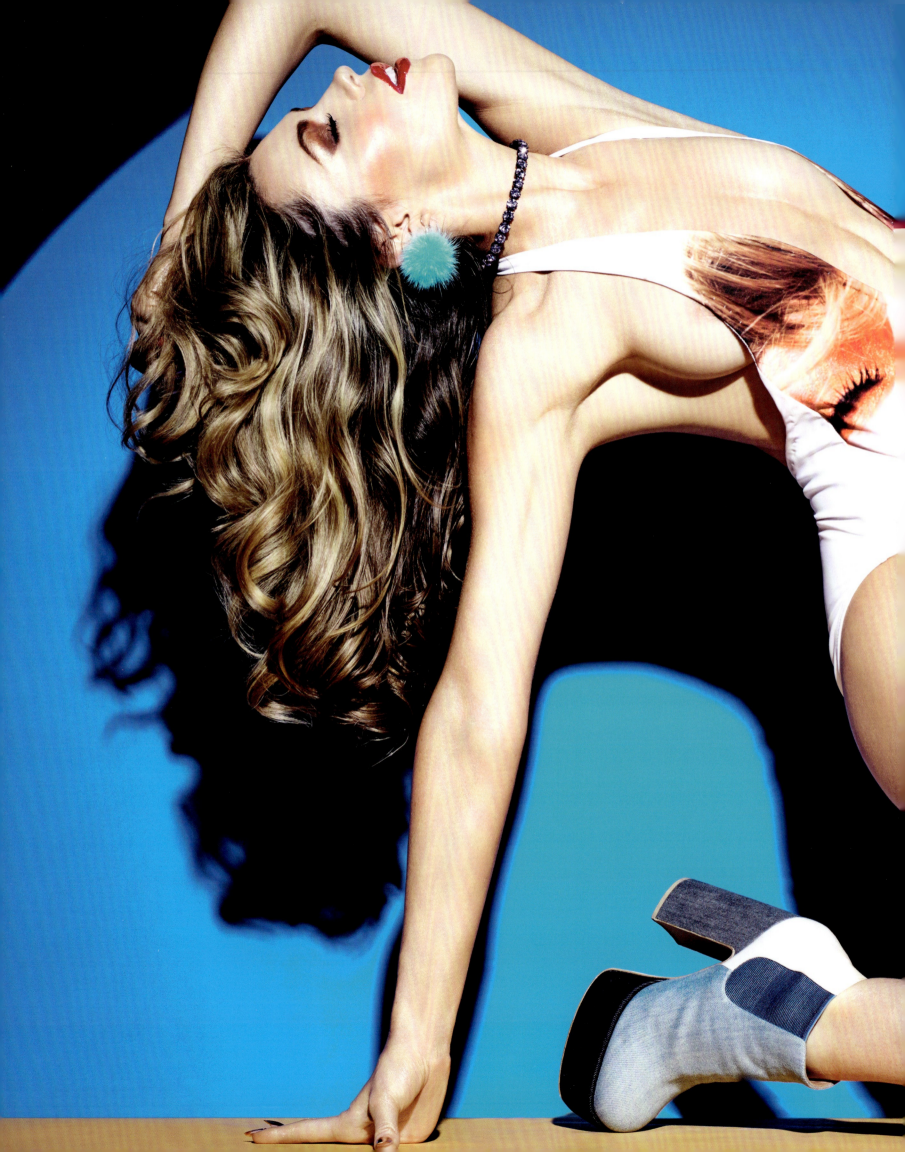

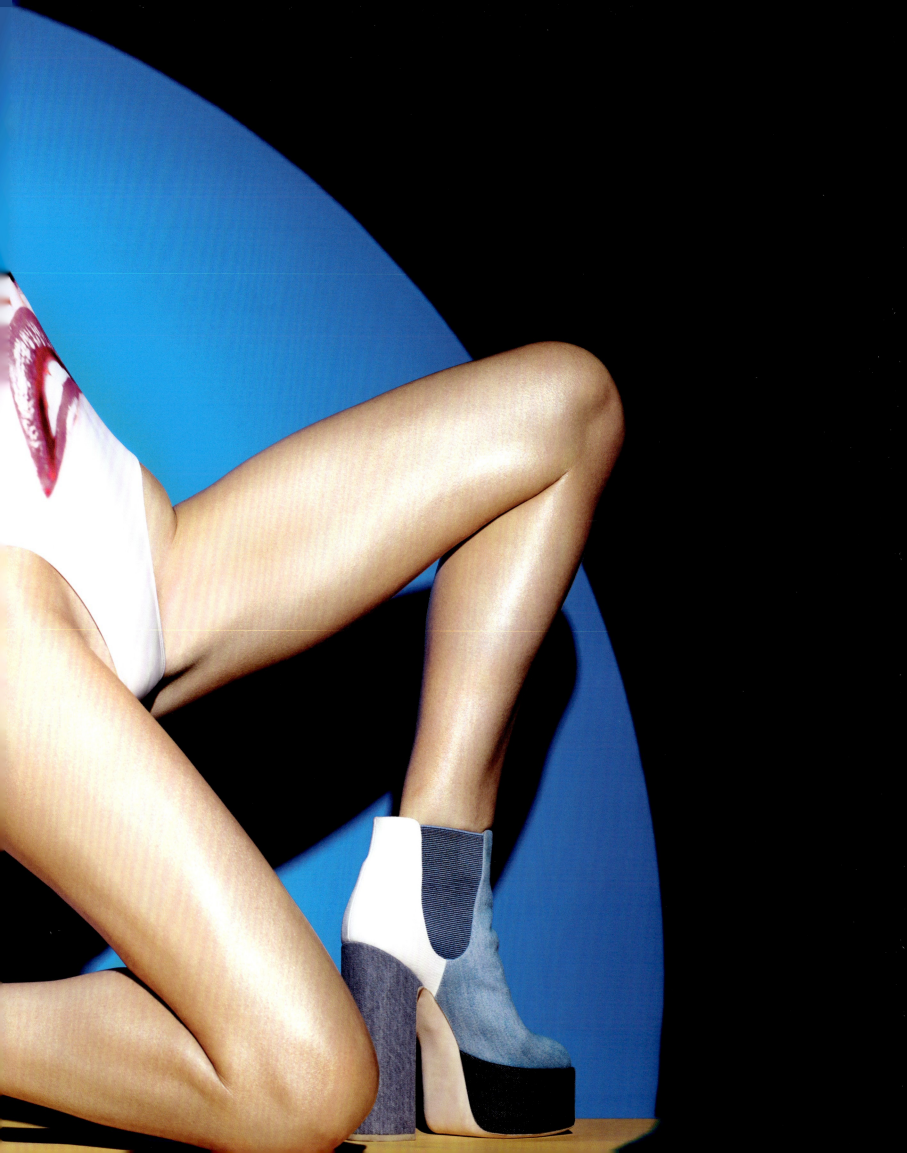

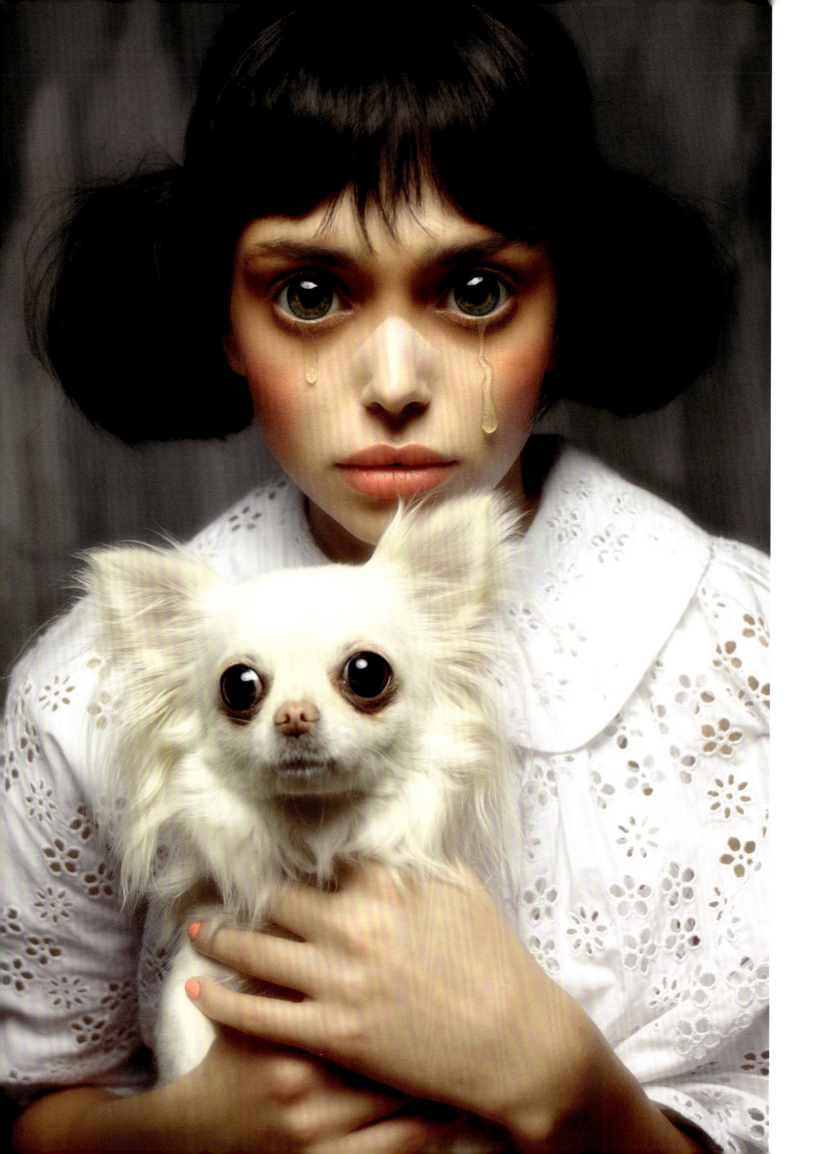

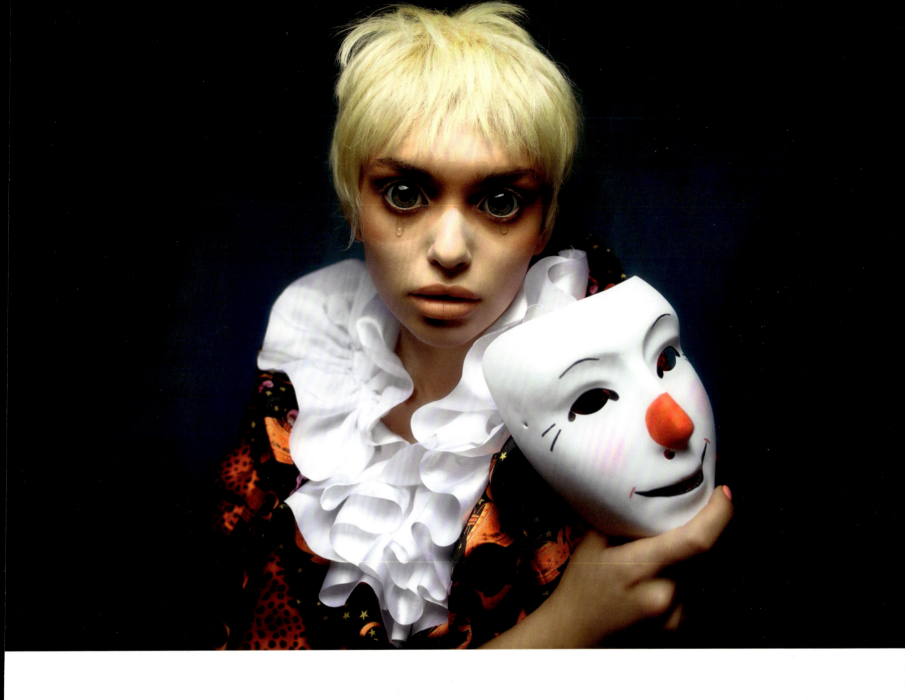

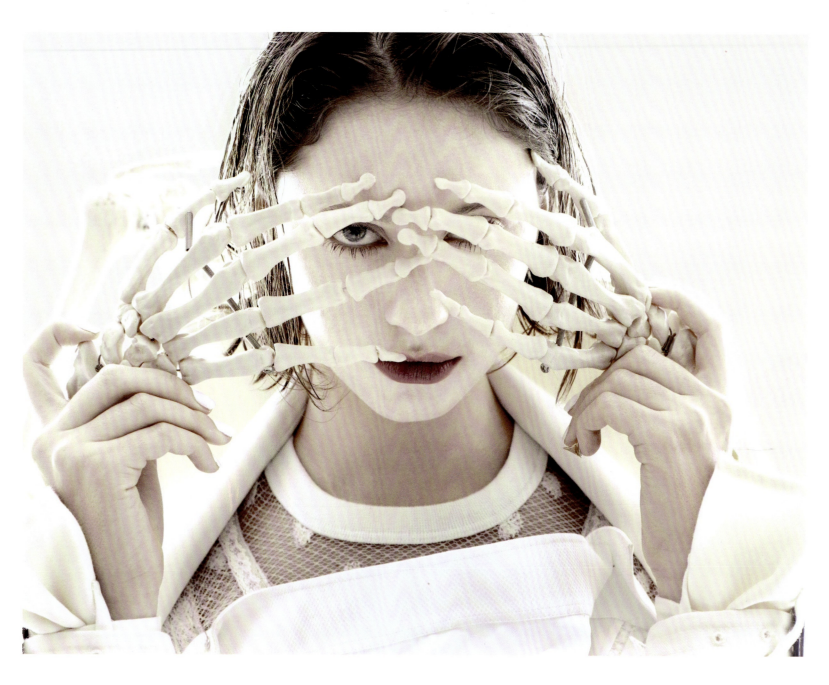
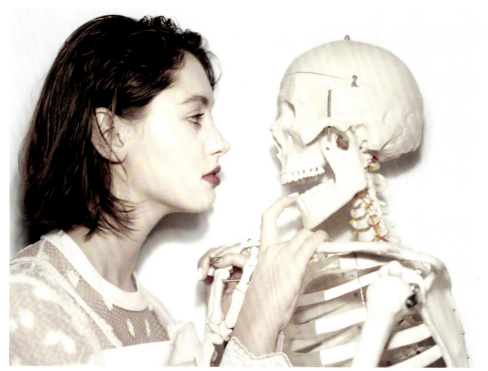

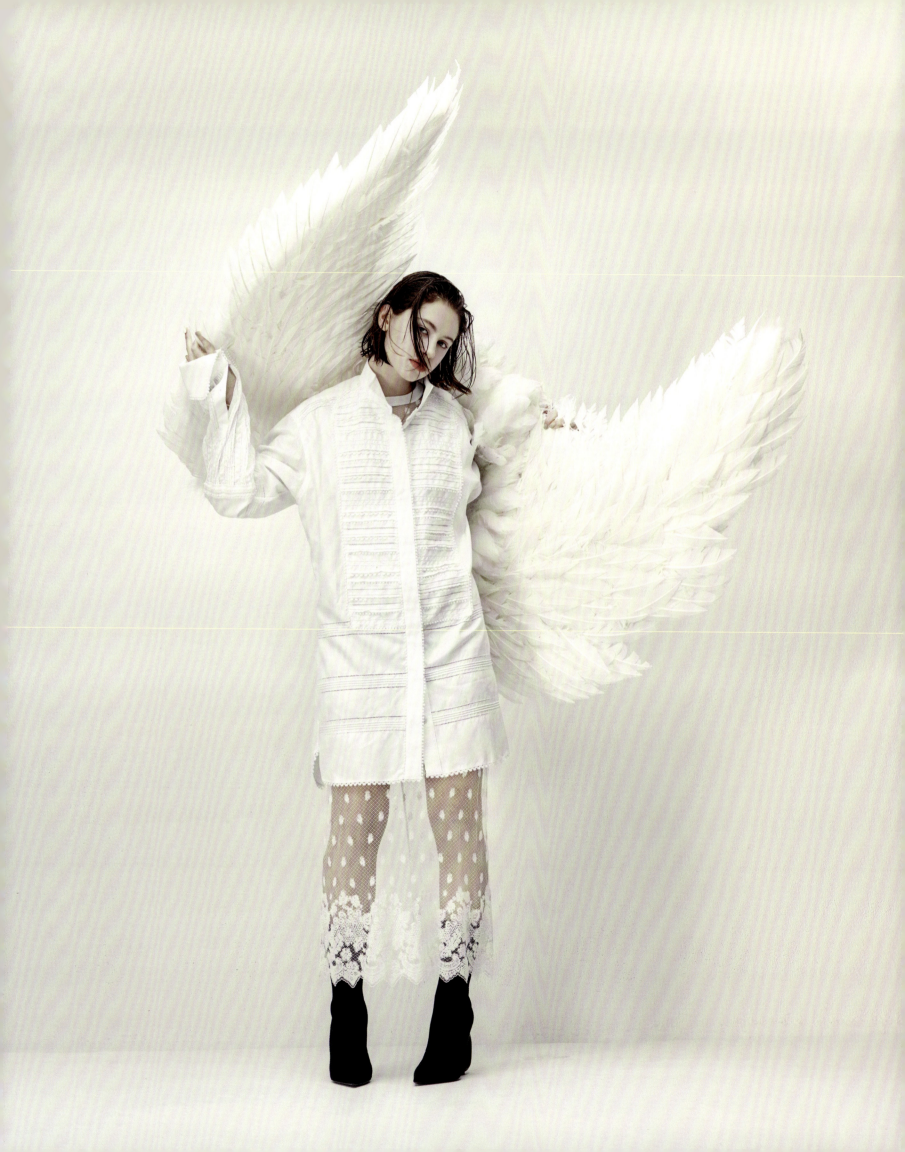

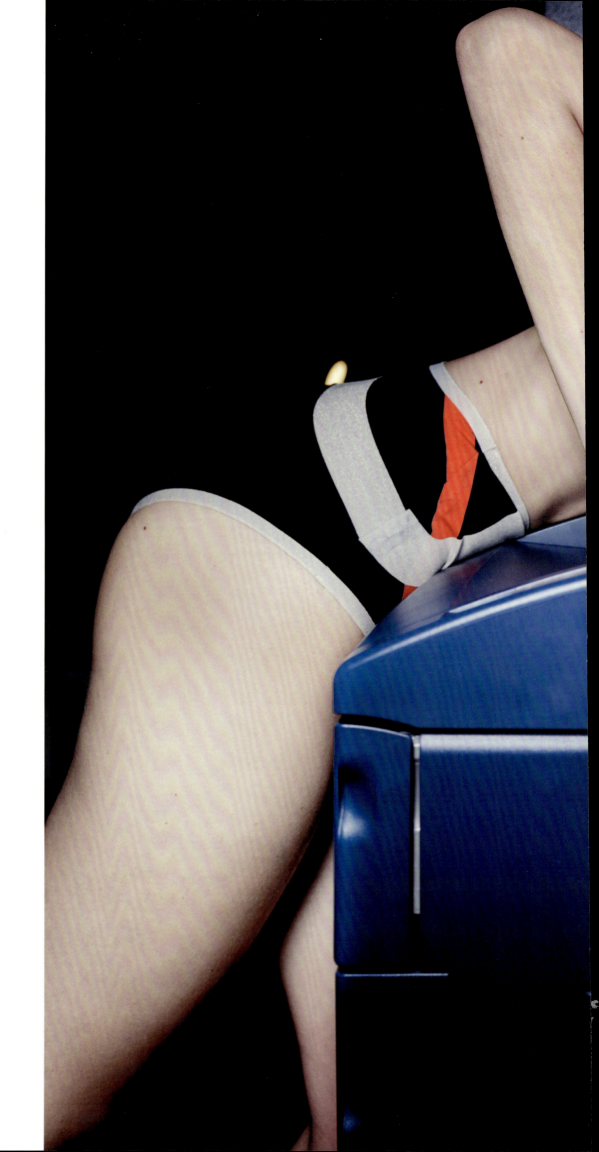

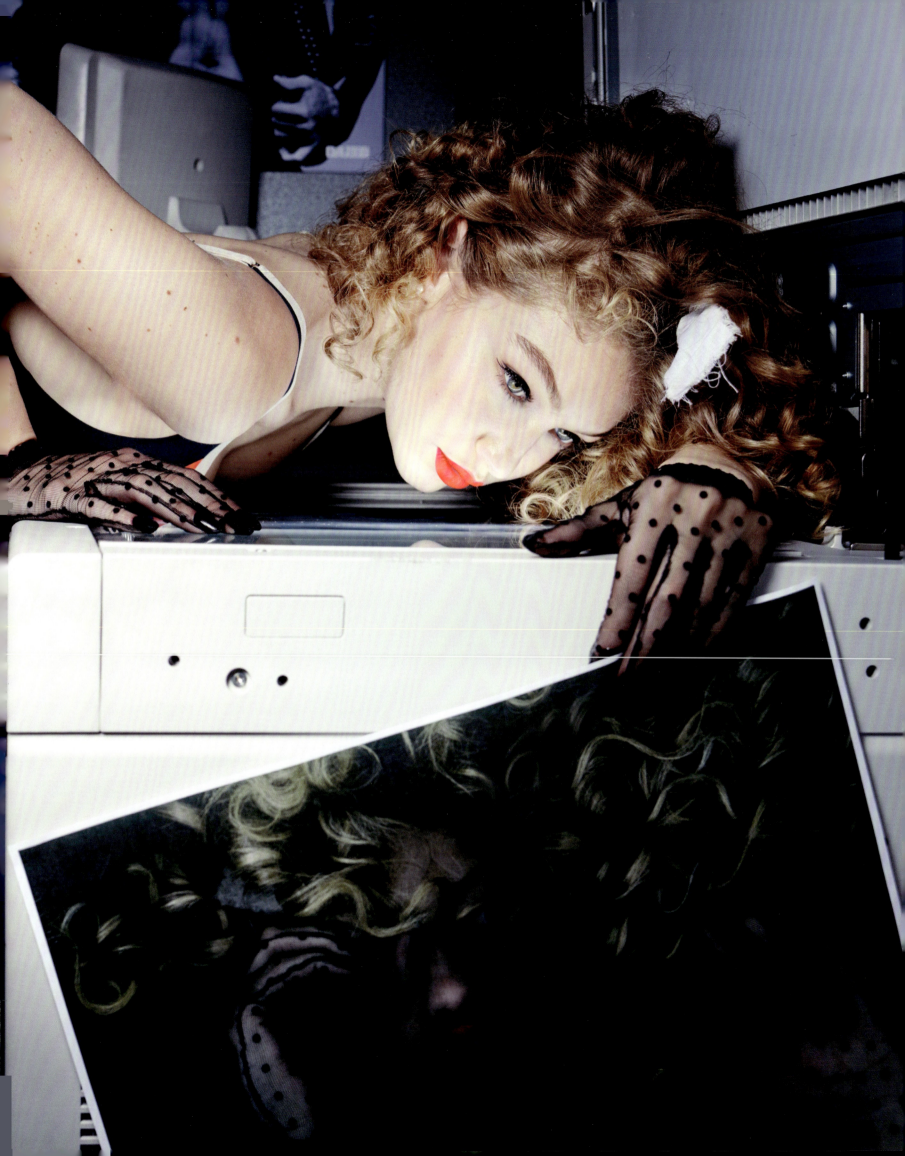

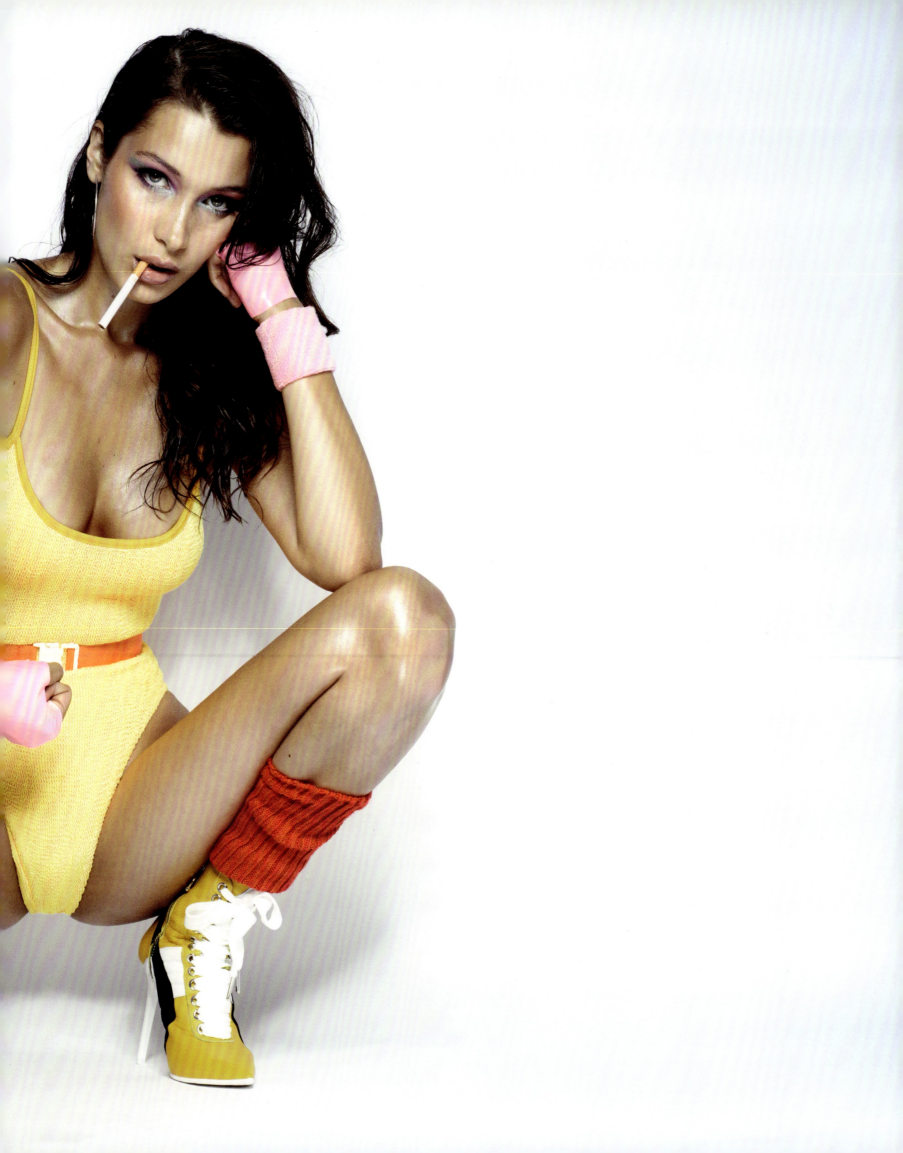

This will sound weird, but he was totally how I thought he was going to be. It was the 1990s and a very hedonistic time. Of course you hear stories, but I remember just having the same sense of humor and feeling really relieved.

The shoots always become Rankinized. What I mean by that is, there is always an underlying signature to the photographs. By no means though is this easy to spot to the untrained eye—he has such a deep archive and knowledge and it never ceases to amaze me how diverse he can be.

NICK IRWIN

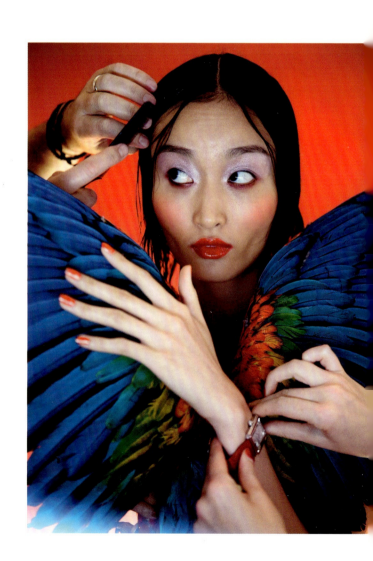

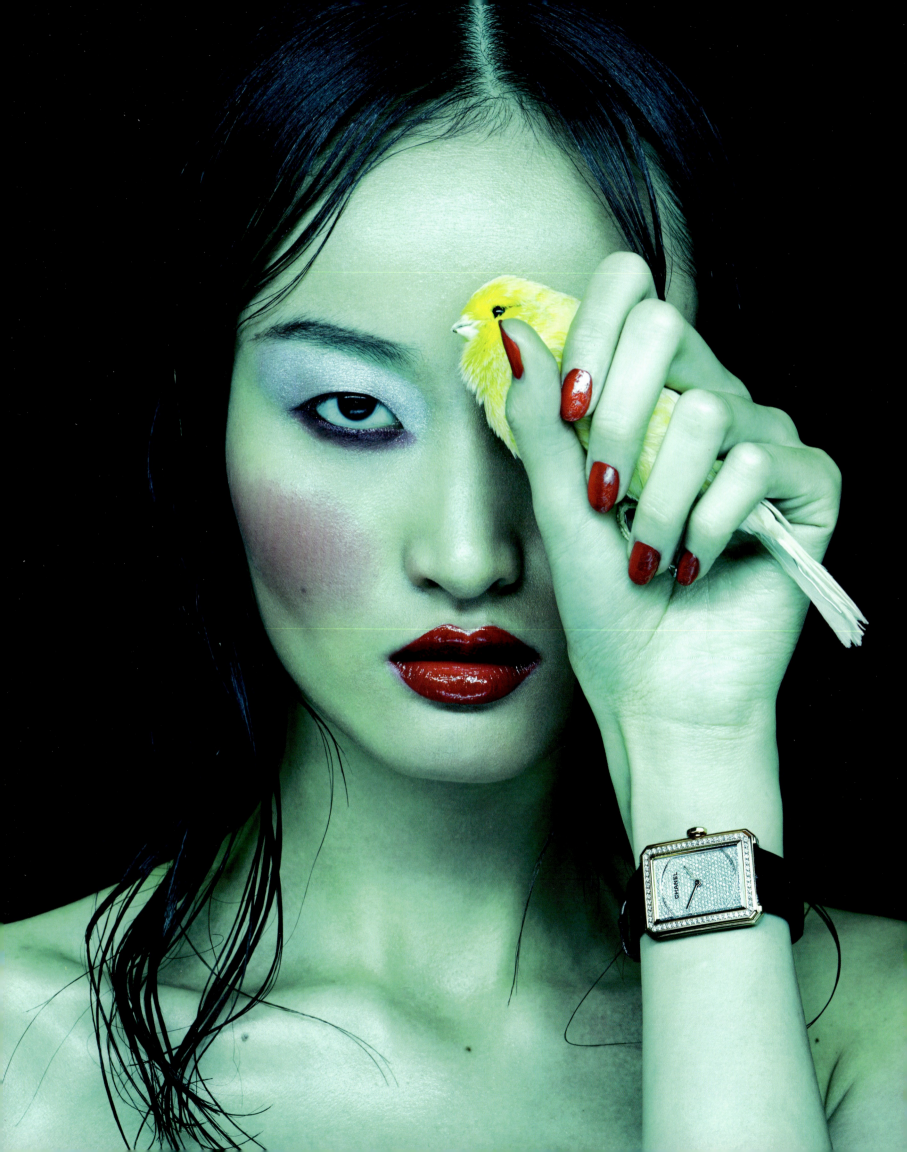

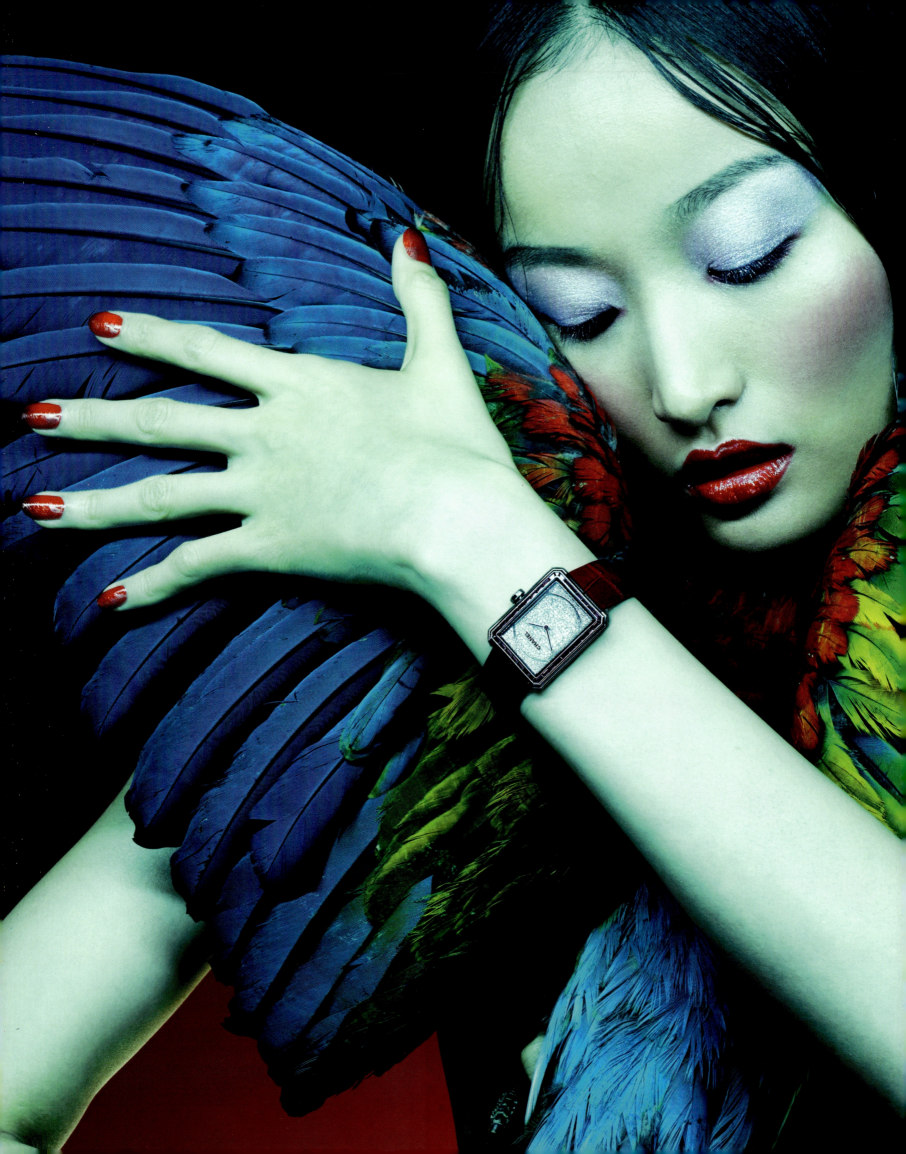

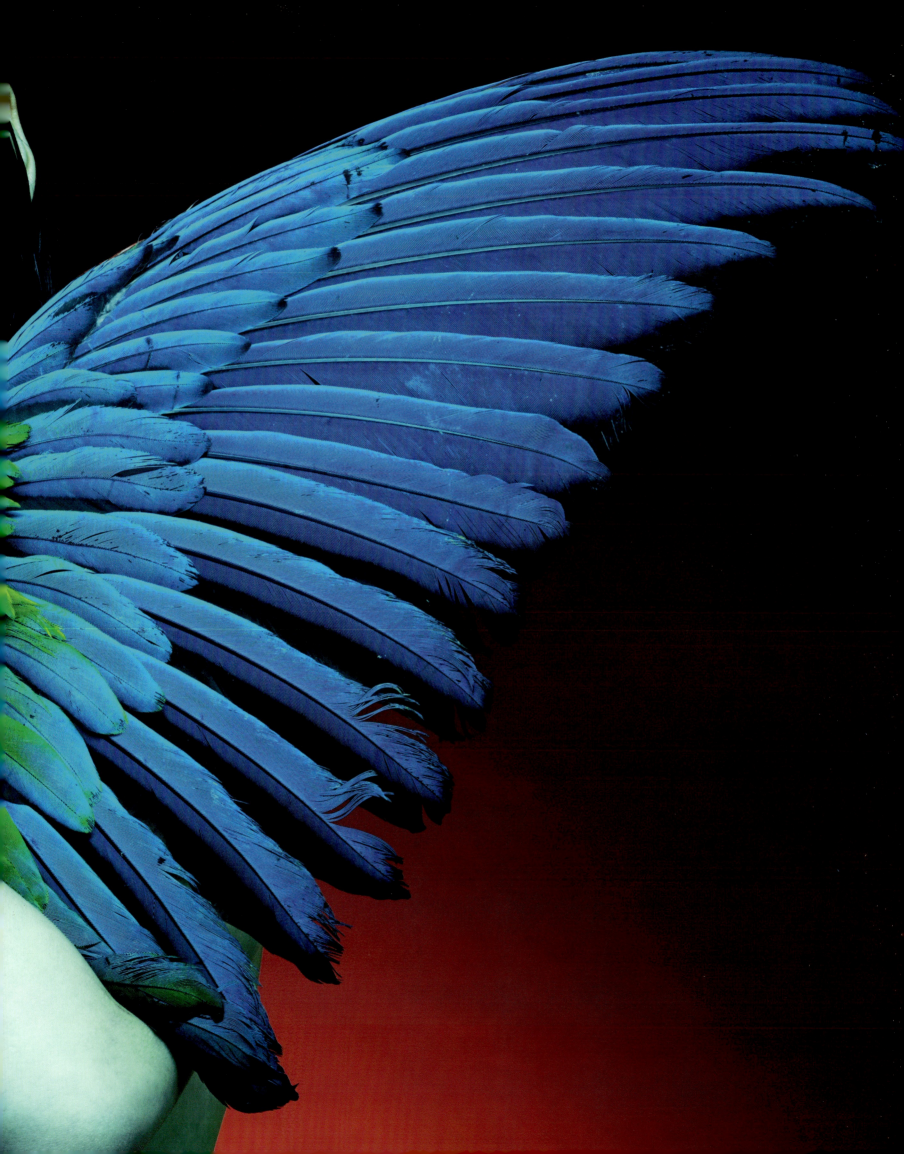

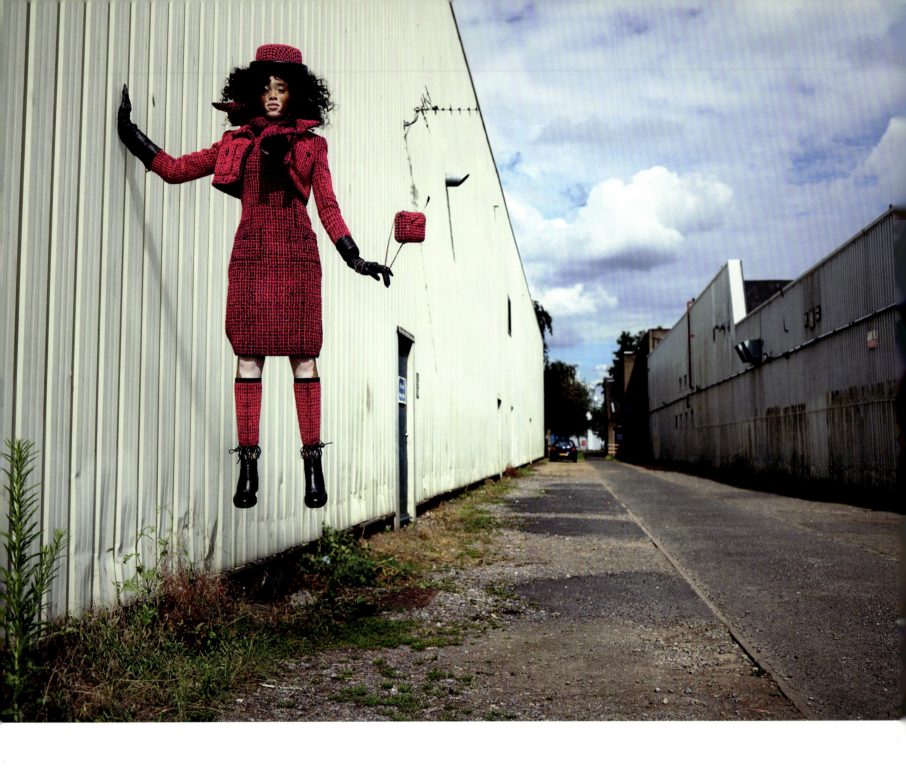

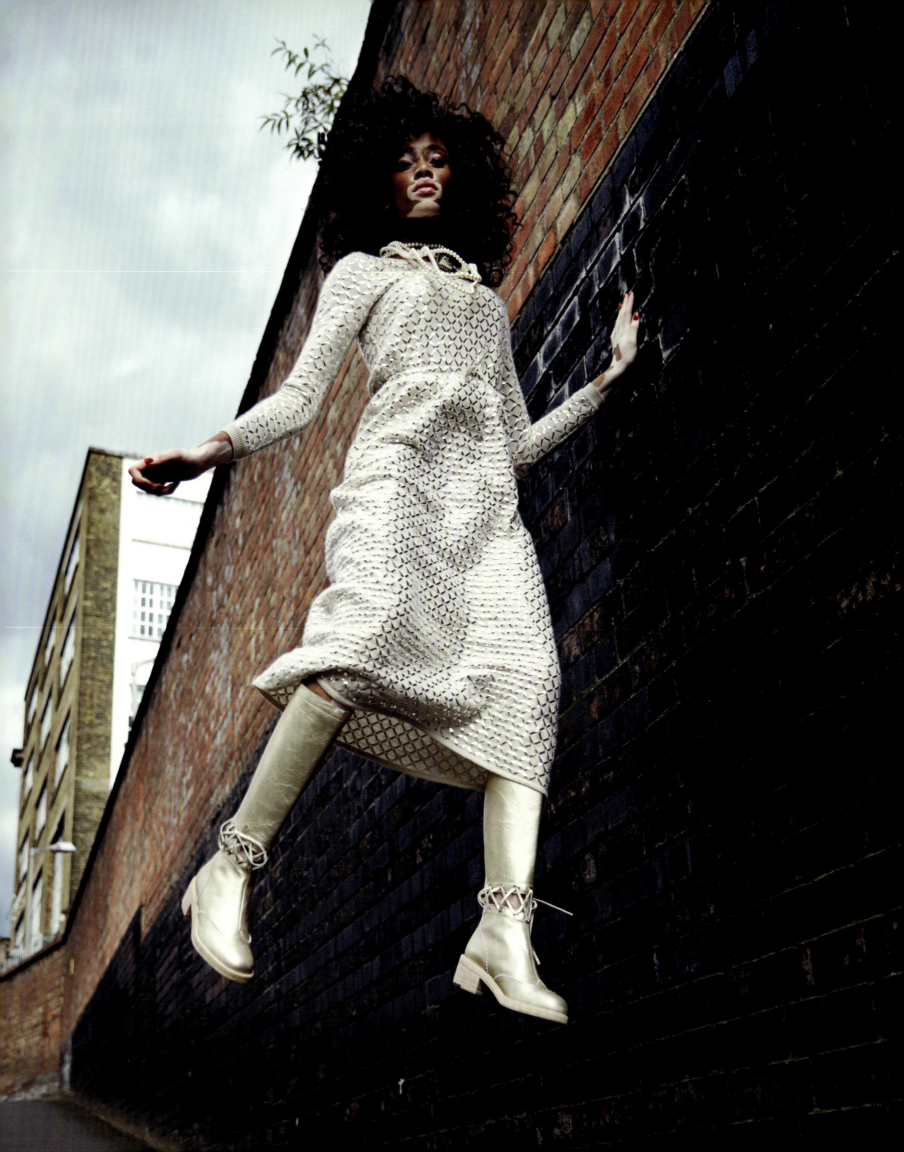

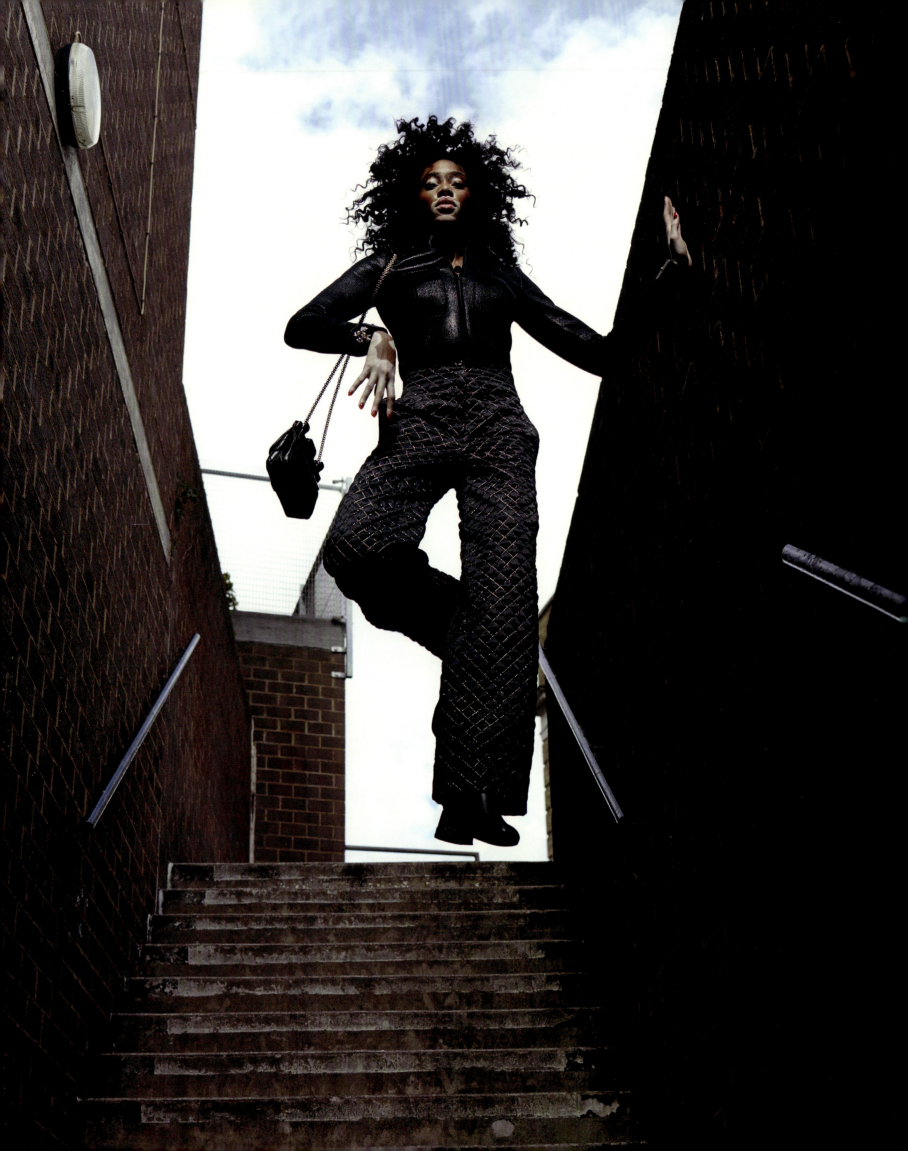

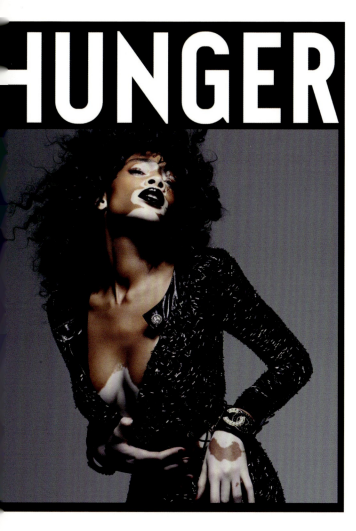

Being on a Rankin set is always dynamic and collaborative—well at least I've found them to be! He usually listens to suggestions and opinions; you just have to be brave enough to give them! I started my career on set with him, so didn't really know any different. I really think being part of his team at the very start of my career has given me huge confidence creatively.

 I don't live and breathe fashion, but I love the process of collaborating with talented people and creating beautiful work. Working with Rankin has given my career far more scope than I ever could have hoped, while still feeling like I belong to a team. Each image we've made brings back so many memories, but mainly of the wonderful people I've met along the way.

 I'd say that Rankin looks for honesty in his work. He doesn't have a specific style but his work is usually always direct, unapologetic, and confronting.

ANNA HUGHES-CHAMBERLAIN

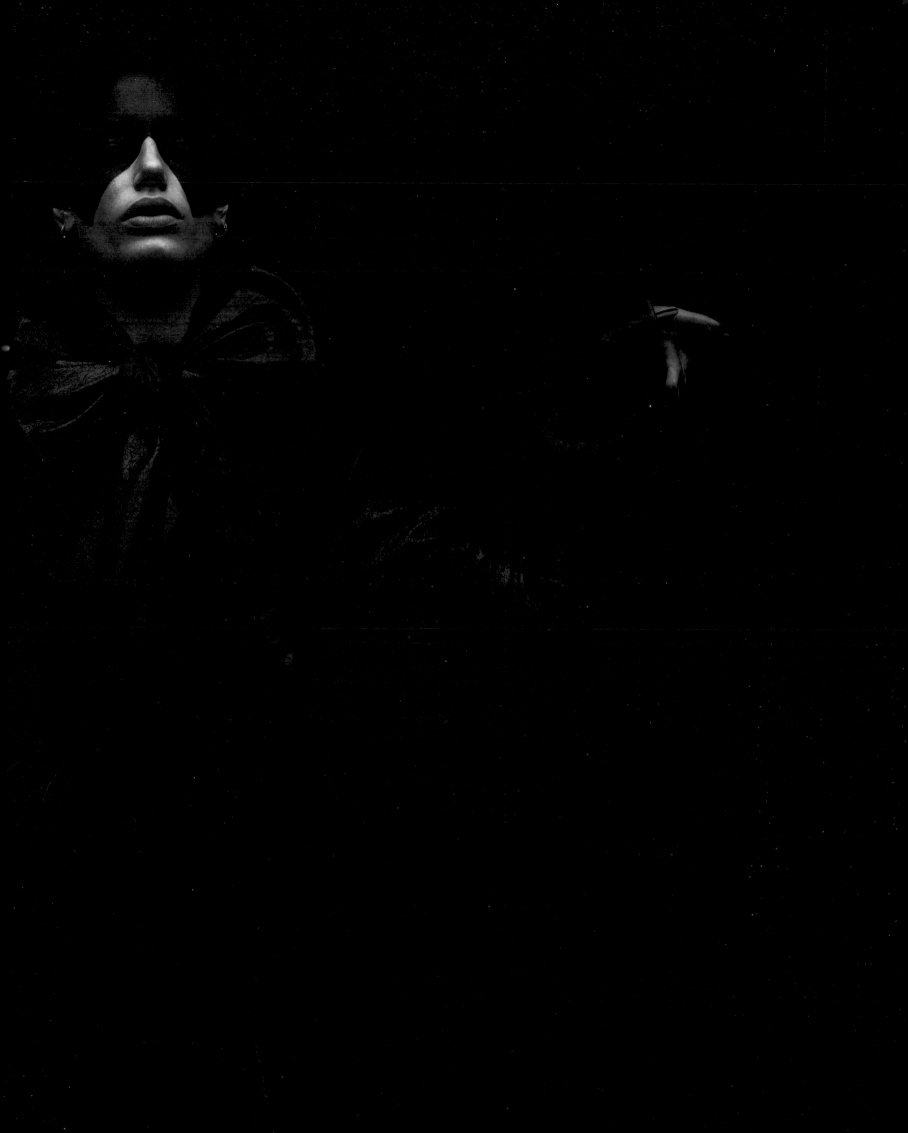

My favorite Rankin image? Oh god…. Well, I have to pick one of the ones I have done with him. I think it's got to be the Marc Jacobs special shoot. We did seven full-on make-up changes and he just captured each one perfectly in like three clicks of the camera. I was nervous about it, but he just got it perfectly. It's awkward and it really conveys the characters that were created.

HOLLY SILIUS

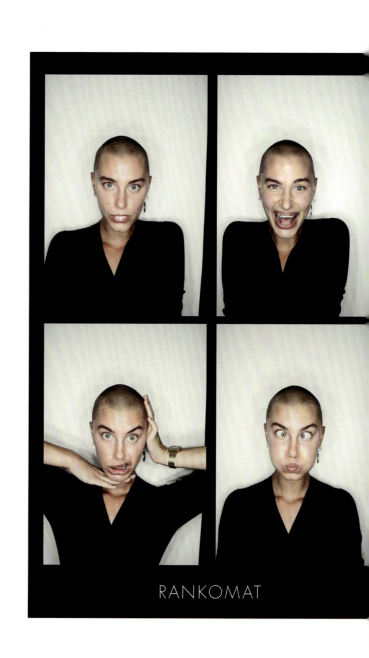

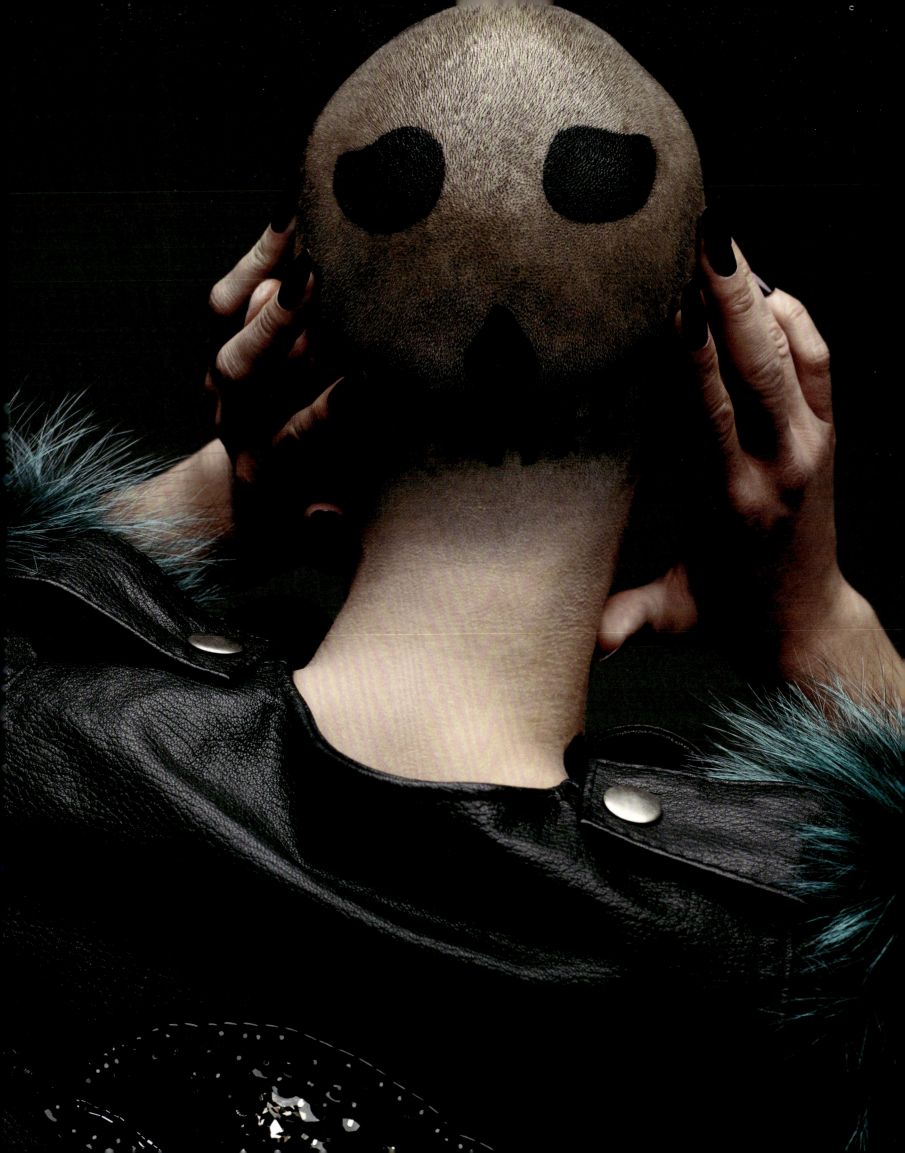

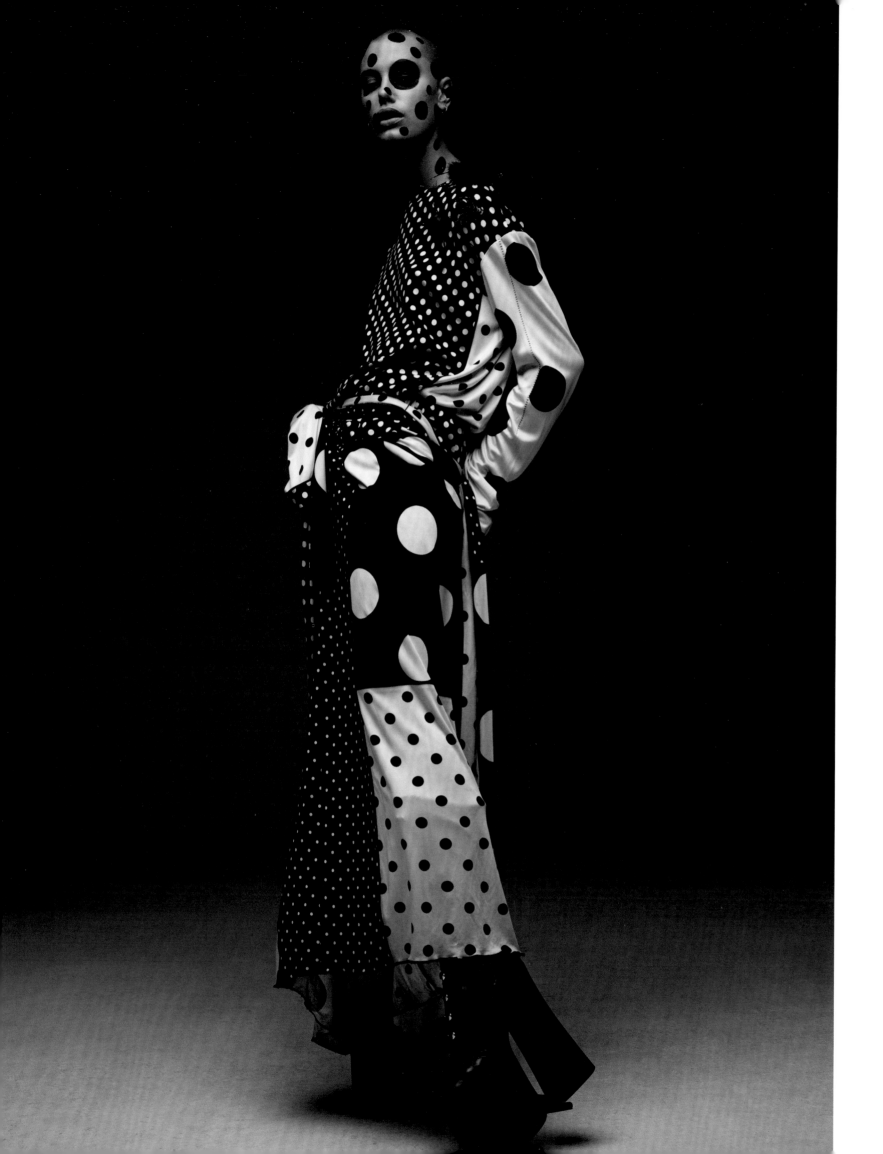

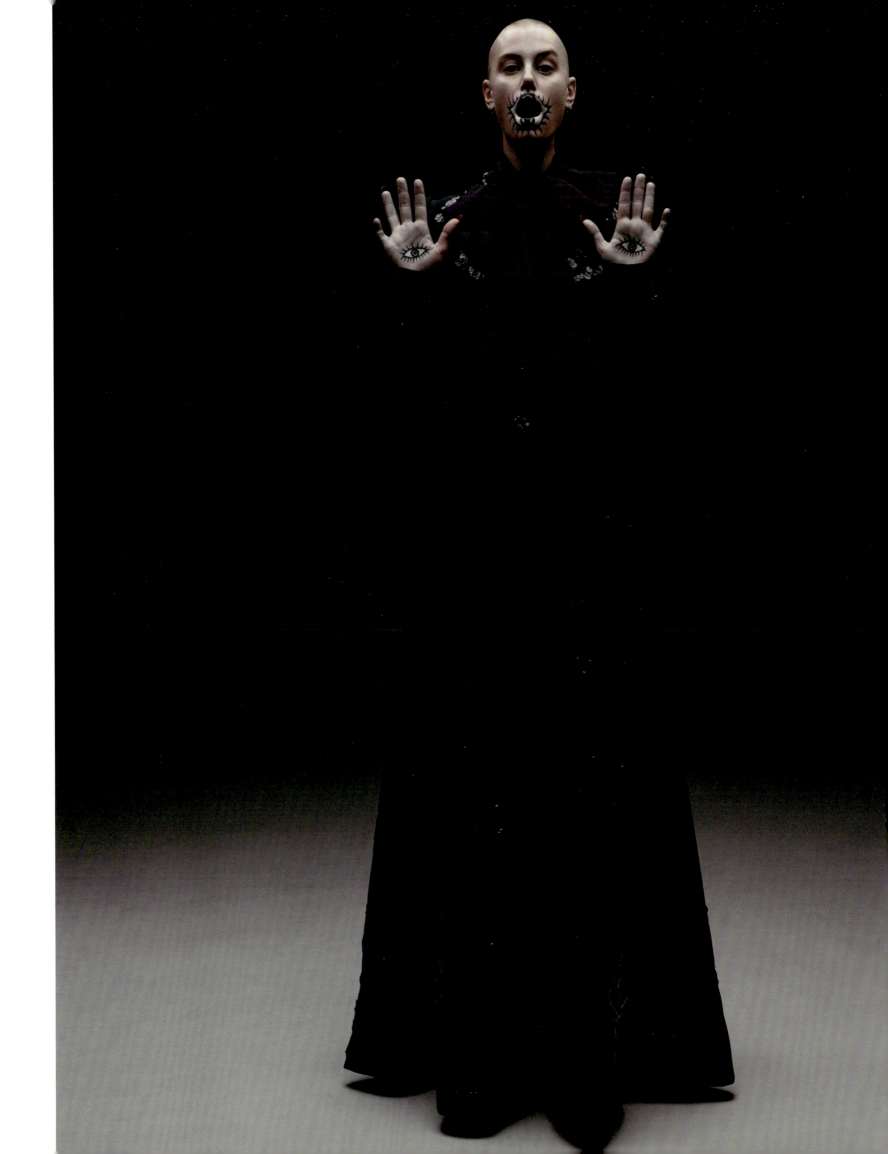

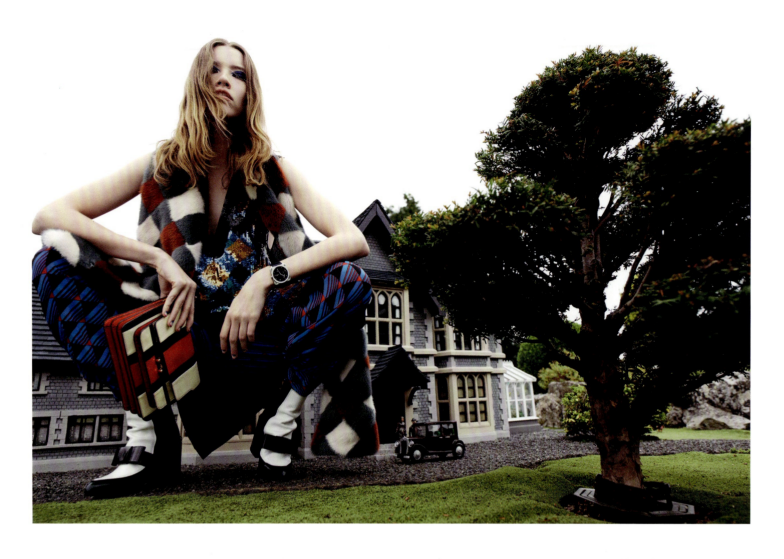
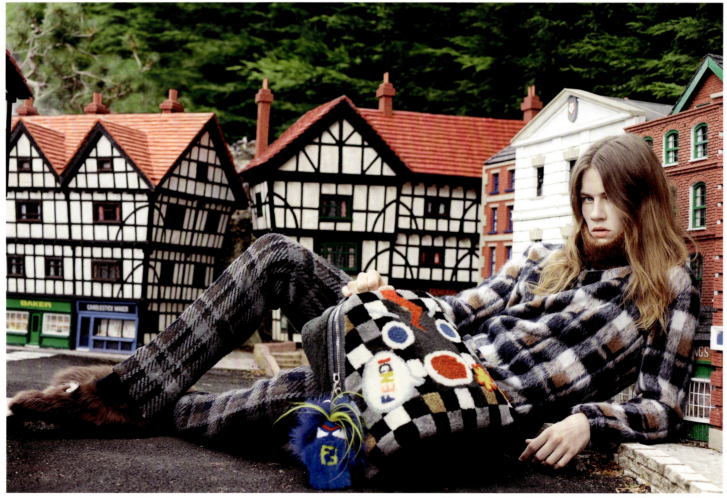

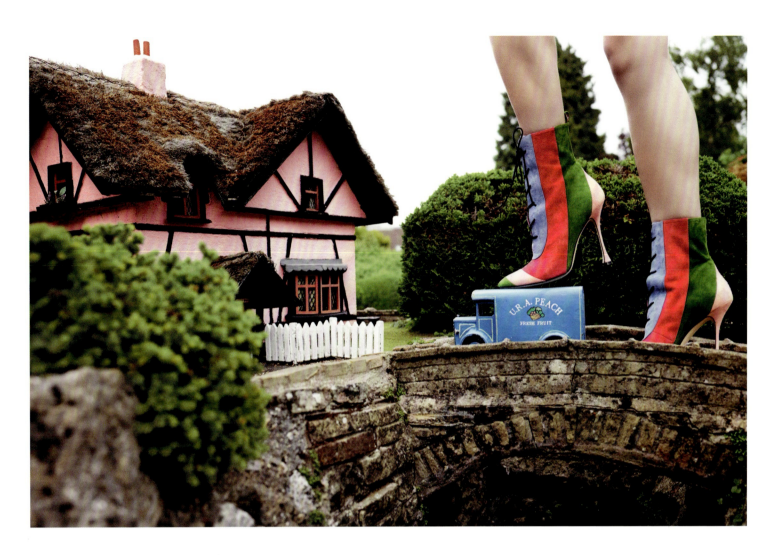
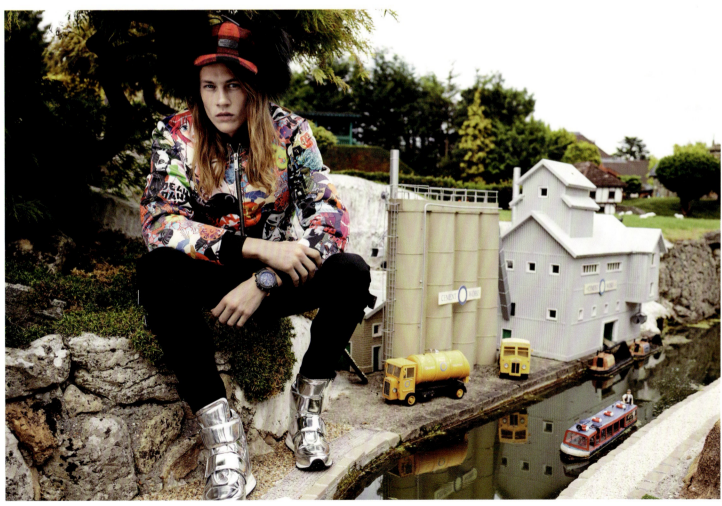

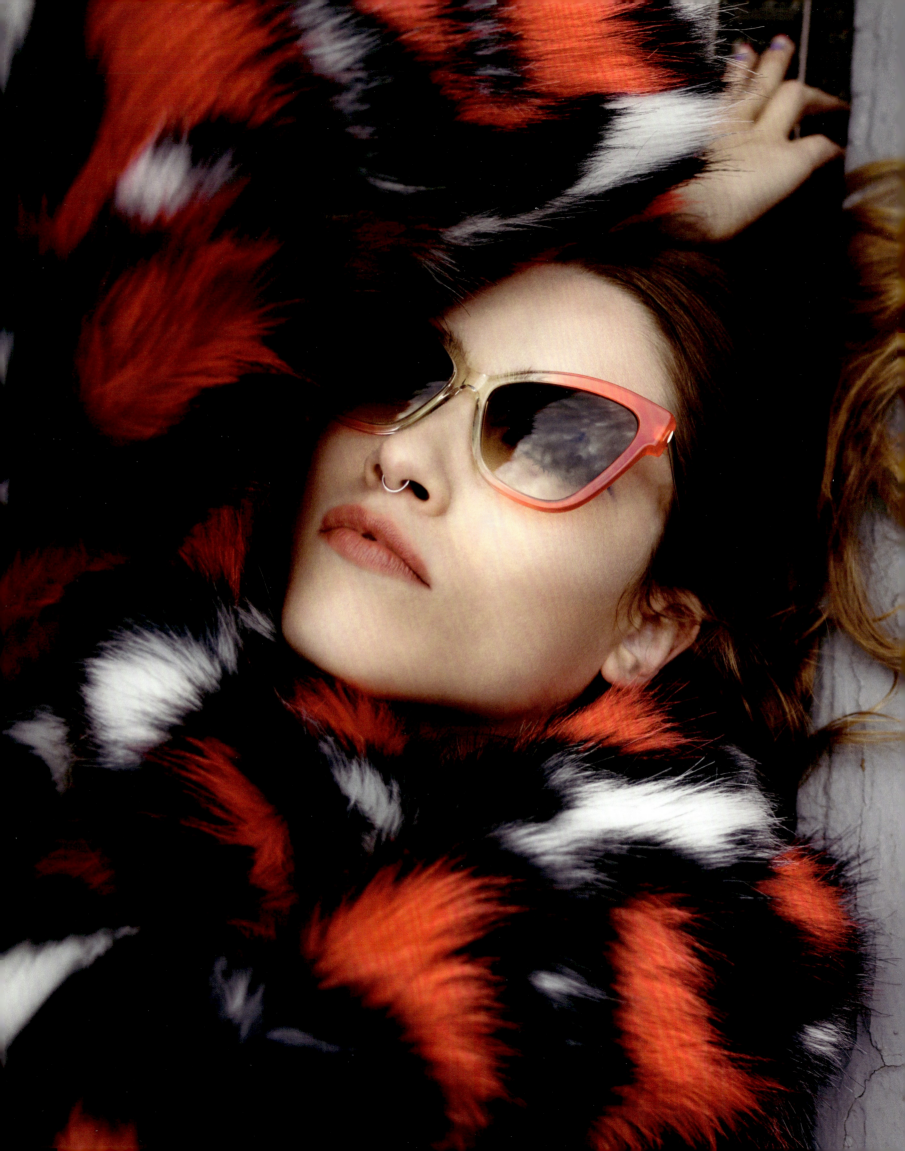

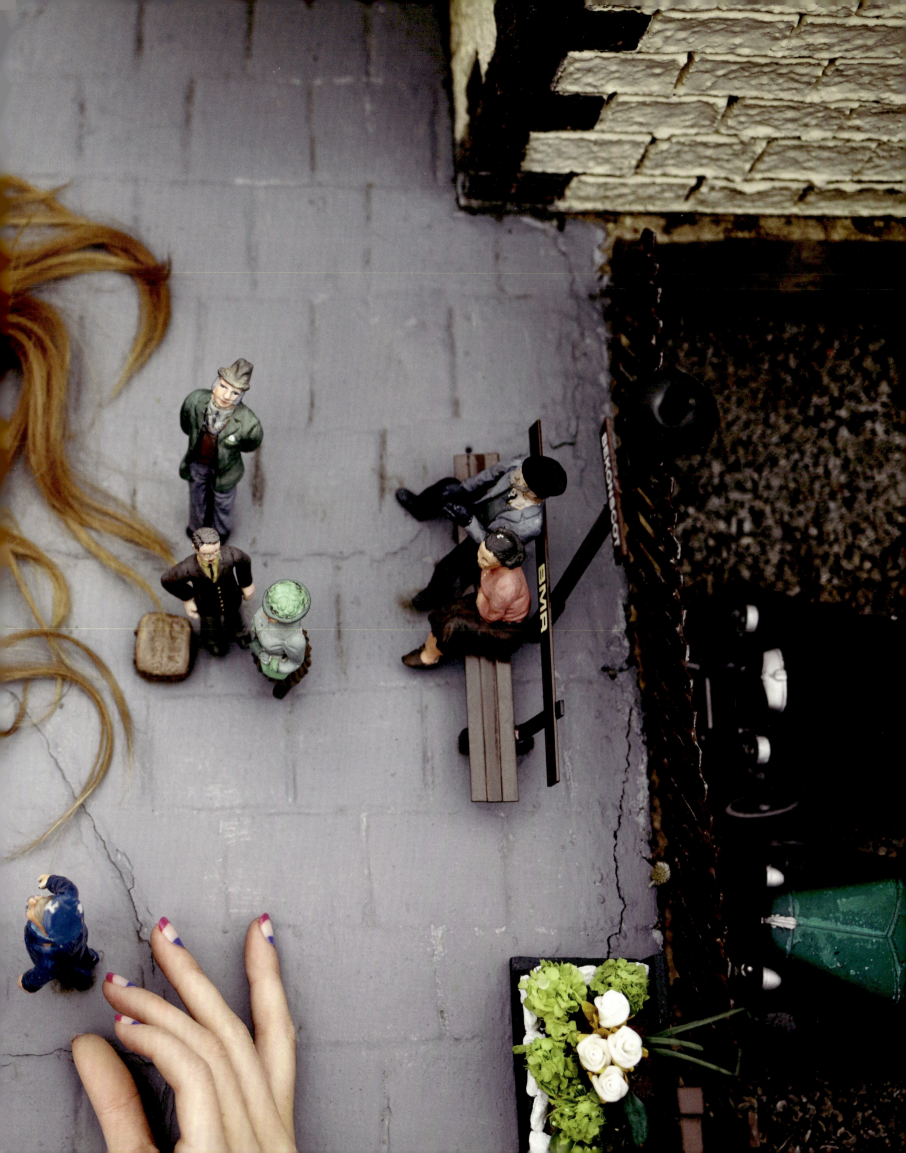

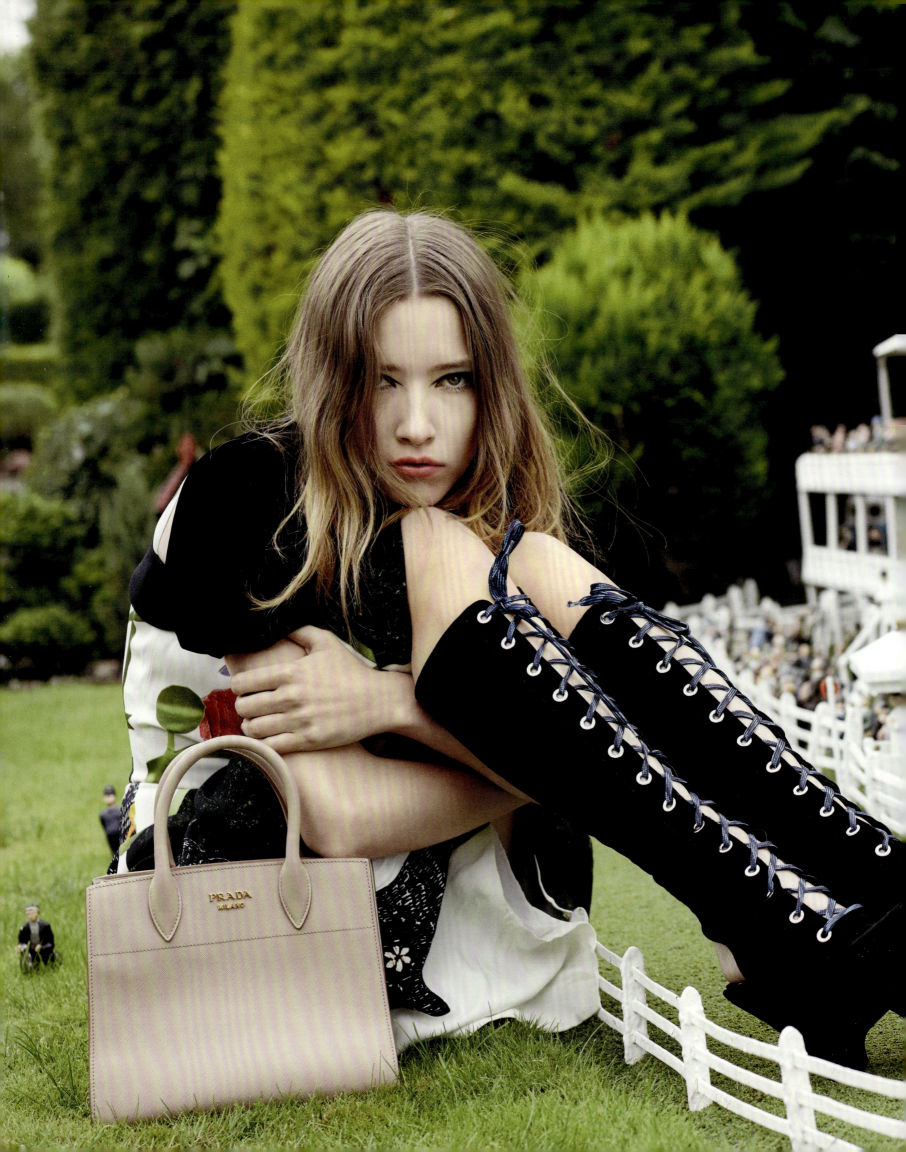

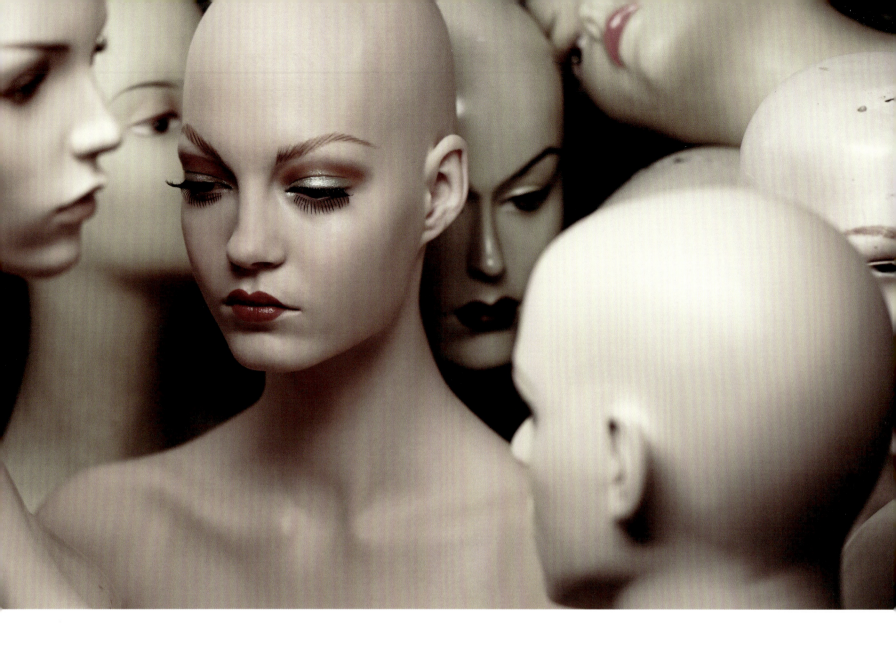

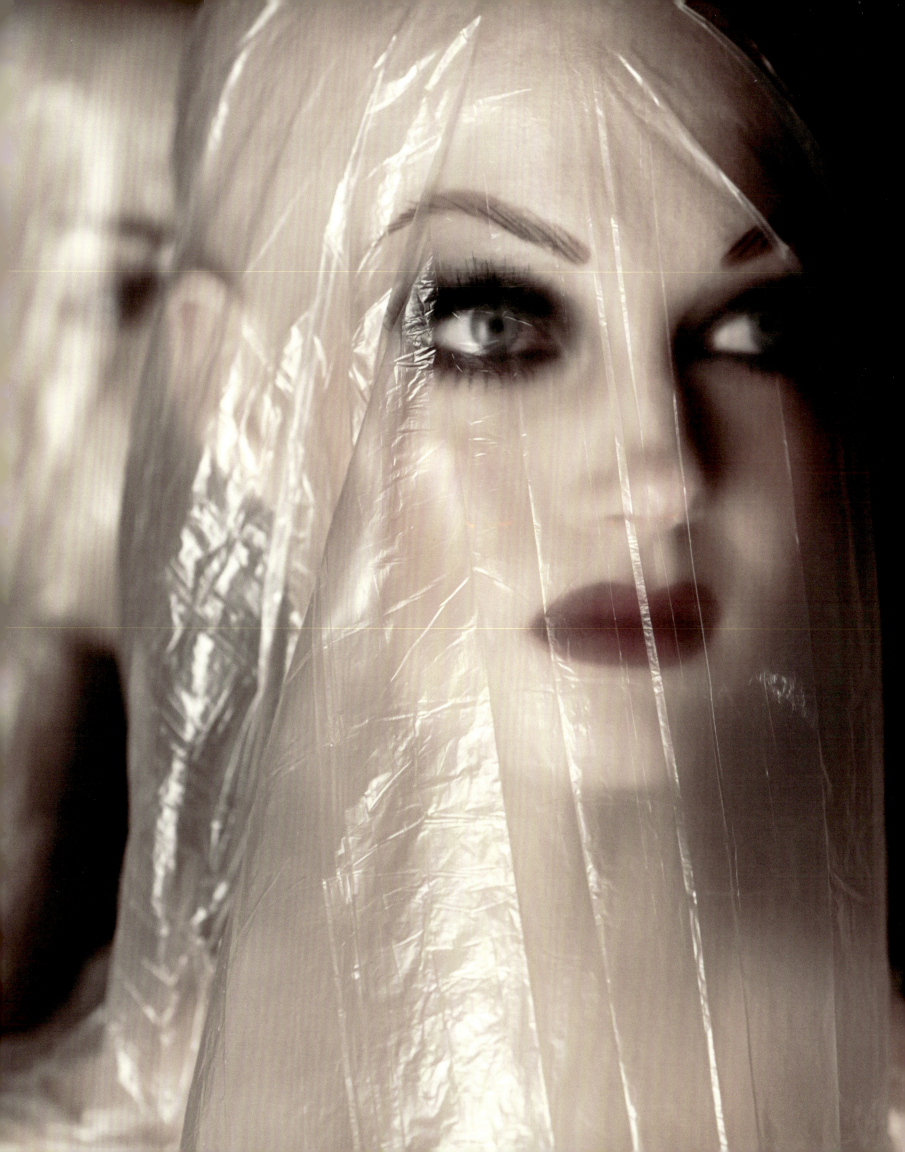

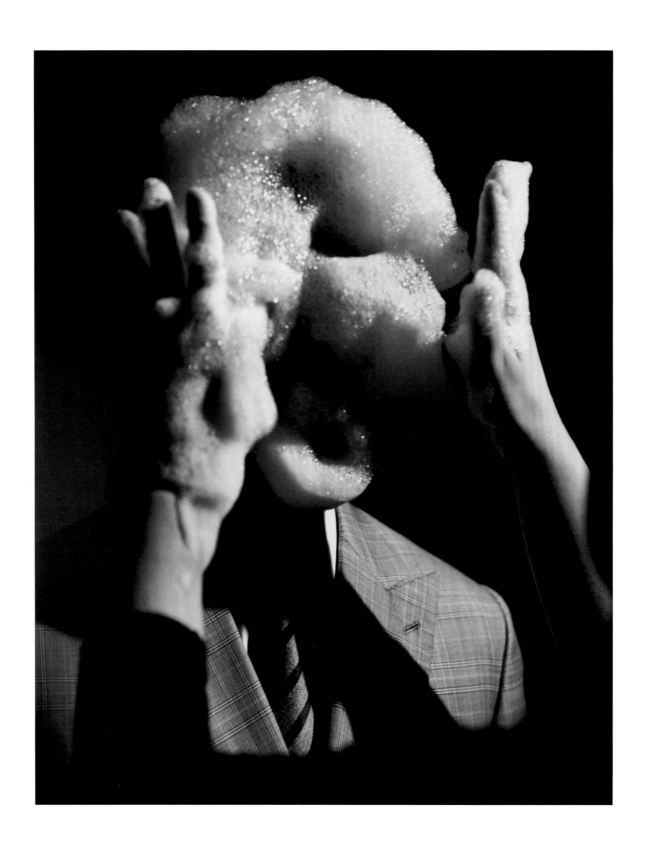

2016–2011

All the Young Kooks
Chin Up
Red Hair Don't Care
Strip
Less Is More Make-Up
Head in the Clouds
Right Way Up, Wrong Way Down
Distorted
The Fearless
The Drop
Crystal Amaze
It's Not That I'm So Smart; I Just Stay With Problems Longer
Coco Cavalli
Into the Mist
Welcome to Oddity Park
Be Still, Beating Heart
Wrapped in Lucid Dreams
The Real Erin
No Yesterdays on the Road
Carbon Copy

His shots are hyper-real! I feel like Rankin captures a moment, but in an A+ way.... His portraits of people really capture the essence of the person, but they will look their best and amazing. In his fashion and beauty work, there's a slightly surreal quality to it, a kind of 'moreness' to things—a transcendental quality.

ANDREW GALLIMORE

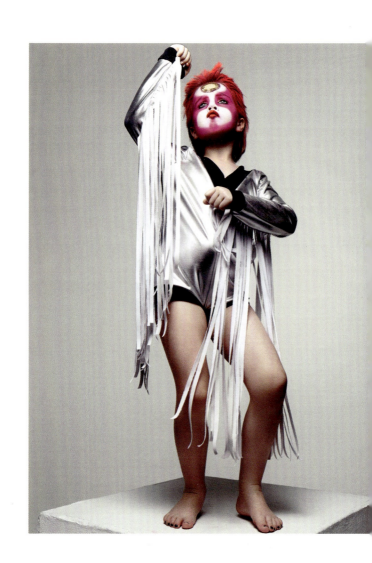

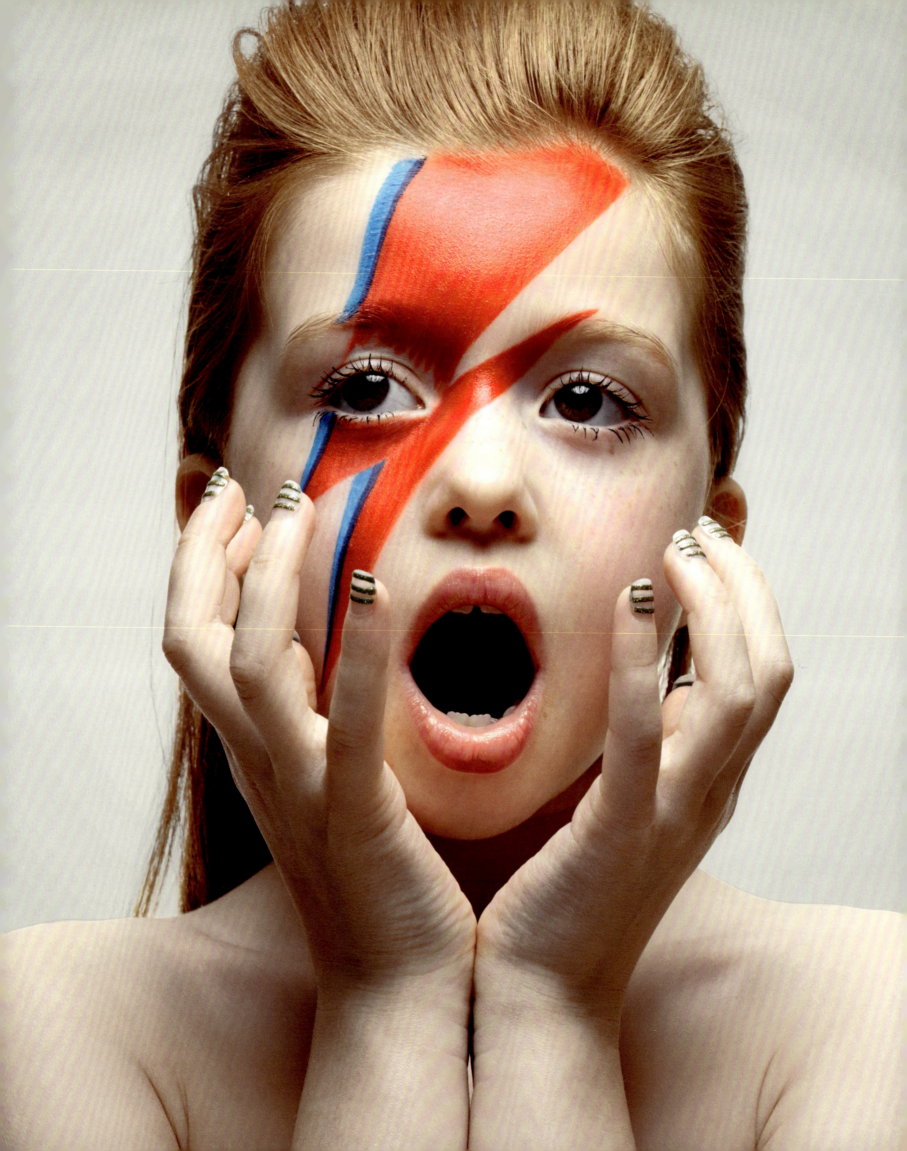

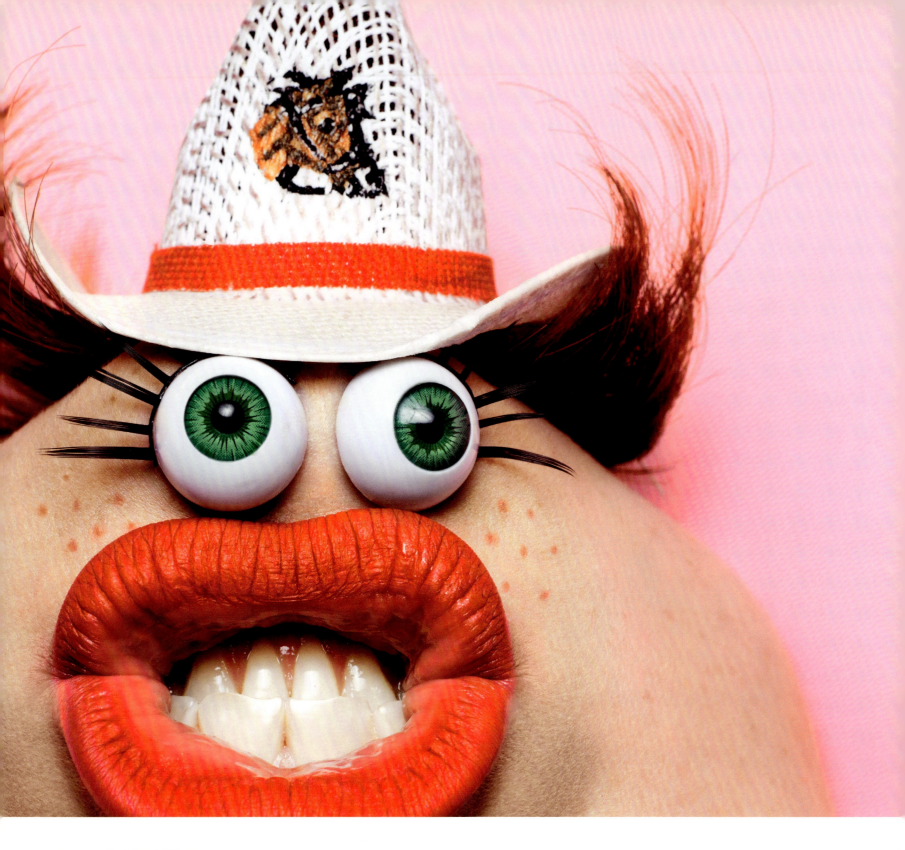

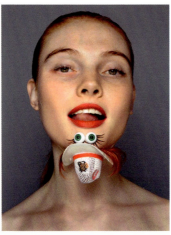

It's really clear from working with him that he enjoys strong personalities and people who can hold their own. He certainly doesn't suffer fools easily. The classic 'Rankin Model' is probably a girl with a bit of attitude, cheek, and sex appeal. I'll let others decide if that applies to me....

GEORGIE HOBDAY

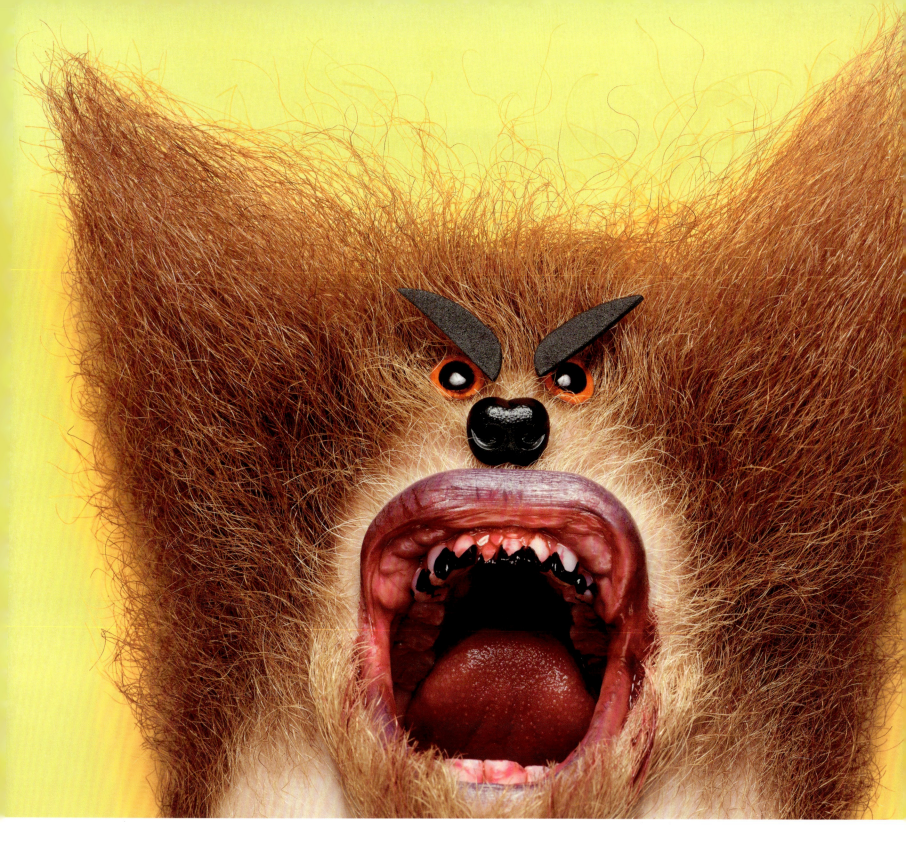

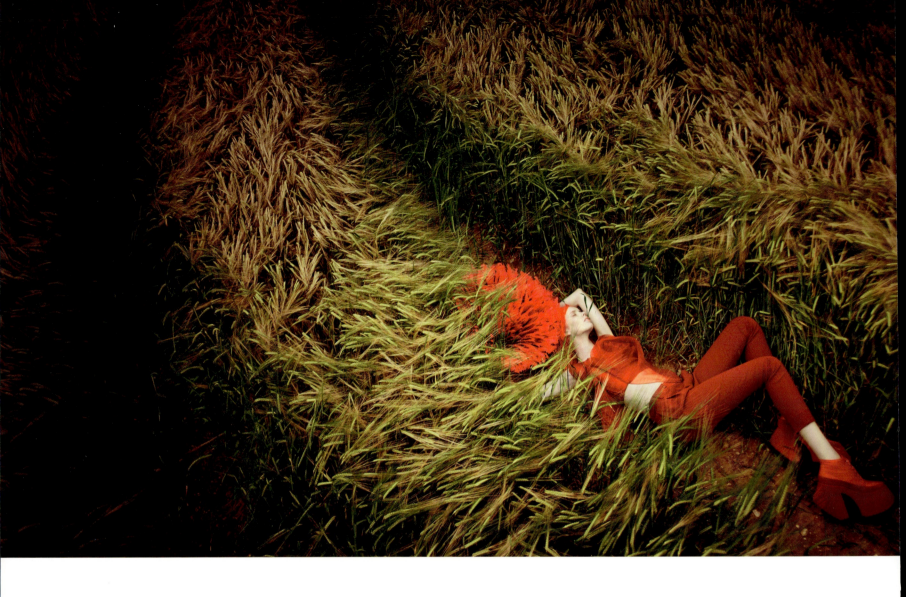

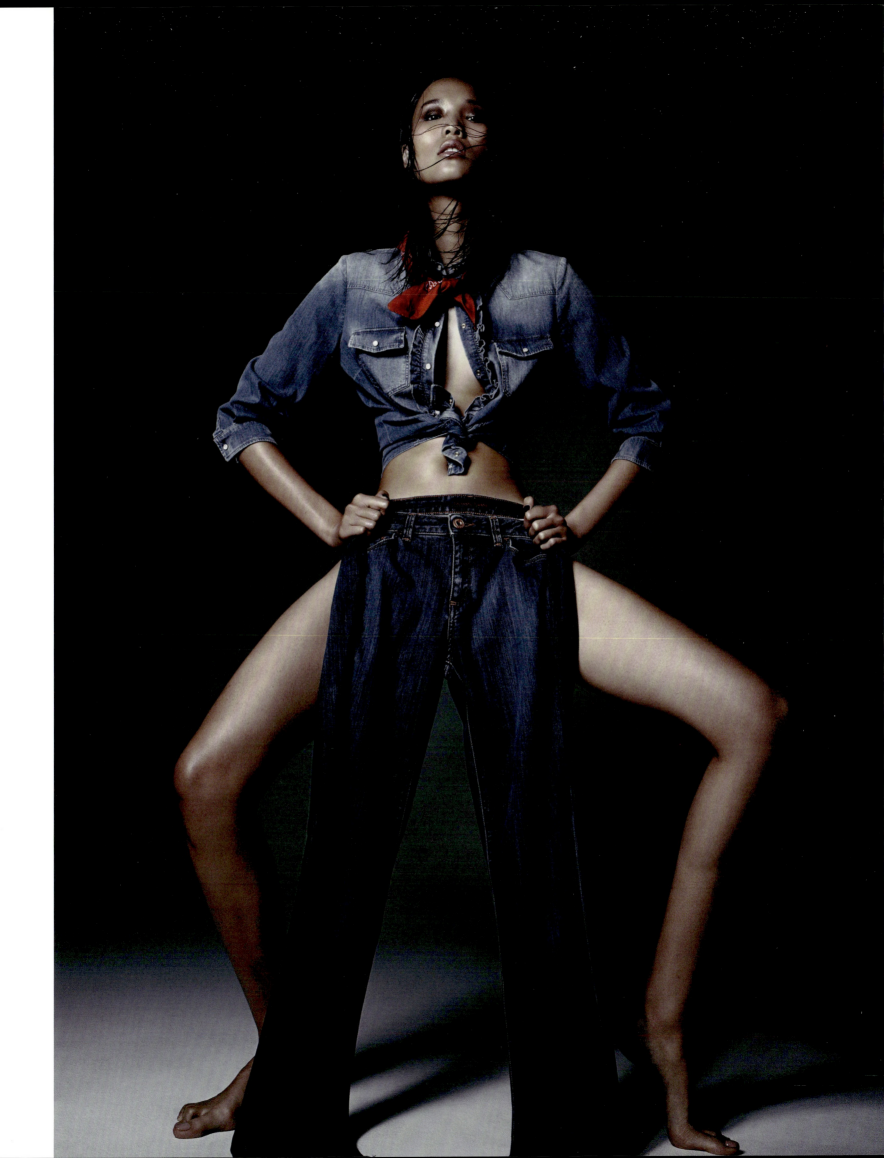

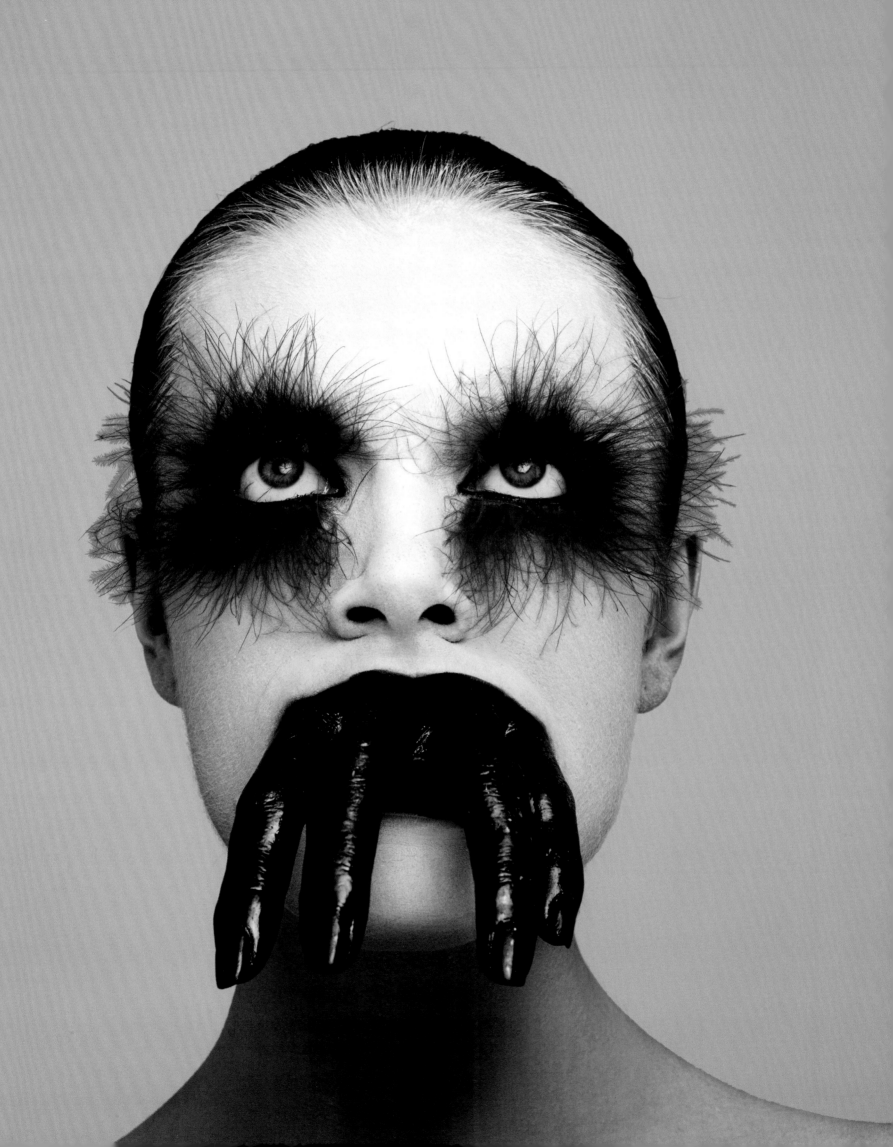

When I met Rankin I was sixteen, and it was my first big shoot with a big-deal photographer. I remember being very nervous and hoping I'd make a good impression. It was all a bit surreal.

Shooting with Rankin definitely feels like a collaboration, there is never a lot of direction. The ideas and feeling for the shoot are presented through the mood board, and then through the hair and make-up process you start developing a character, per se, and it builds from there.

When you're on set you want get an amazing picture, which is going to make the whole team happy and proud, but you're not thinking about all the other people that will see the final image and what they will think—at least I'm not. At the end of the day, these images are art, but when you're the model it's hard to see yourself in that light.

ELLEN BURTON

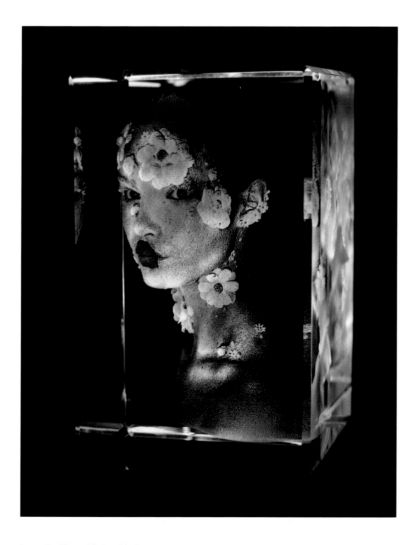 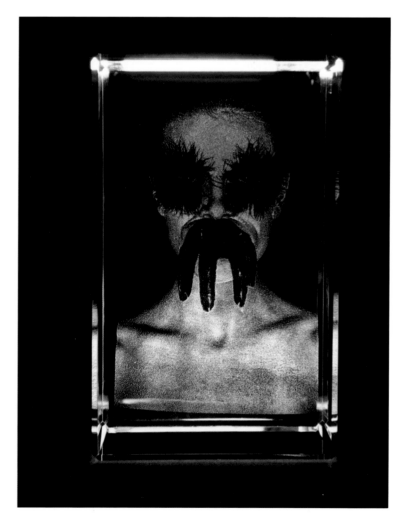

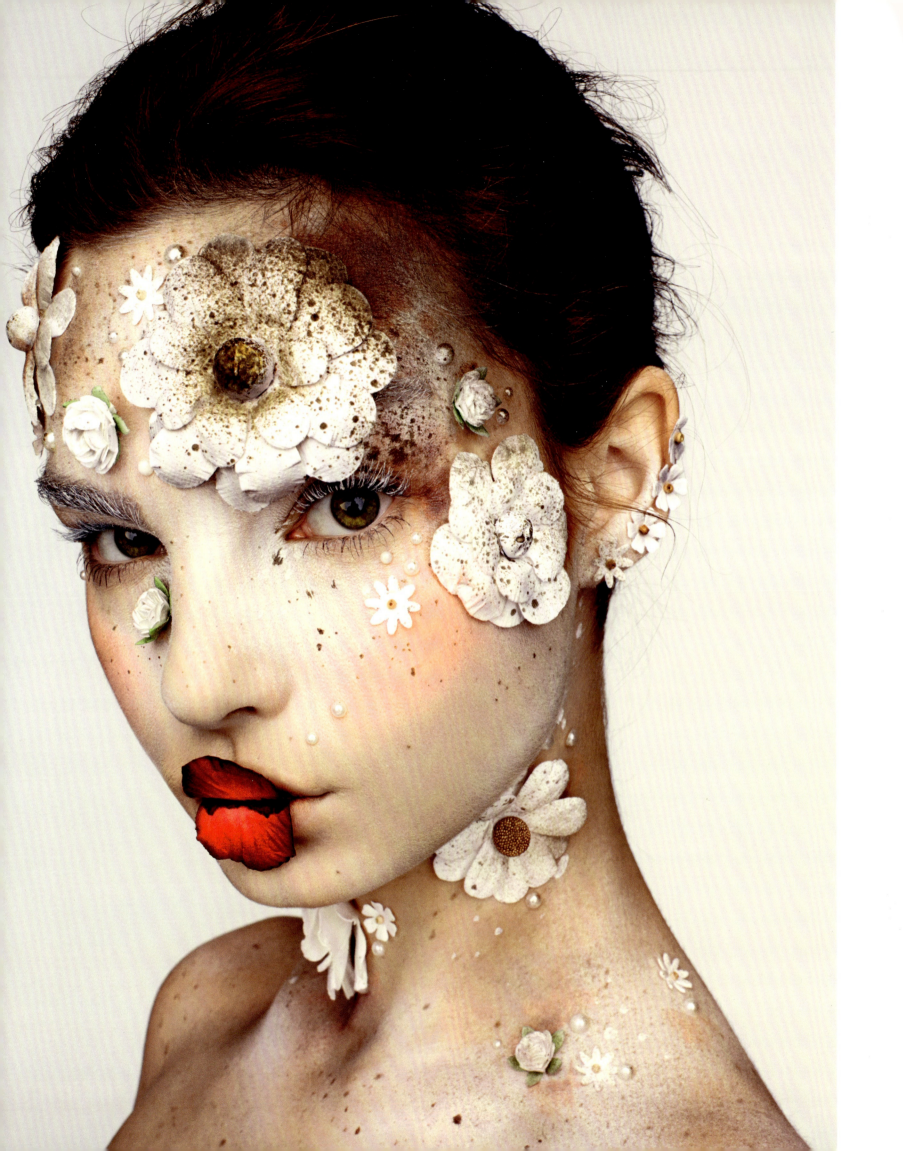

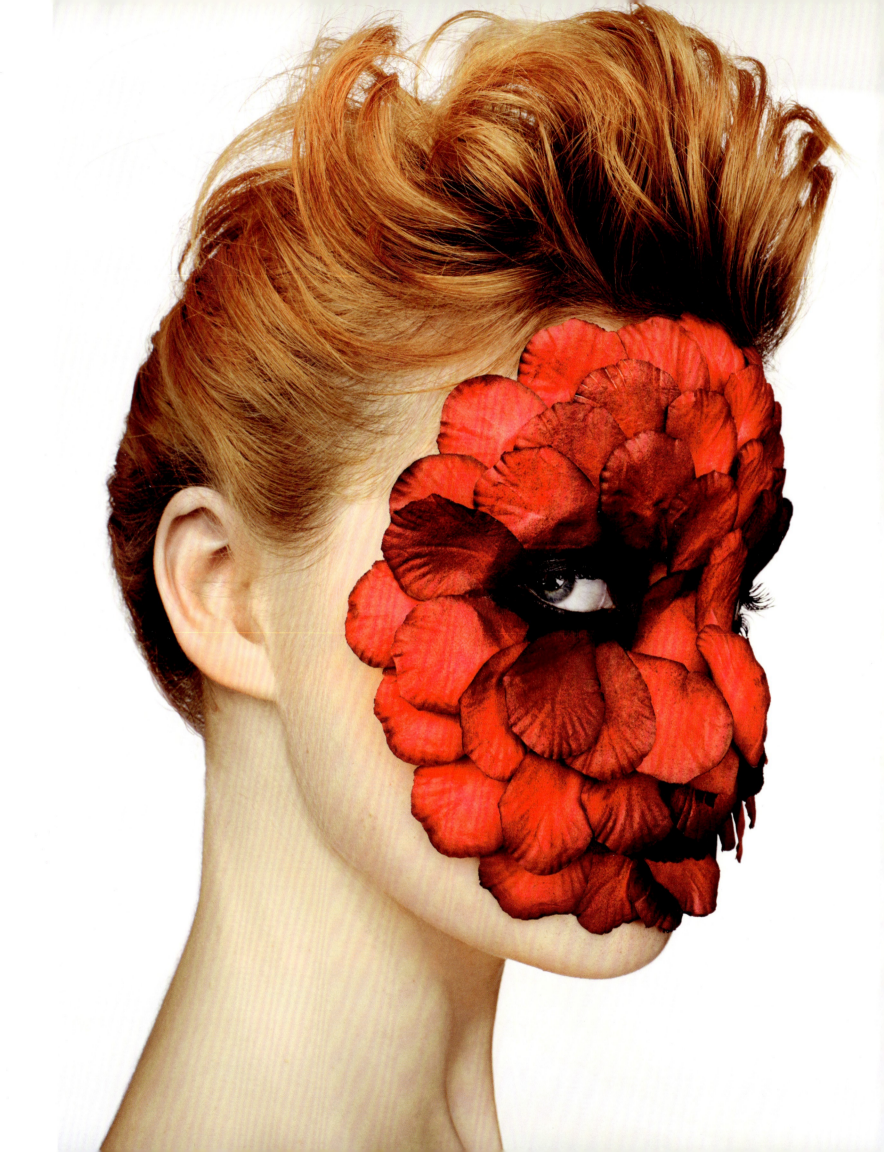

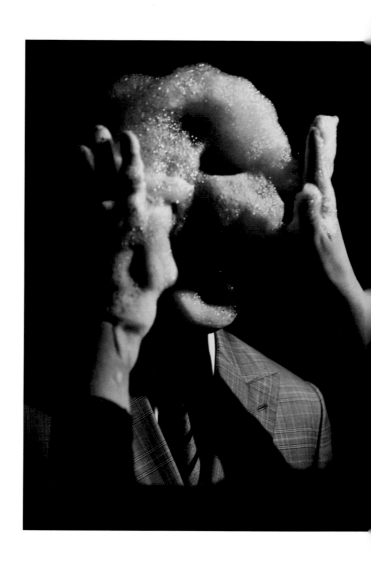

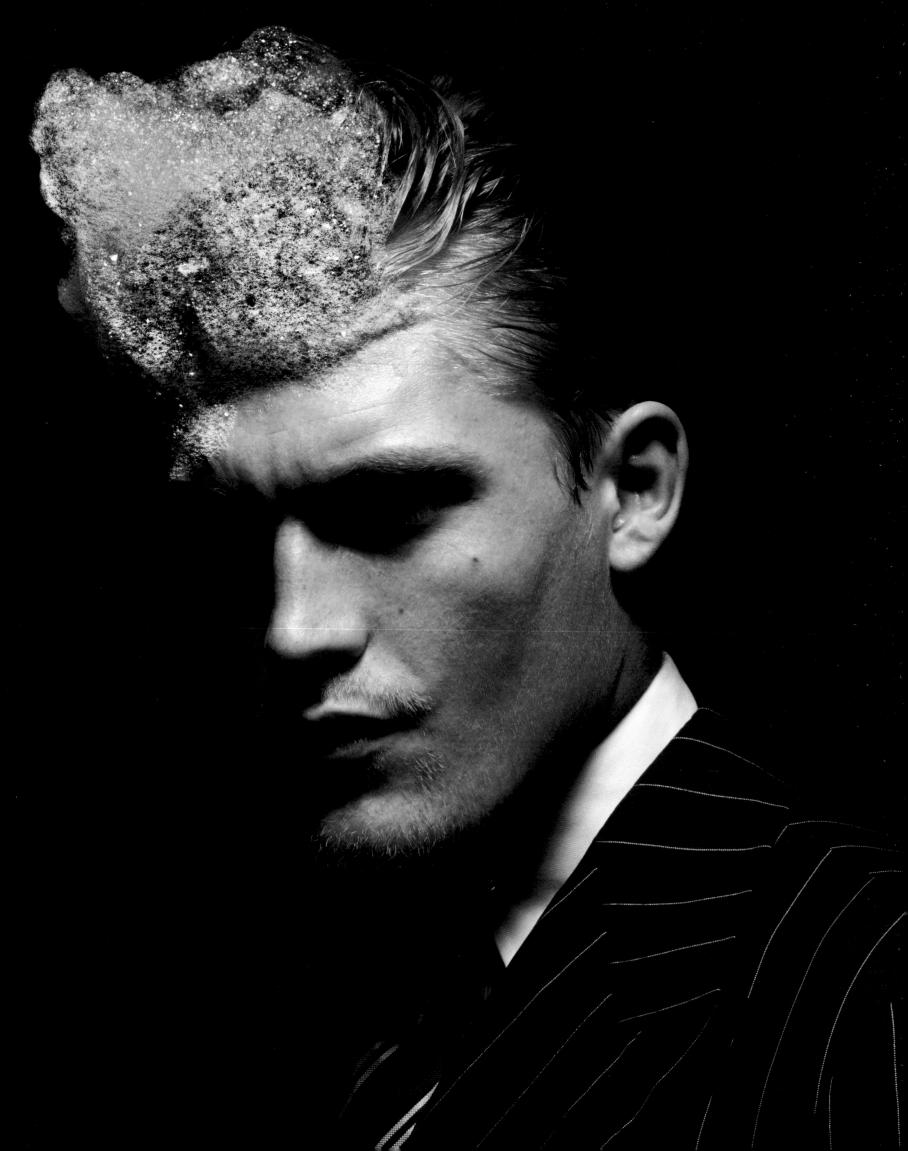

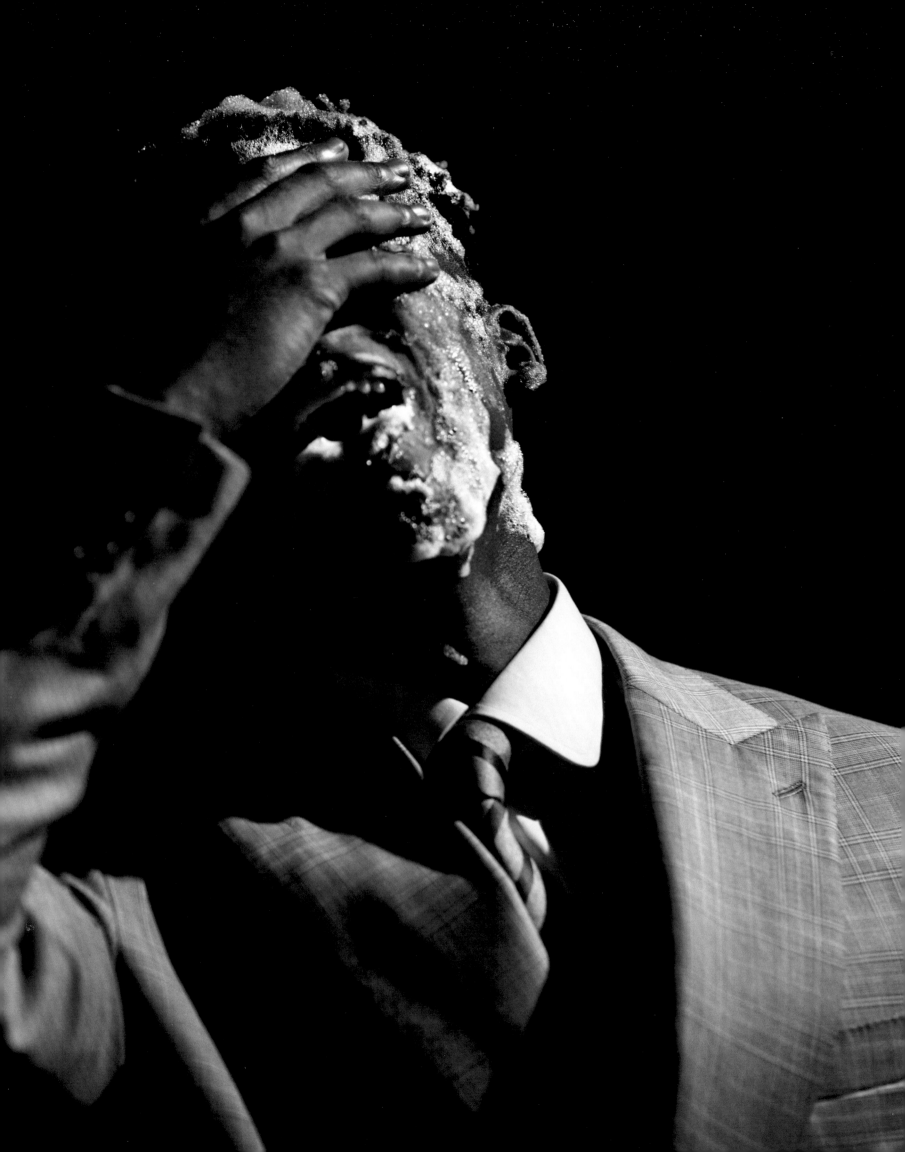

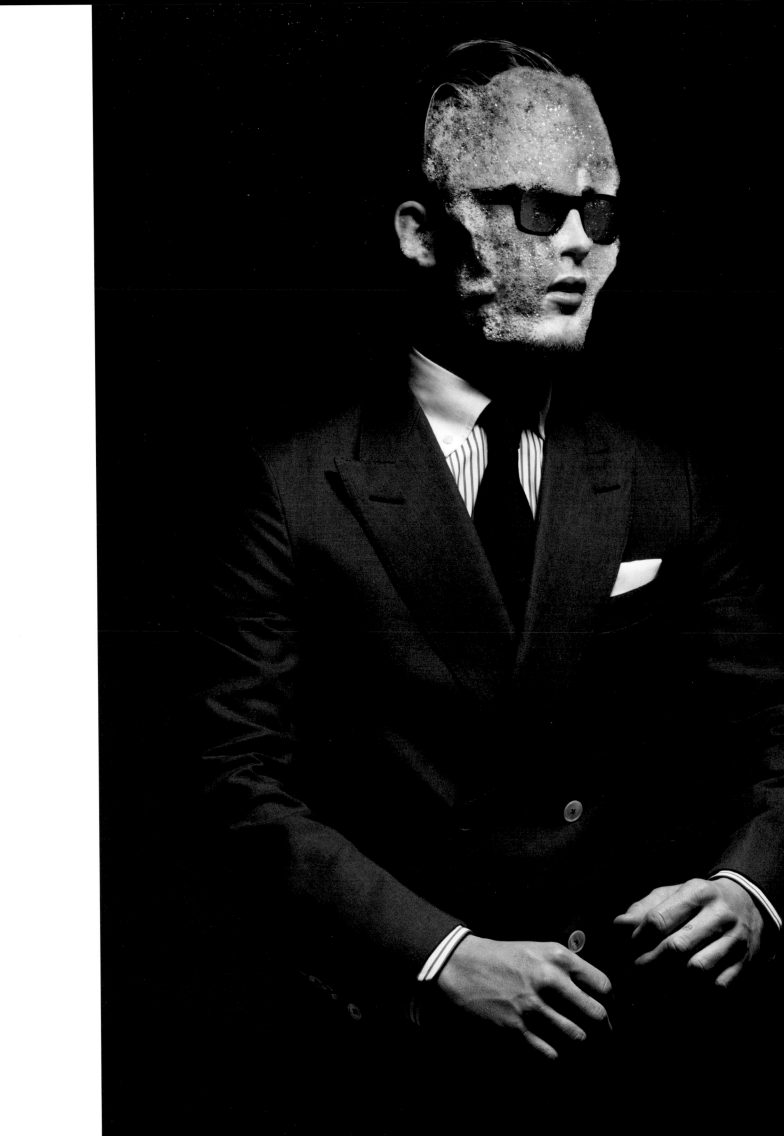

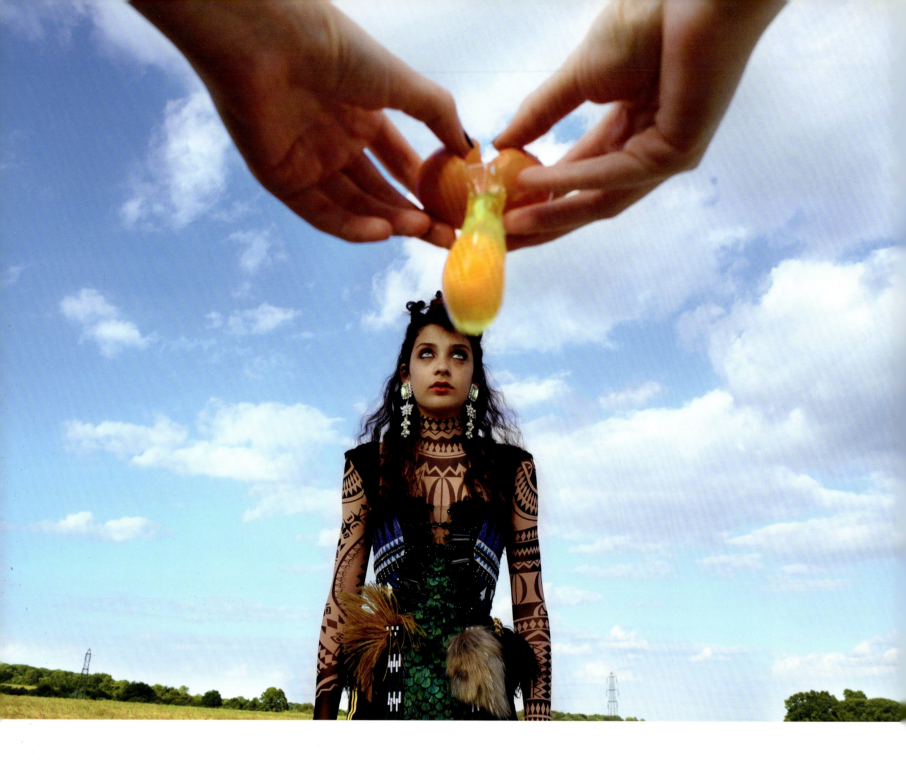

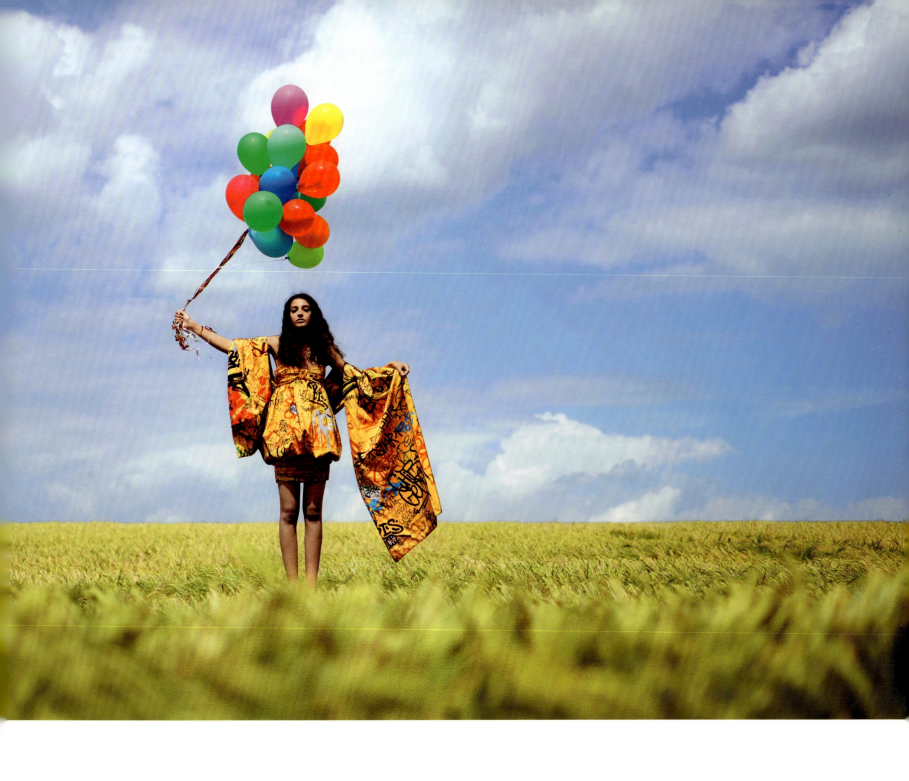

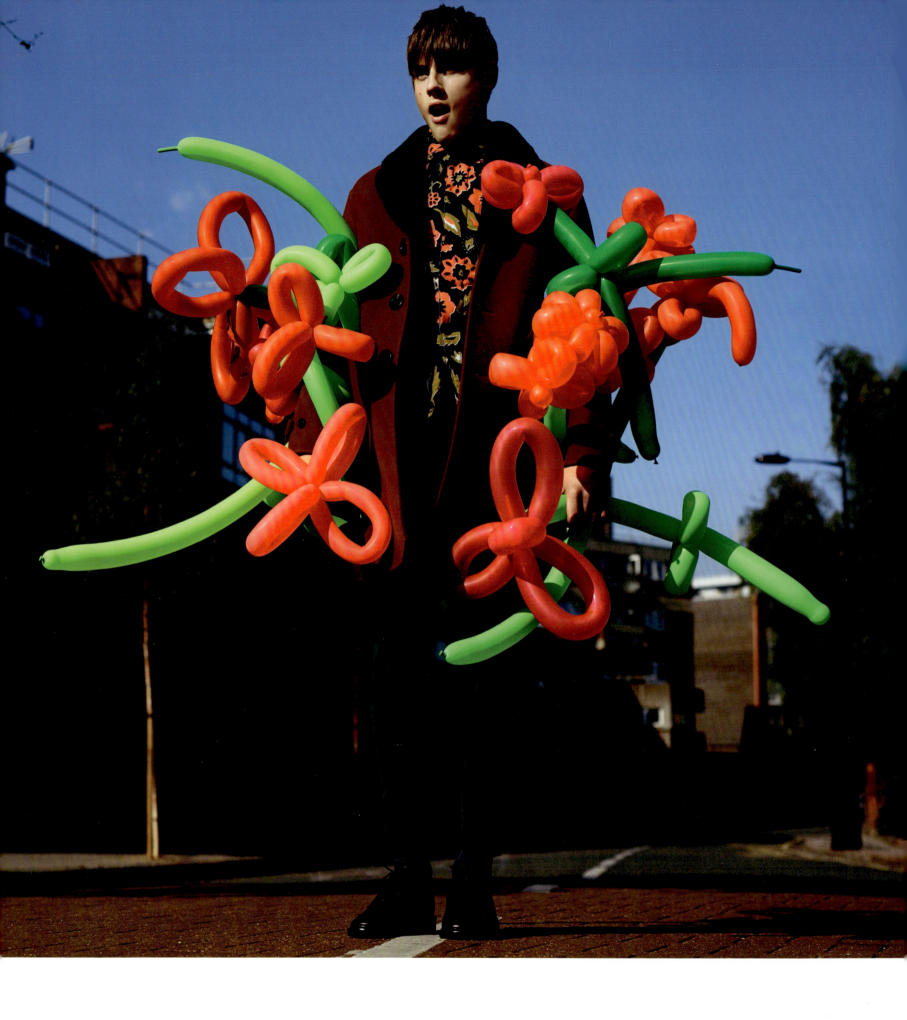

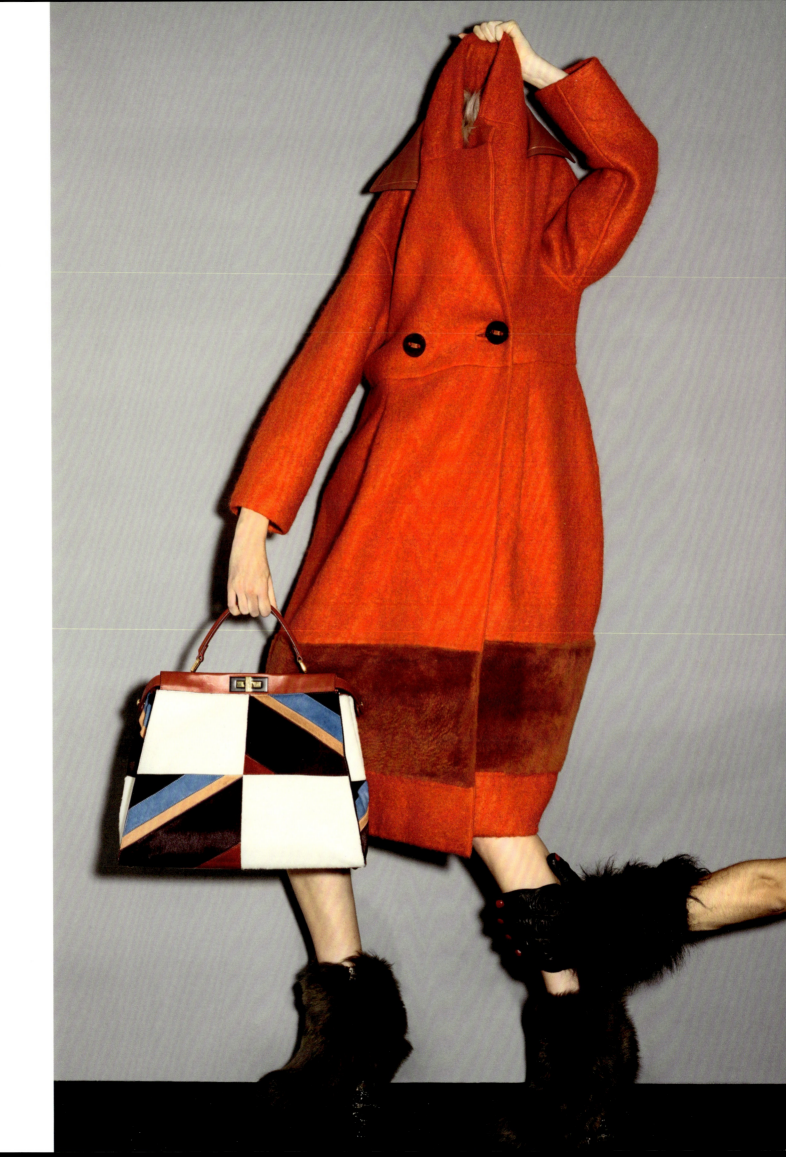

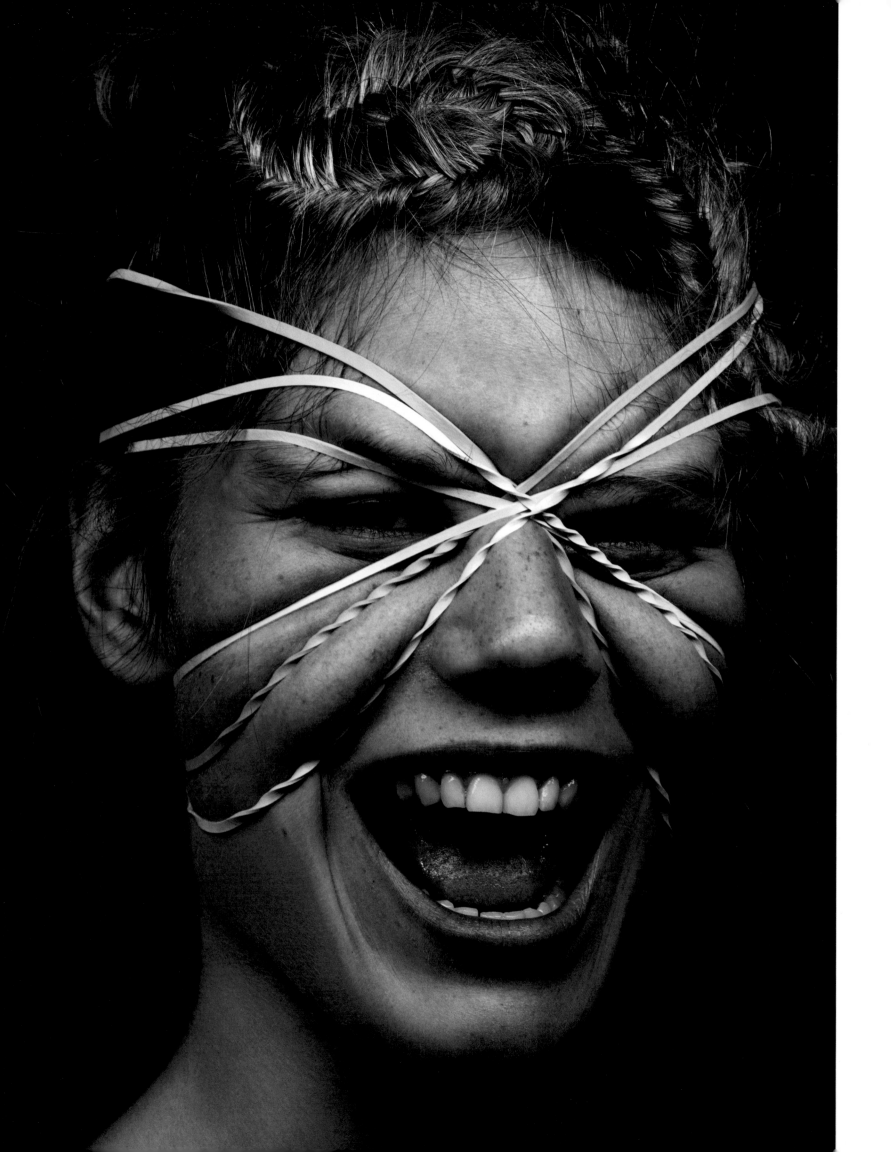

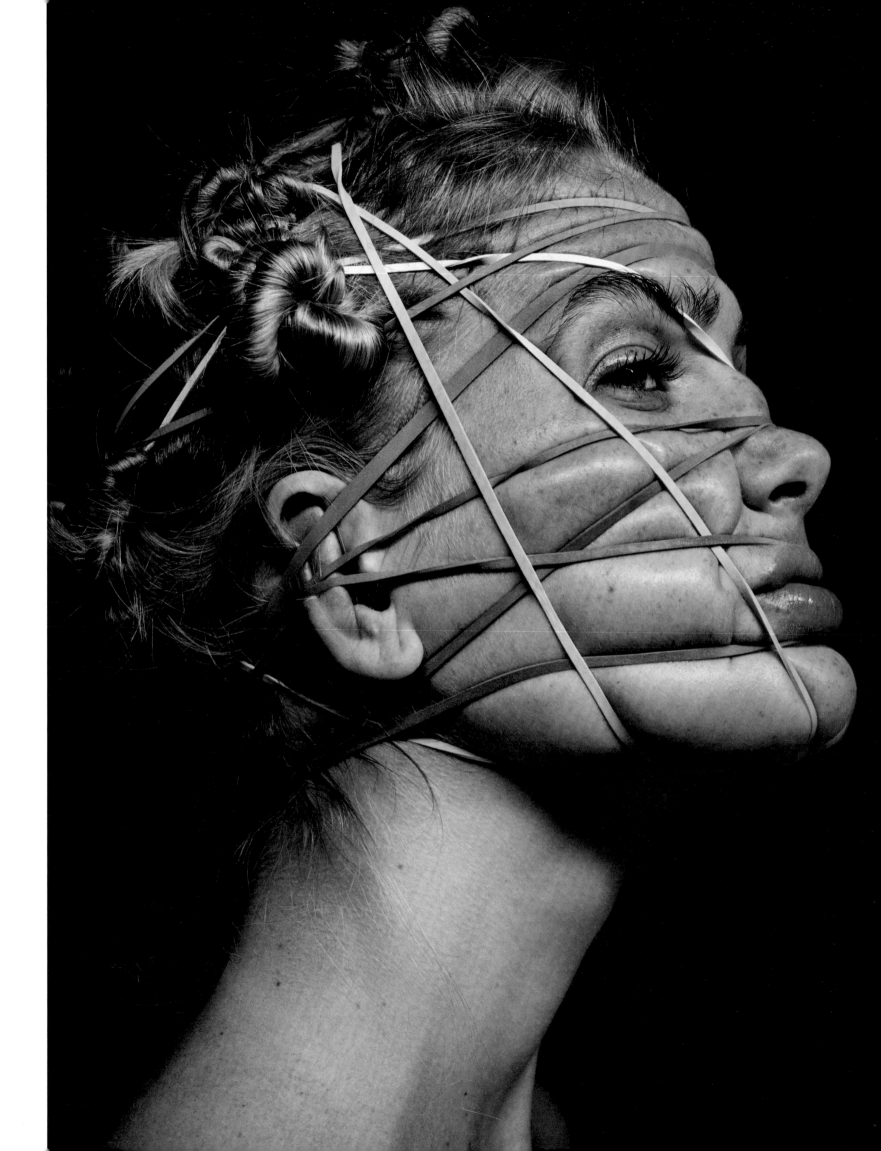

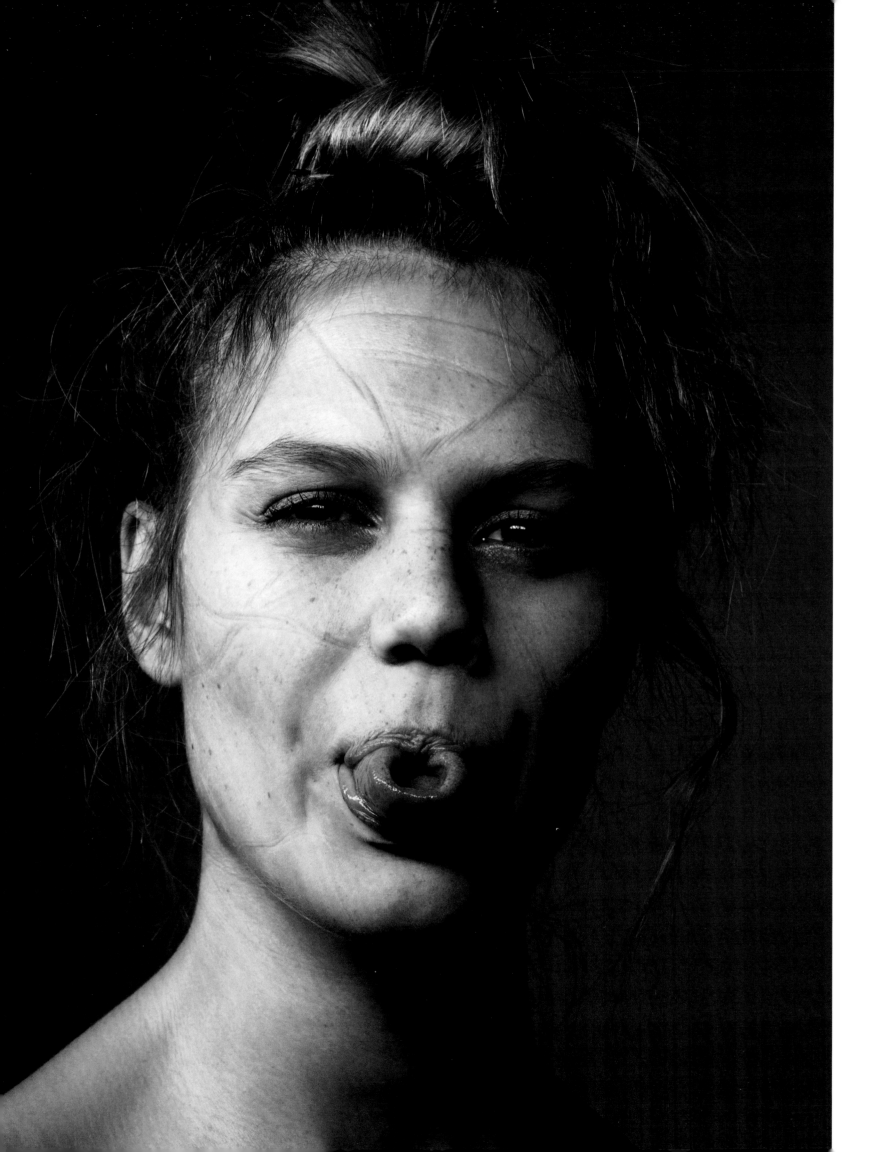

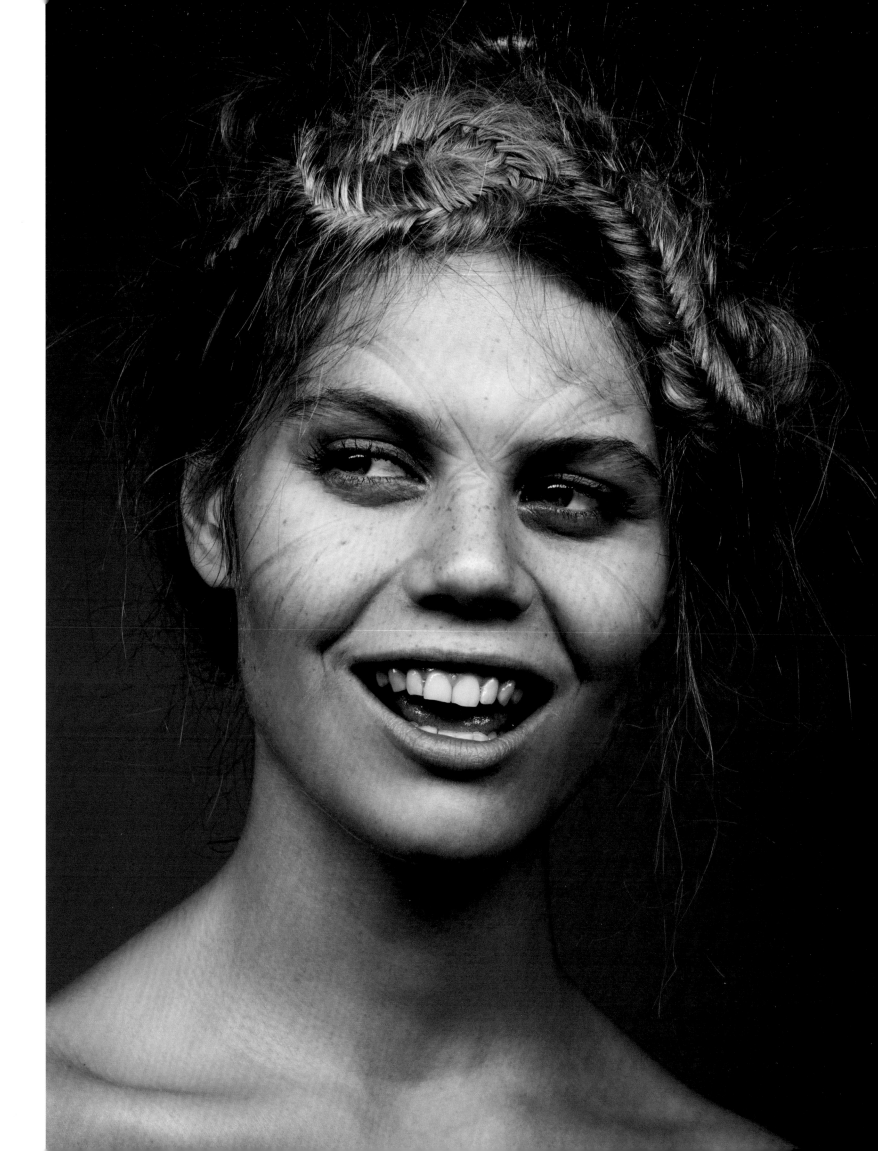

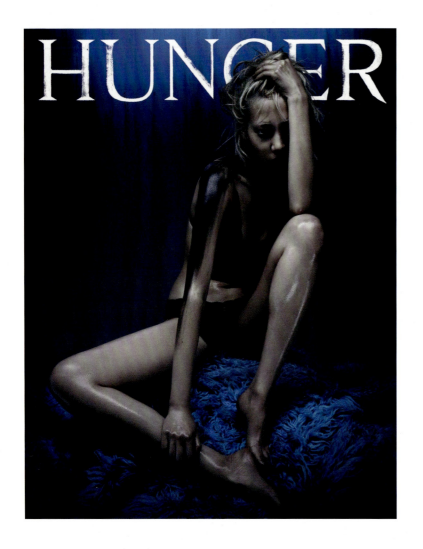
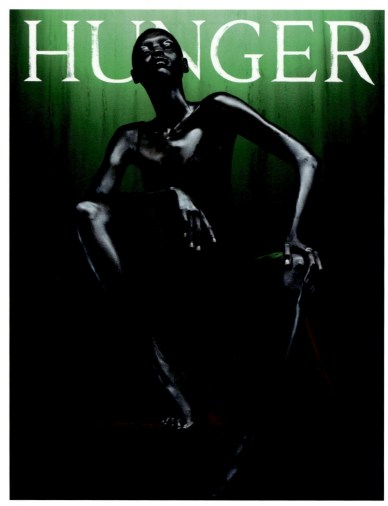
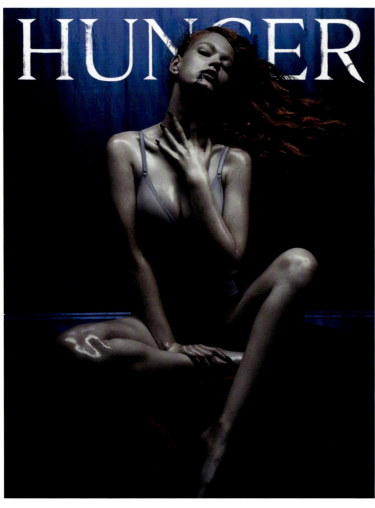
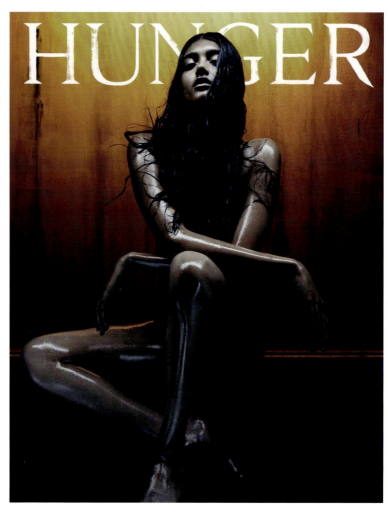

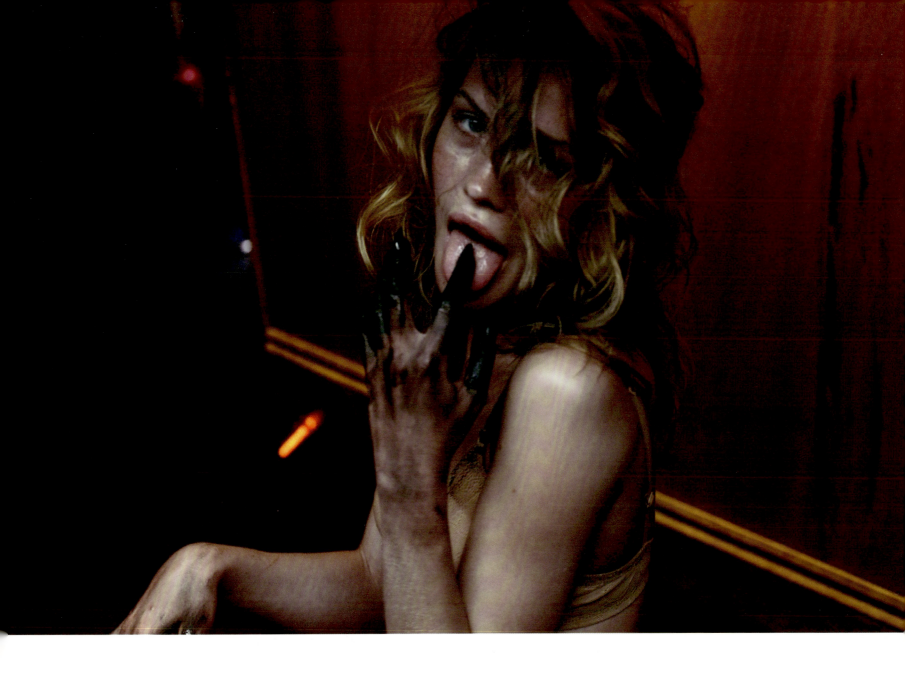

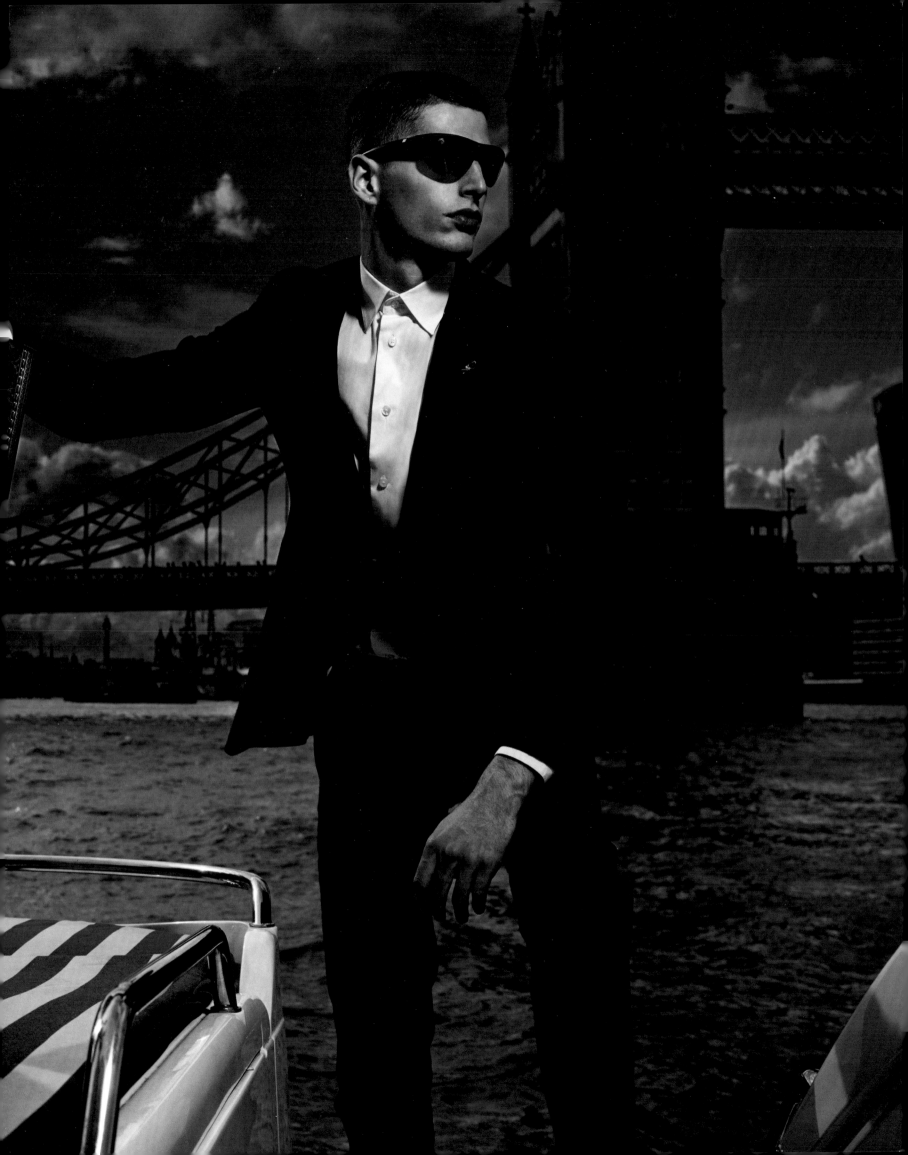

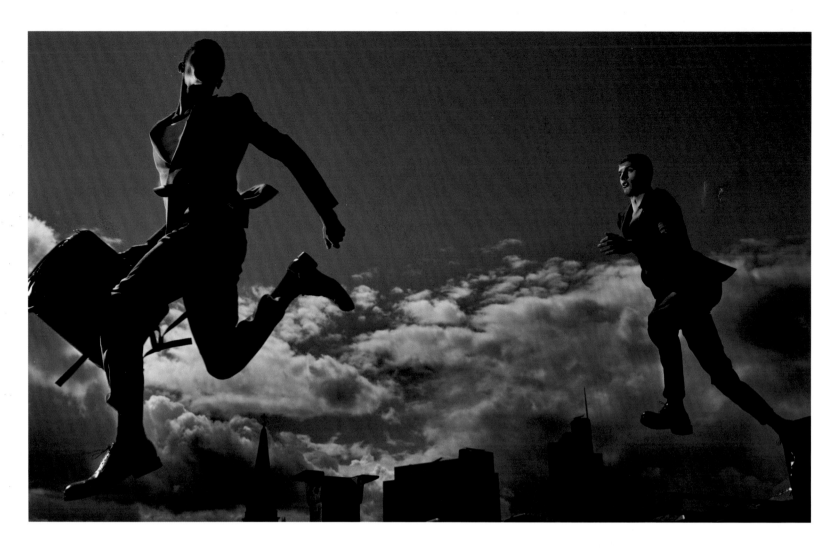
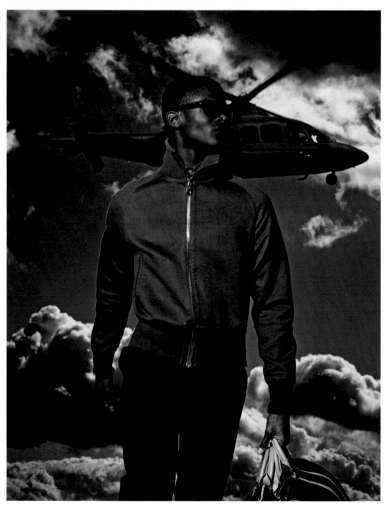

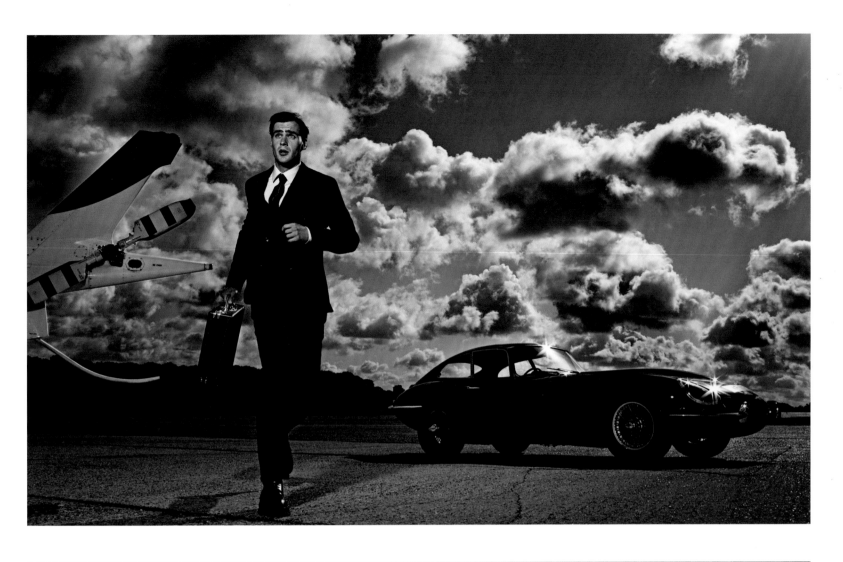
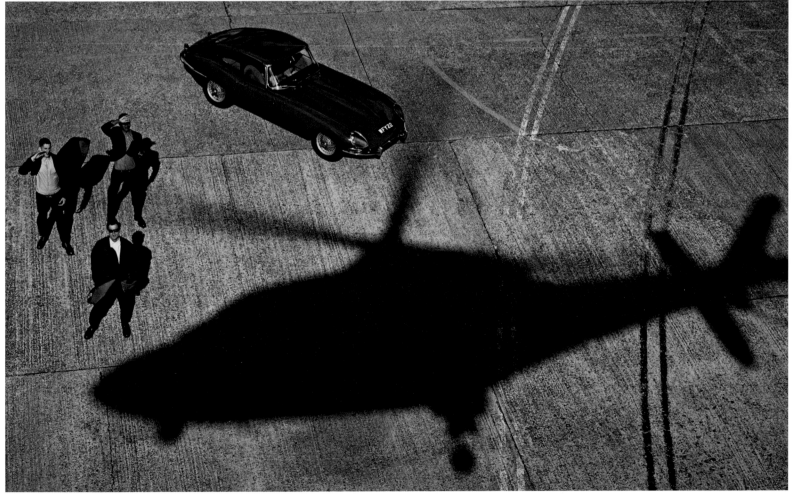

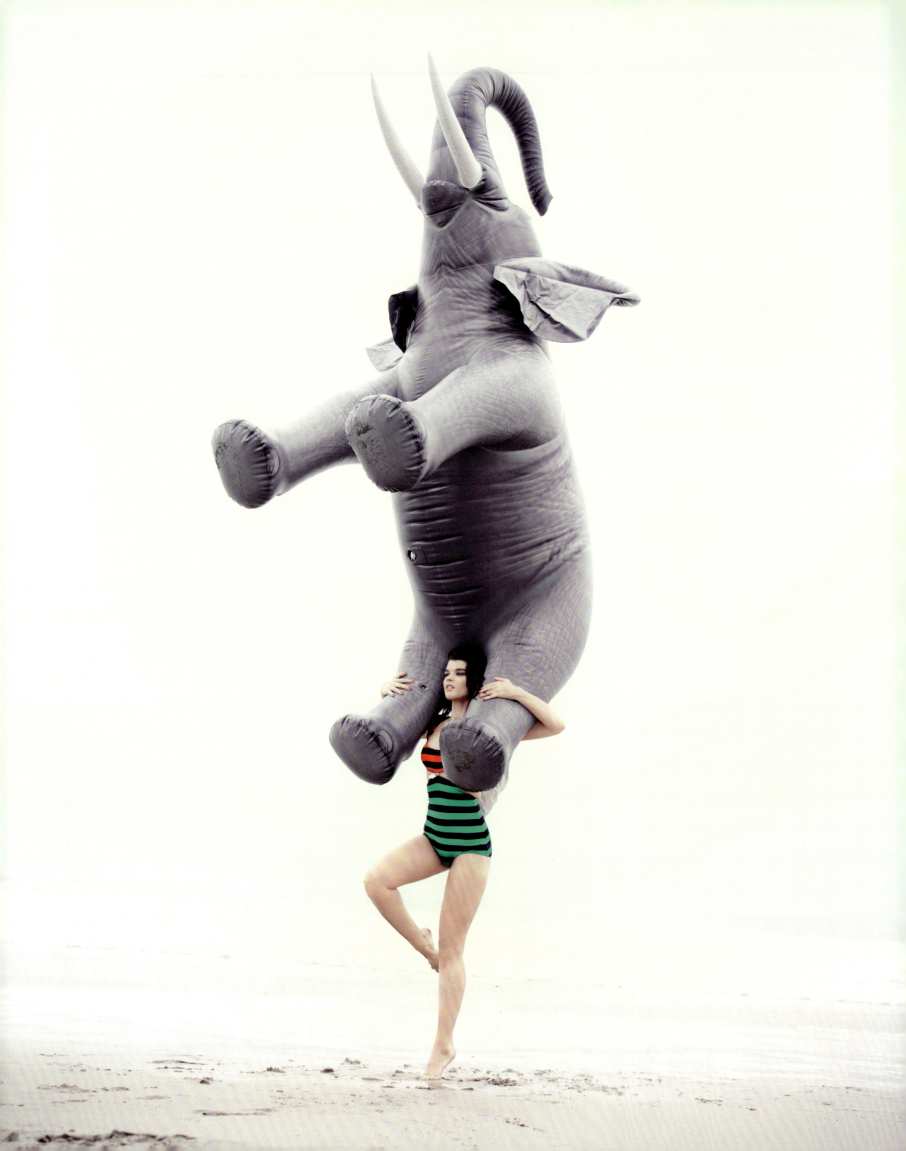

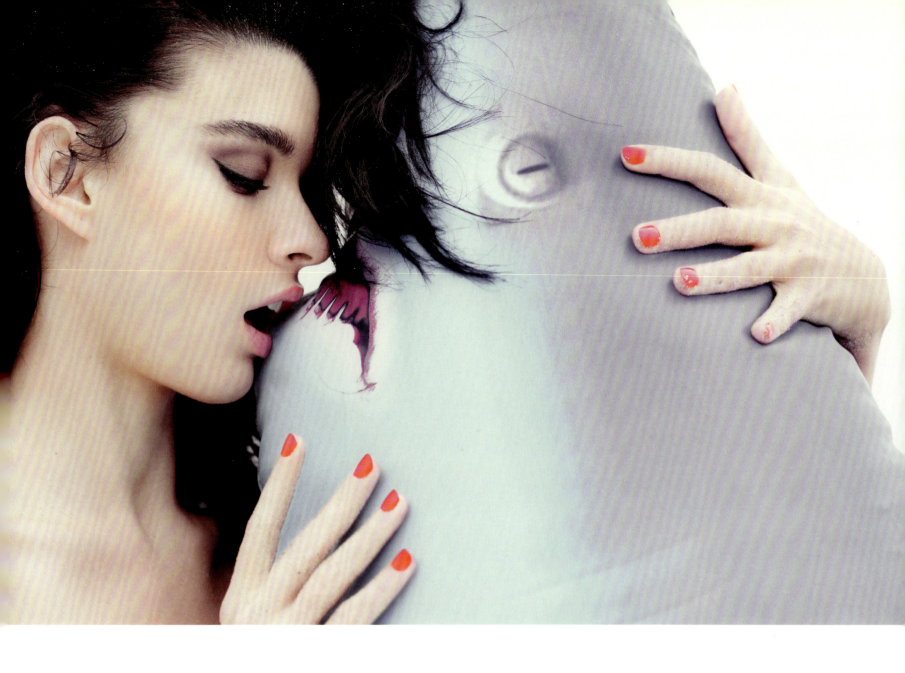

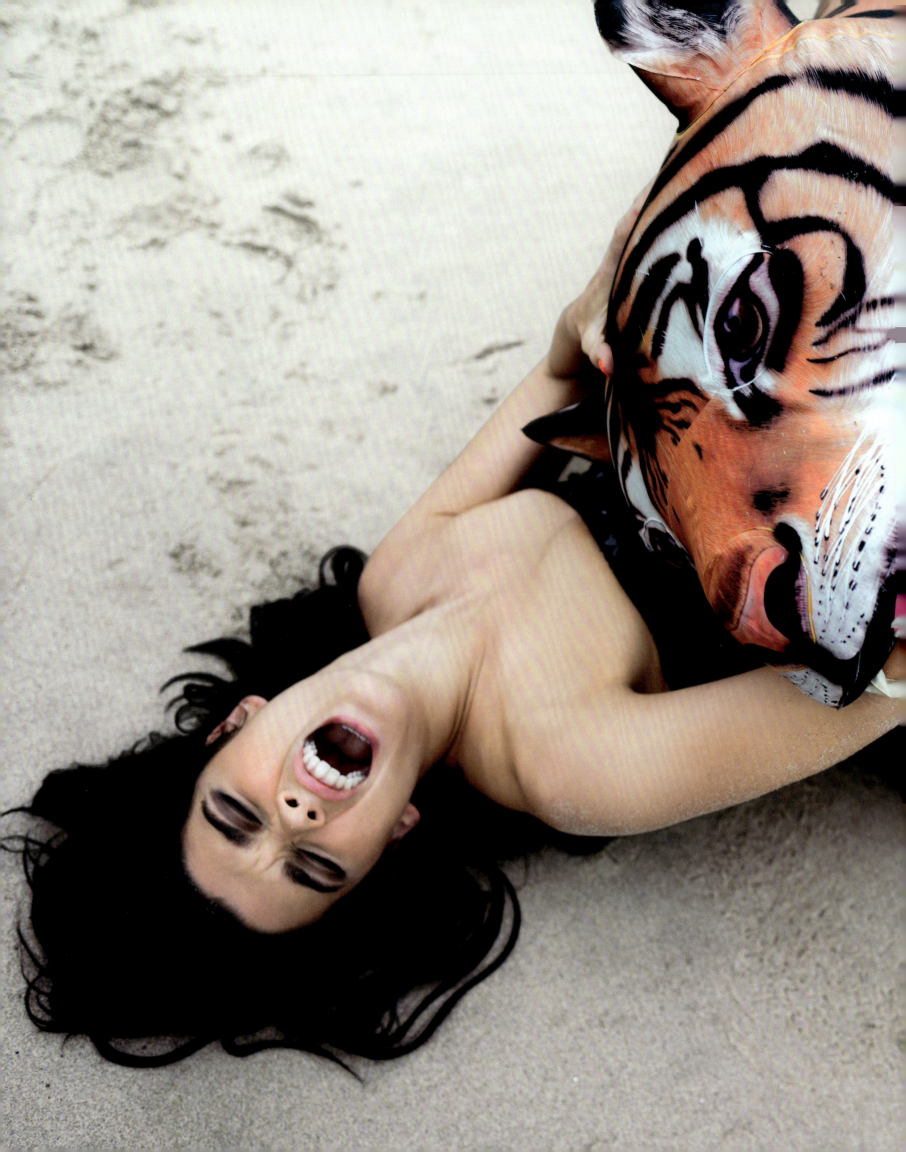

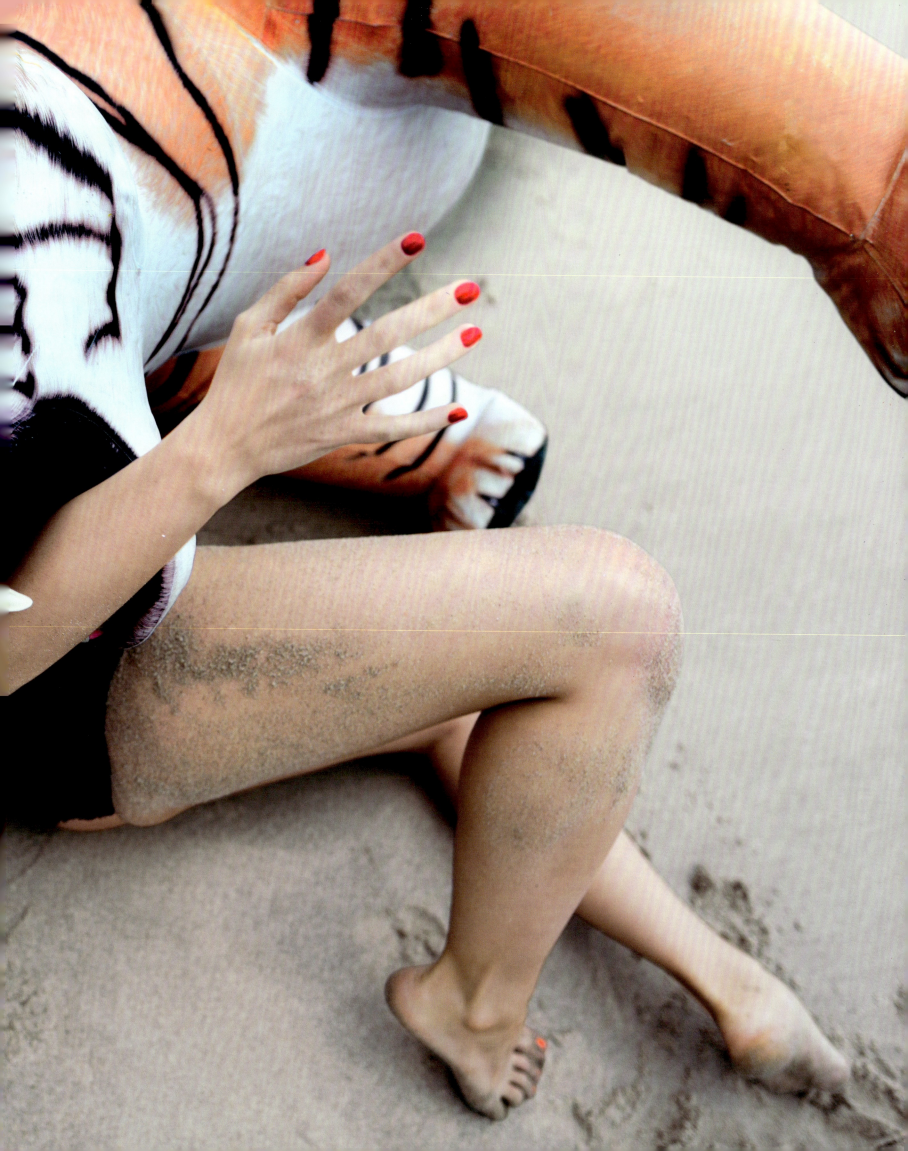

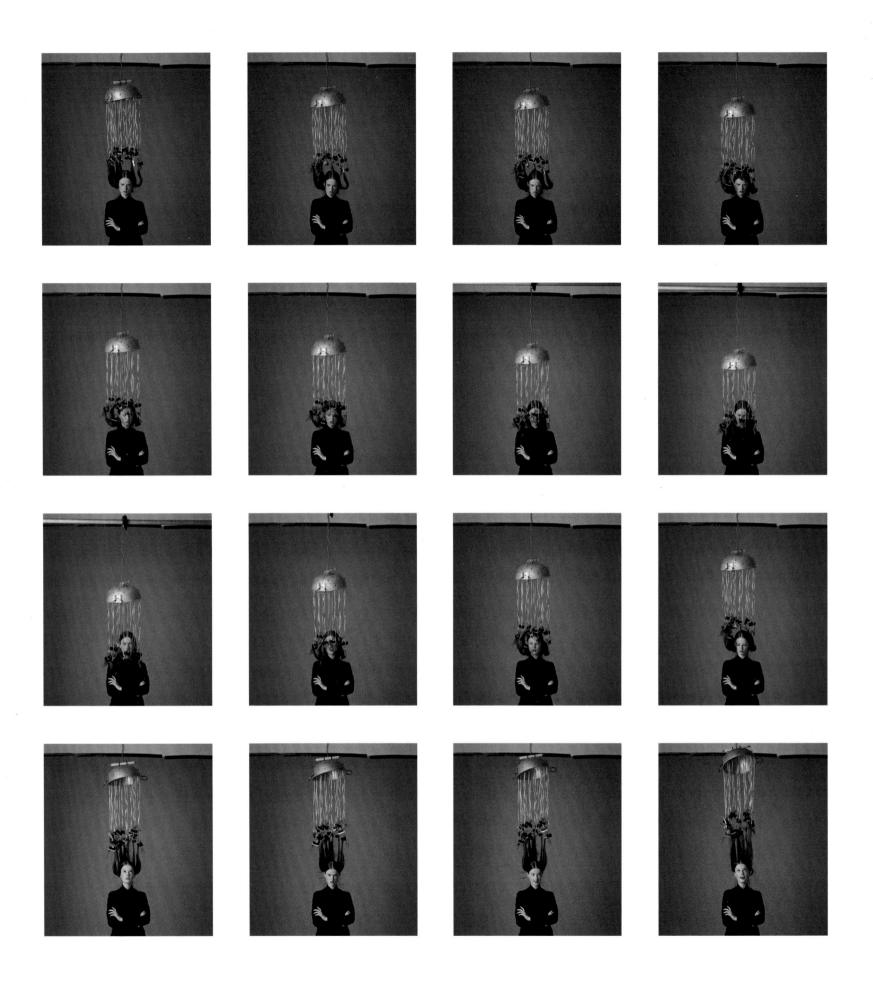

It's Not That I'm So Smart; I Just Stay With Problems Longer | 2013

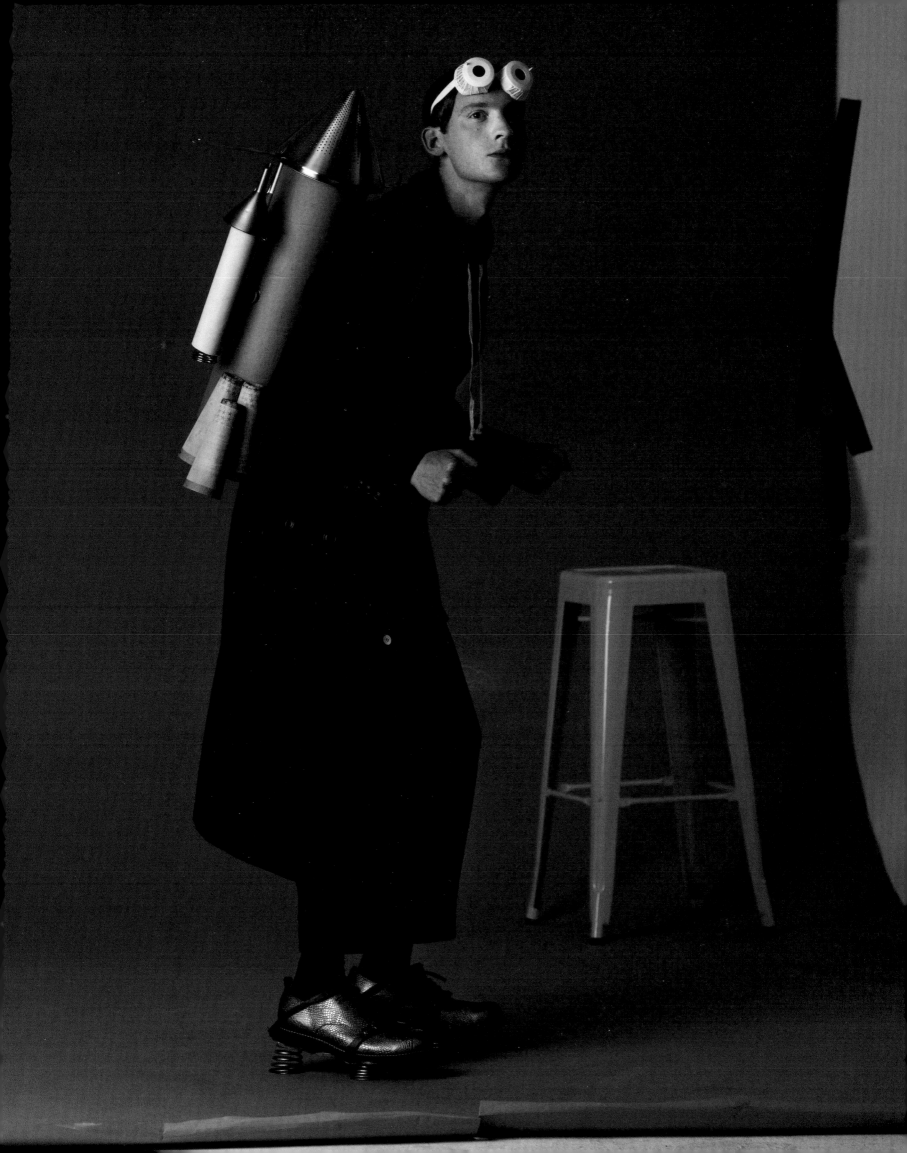

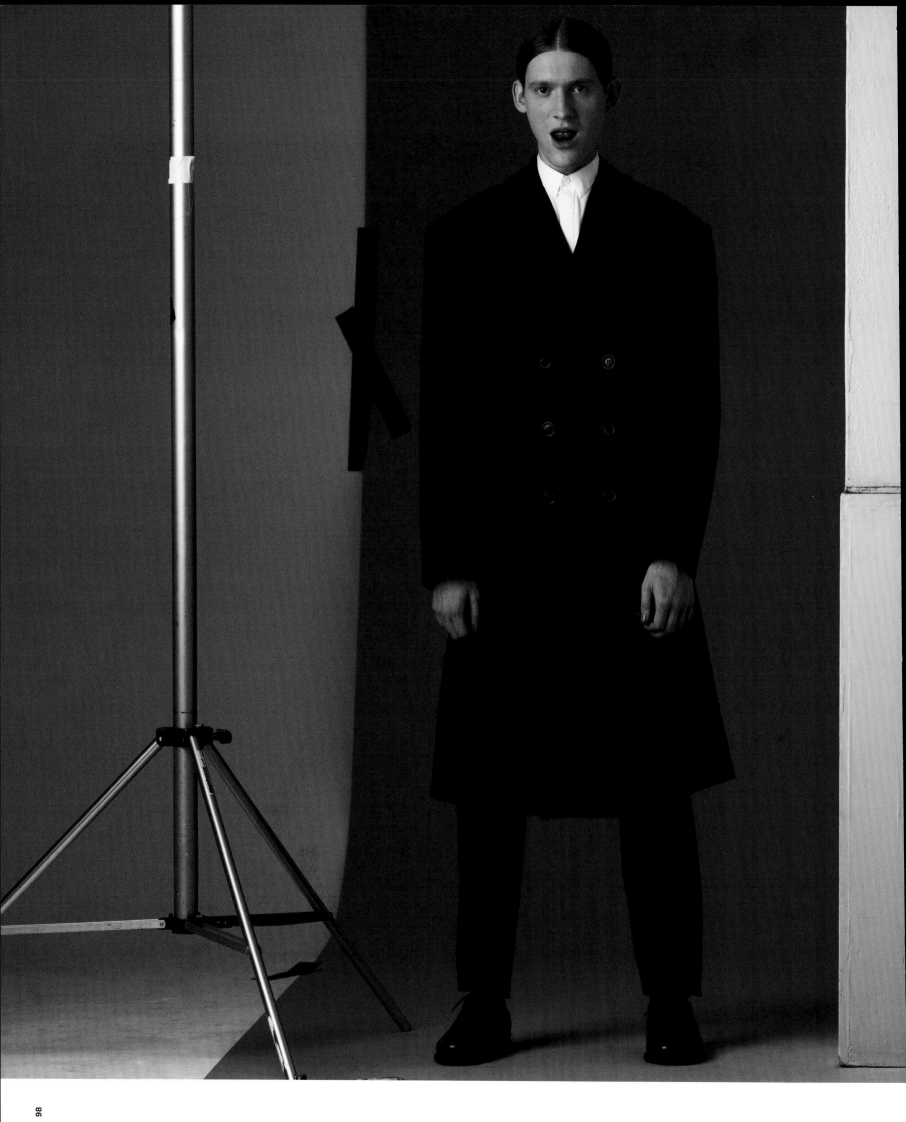

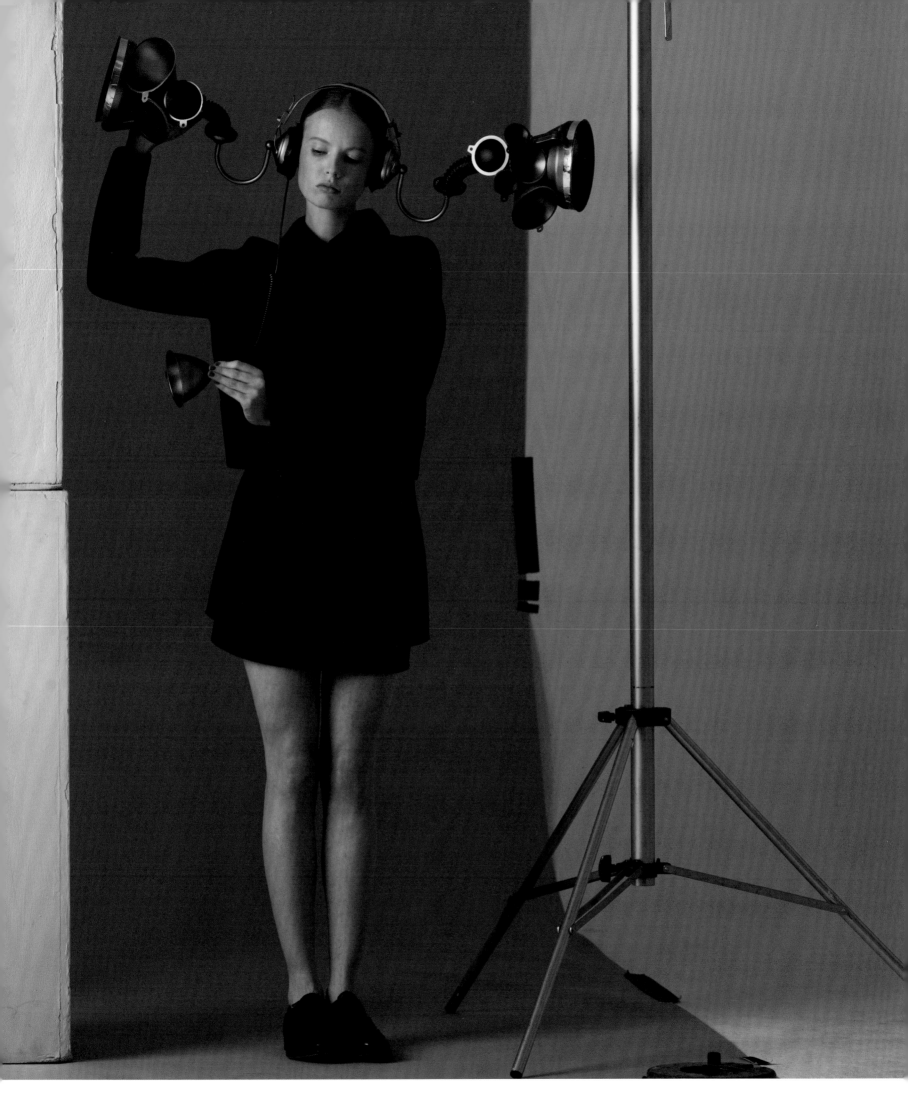

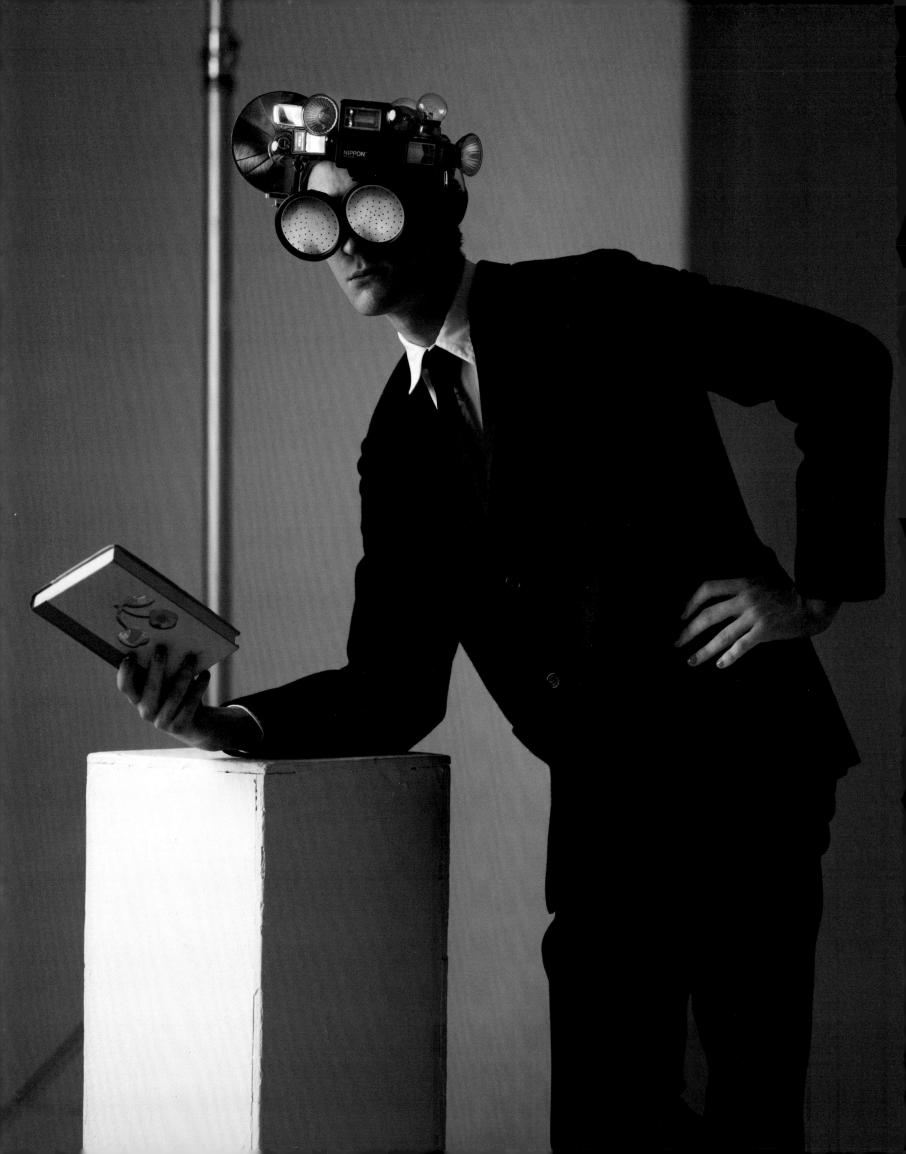

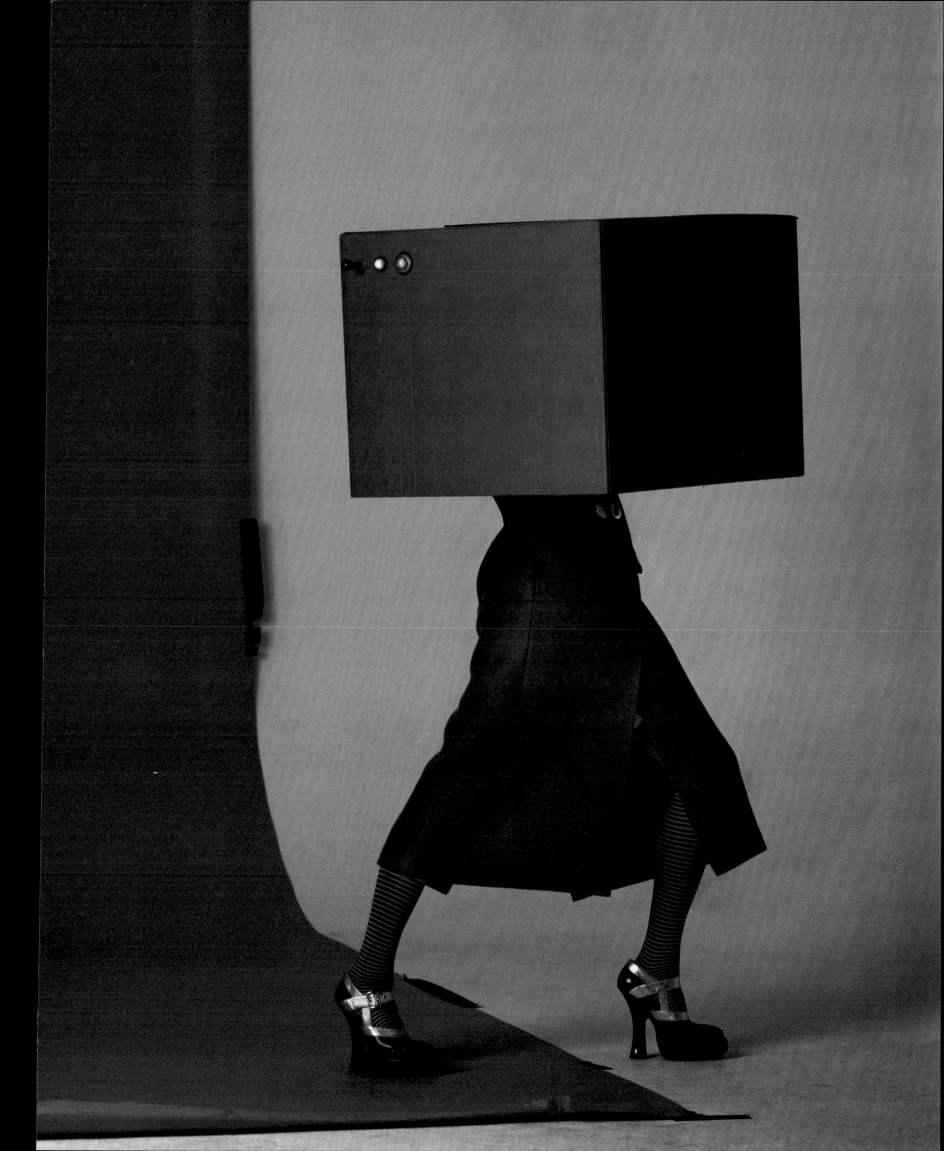

Some photographers establish a distance that prevents any communication. With Rankin, I was expecting a little of this hierarchical distance. On the contrary, I discovered a very cool person who likes to joke to make everyone comfortable.

The difference between his sets and other shoots is the incredible energy of the whole team in the studio. Each person has their own importance, from the first assistant to the last, and everyone is there for the same purpose—to make a beautiful picture.

I deeply believe that the success of a shoot is the result of an alchemy. It is the result of teamwork, where everyone contributes to the creation of an image. Dialogue is essential to express yourself, to bring your touch, and to know where you are going. Rankin gives people this opportunity. There is almost no limit to creation with him. He likes make-up, hairstyles, people. His enthusiasm, his energy is communicative. He pushes us to surpass ourselves.

Rankin's style is a strong, sensual universe with a very masculine look without ever being vulgar. There is an aesthetic close to perfection without losing emotion. He takes the liberty to explore different universes. It's rock, off the wall with a touch of typically English humor.

CAROLINE SAULNIER

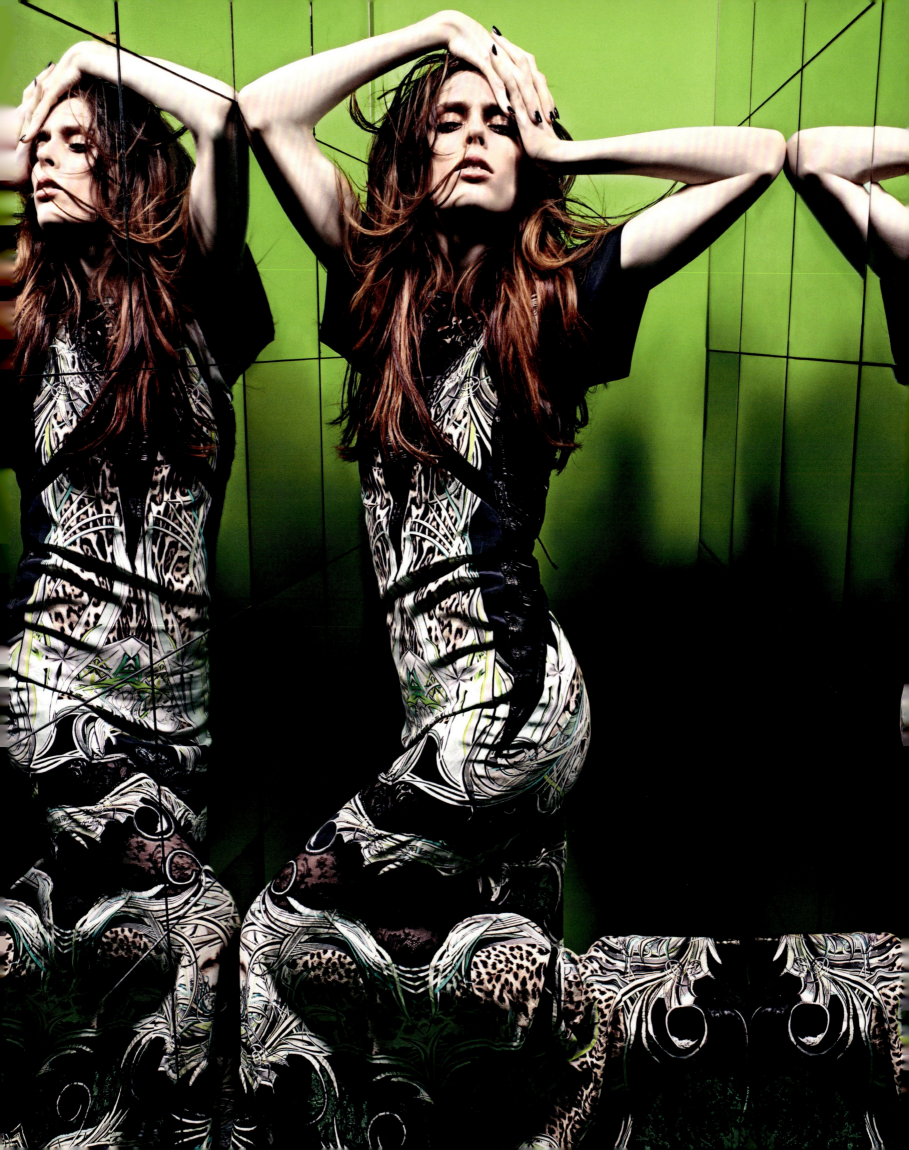

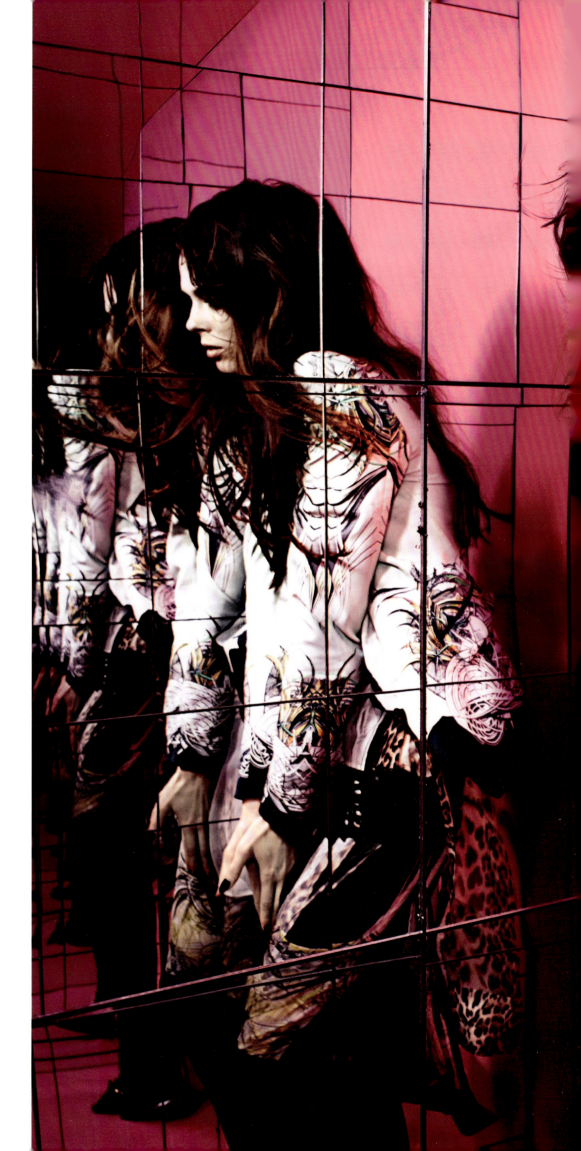

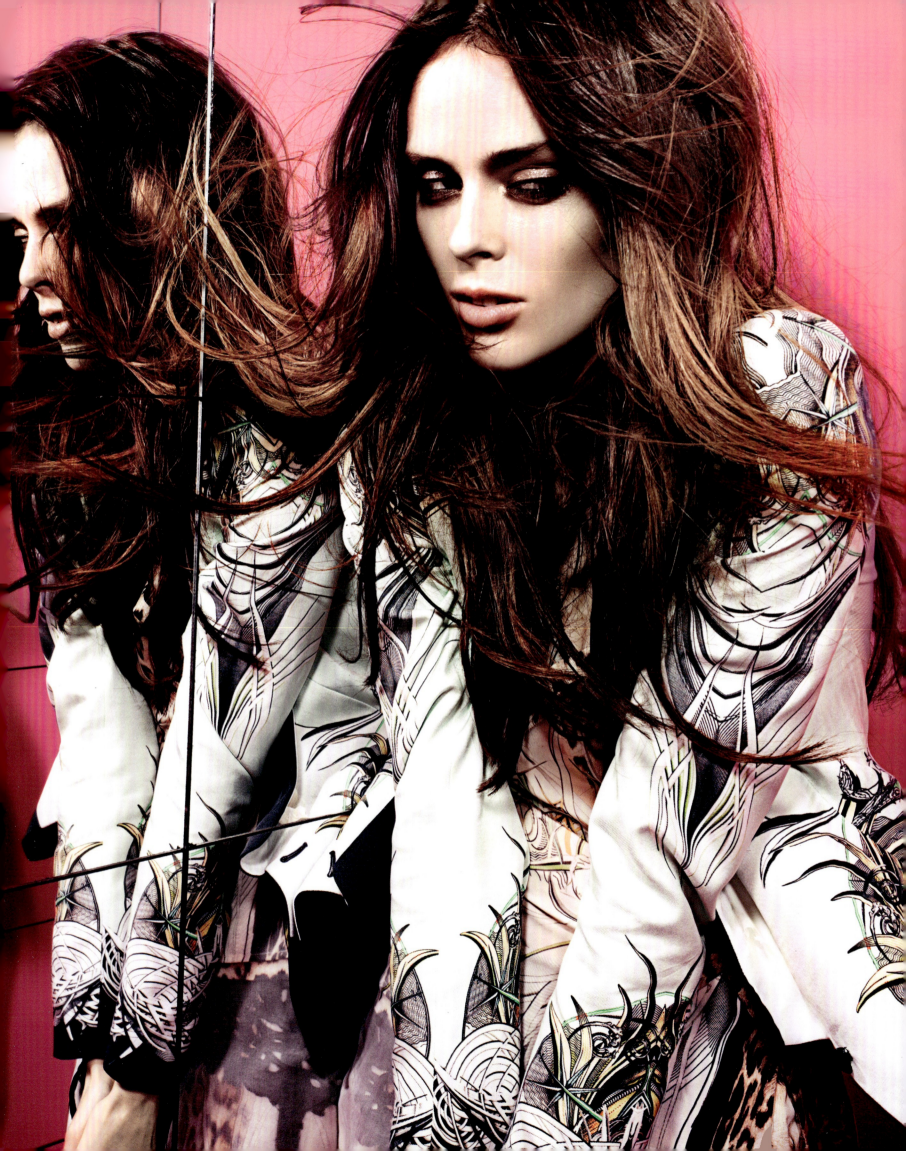

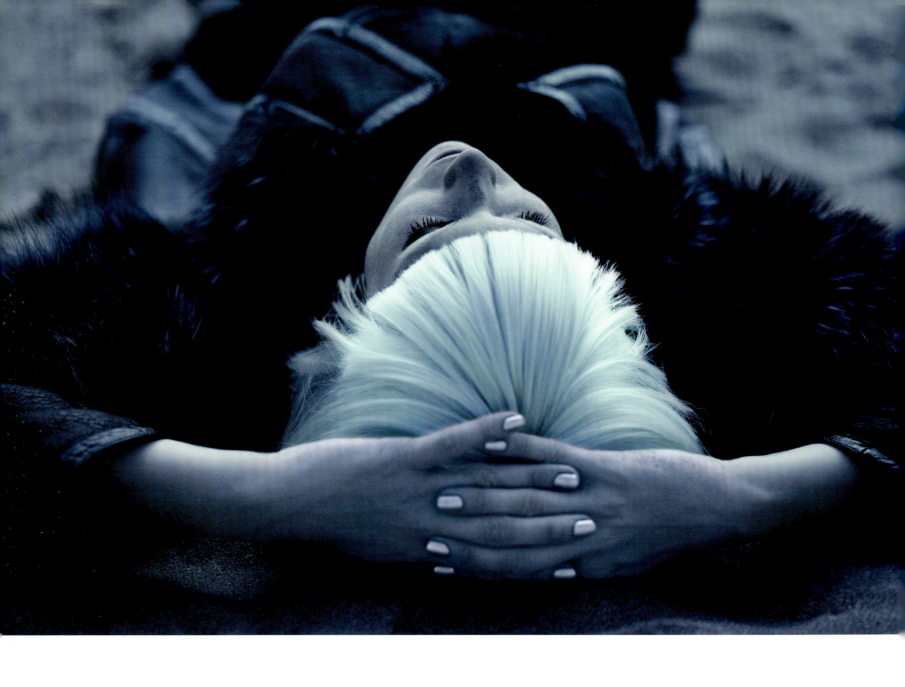

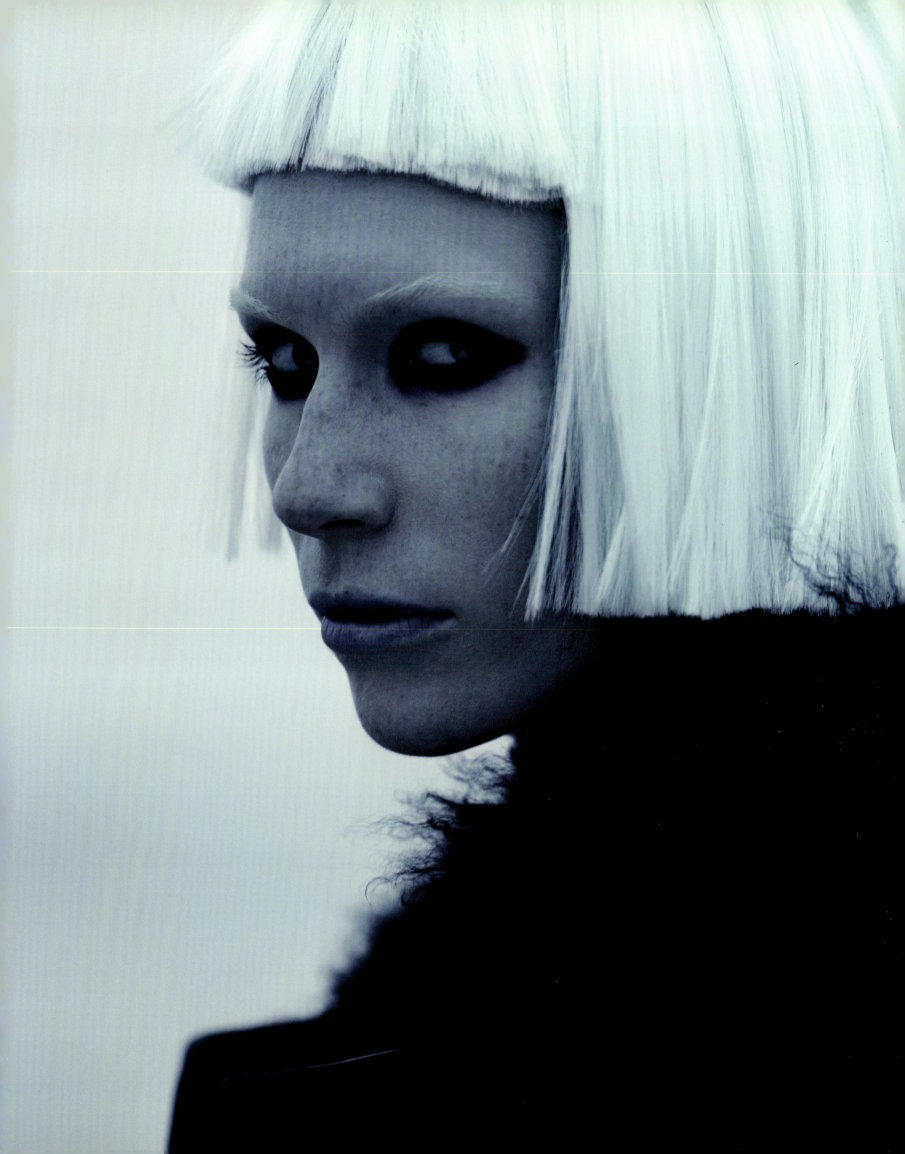

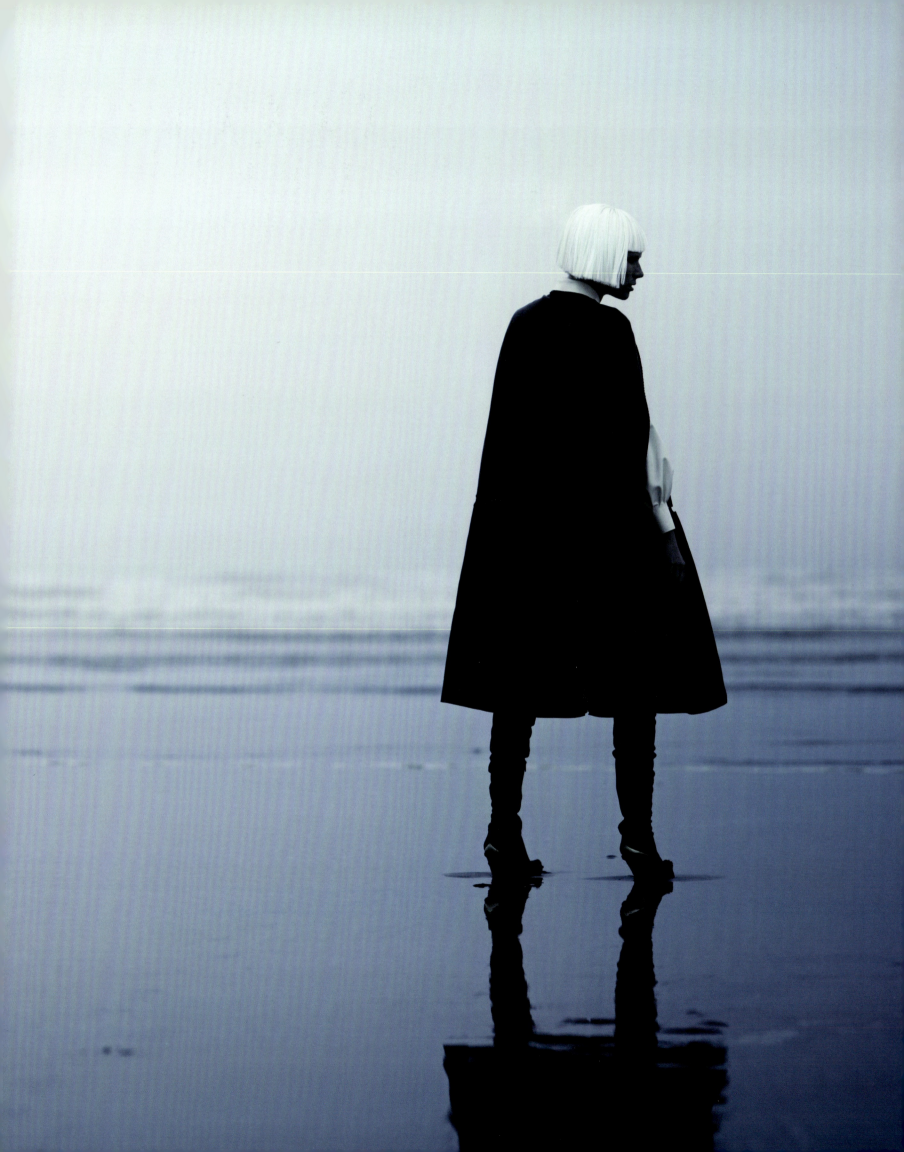

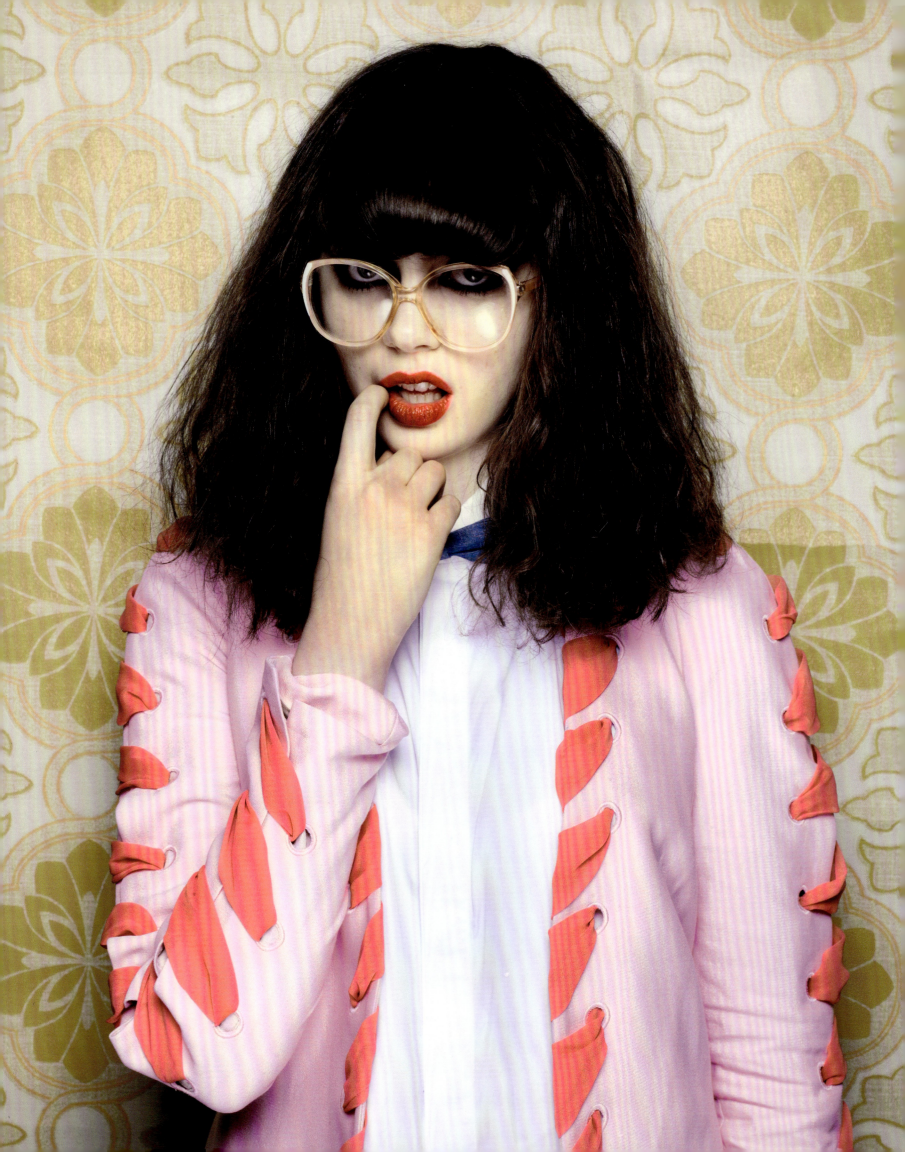

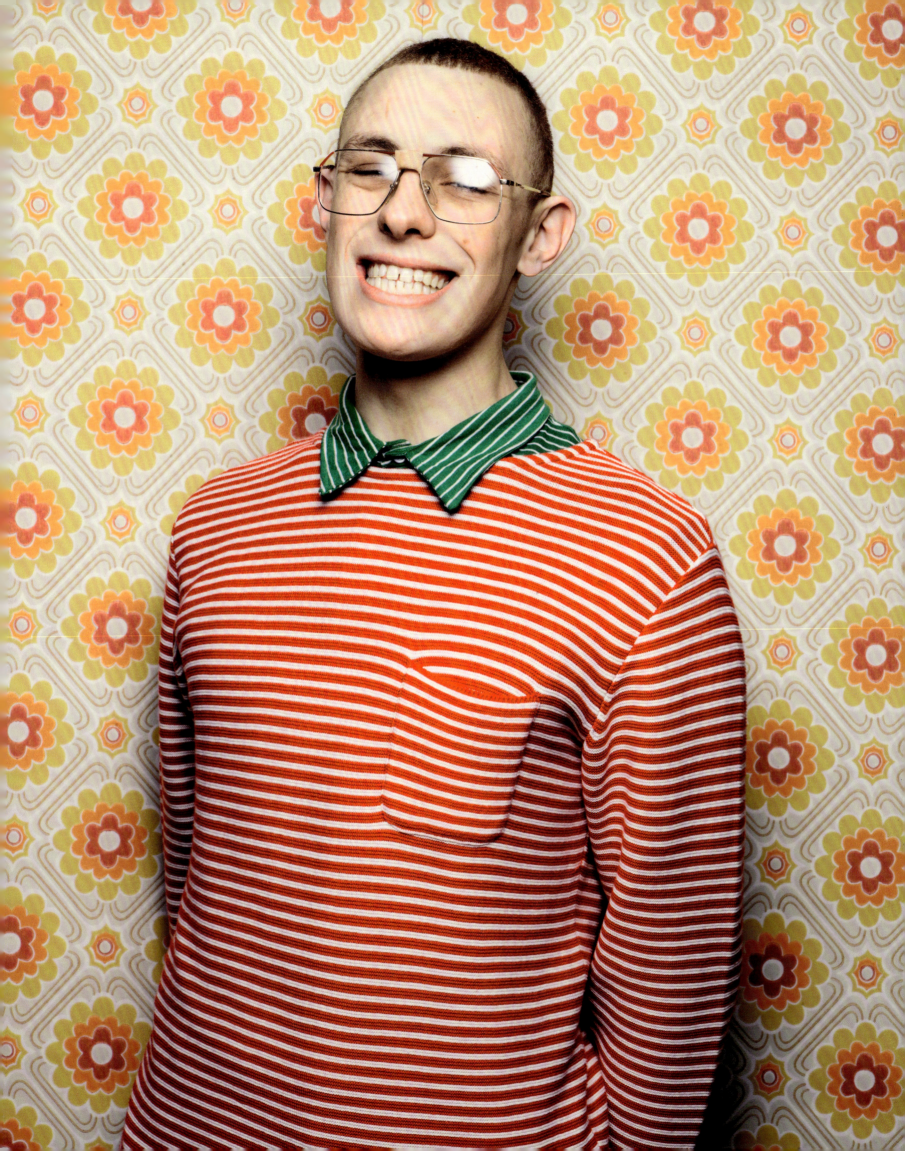

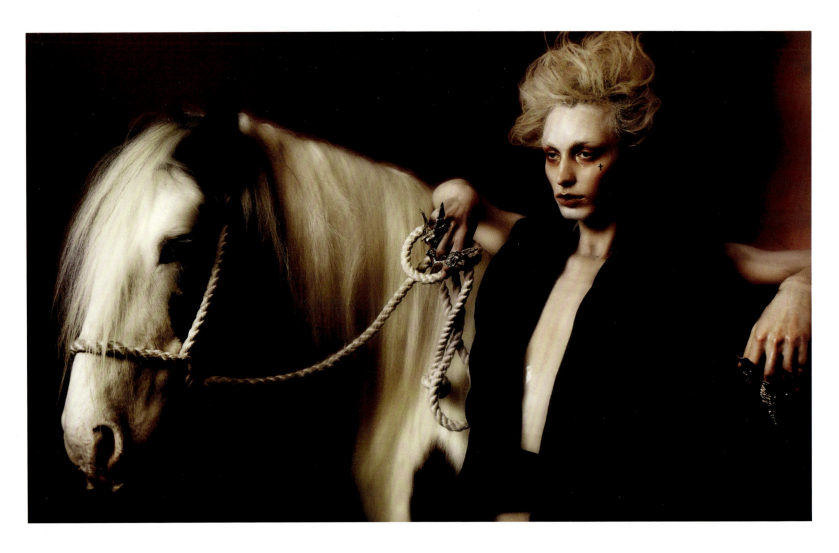
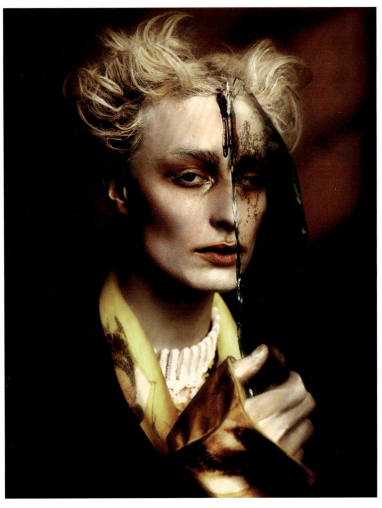
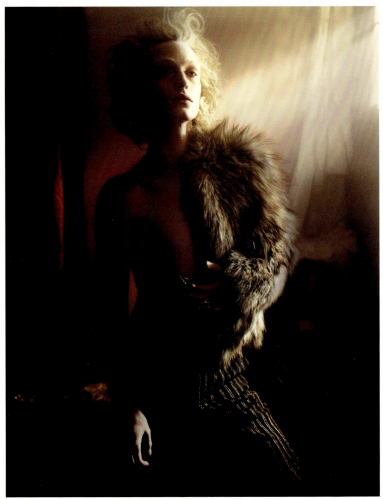

Previous
Welcome to Oddity Park | 2012

Be Still, Beating Heart | 2012

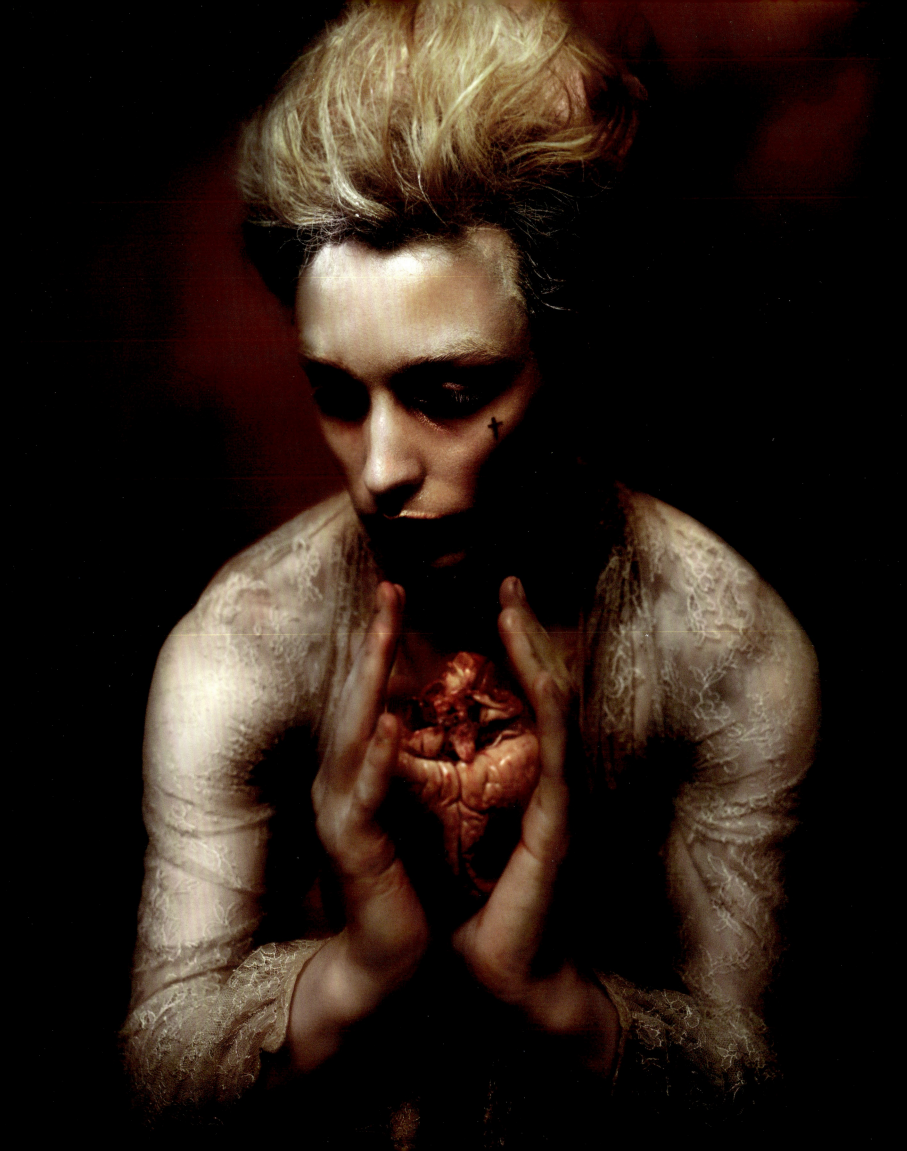

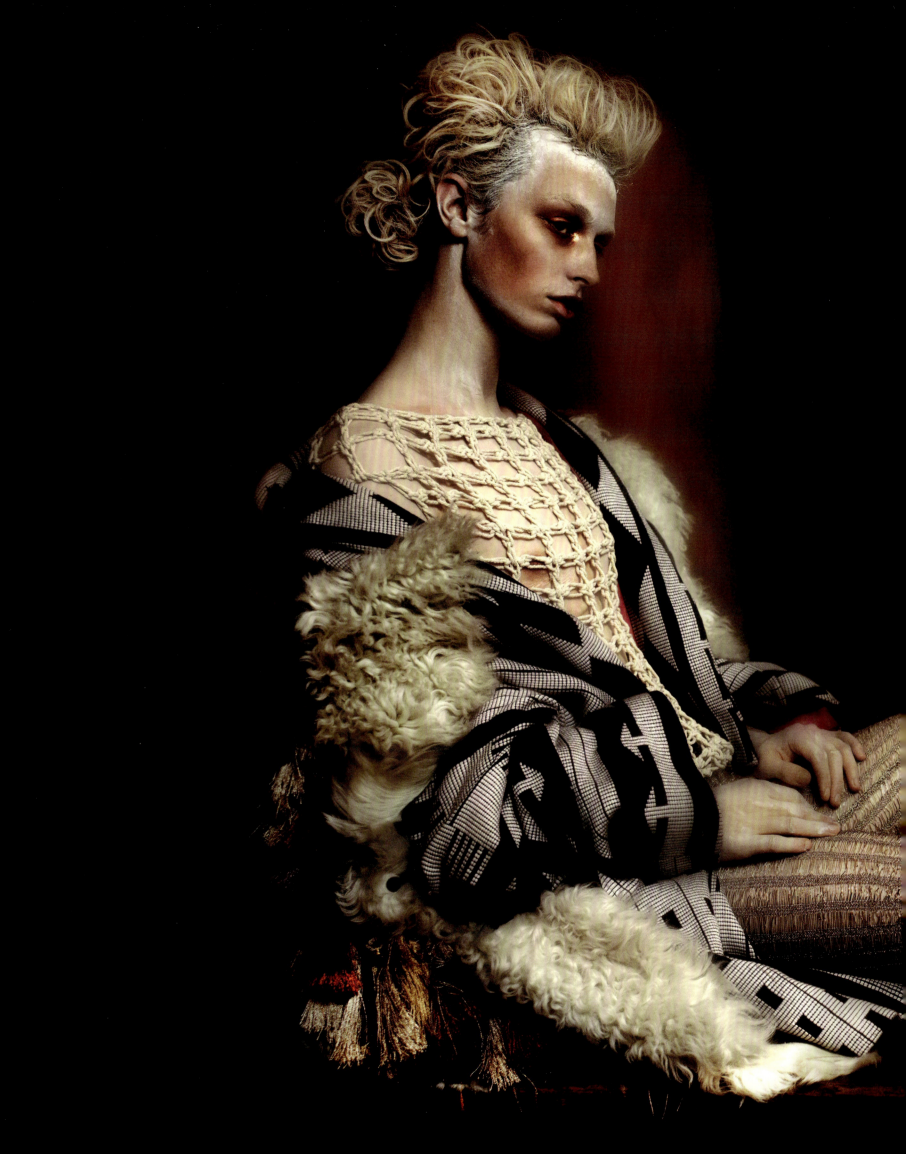

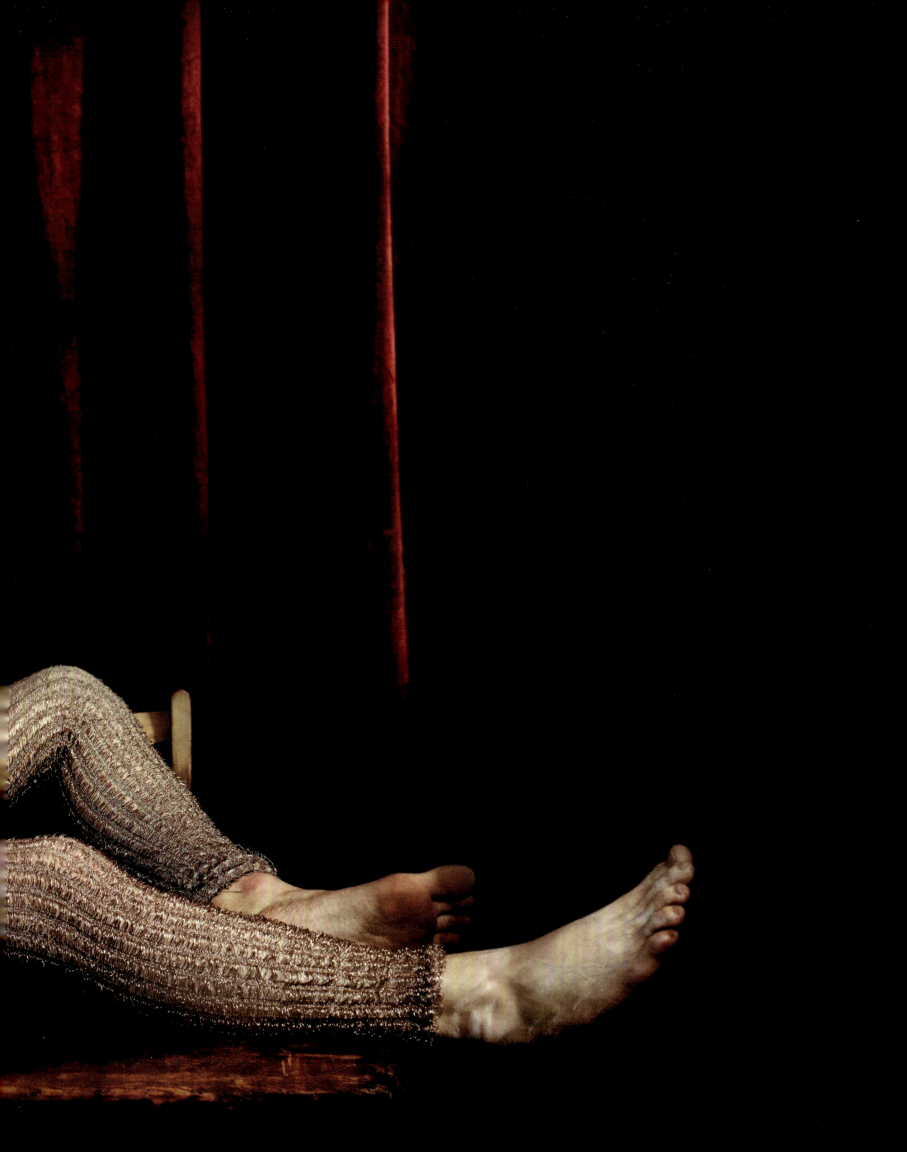

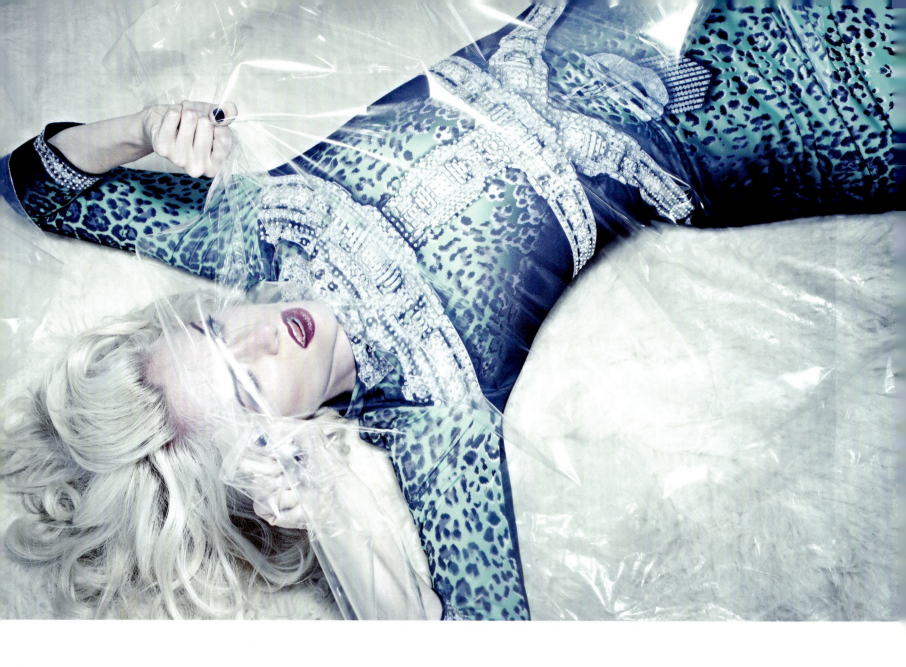
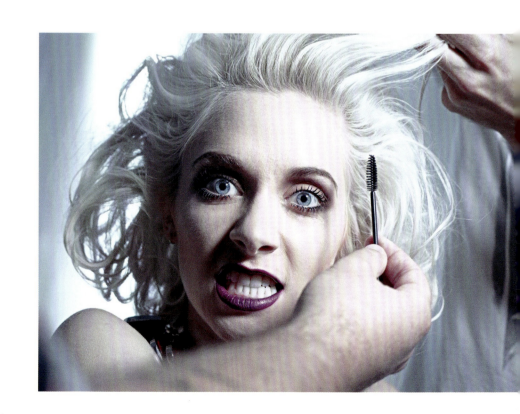

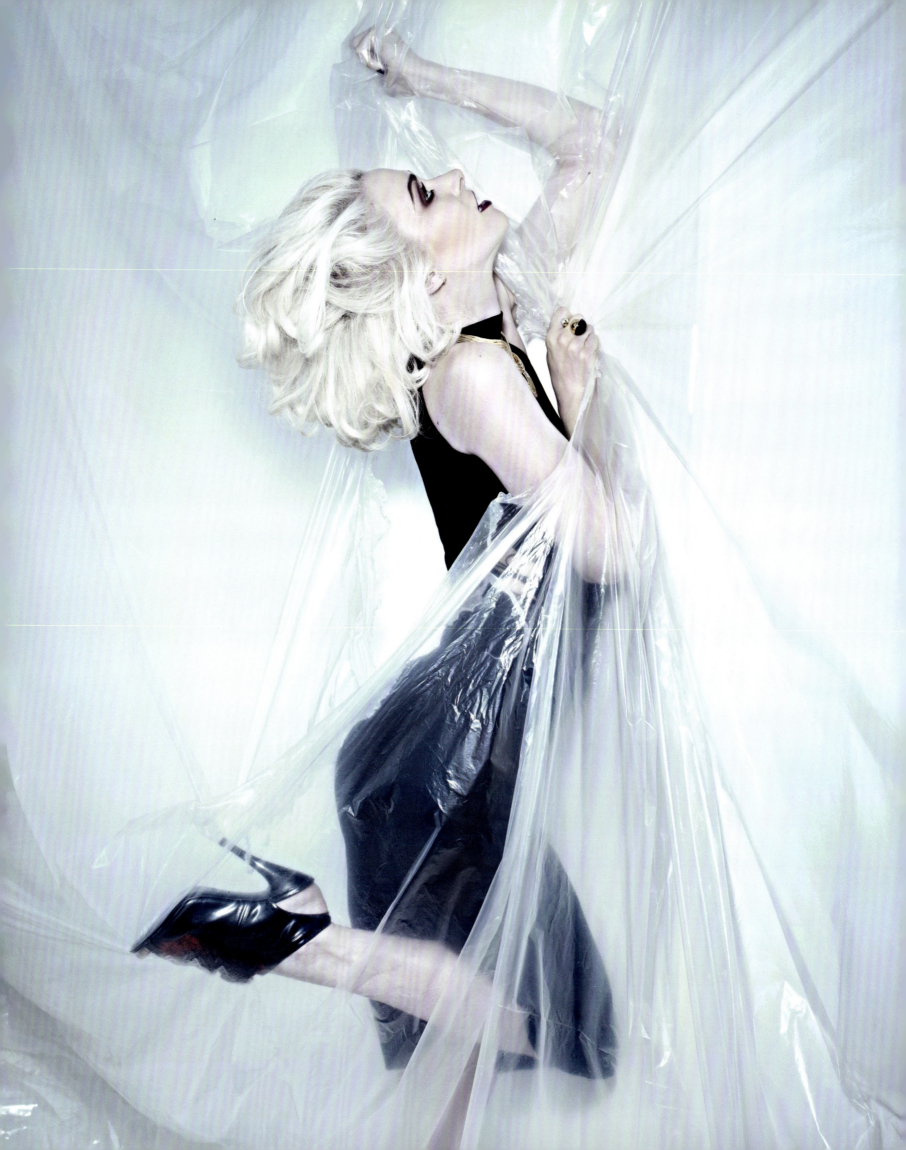

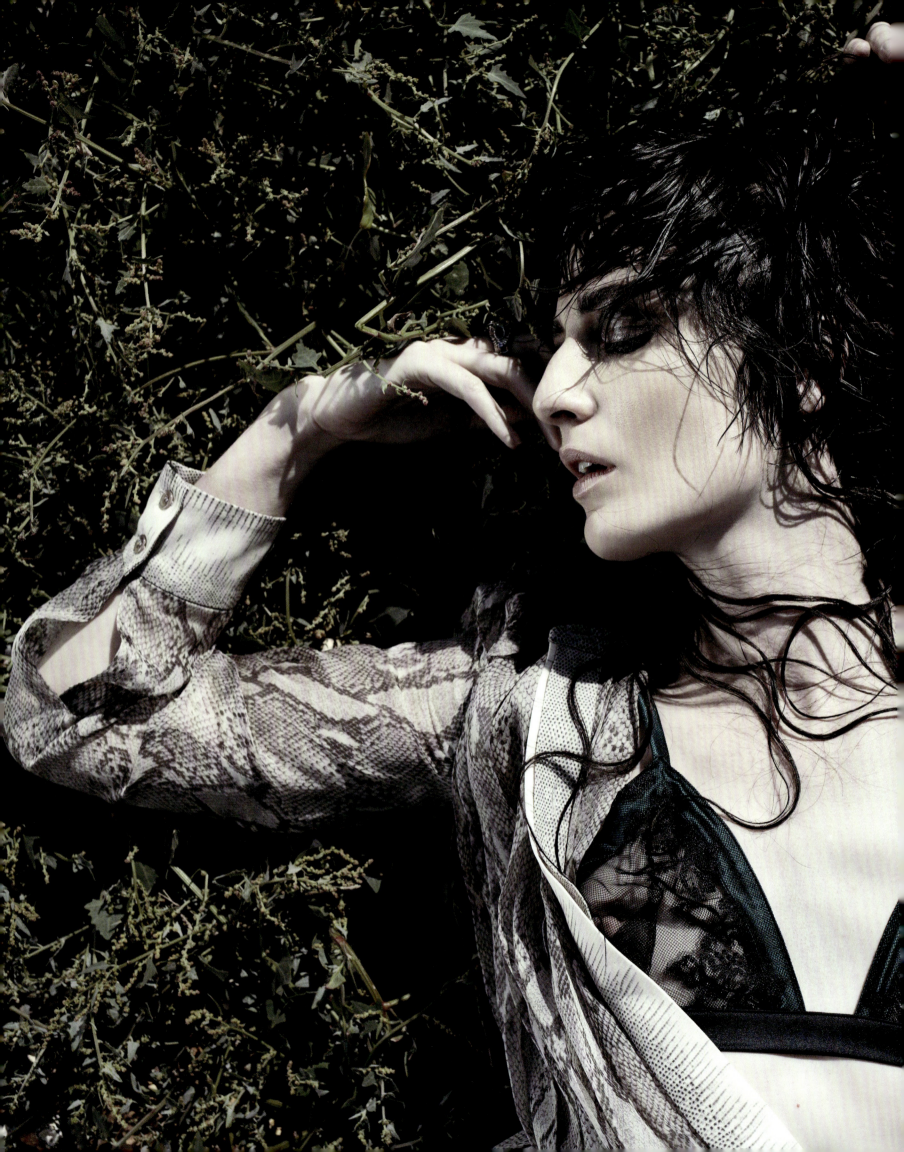

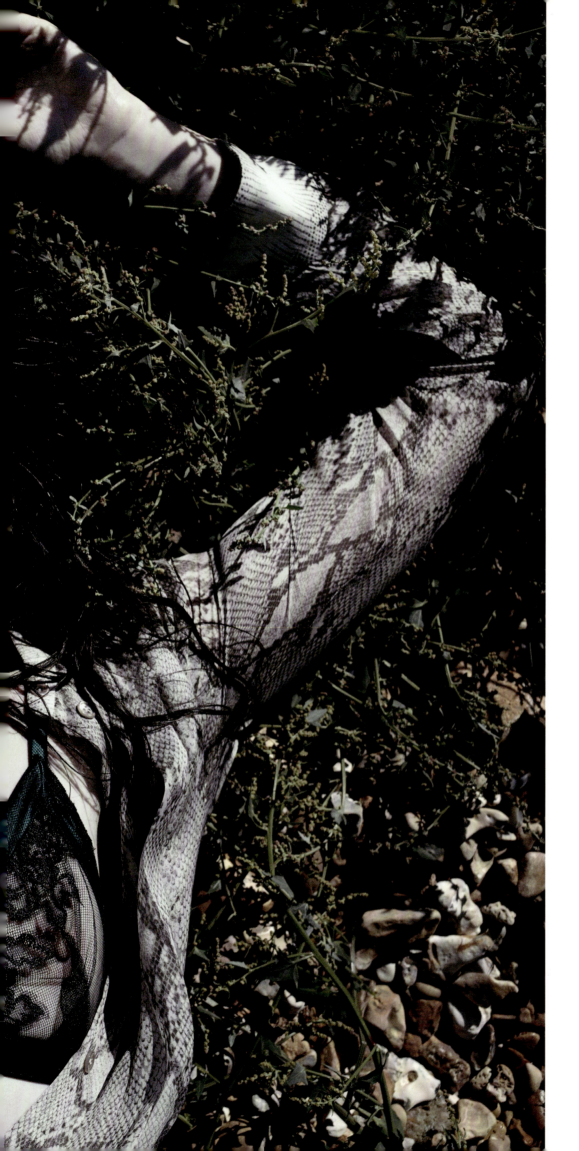

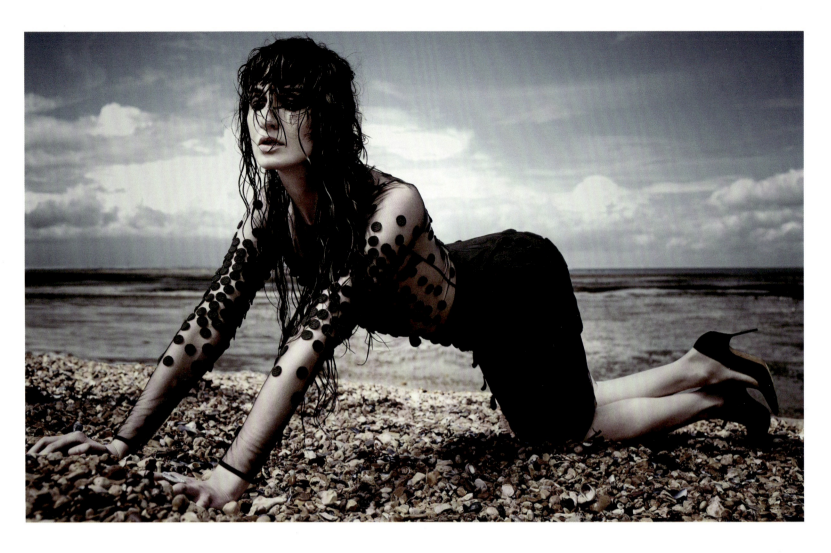
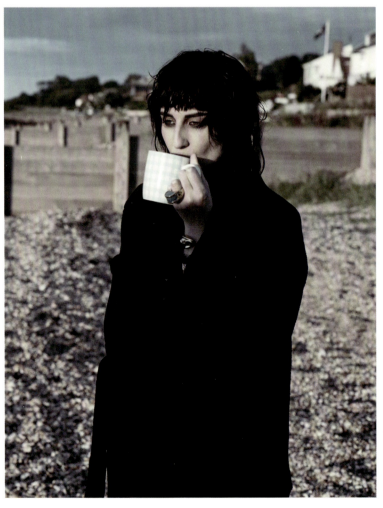
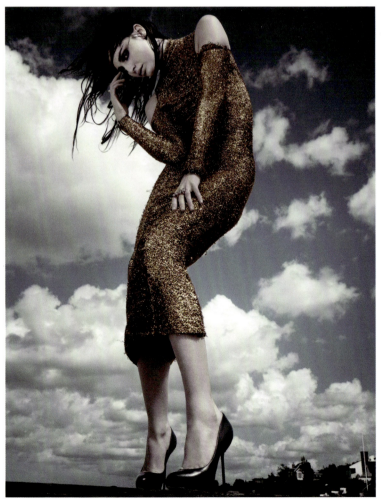

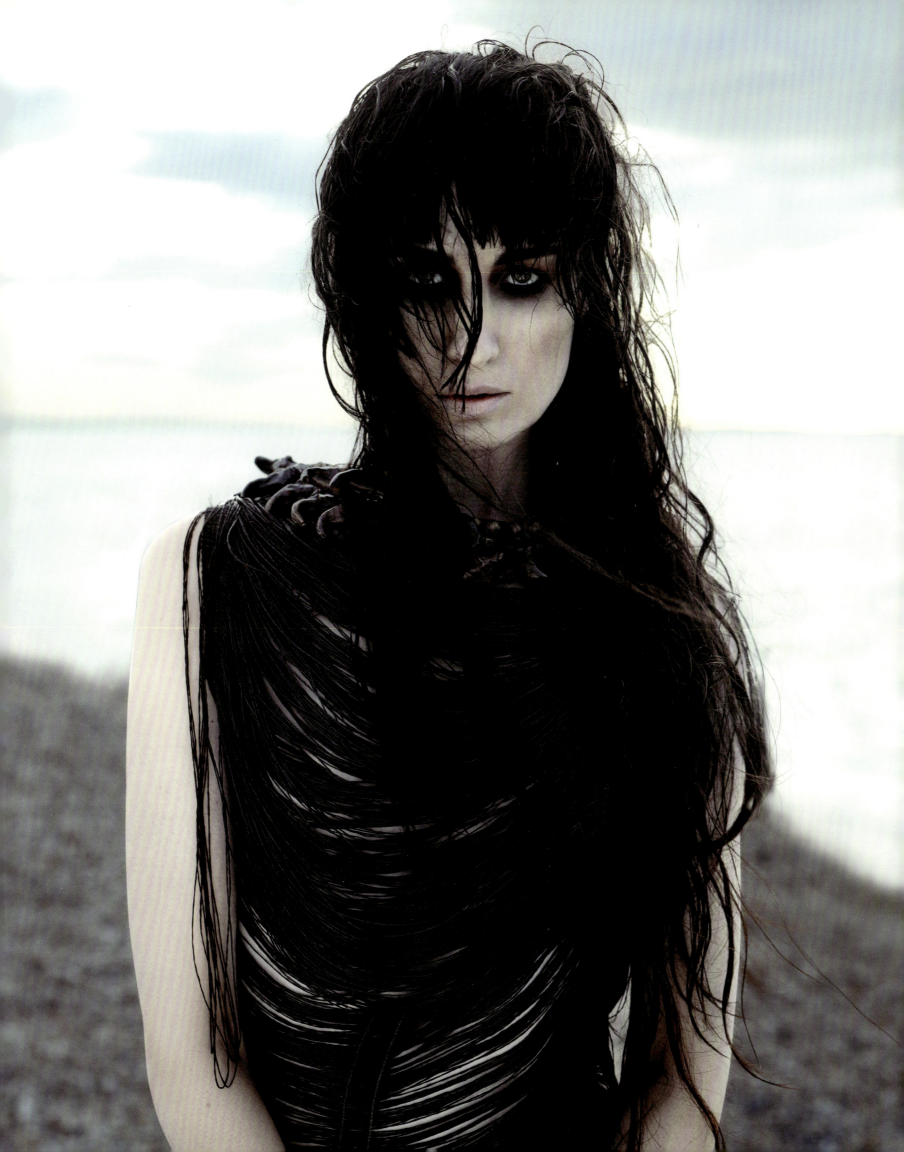

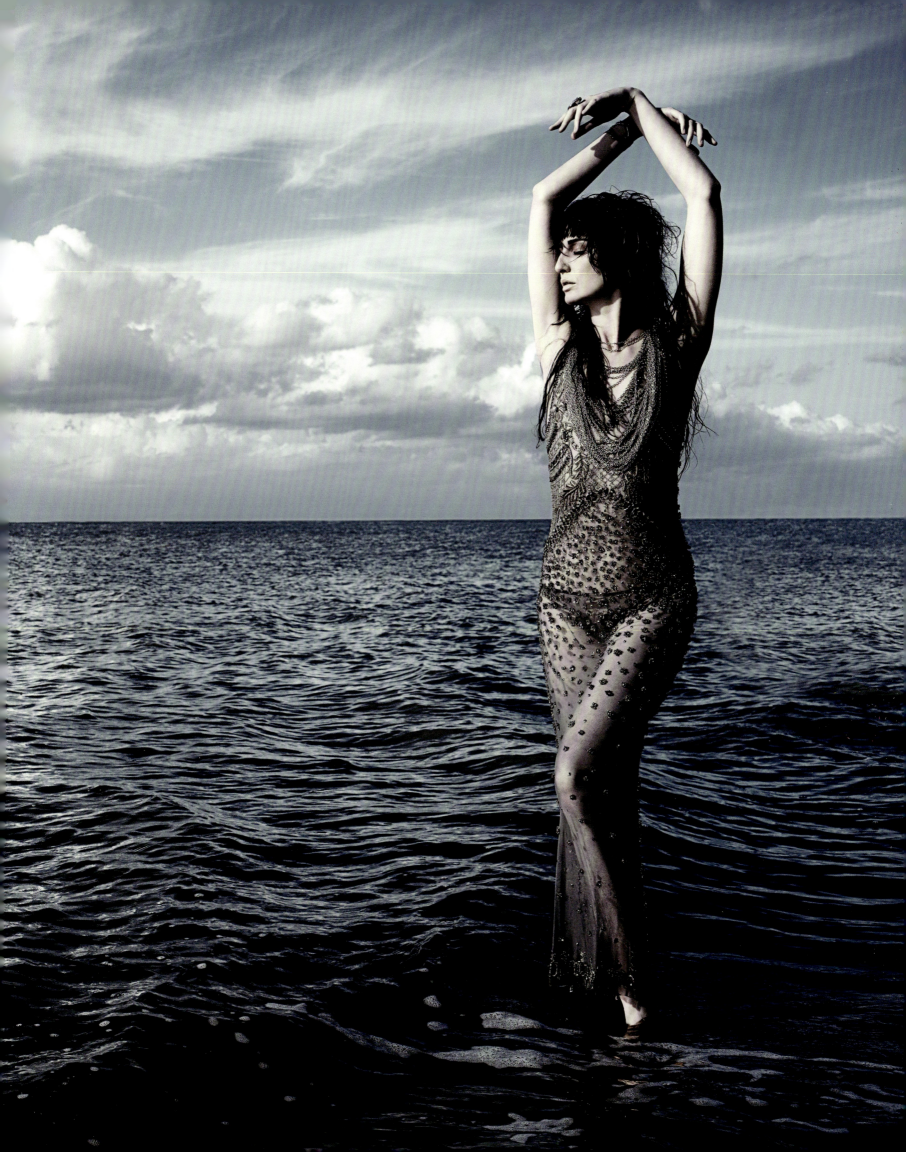

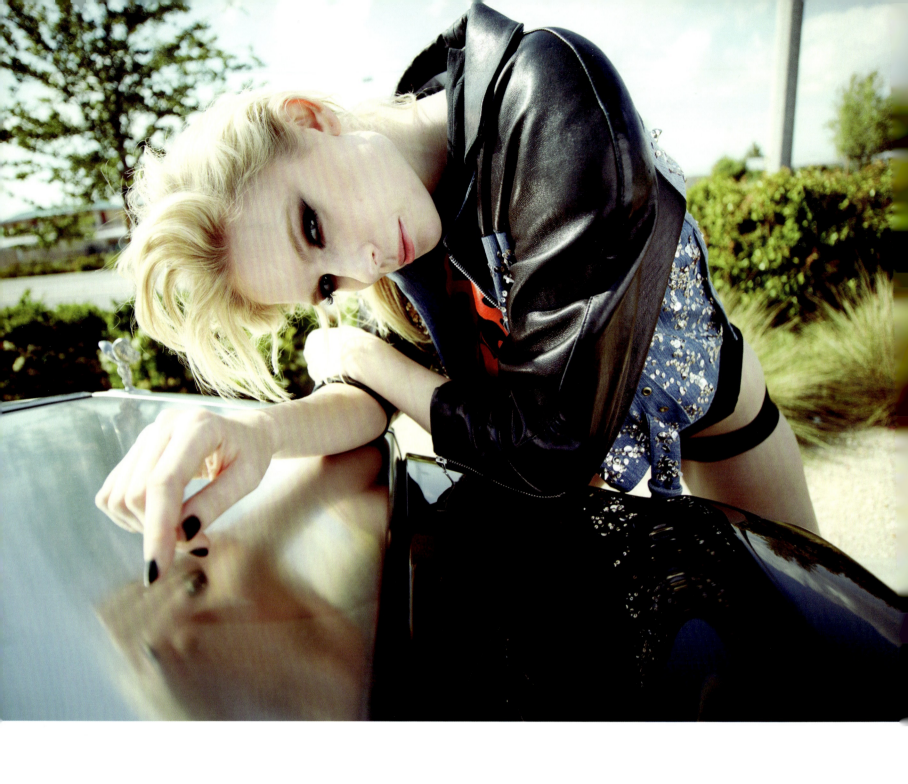

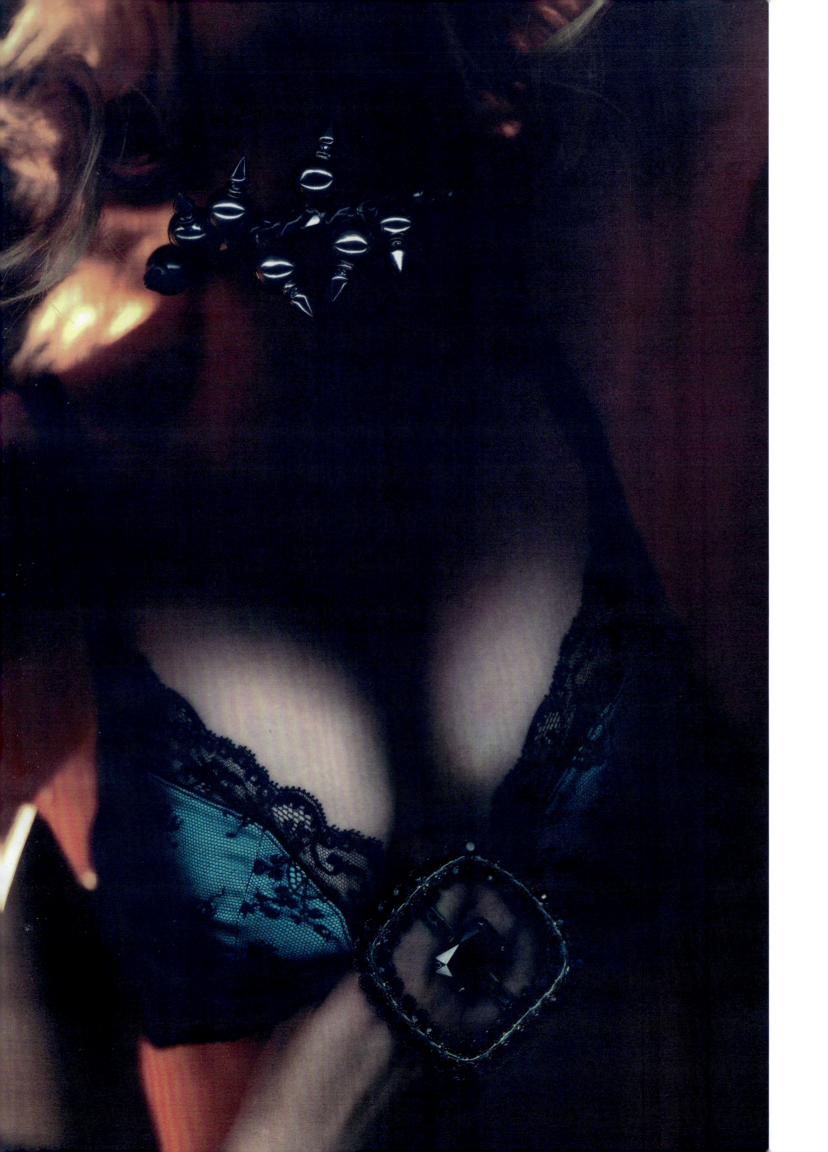

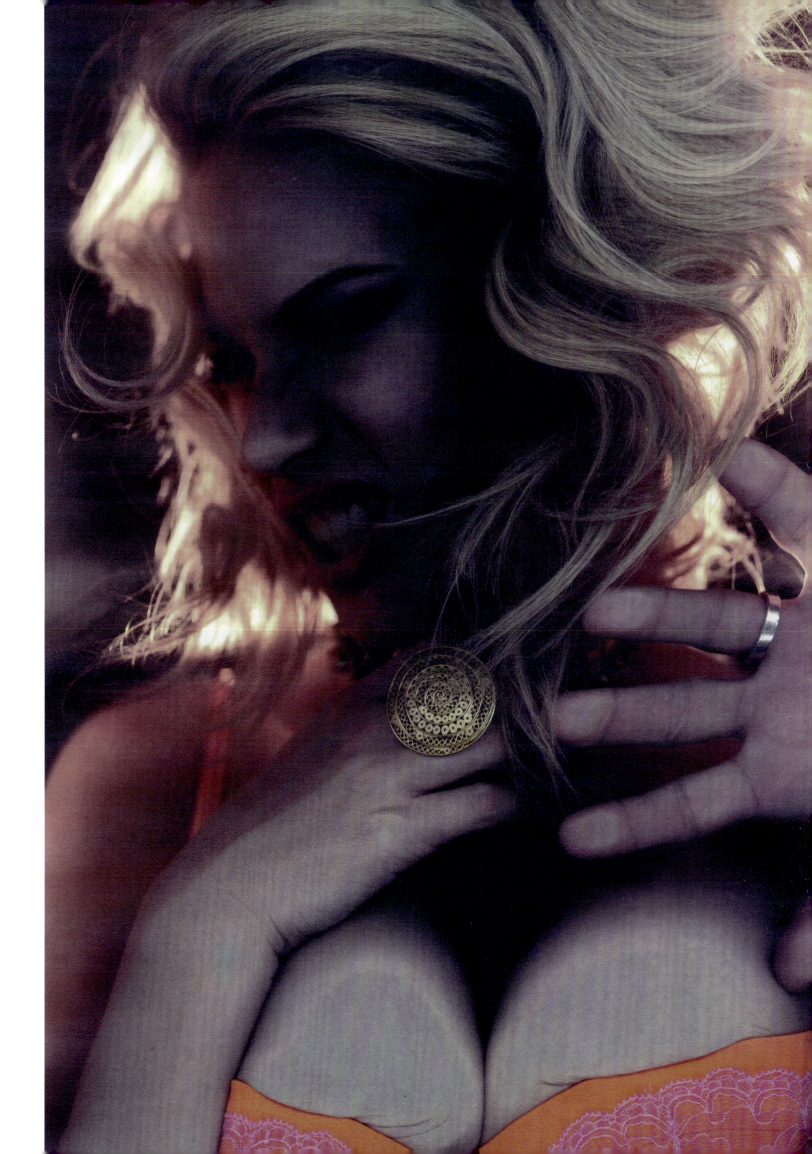

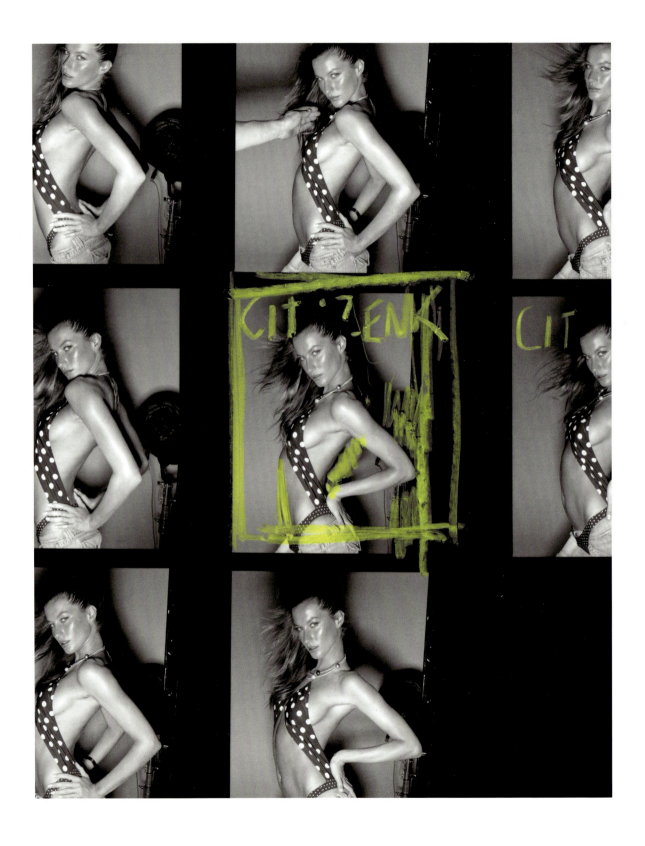

Killa Milla
Jefferson × London Club
Paper Doll
Painted Veils
International Woman
Interzone
Celluloid Closet
And God Created Eva
Paris Plage
Lust & Luxury
Haute Couture
Elle Macpherson Intimates
Glamorama
Touched Up
Bimba Bosé
Animal Magnetism
Livestock
Bag Lady
I'm only 13
Beauty Queens
Bootyfull
Underwhere?

2011–2001

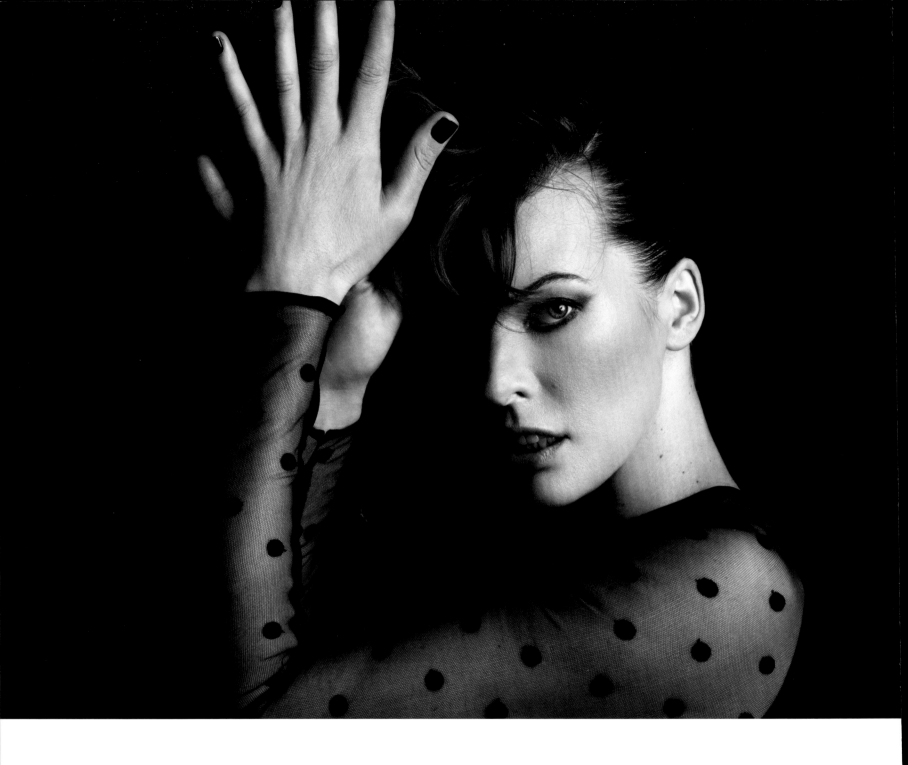

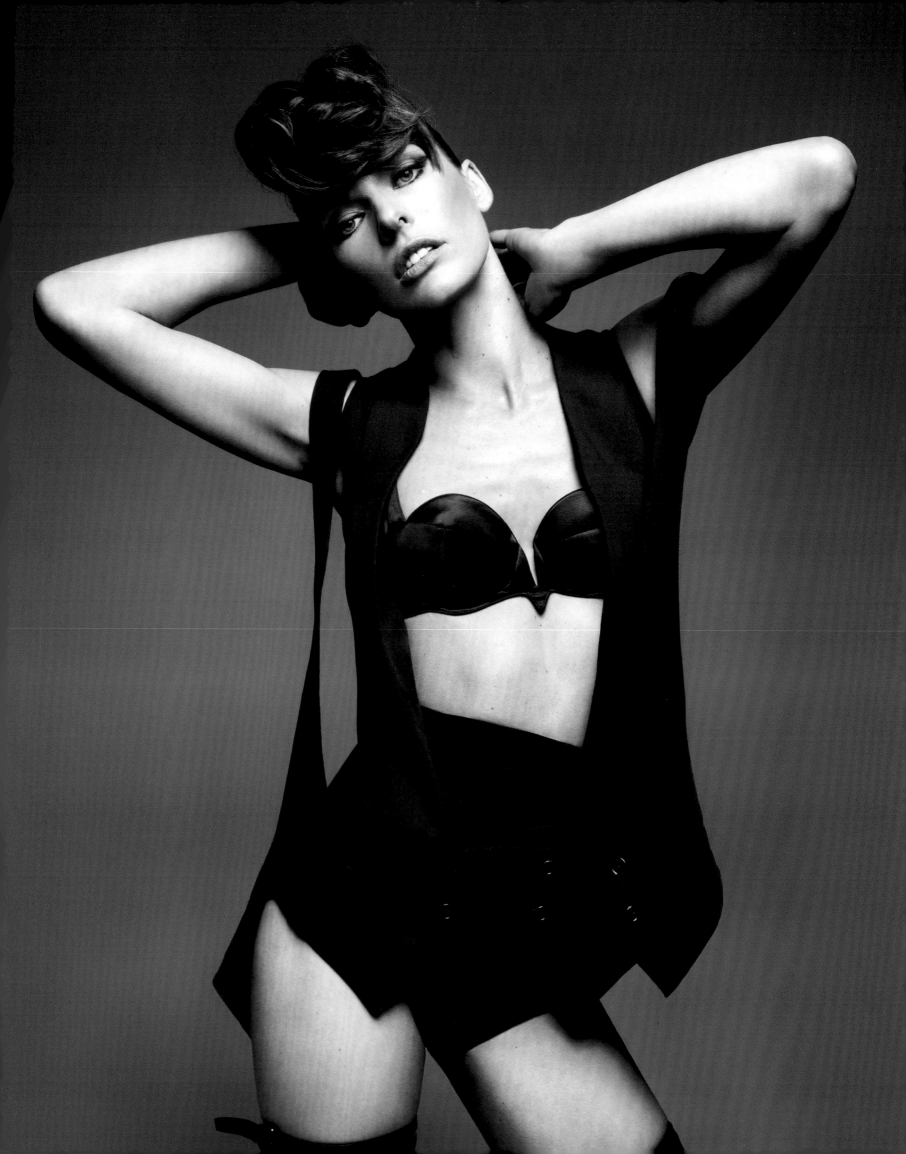

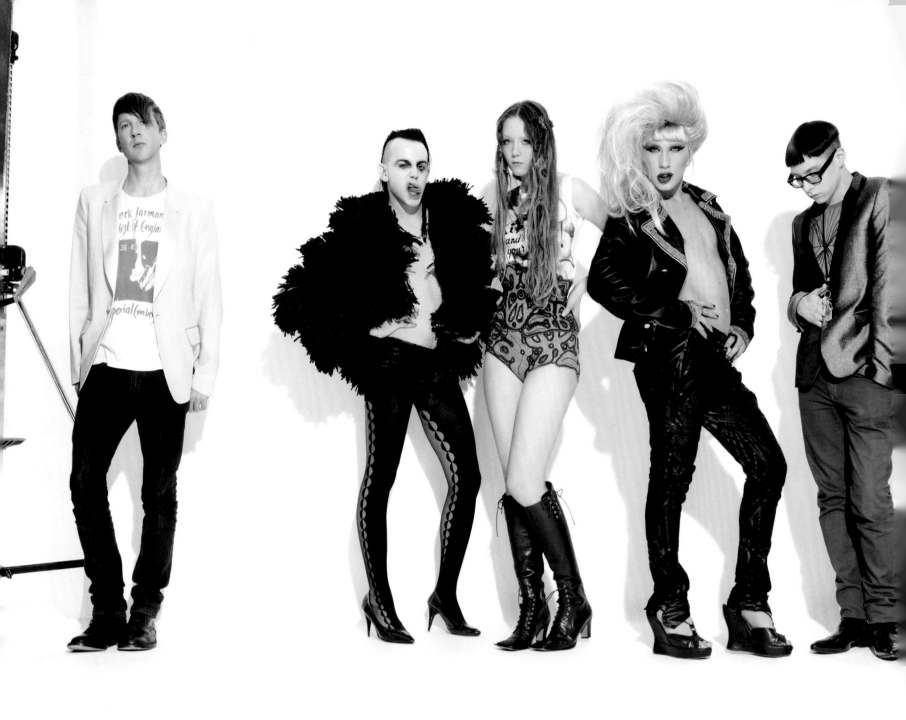

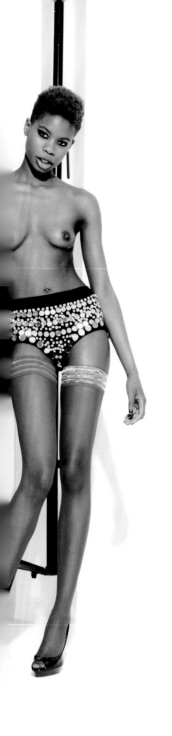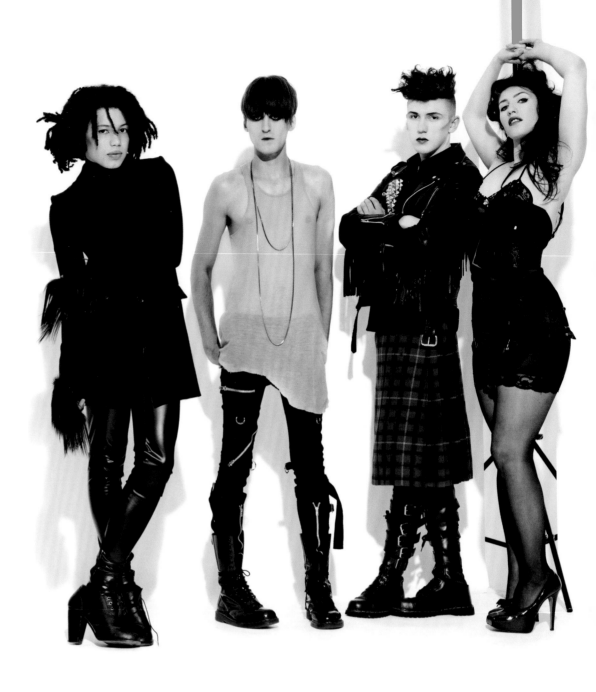

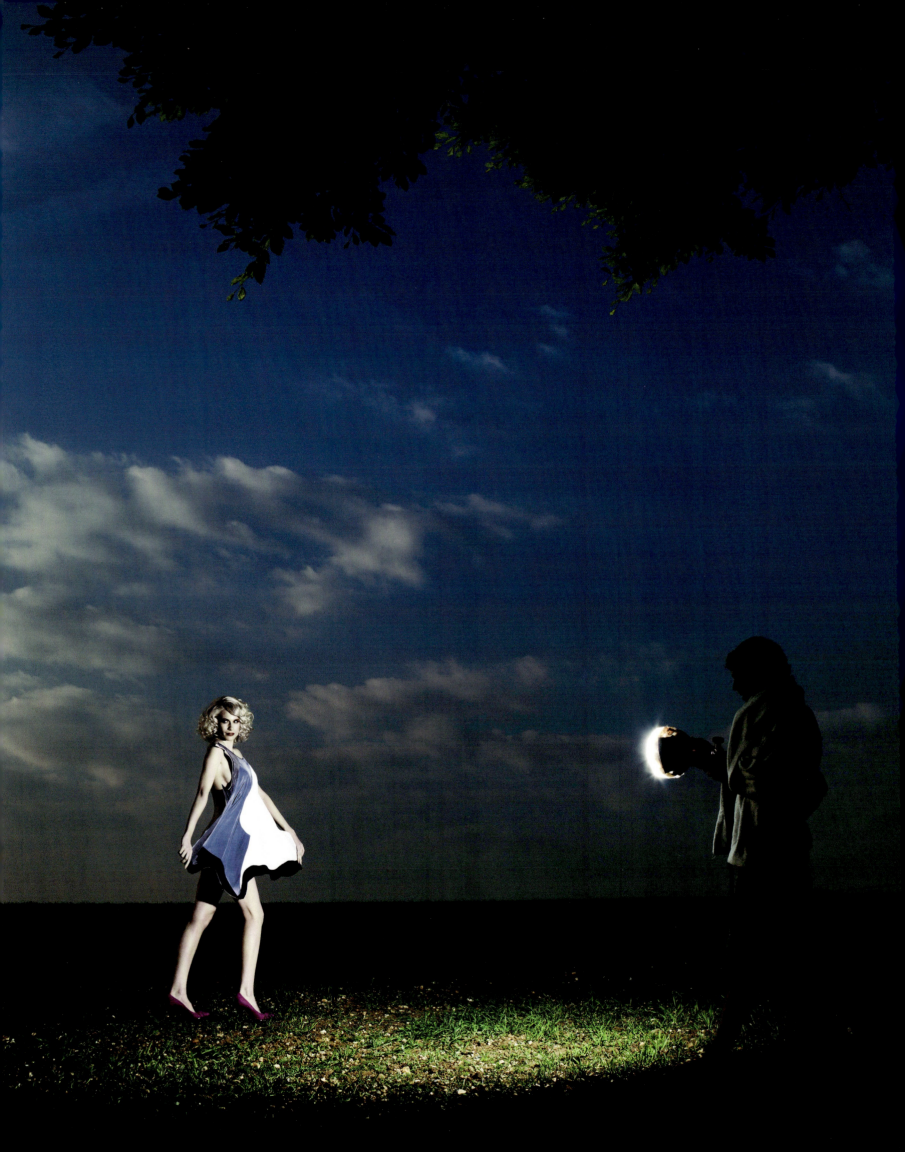

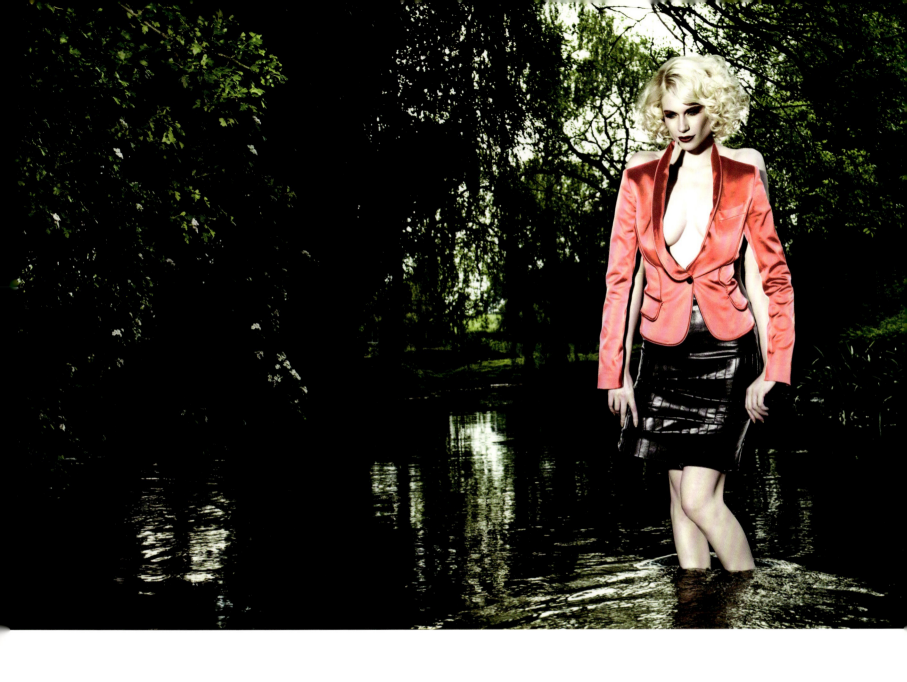

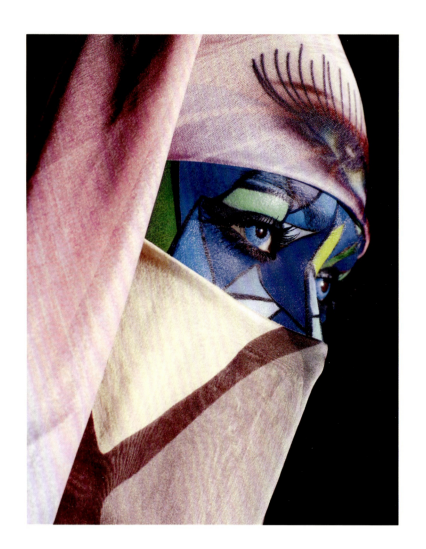 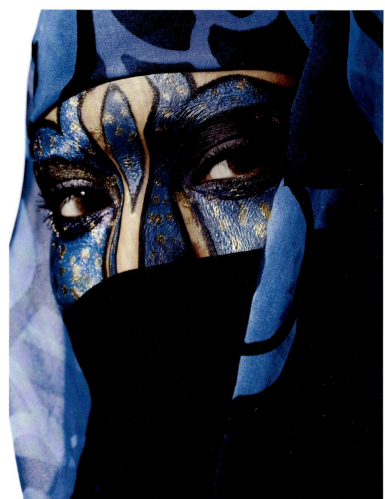

I expected a very energetic set as his sets are always beyond! Usually lots of people are involved (producers, assistants, and film team, etc.) and shots are done very fast before energy levels go down. When I see these images, I still feel the energy and can almost hear the loud music from the day.

 I think it's nice that you can look back and feel the images represent the time they were shot, what was going on by then, and what was in the air. It's great if someone feels something special from the picture we created. Even if they don't know the process of the shoot, they are sharing something with all of us who worked on the image.

AYAMI NISHIMURA

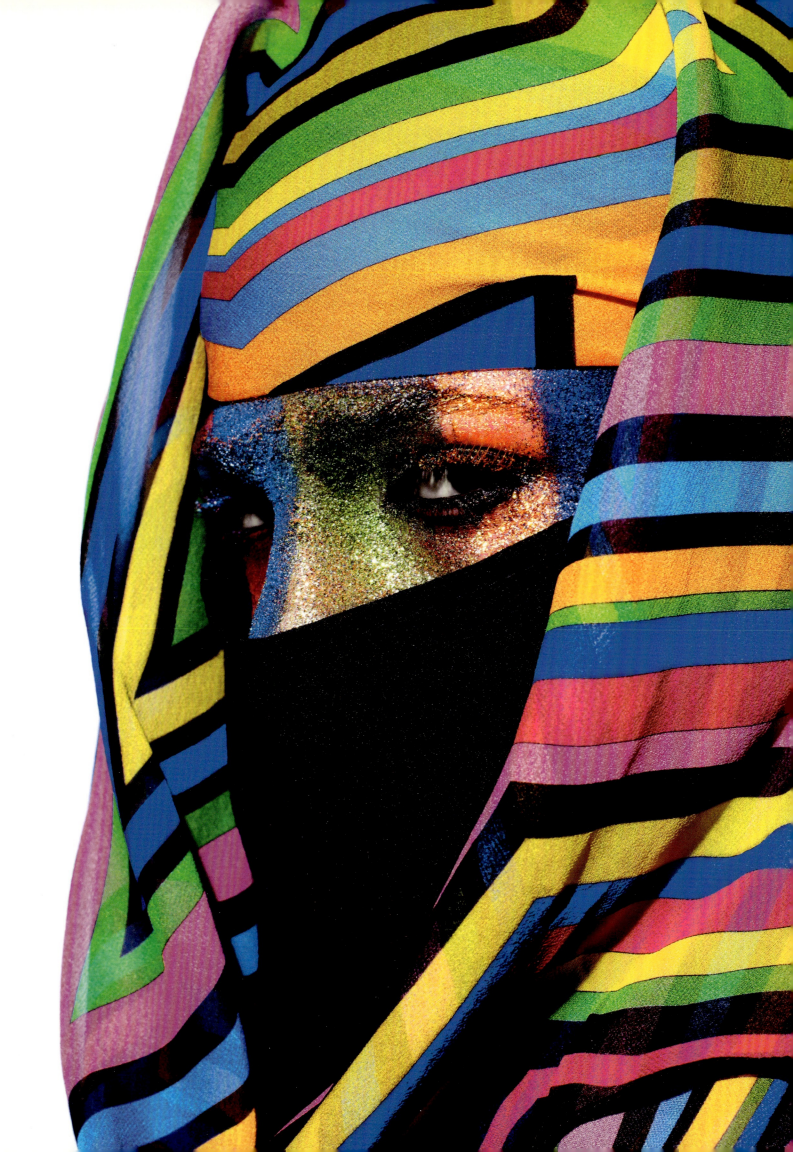

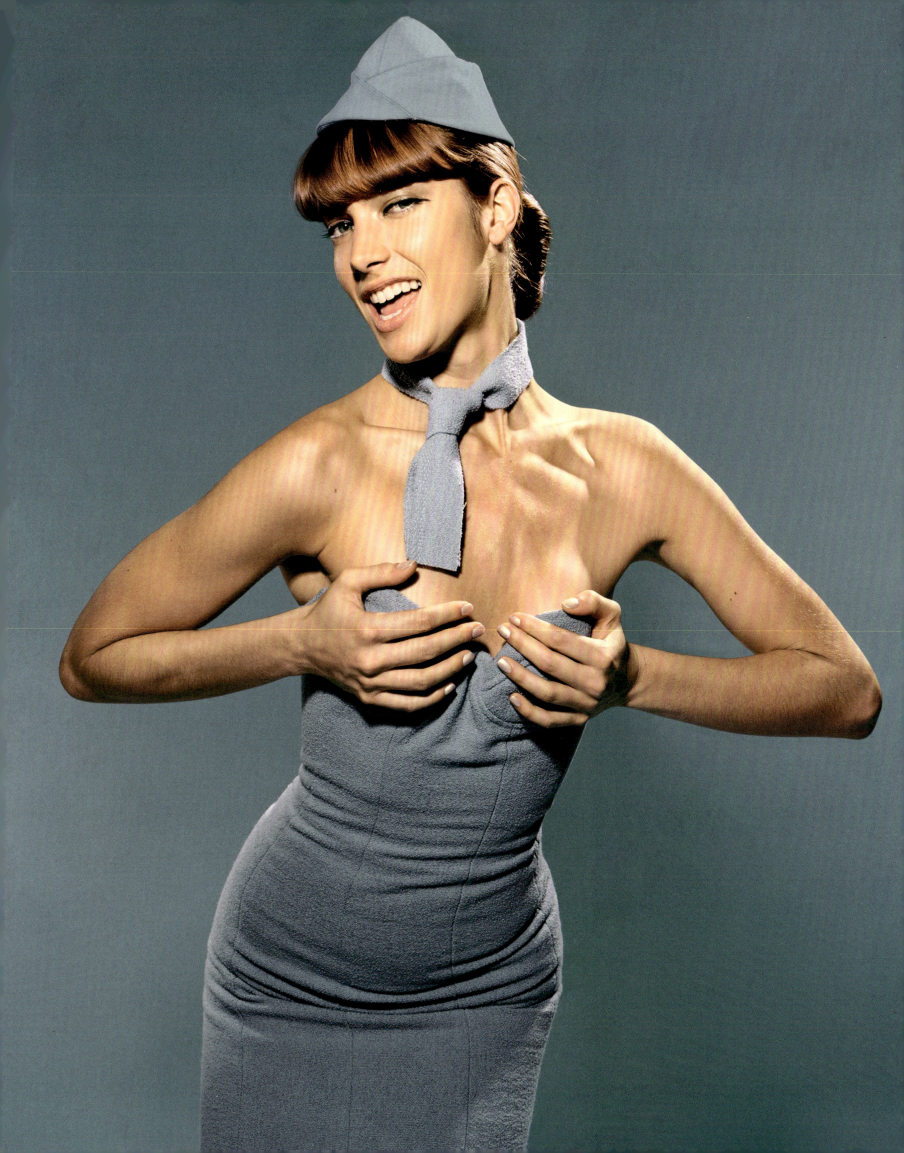

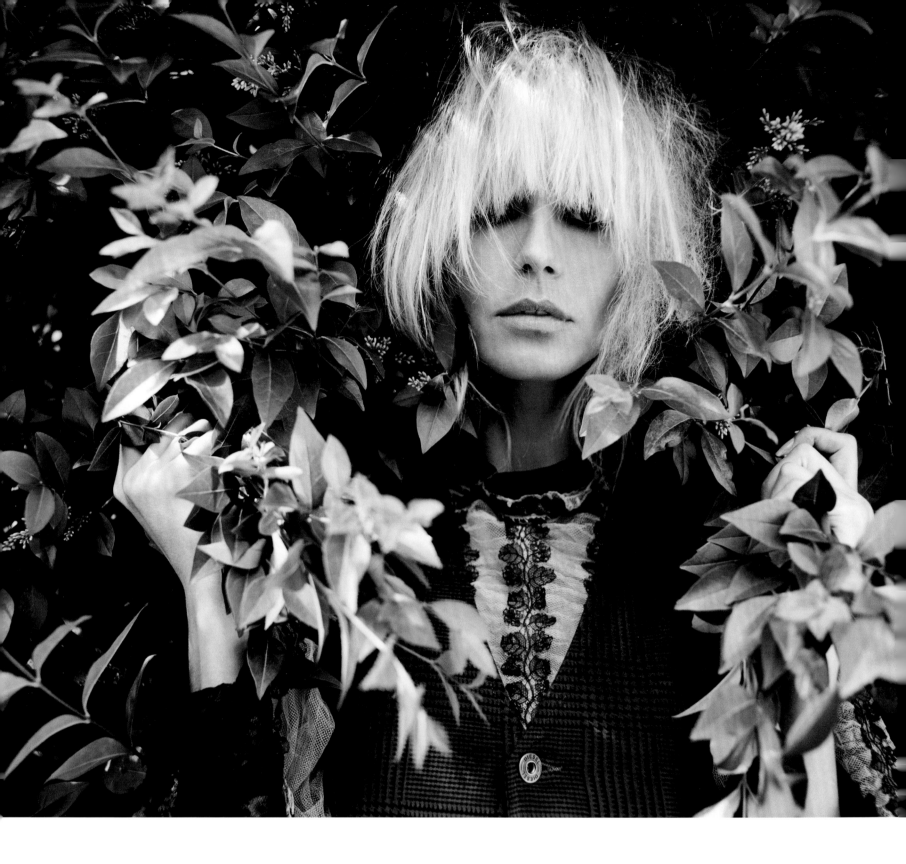

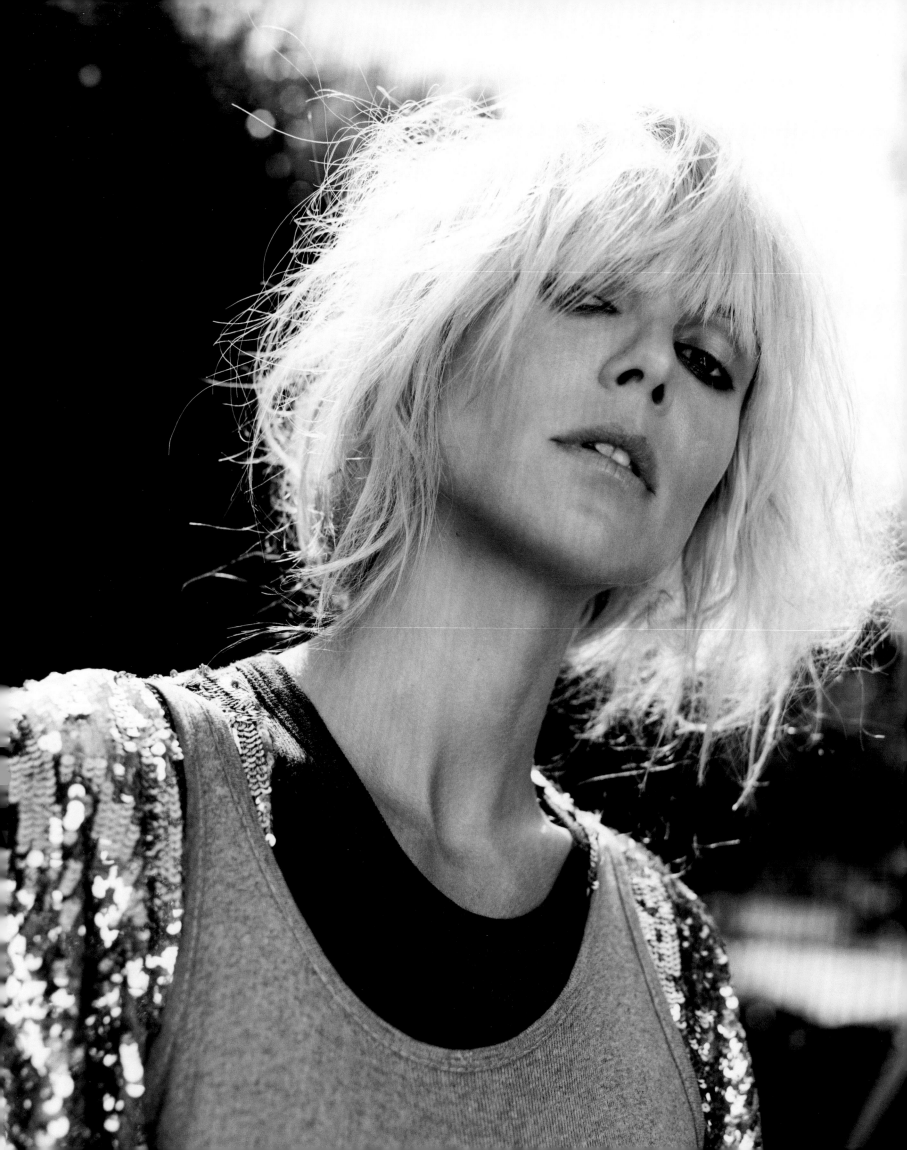

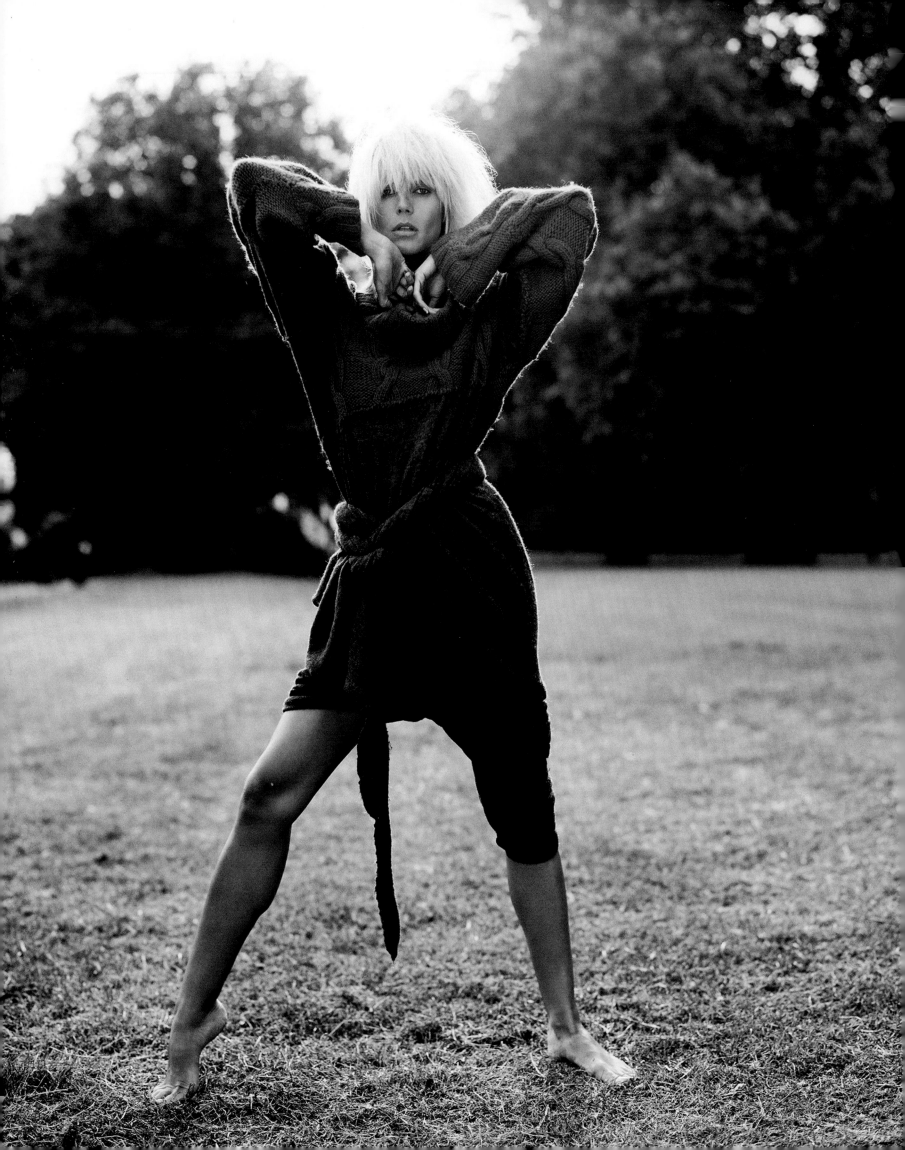

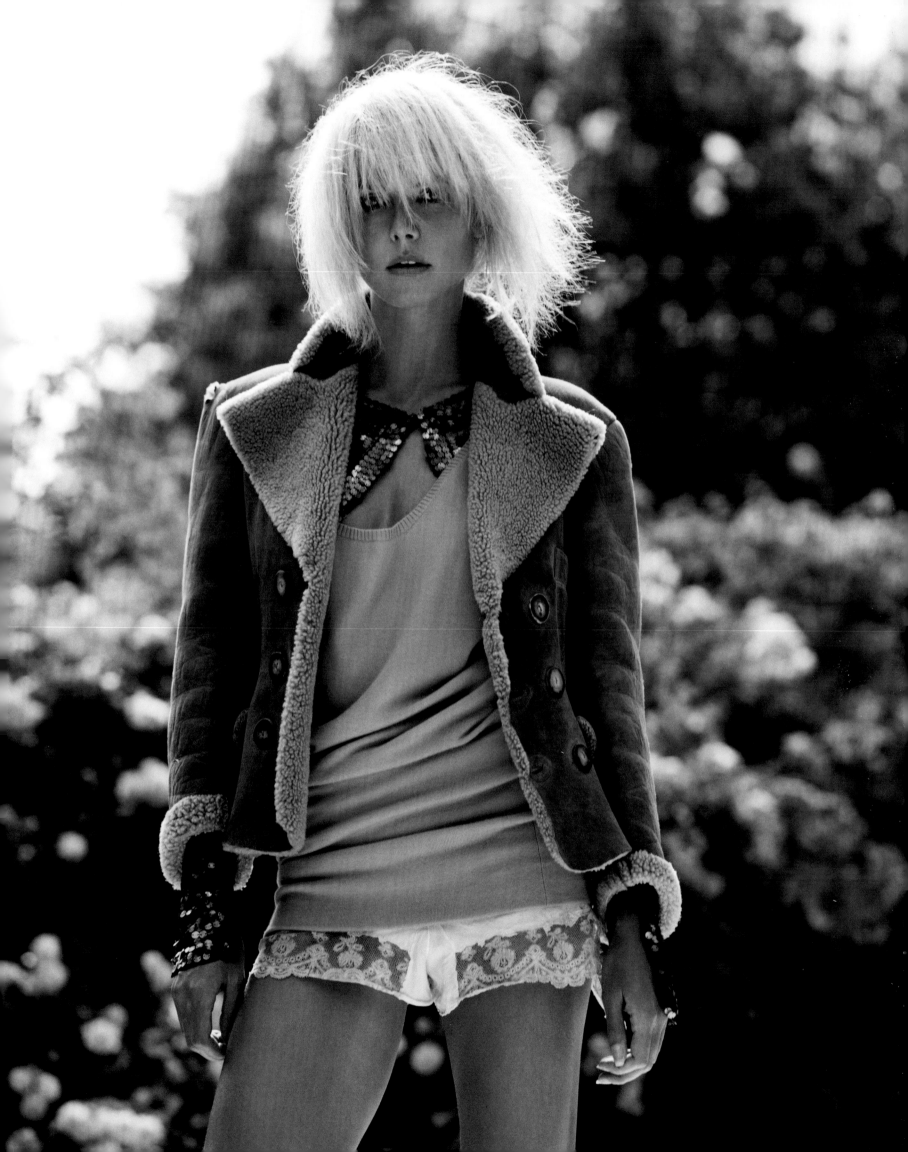

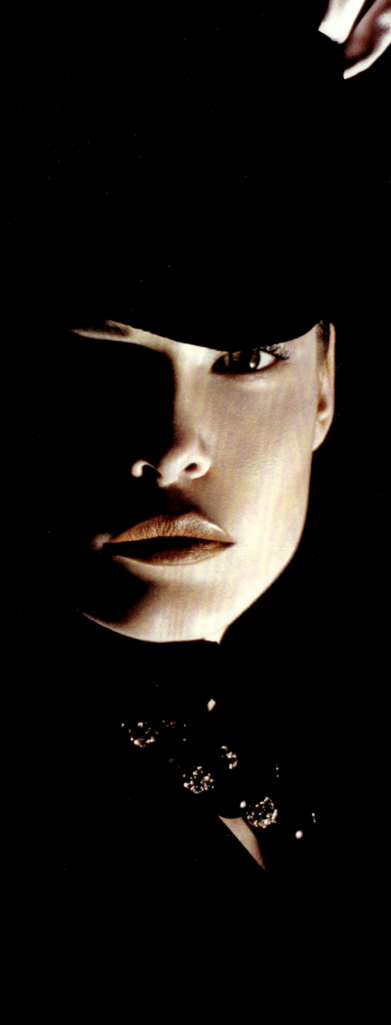

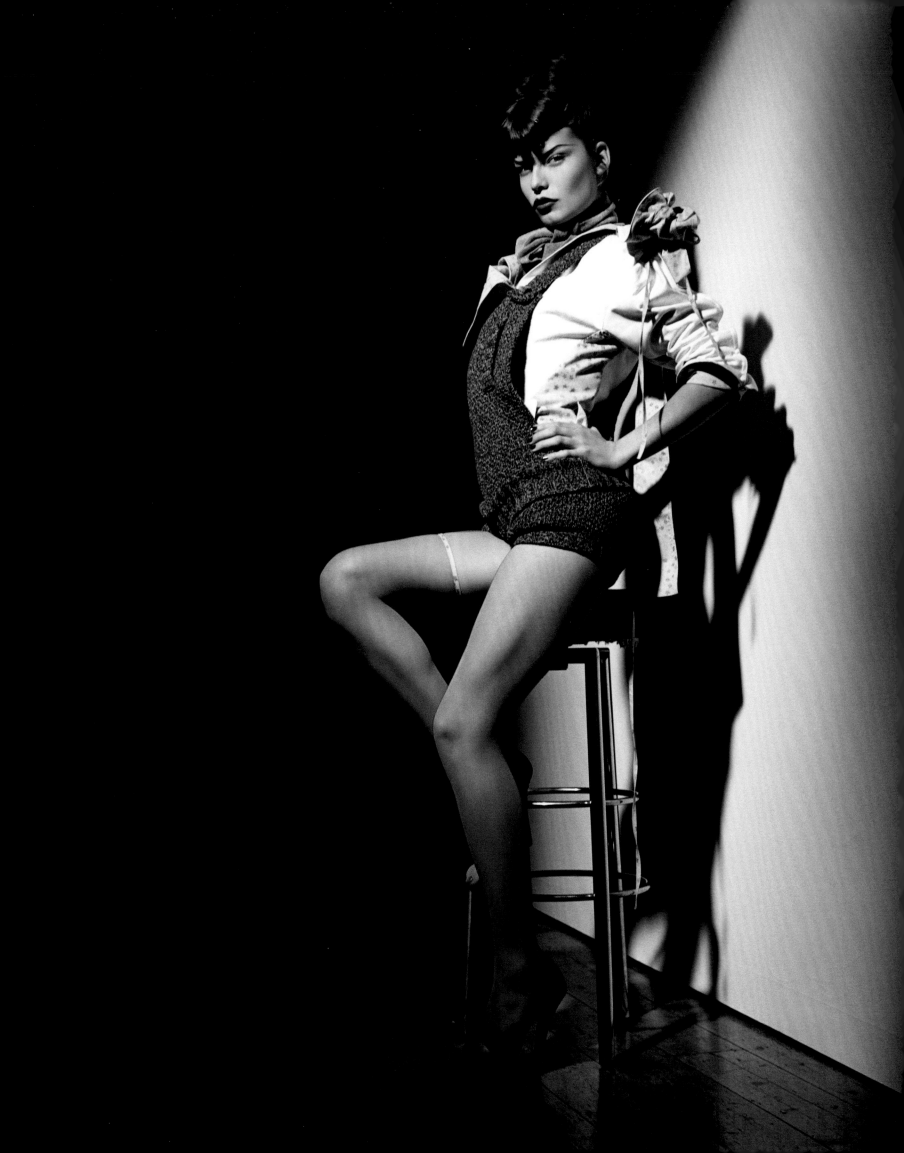

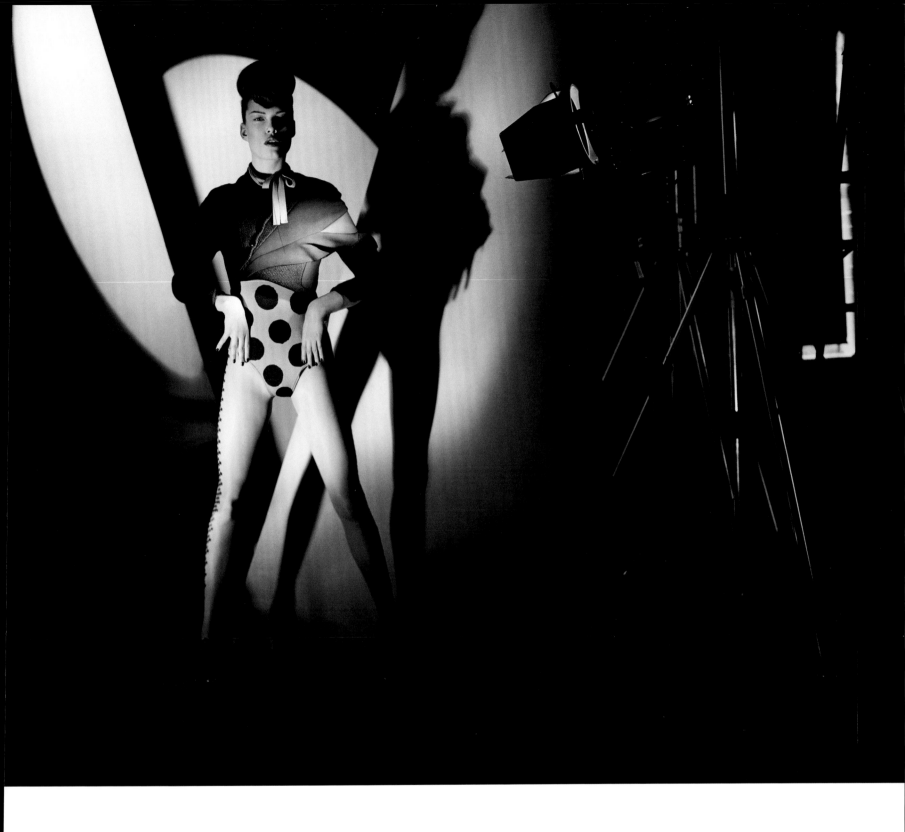

Celluloid Closet | 2003

Rankin is a control freak, a scary, caring, loveable monster.

VAL GARLAND

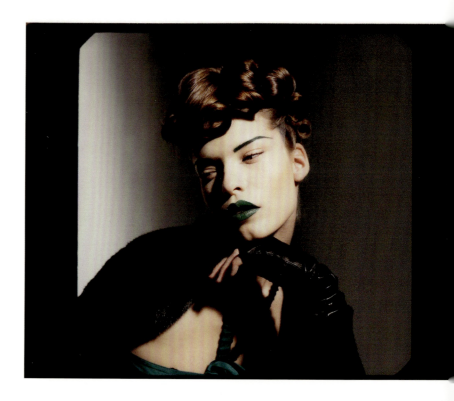

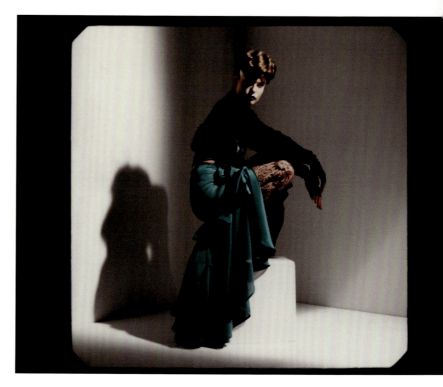

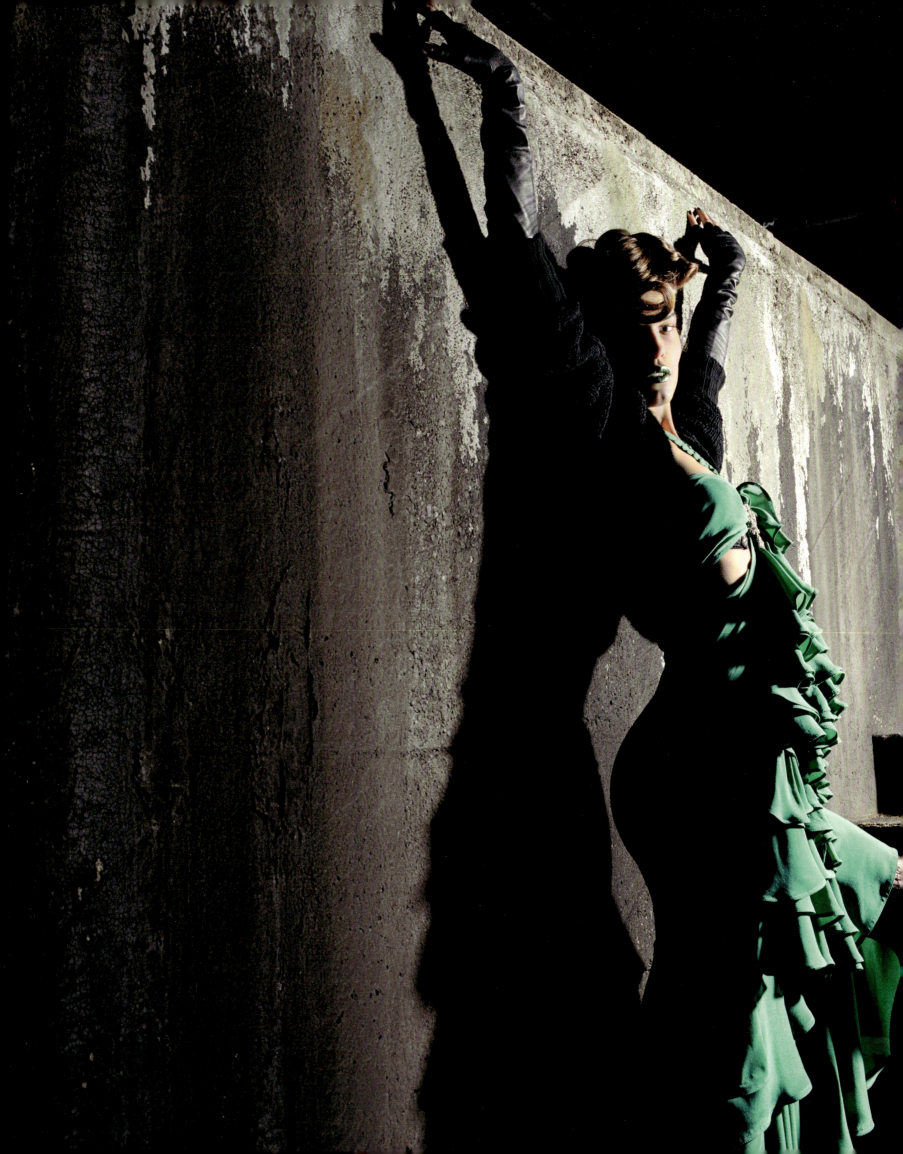

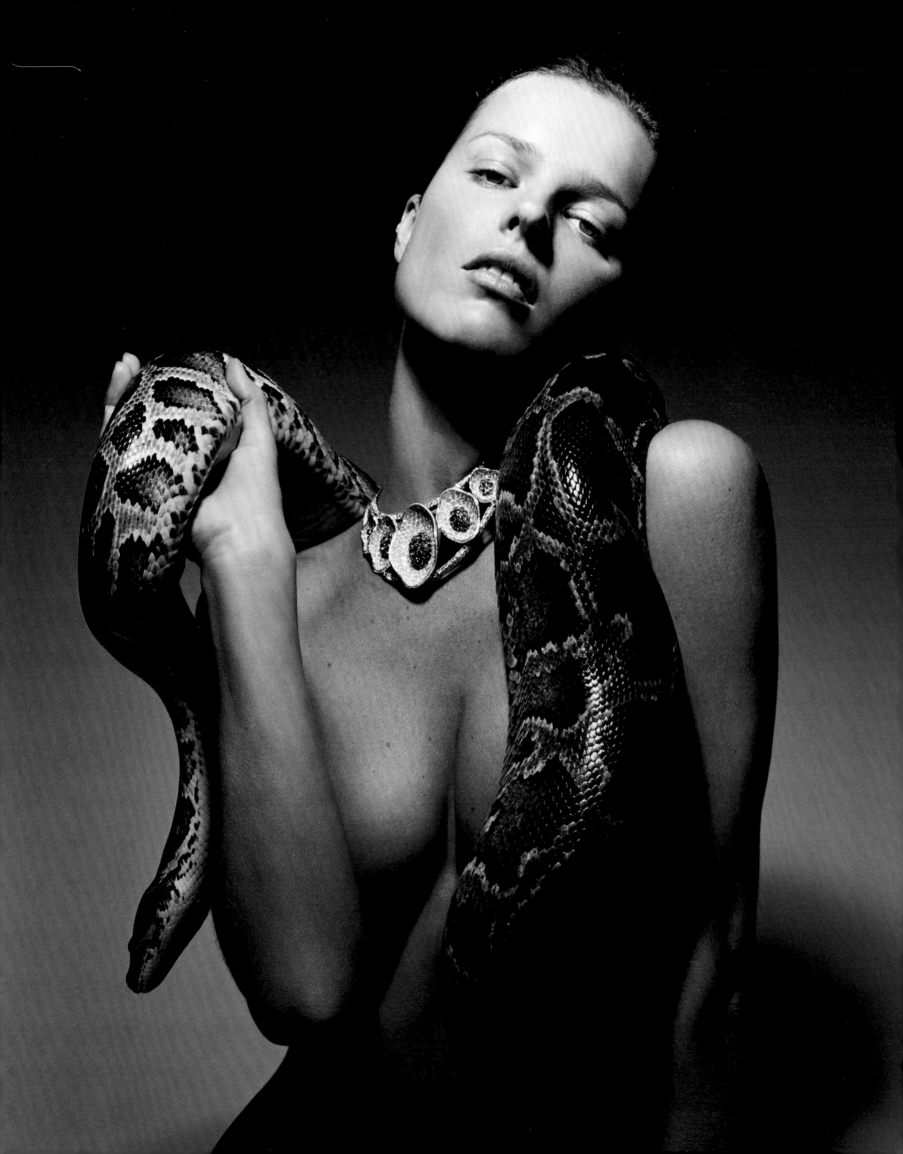

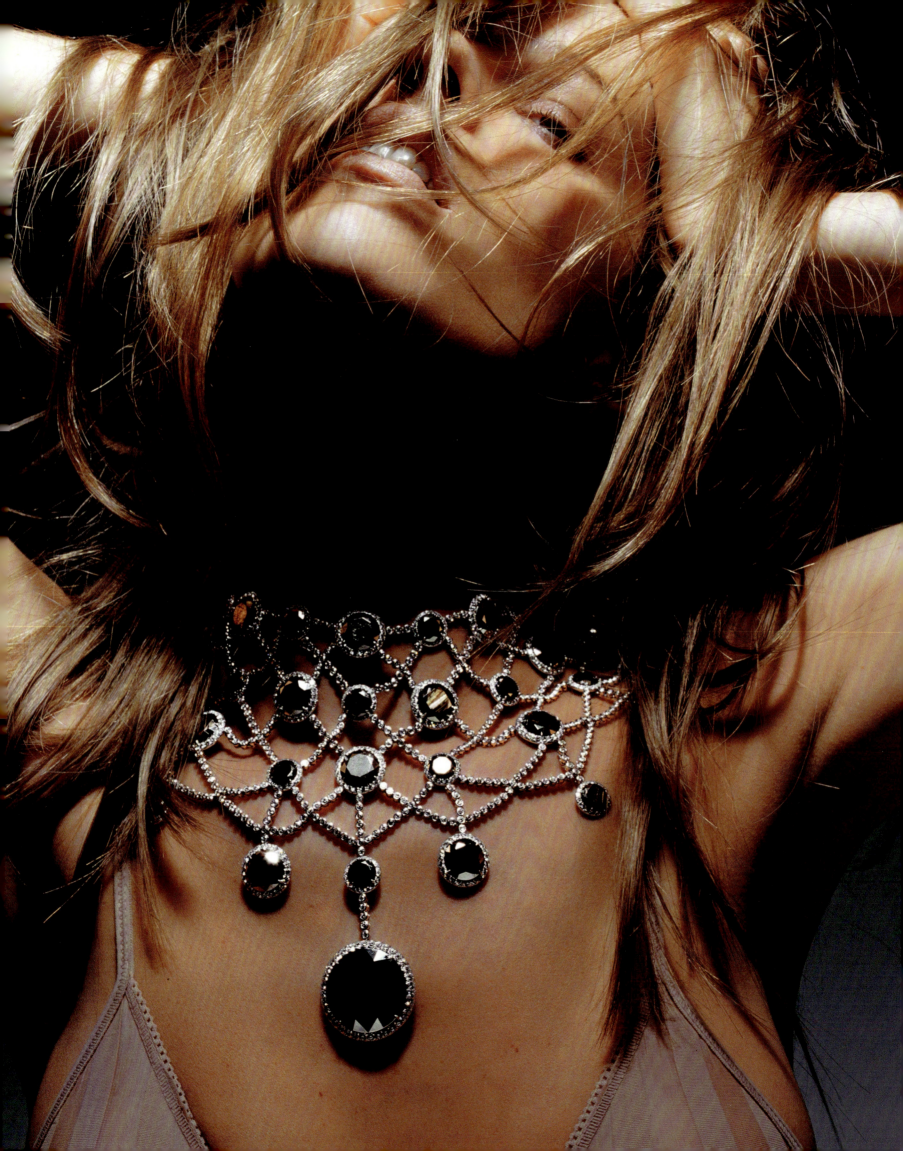

Paris Plage | 2004

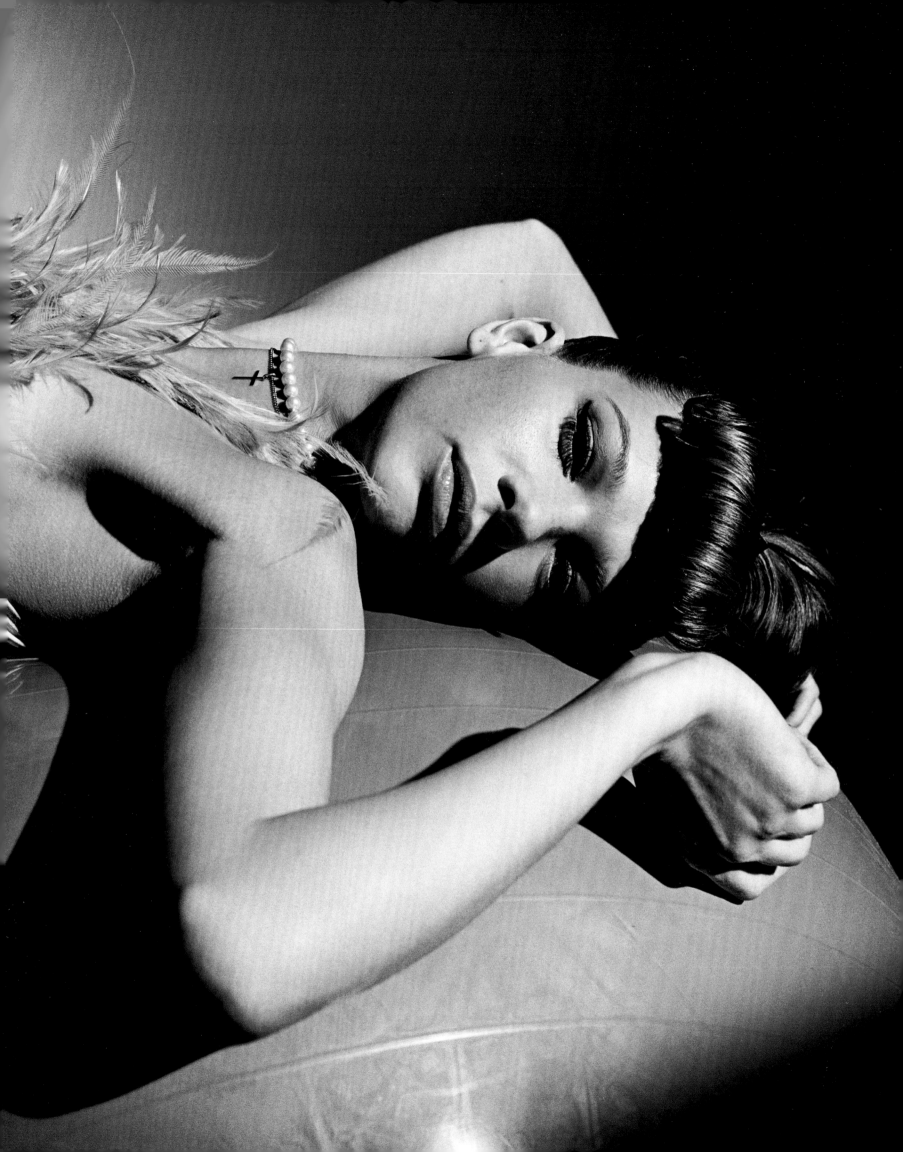

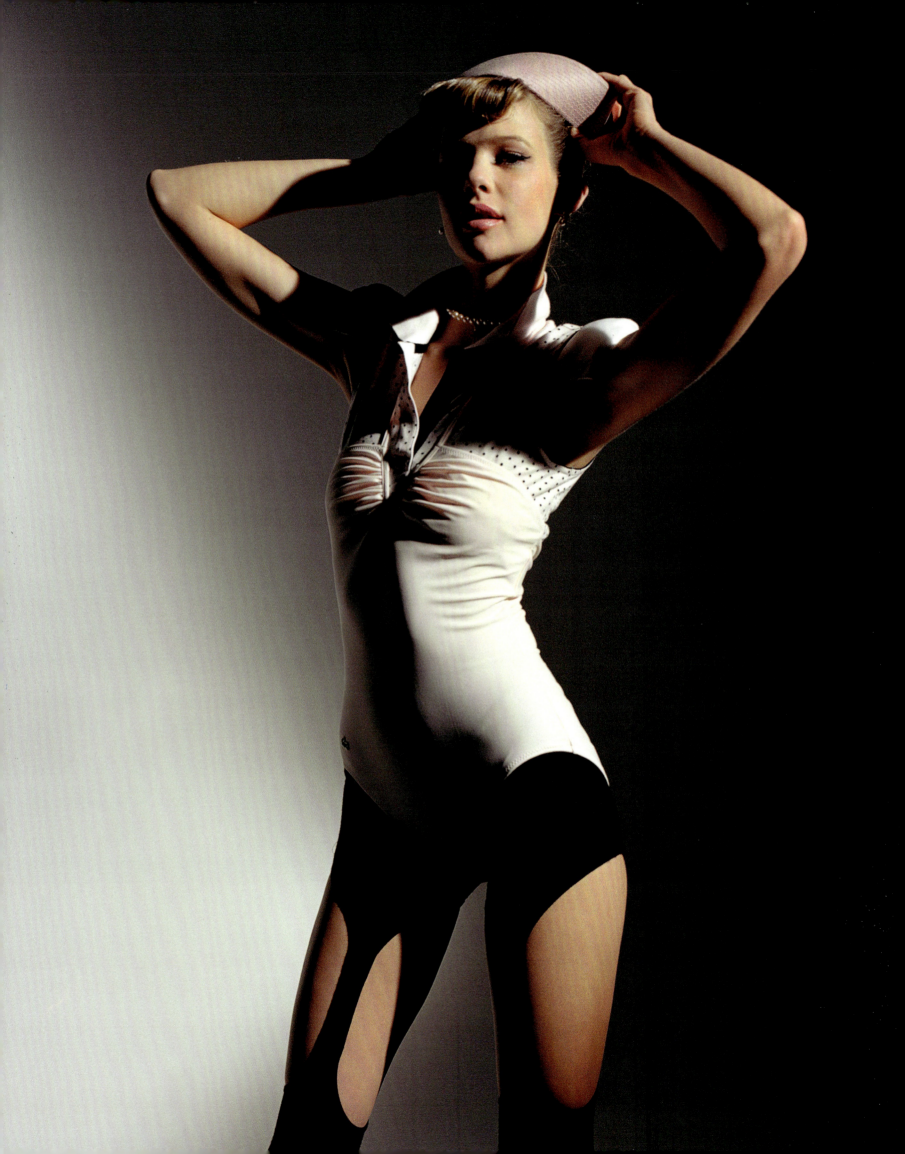

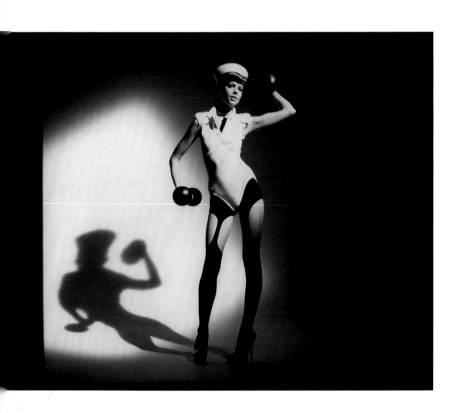

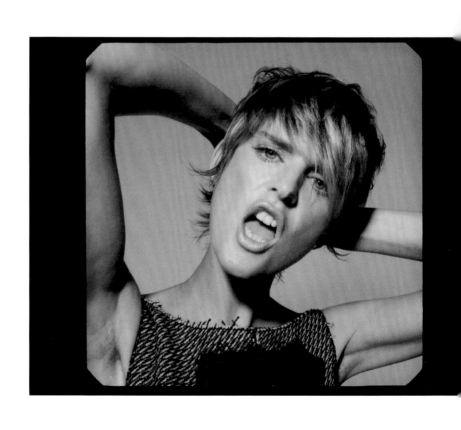

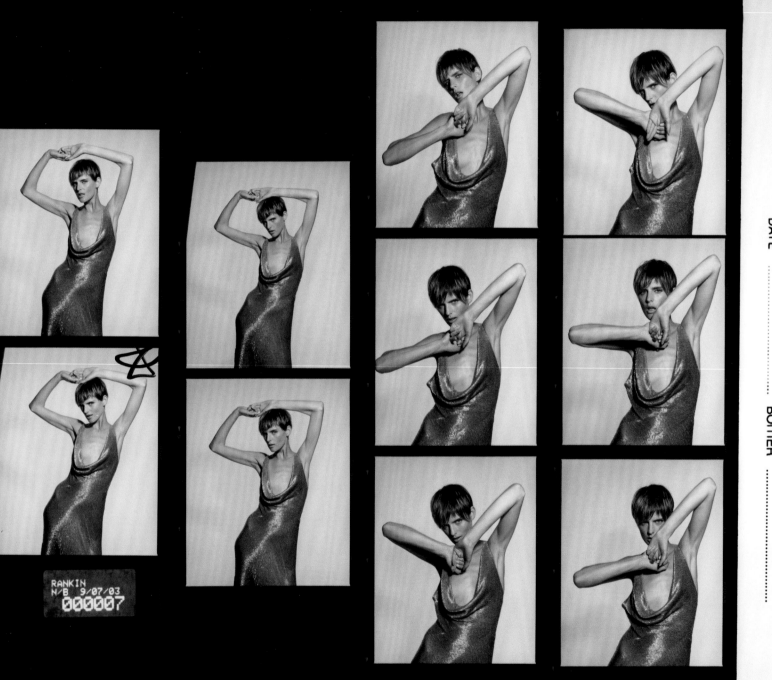

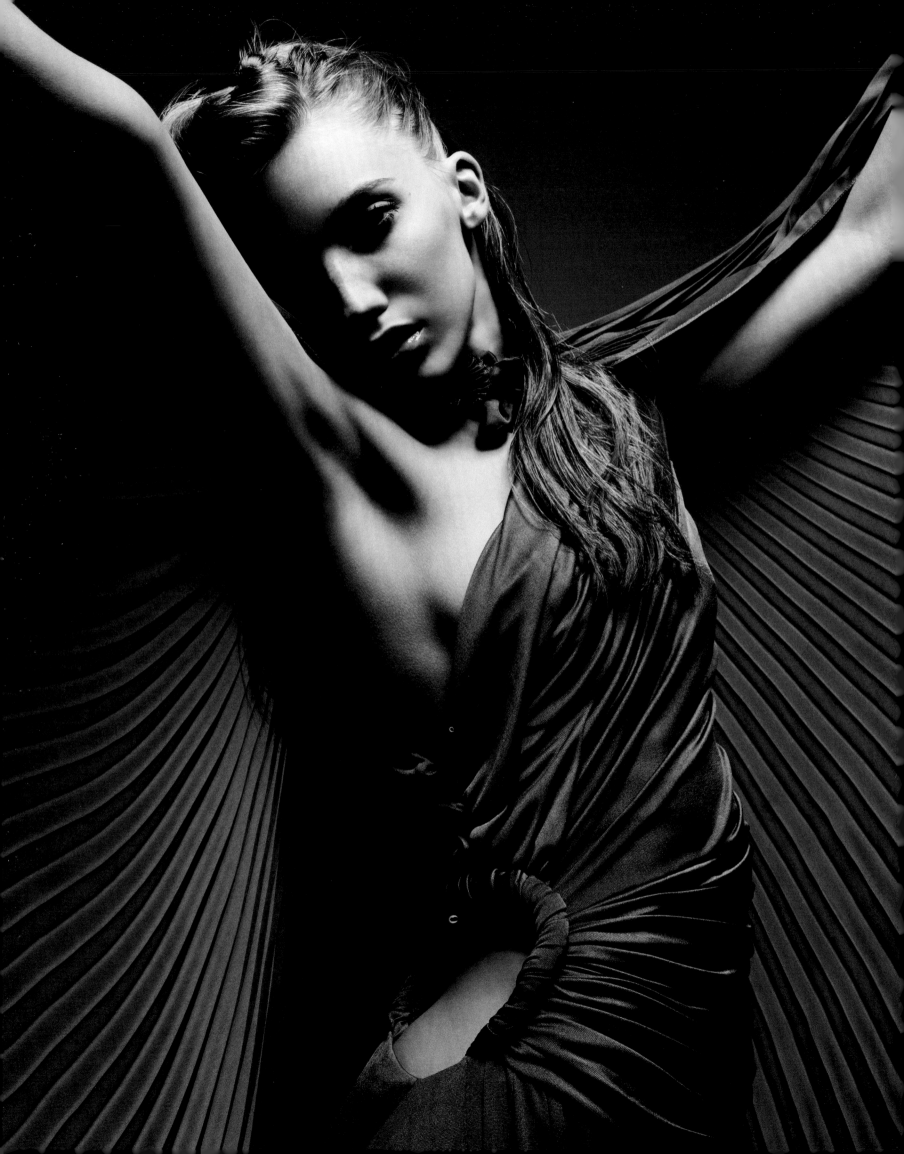

Haute Couture | 2003　　　　Elle Macpherson Intimates | 2003

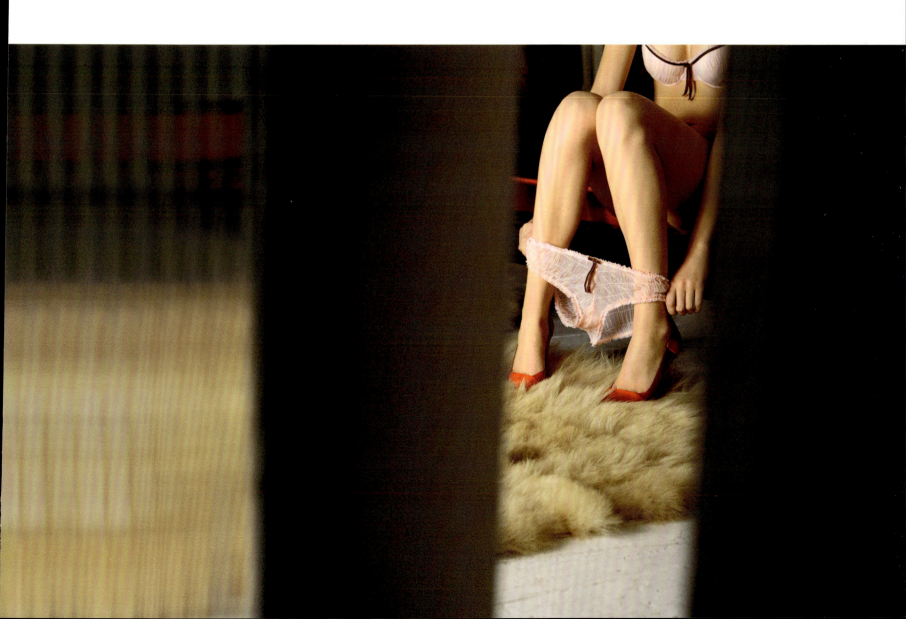

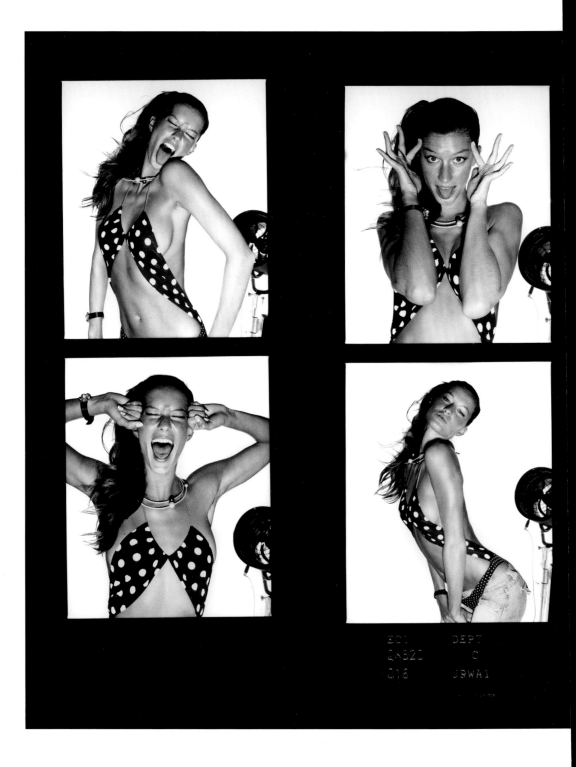

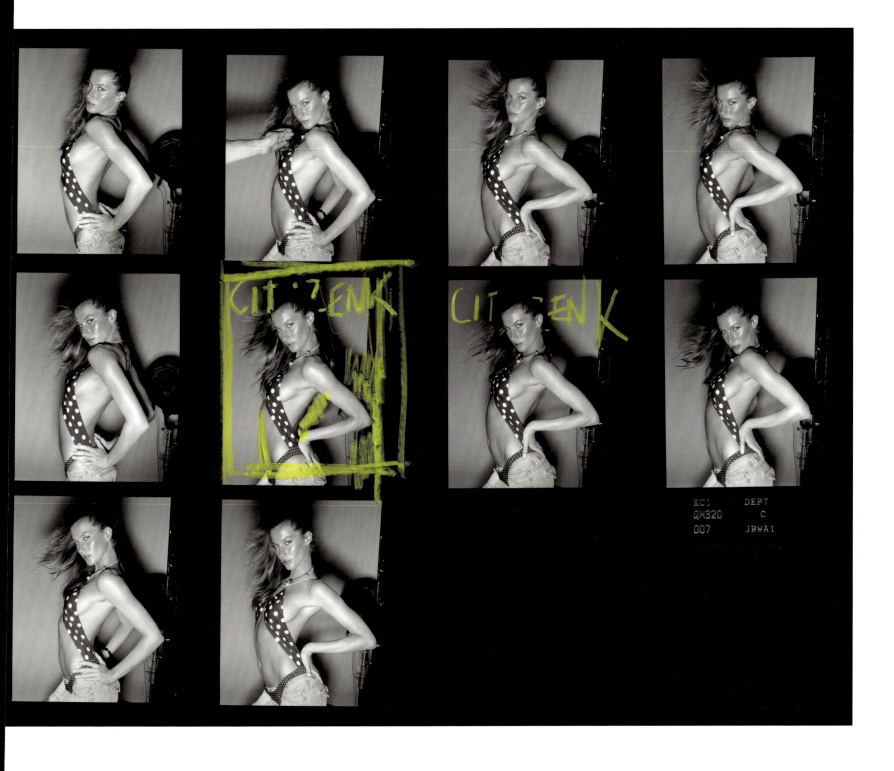

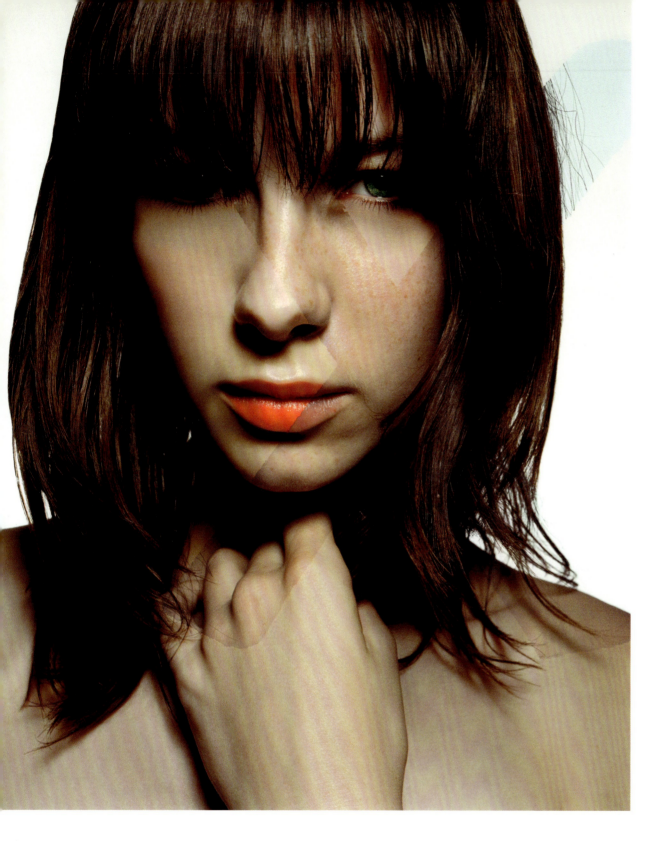
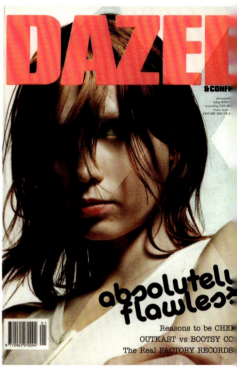

Touched Up | 2002

Next
Bimba Bosé | 2001

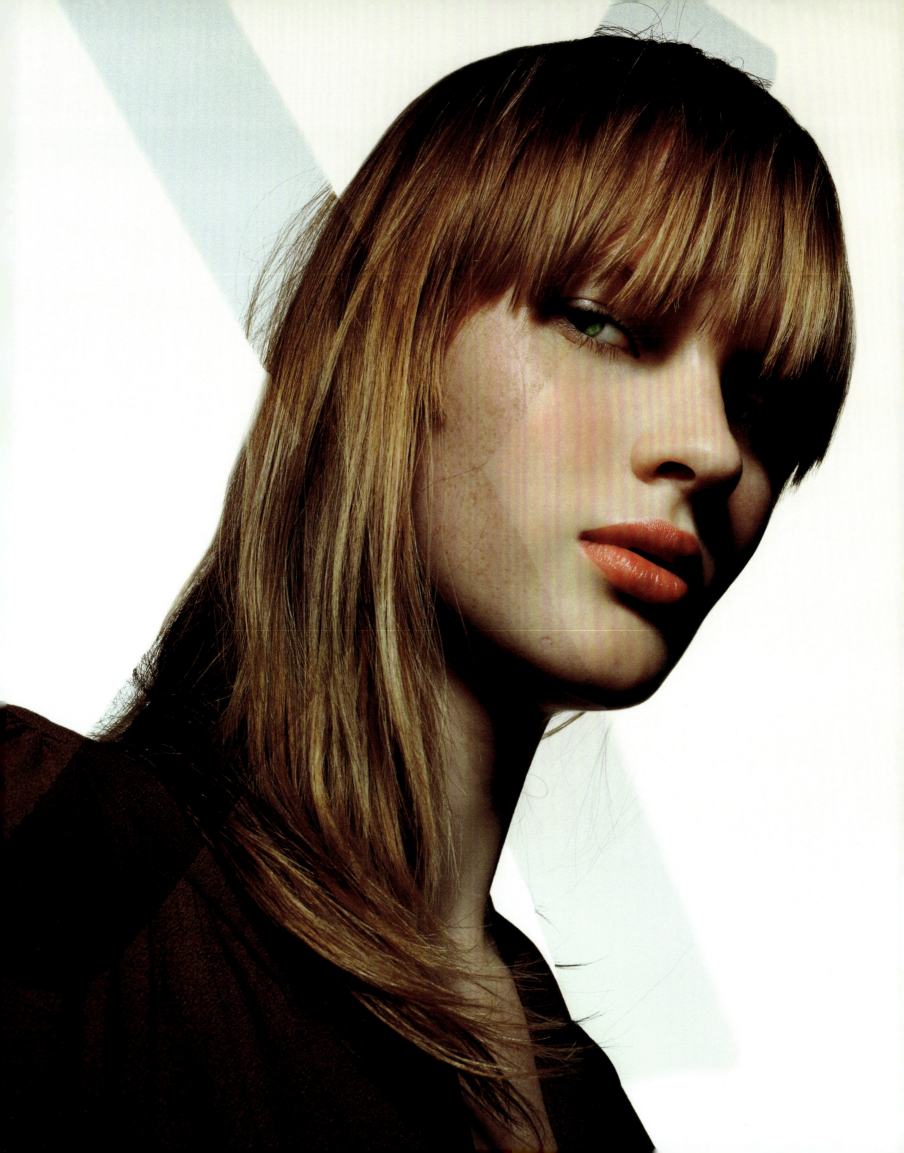

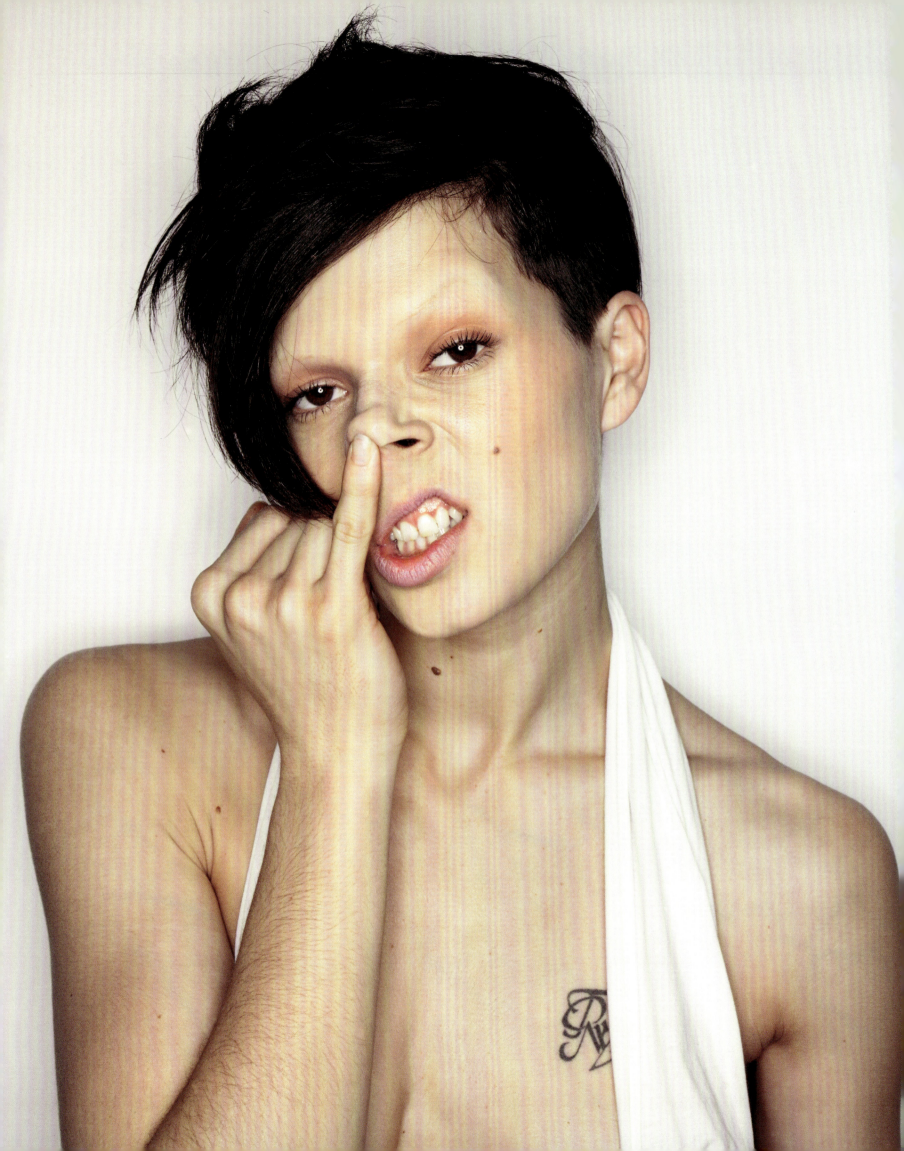

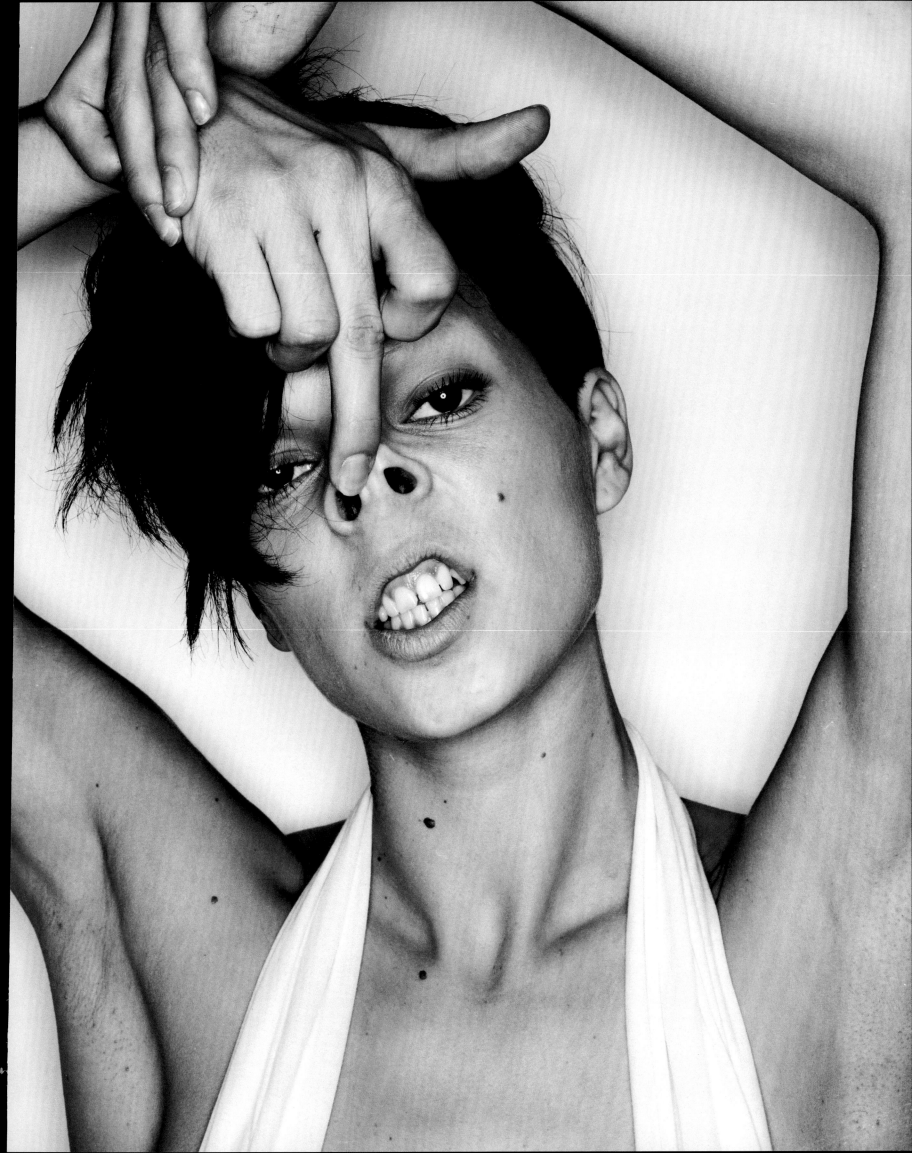

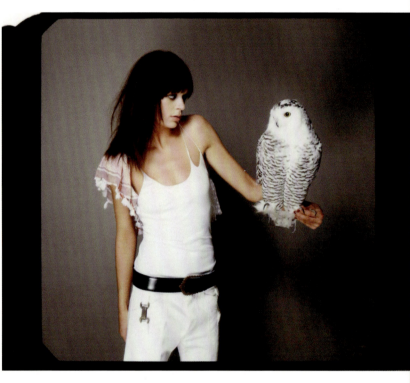
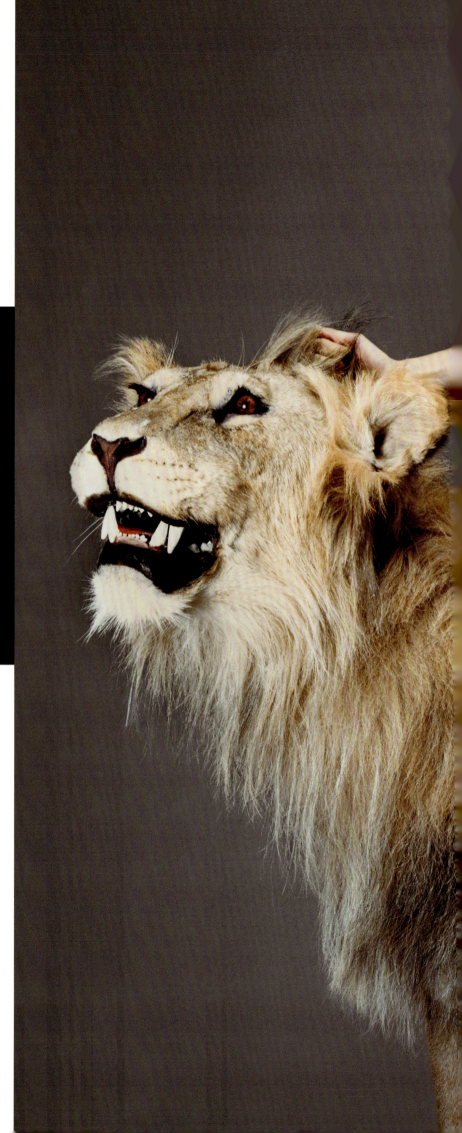

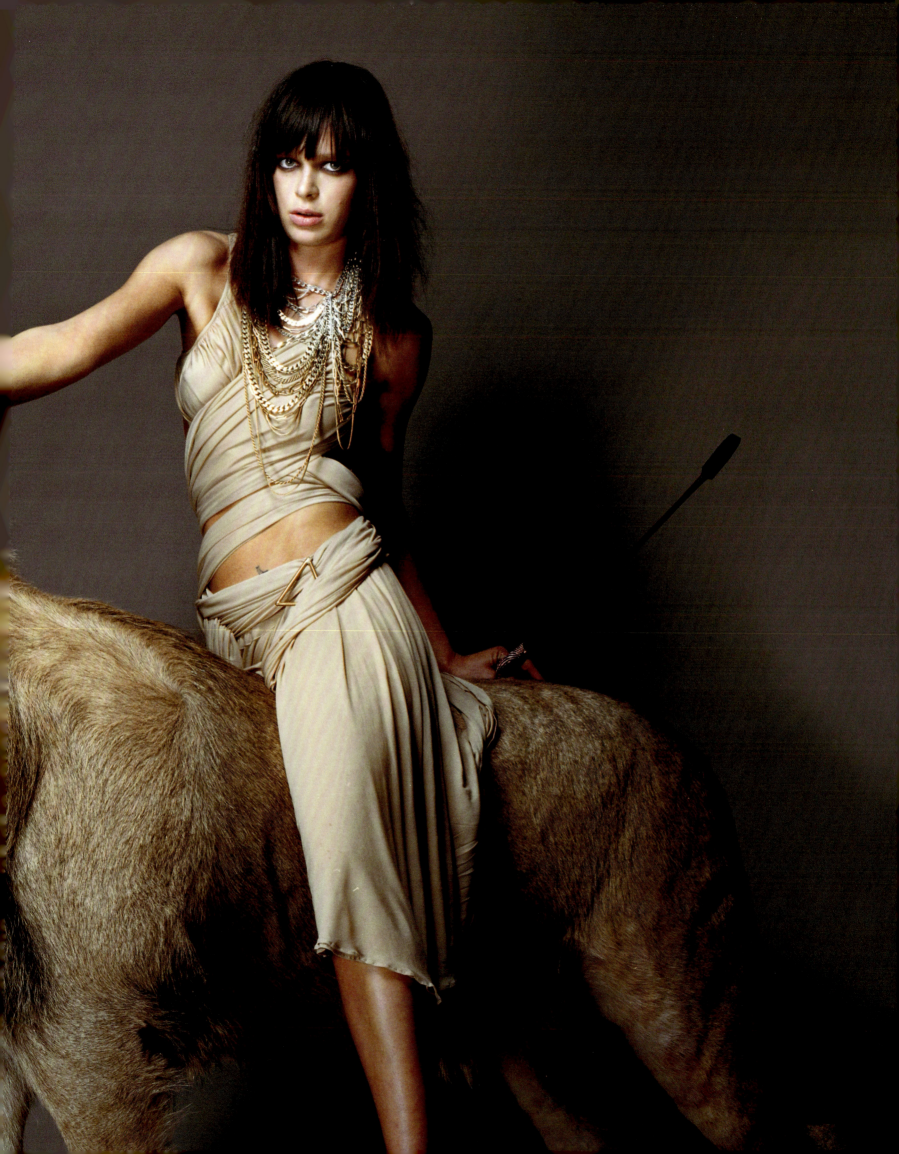

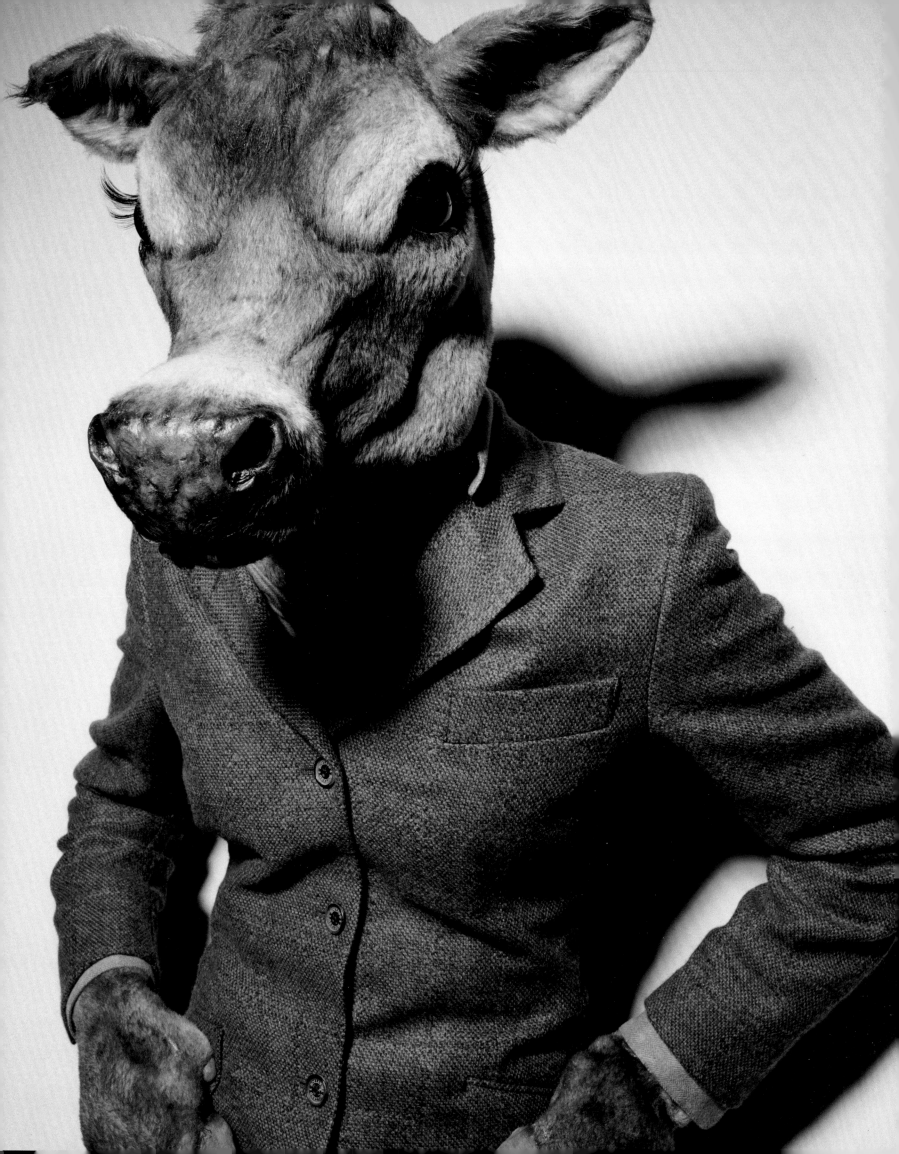

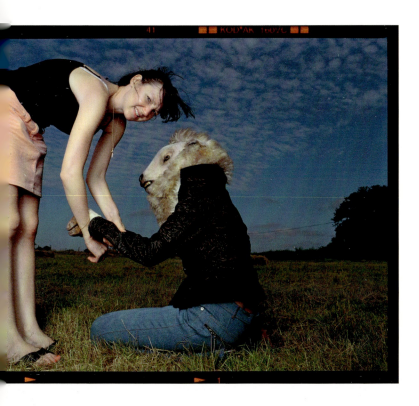

Livestock | 2001

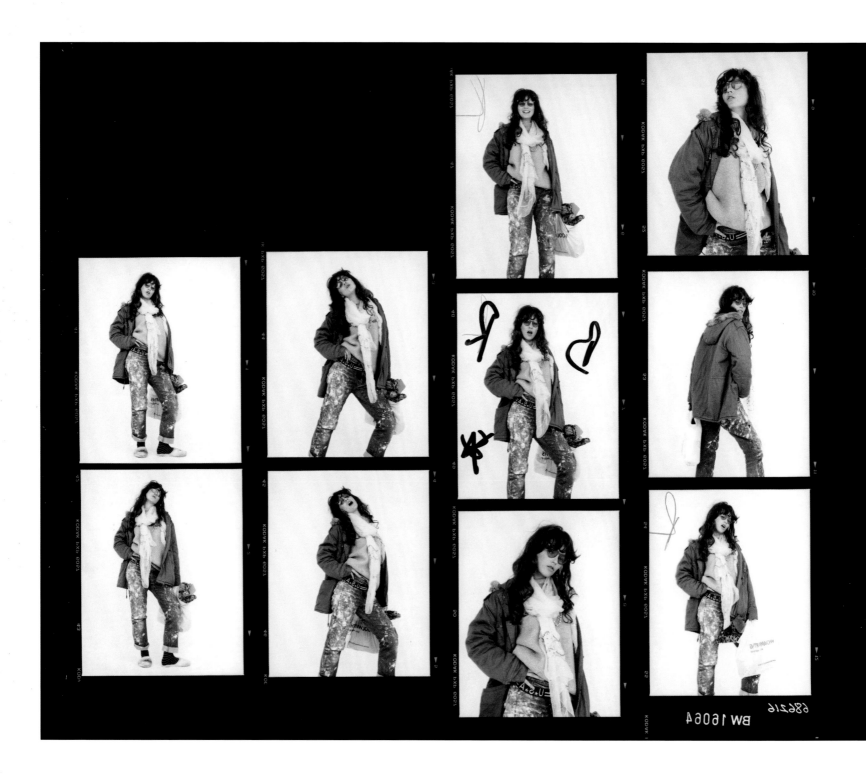

170 Bag Lady | 2001

Next
I'm Only 13 | 2001
Beauty Queens | 2001

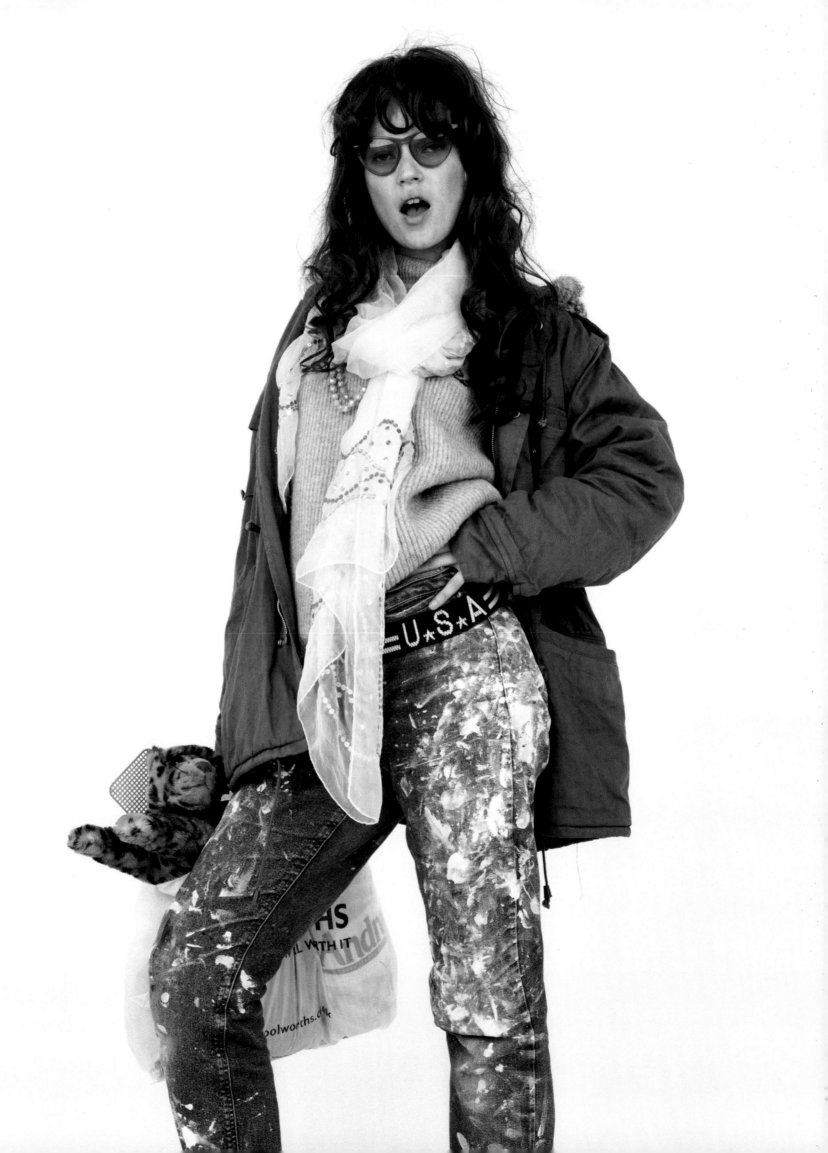

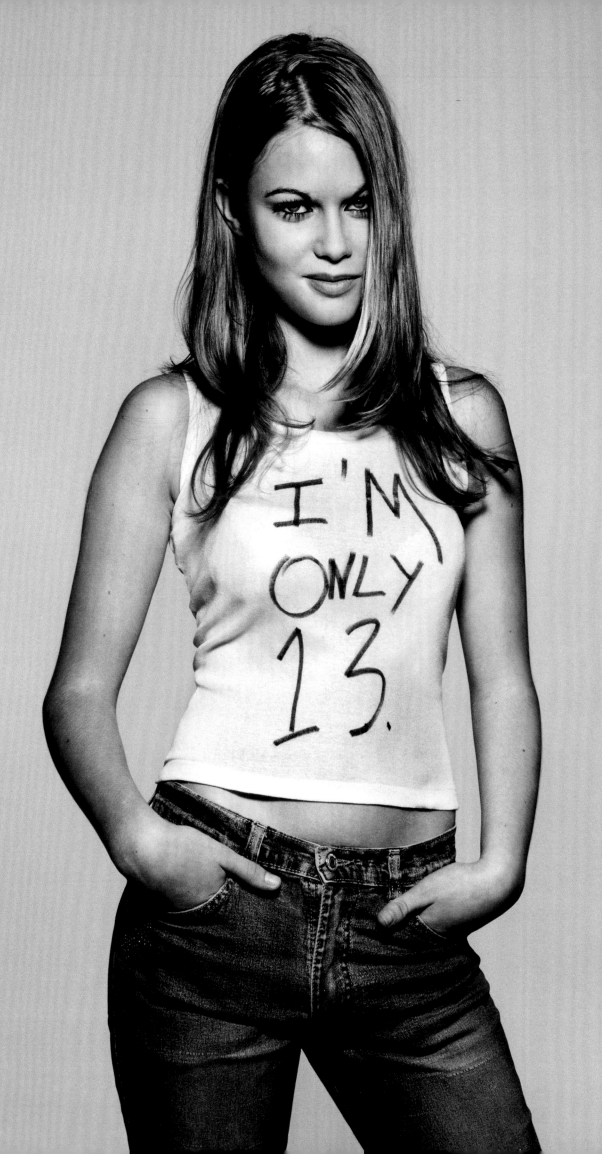

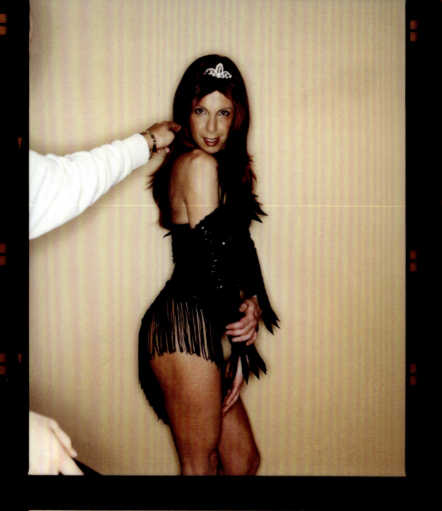
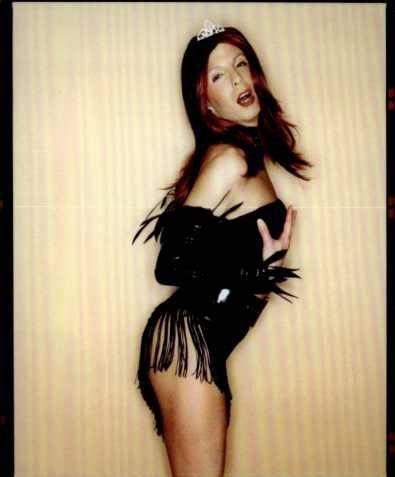
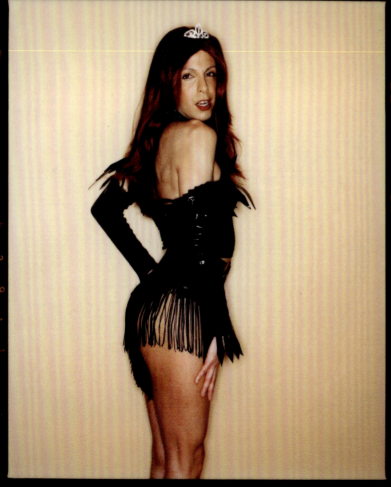
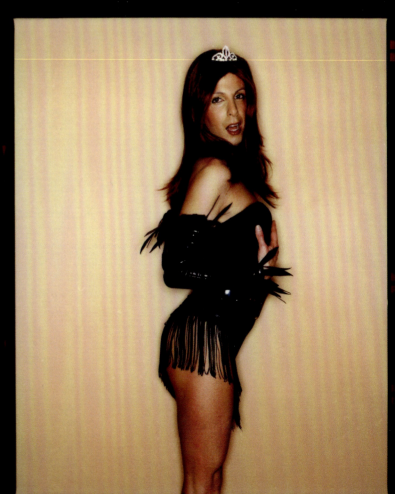

Why did Rankin cast me? I'd say it was my ginger hair. I was lucky being part of Madonna's 'Drowned World/Substitute for Love' promo, the cover artwork for which was photographed by Rankin. It was then when I first noticed his ability to capture characters. I noticed the way the light was done differently to other photographers around at the time. When my agent rang me some years later with, "Are you free for Rankin?" I immediately knew that I could trust the outcome and said: "Yes, awesome!" I felt honored to collaborate with such a visionary talent.

MARTIN MEISTER

I remember he was very friendly, as there were rumors of a bad temper!

RUPERT MEATS

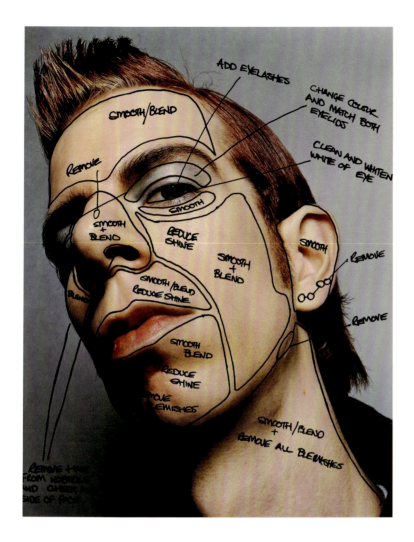
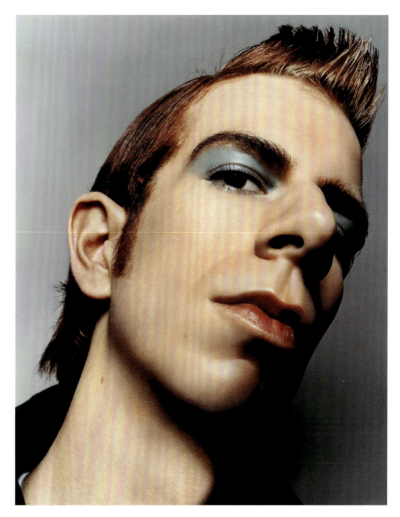
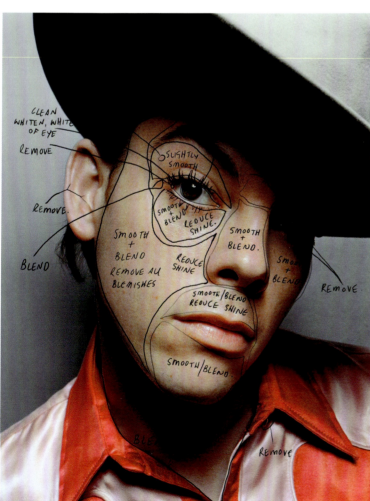
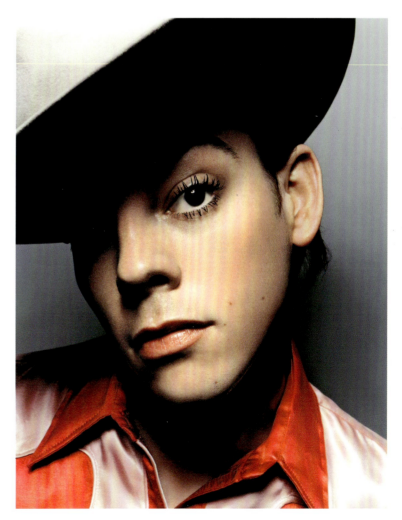

Bootyfull | 2001

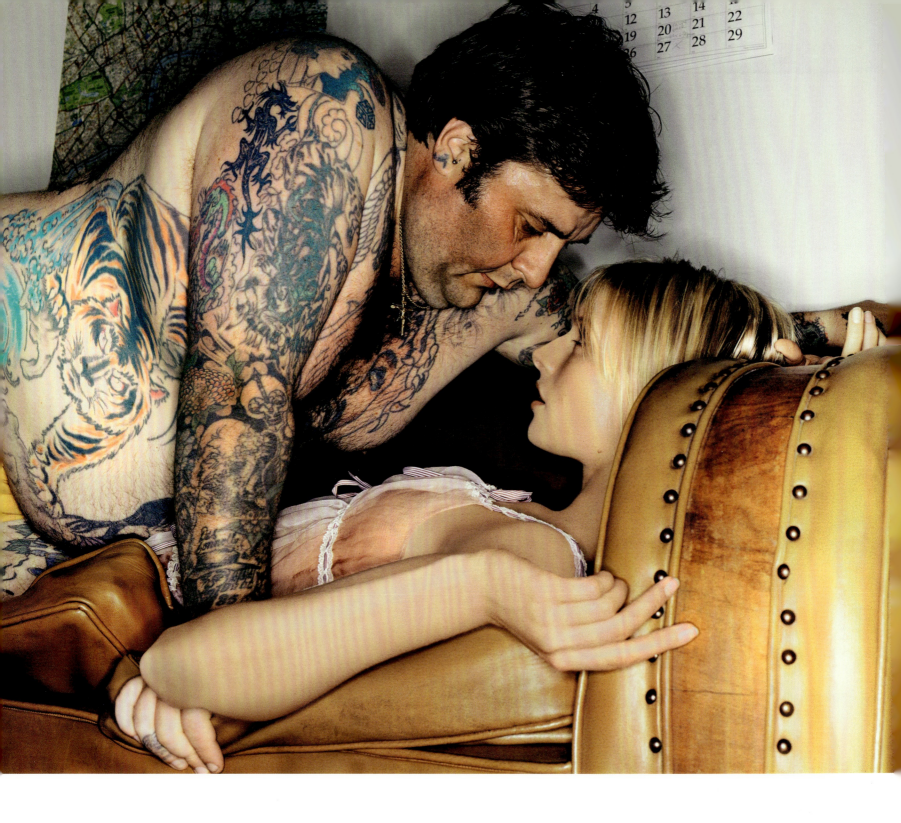

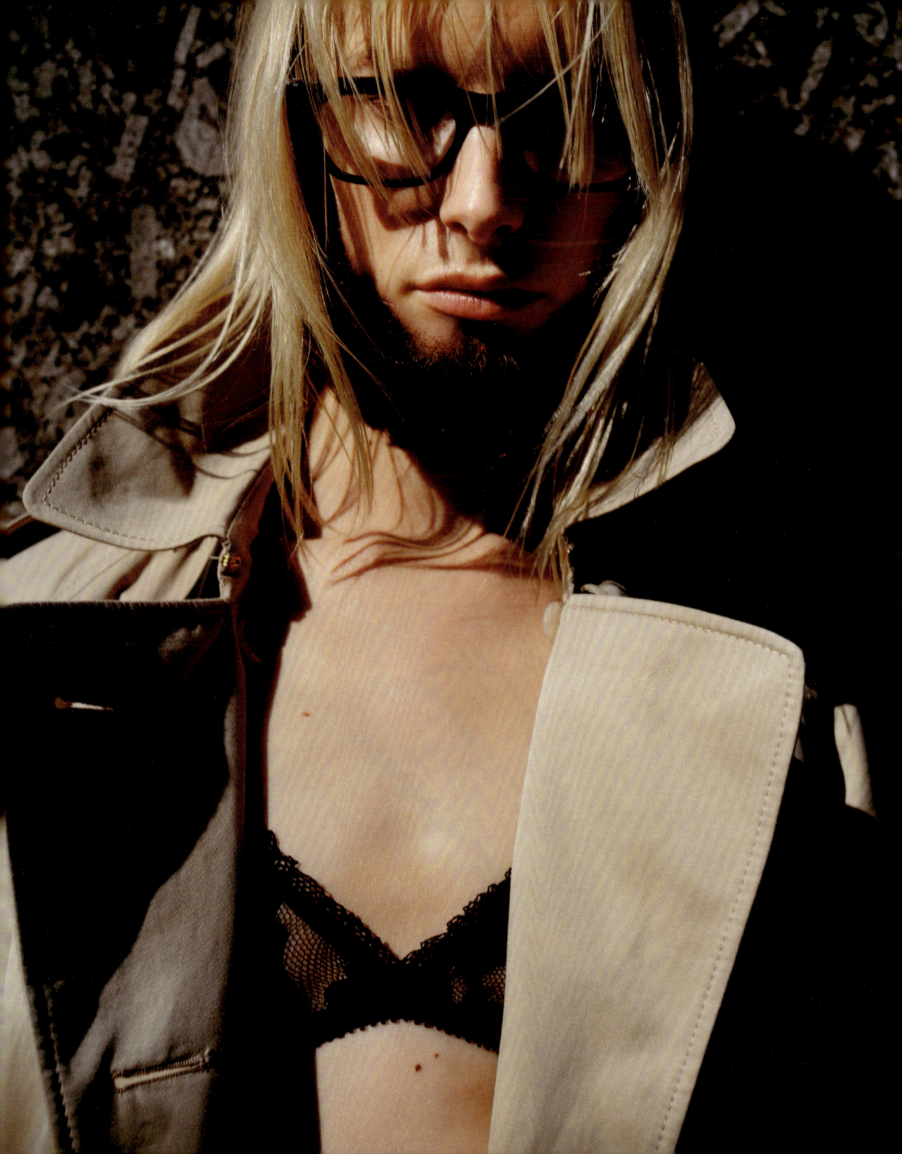

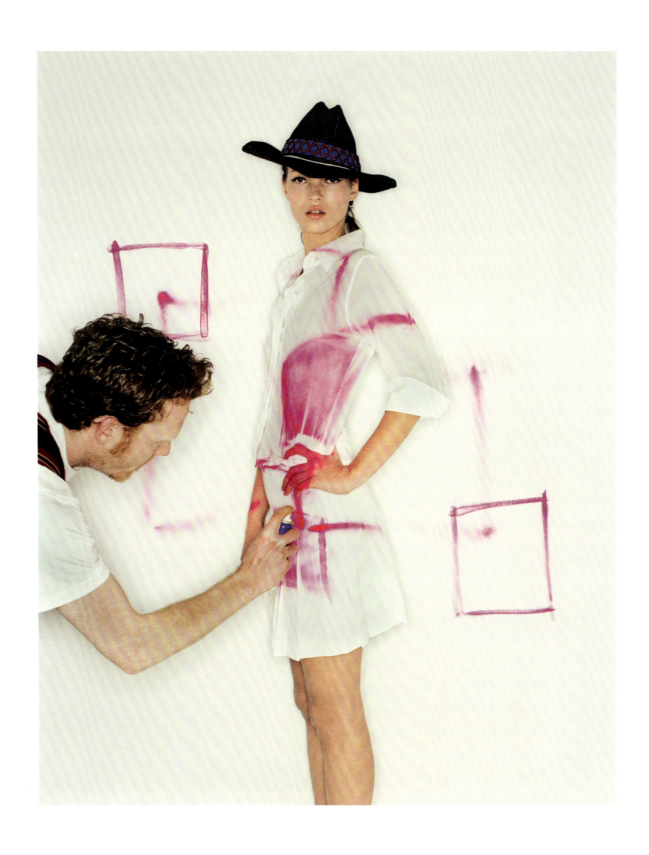

2001–1996

Big Night Out
London Fashion
Meltdown
Sweaters
Kate's Allure
Cheeky
Viva La Revolution
Turn the Dark On
Bra Zilch
Big Issue
How The West Is Worn
Baked Alaska
Stranded
Sparkly Gisele
Spray Paint Kate
Flesh for Fantasy
Highly Flammable
P/ain
Dead Fashionable
Faking It!
Obsessive Behaviour
Touch Your Toes

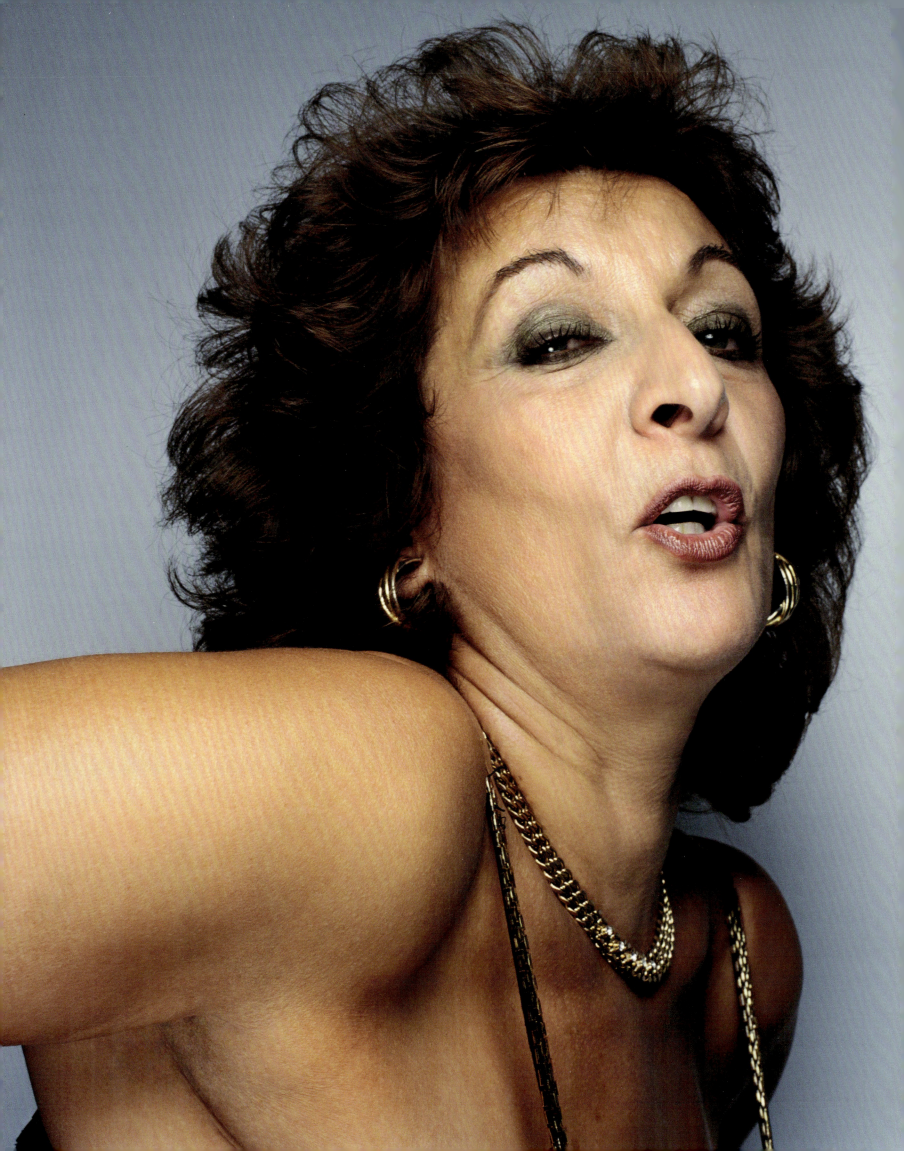

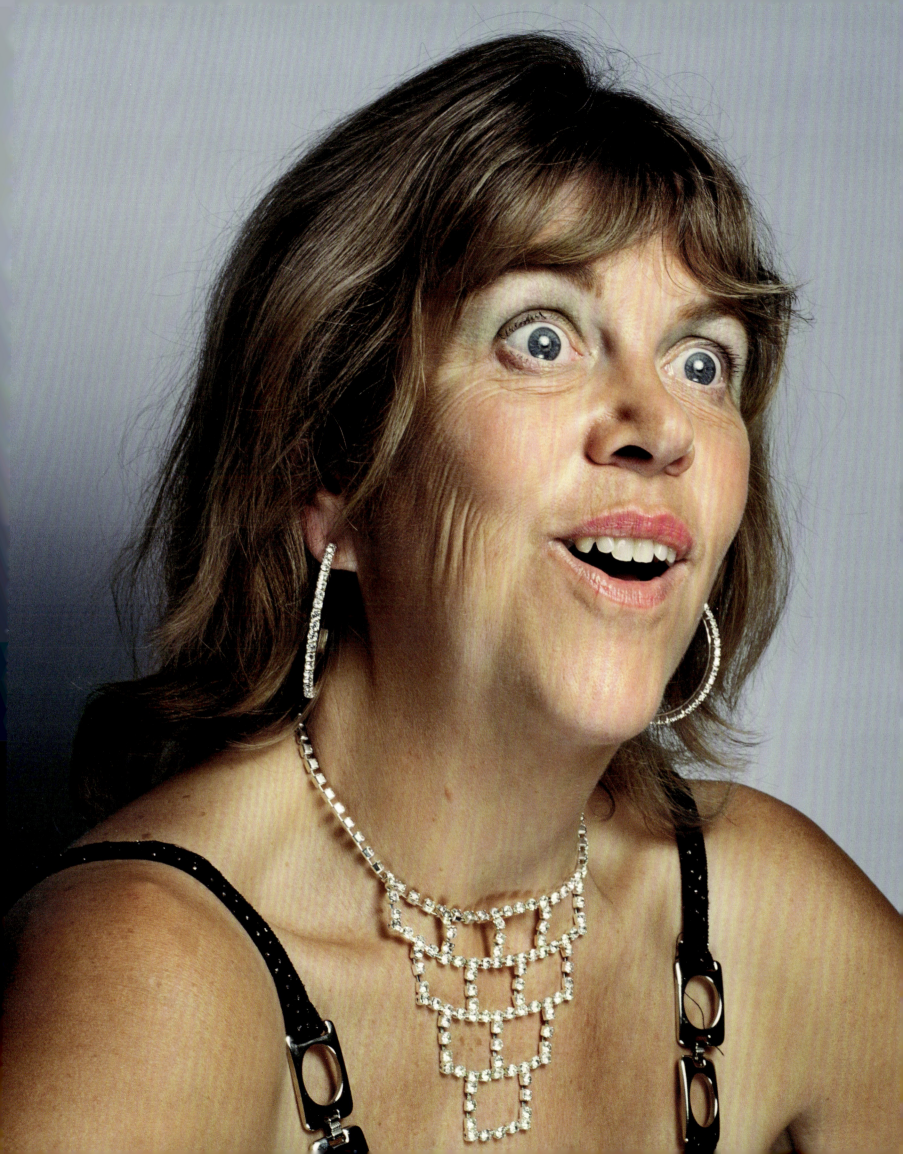

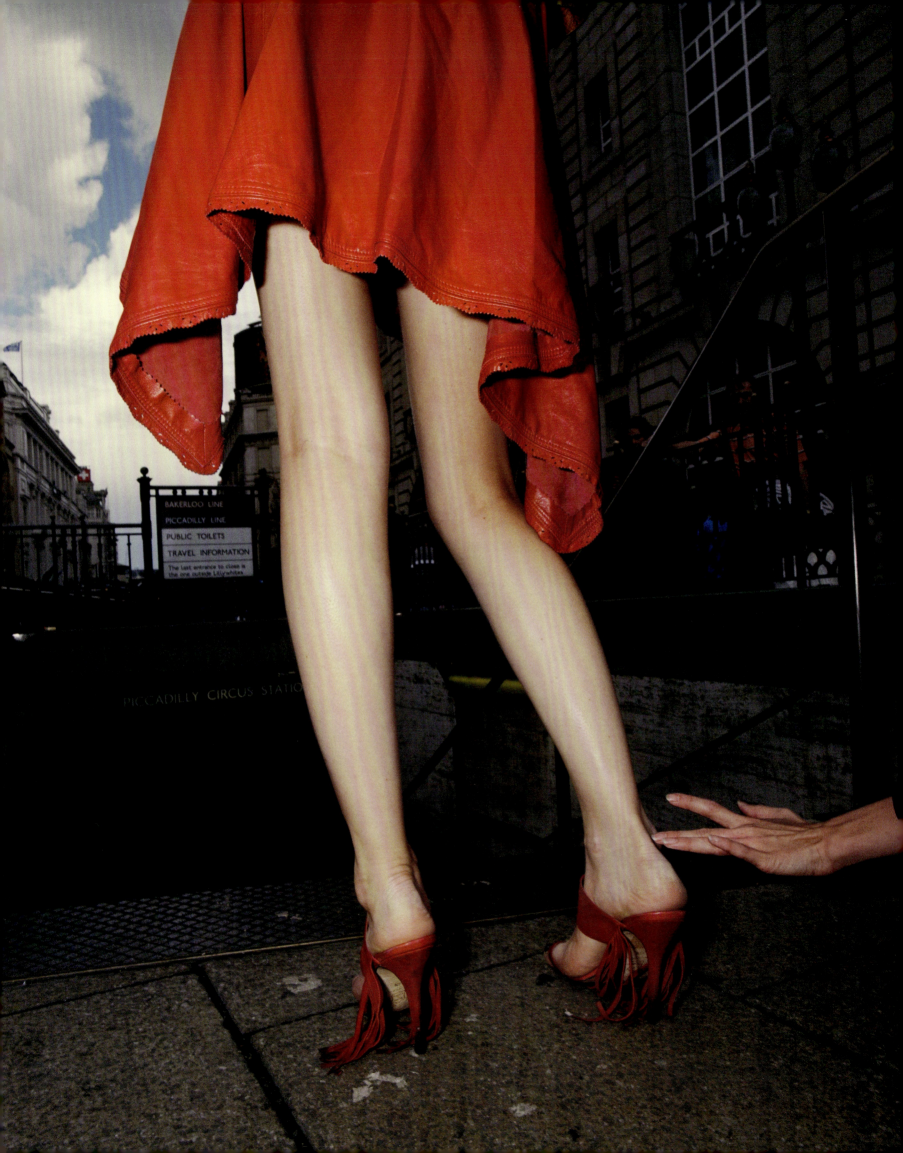

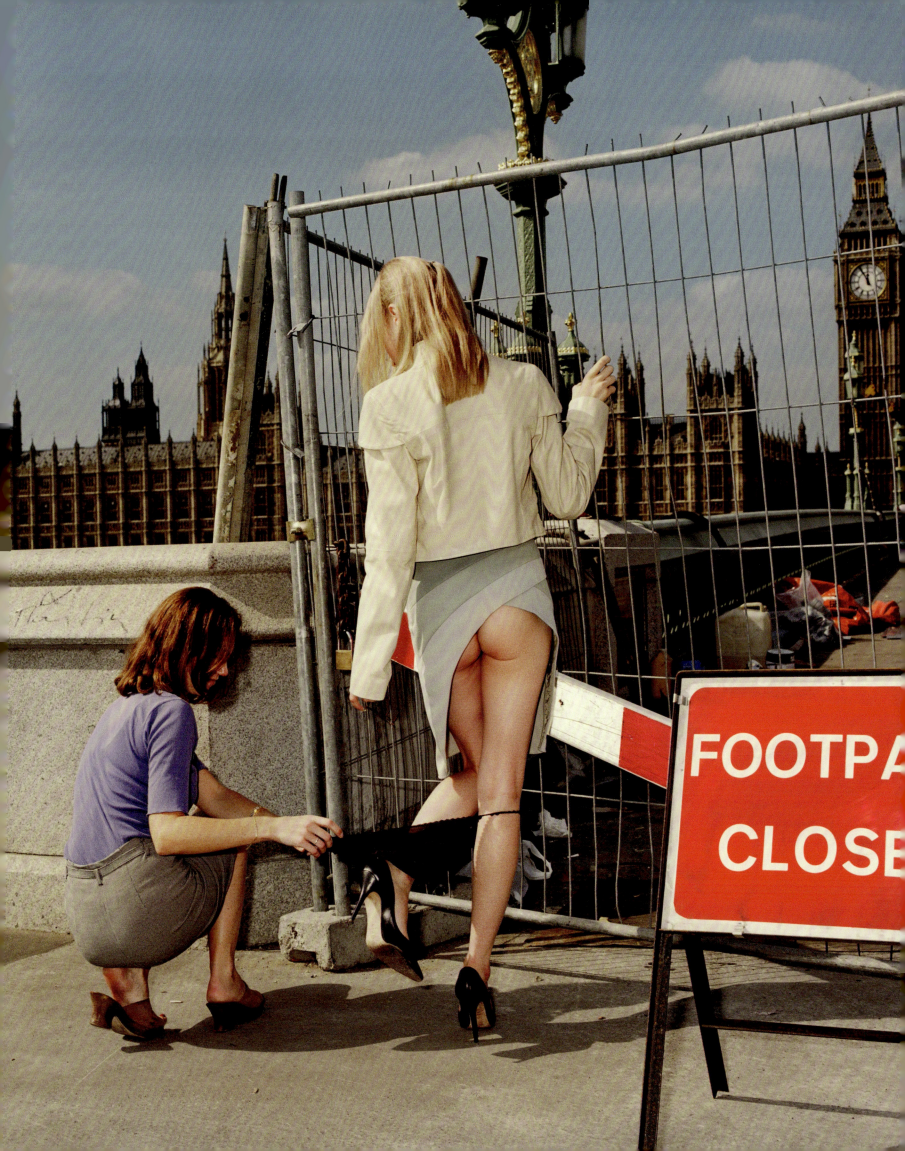

Rankin's photos always pushed the boundaries, especially some of the shoots I worked on like the farmyard animals, the cats, the melted wax models, the 'Underwhere' story. When I look back at them now, I think they were pretty groundbreaking and out there, especially considering how commercialized and air-brushed, safe and perfect fashion images have become. Back in the day, however, Rankin was pushing people's buttons and shooting stories without a care as to what other people would think.

He's always been pretty fearless and I think that's what attracted me to working with him and to continue doing so as I was pretty shy, but in Rankin's company on set, I couldn't be and it would push me out of my comfort zone in a good way.

It's very refreshing to look back and think of all those stories as breaking the rules of what was traditionally considered a 'fashion picture.' There were no rules with Rankin about what made a great 'fashion image,' and that is what I feel is so relevant about them now.

With the fashion stories, it was always the 'image' that was important rather than being a slave to the fashion trend or idea. The clothes and styling were often a prop to the idea of the story Rankin wanted to shoot, which is more like the approach of dressing characters on a film set.

MIRANDA ALMOND

I had no expectations on what the shoot would be like. Except hoping it was legitimate!

And my first impression I recall… Gorgeous! Intense! Moody! Very focused! He gave me confidence to do what he asked.

JENI KTORI-HOOPER

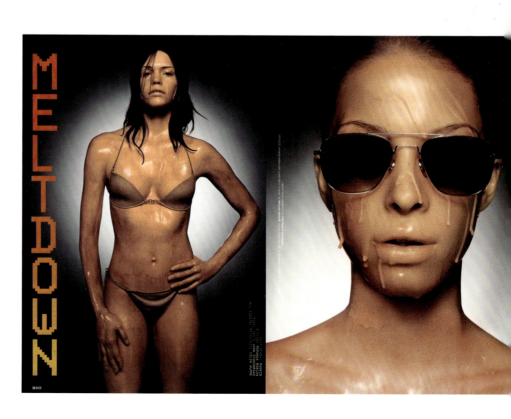

Previous
Big Night Out | 2000
London Fashion | 1998

Meltdown | 1999

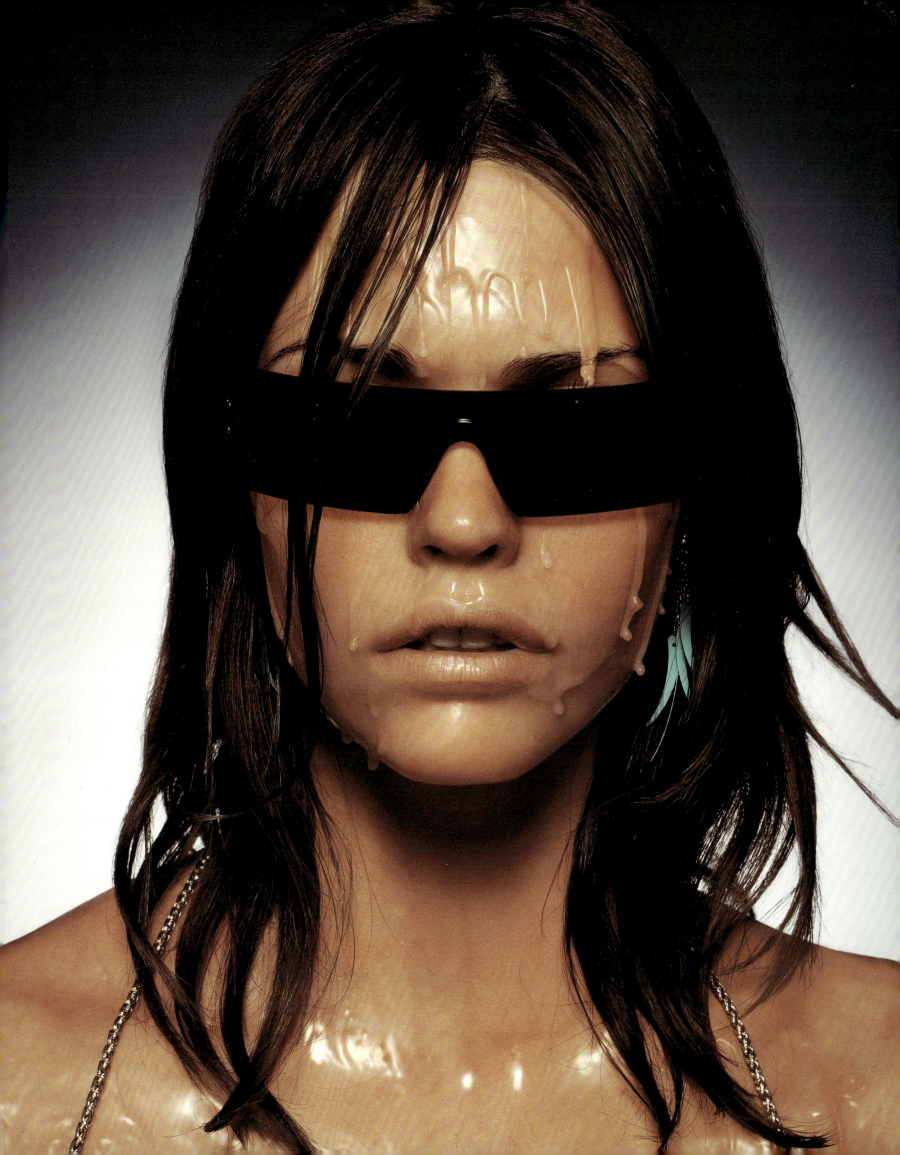

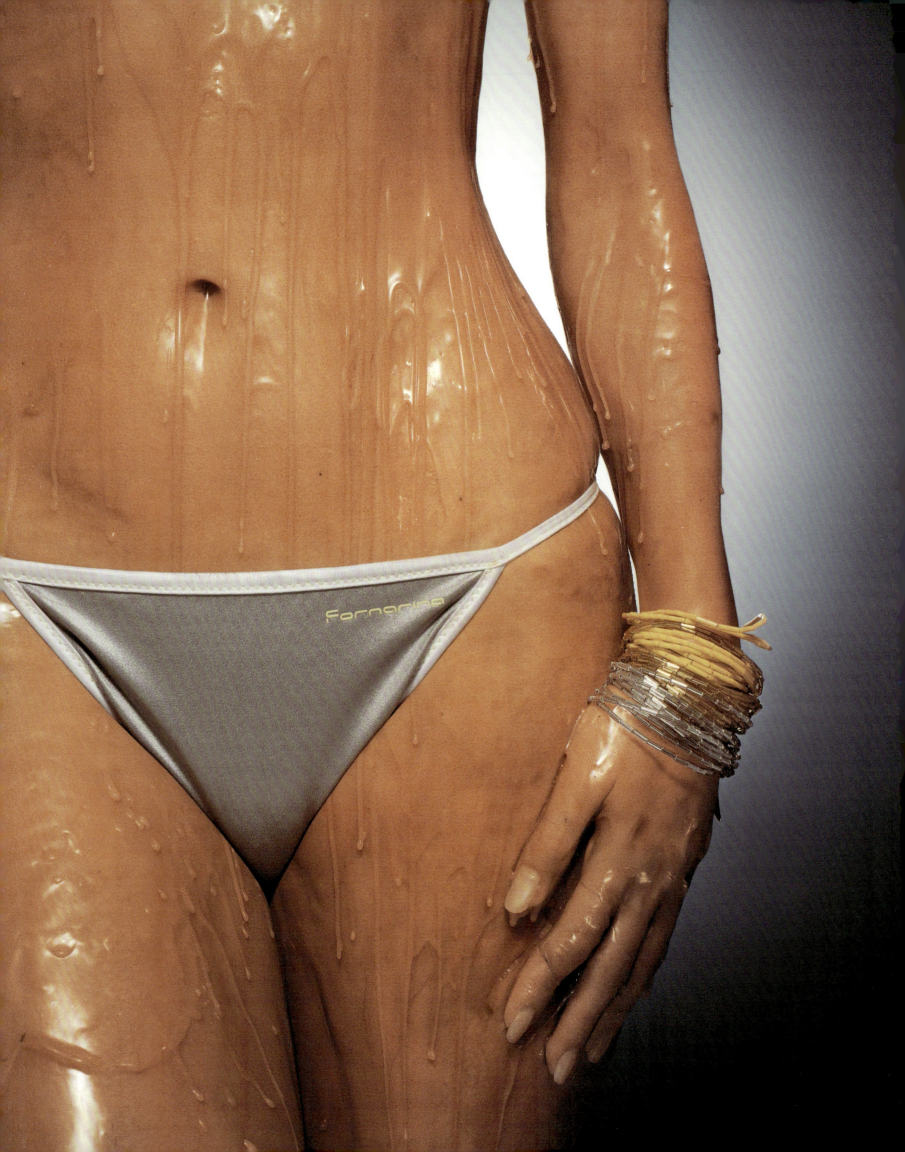

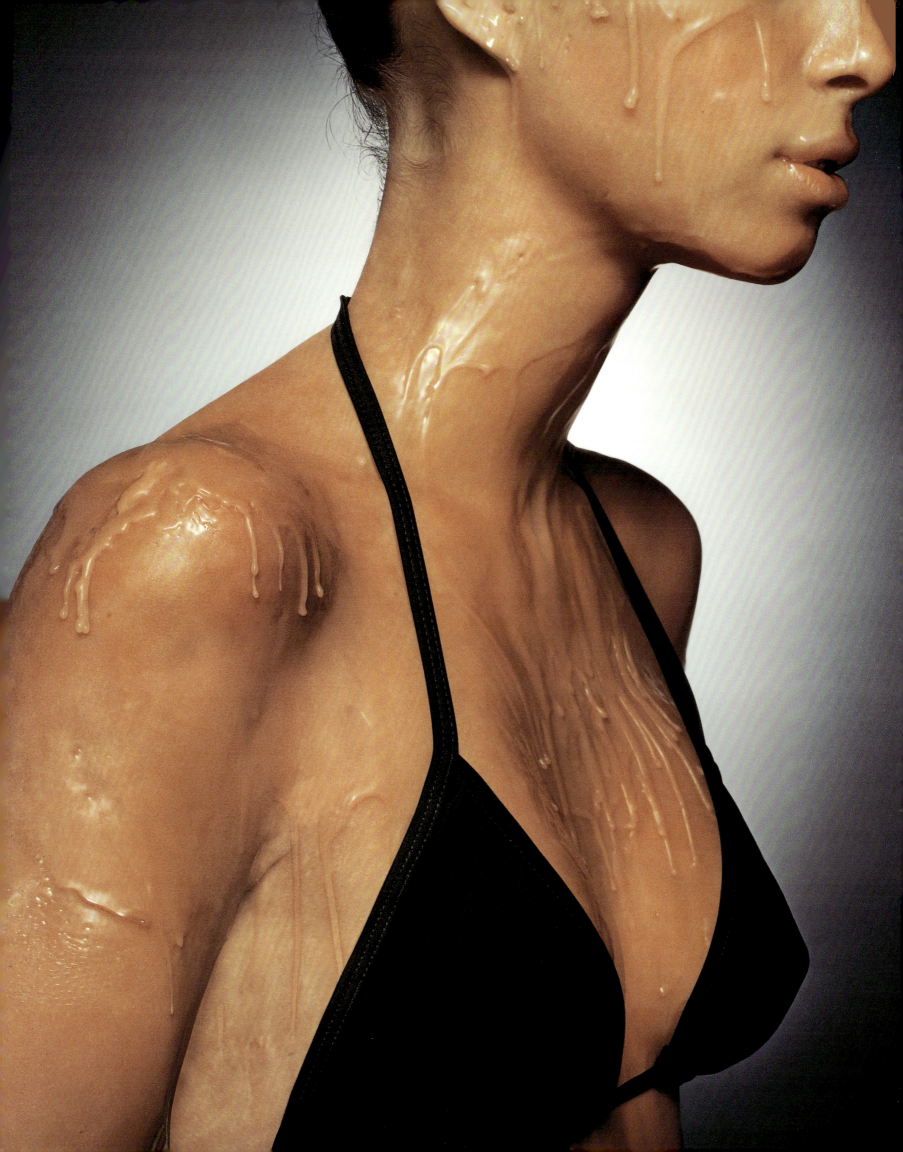

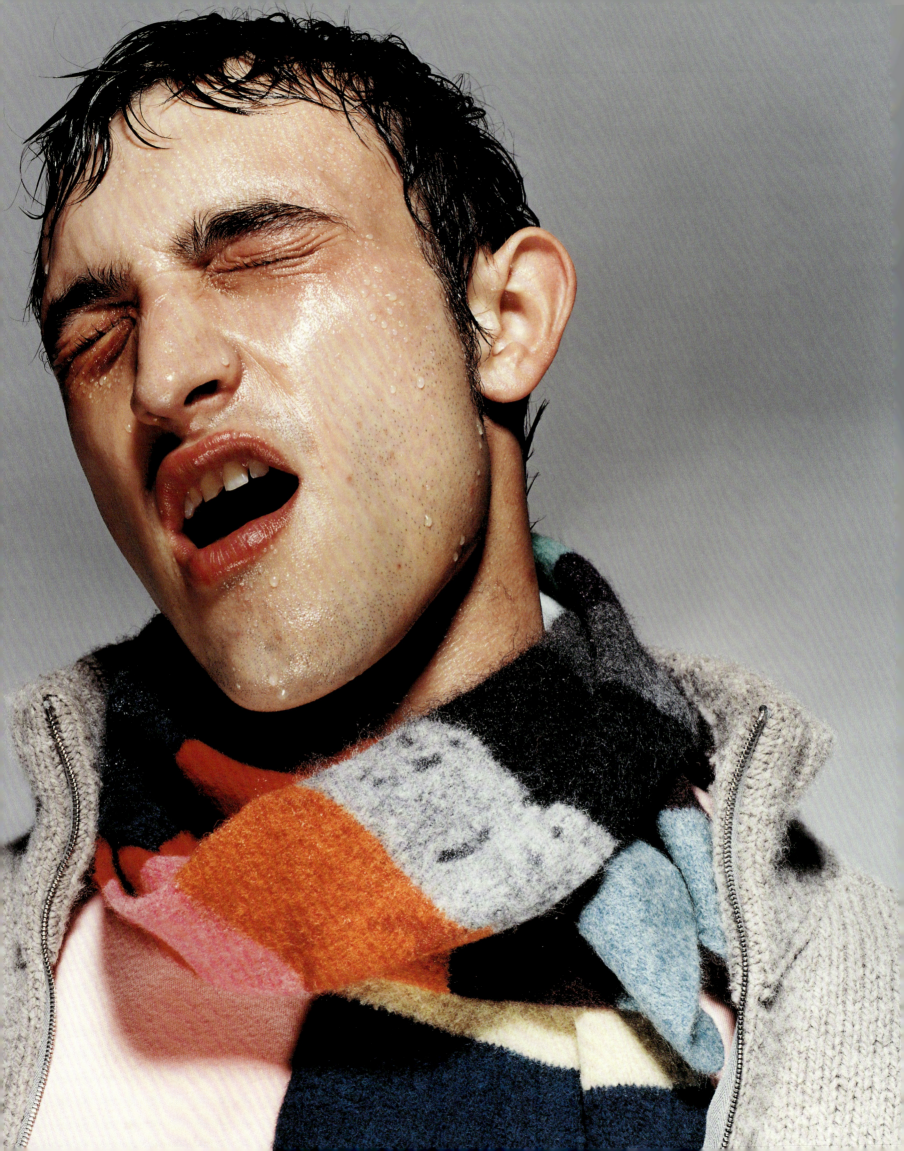

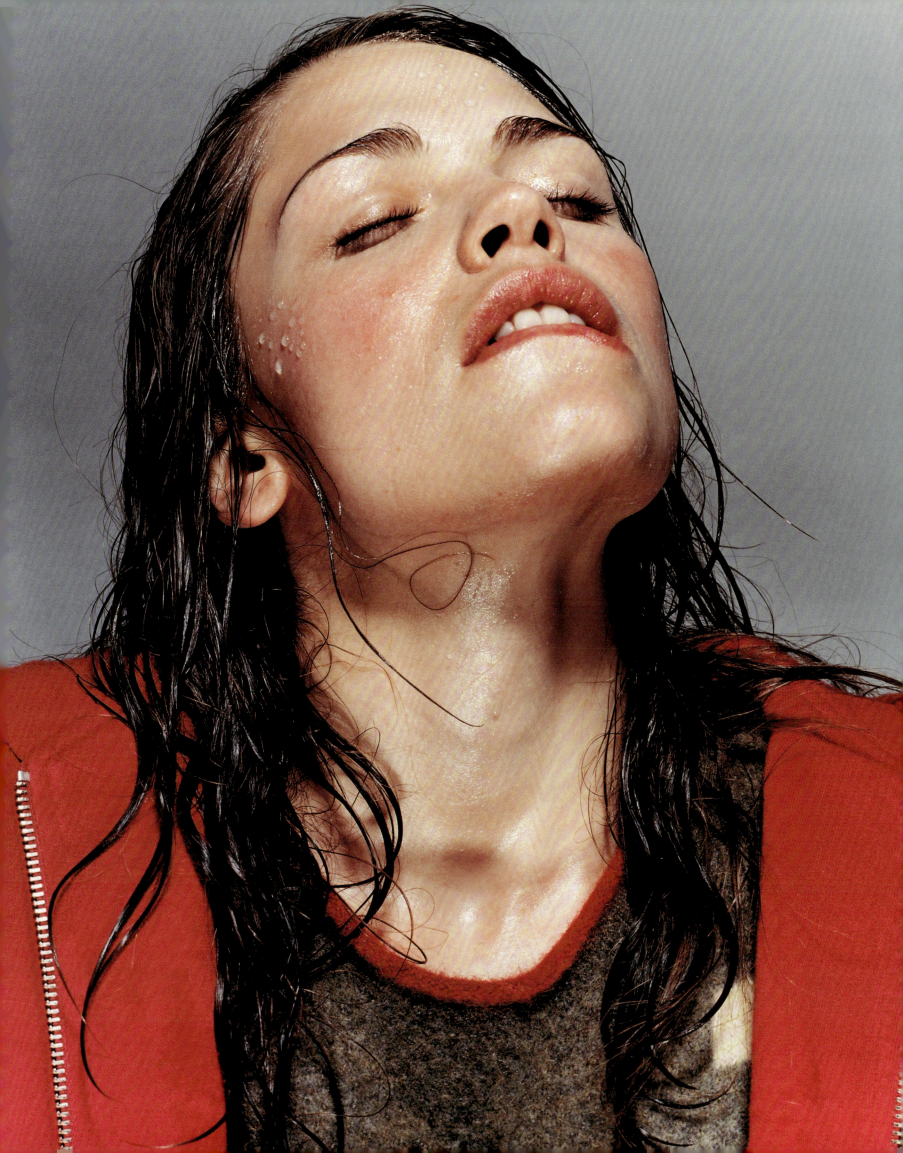

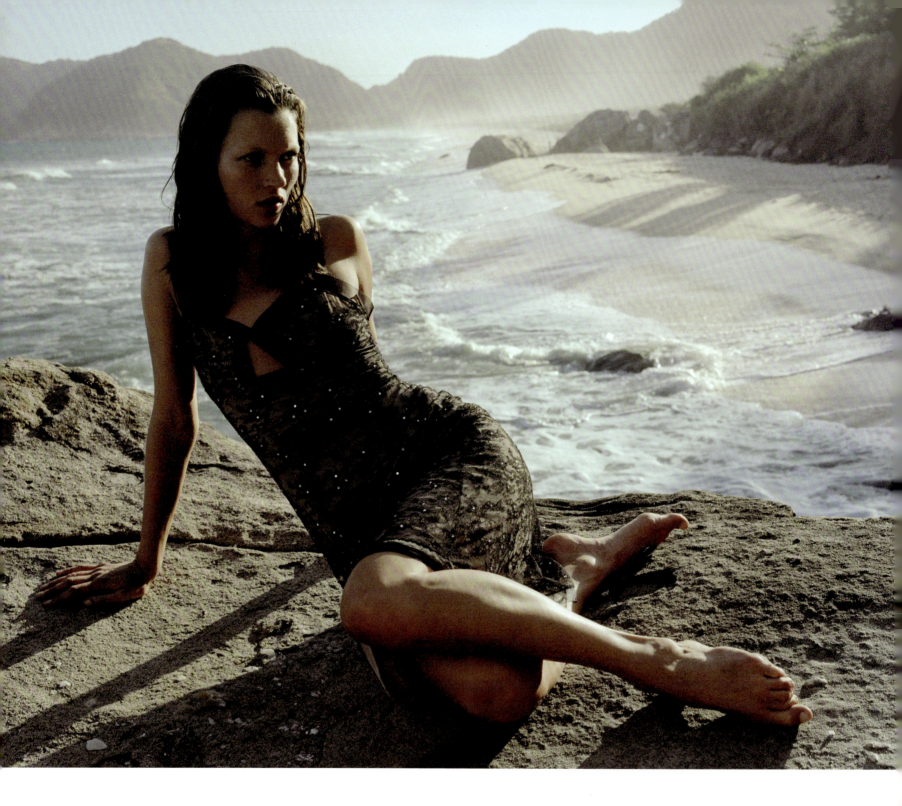

Previous
Sweaters | 1999

Kate's Allure | 1999

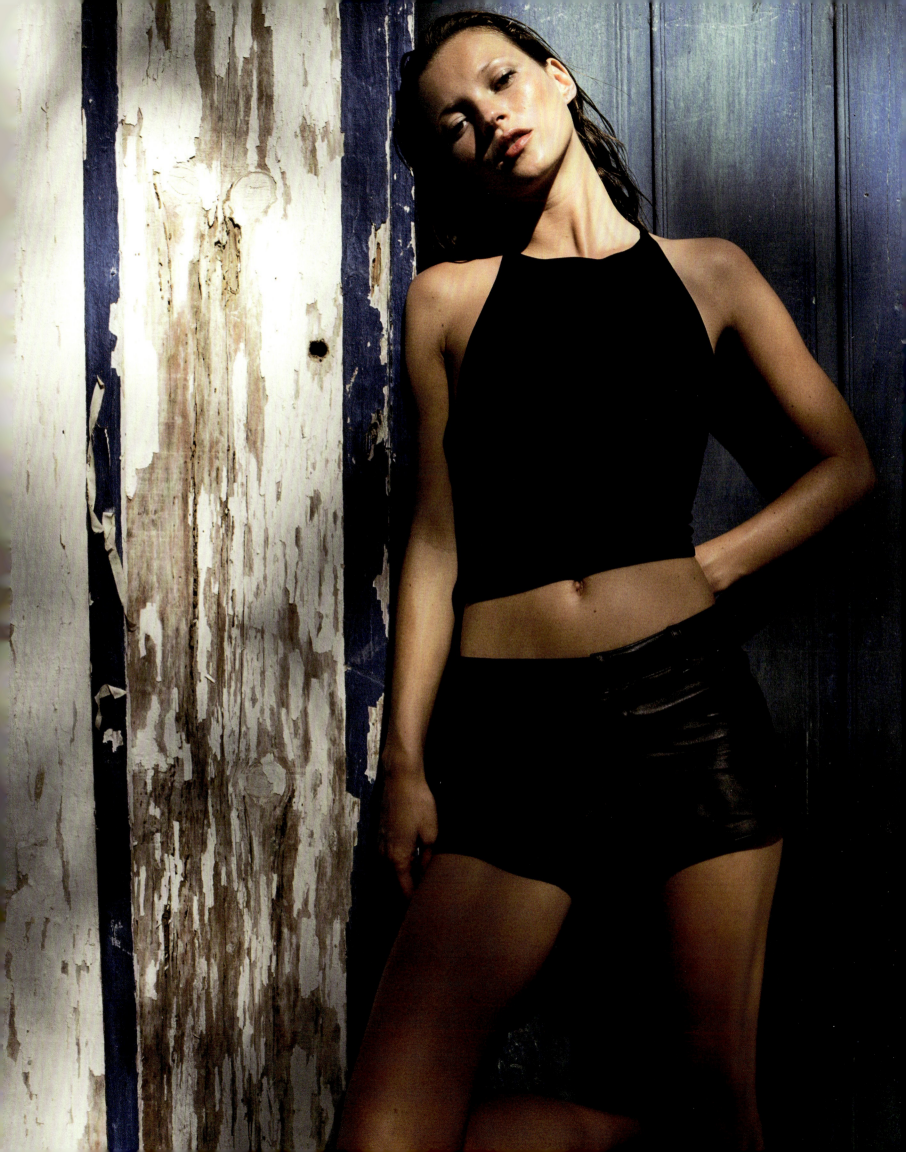

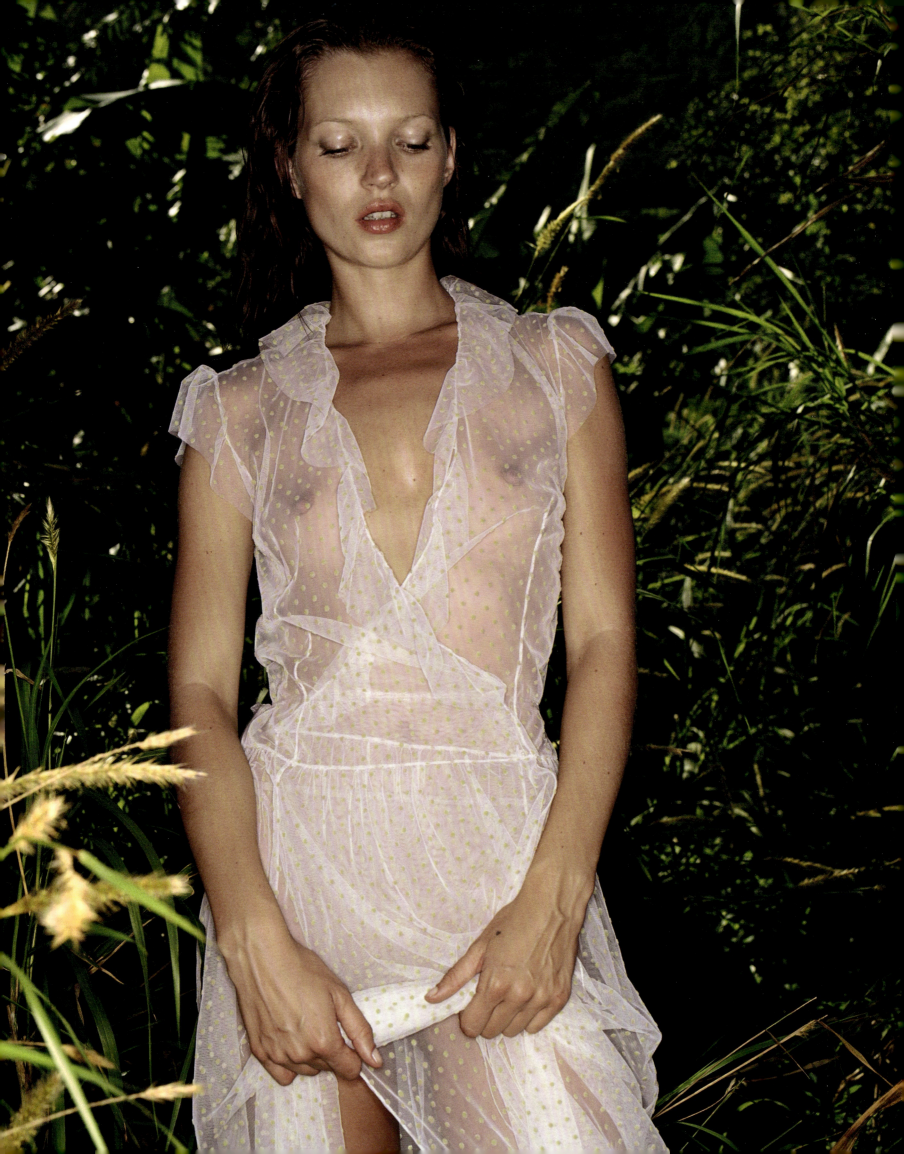

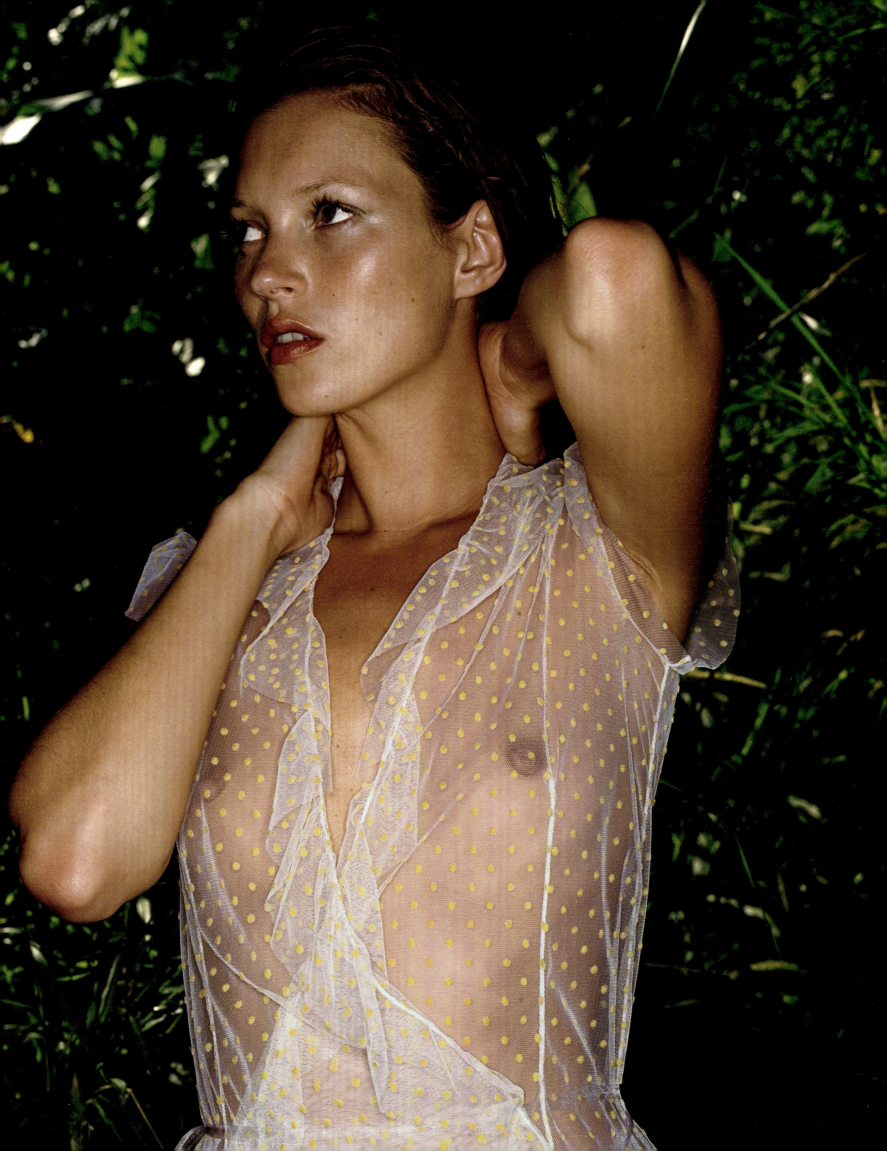

Cheeky | 1999

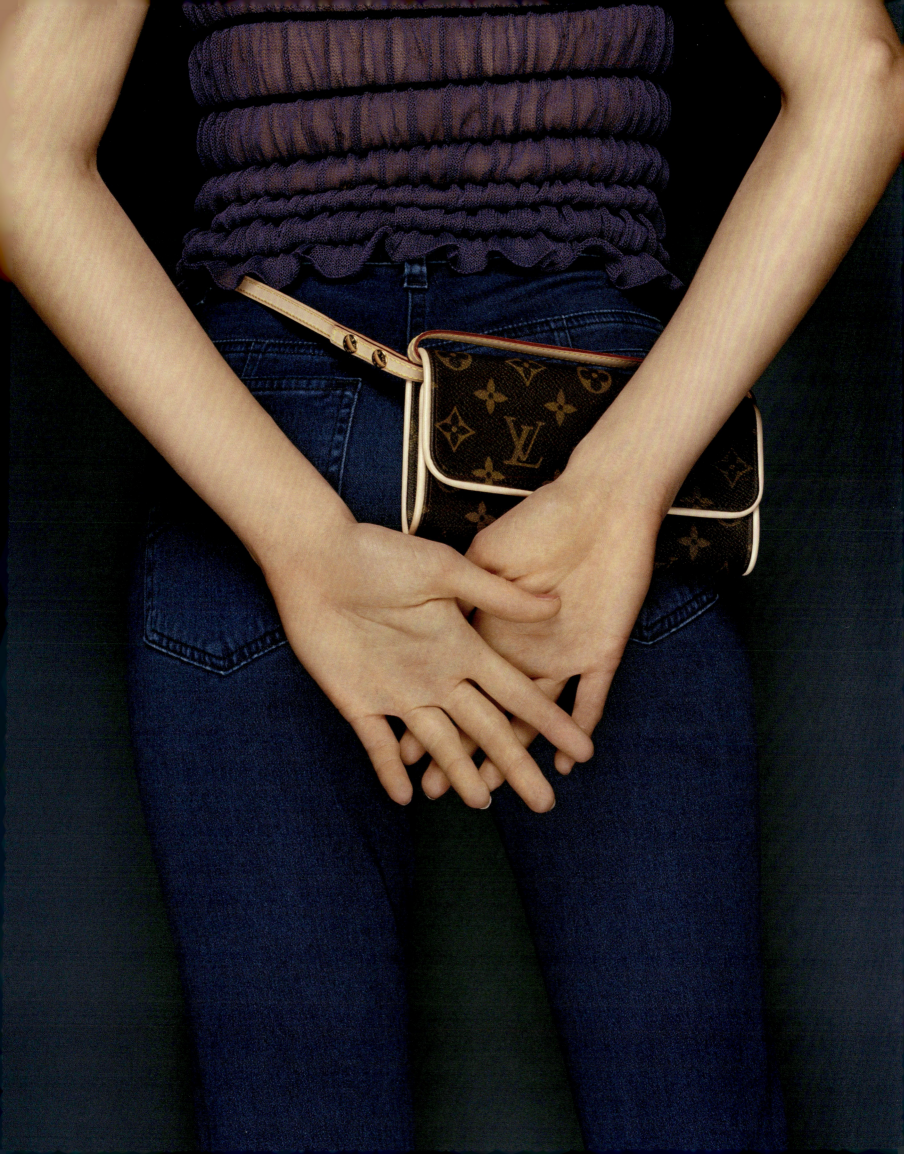

Viva La Revolution | 1999

Next
Turn the Dark On | 1999

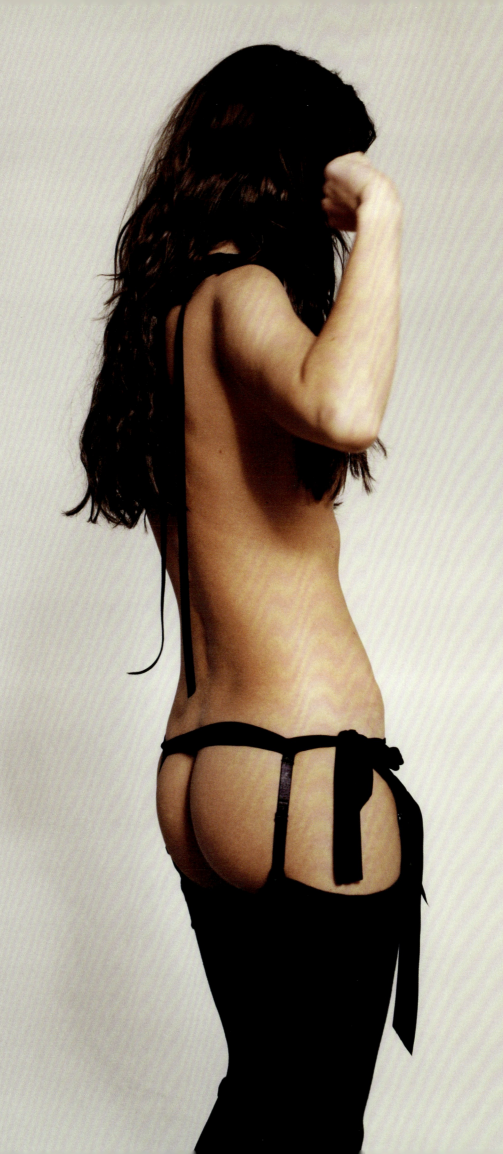

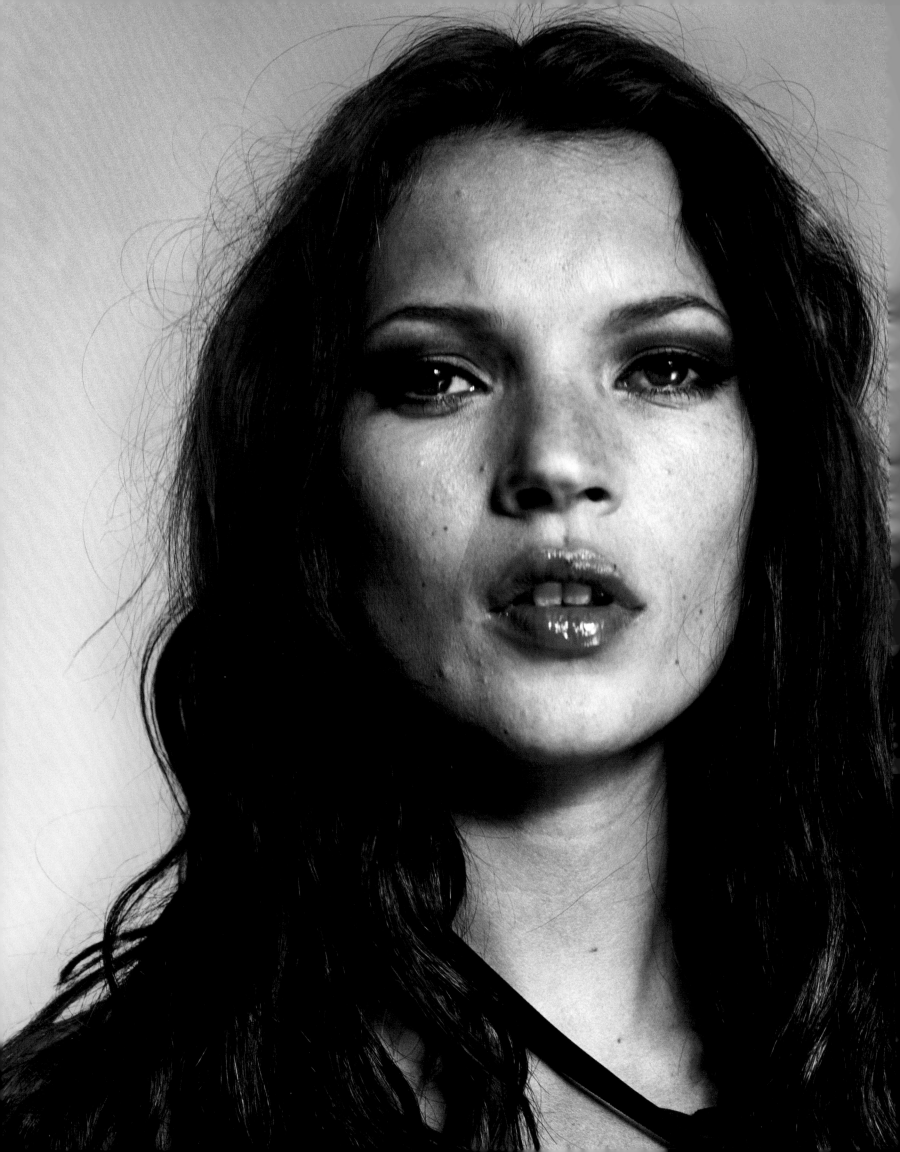

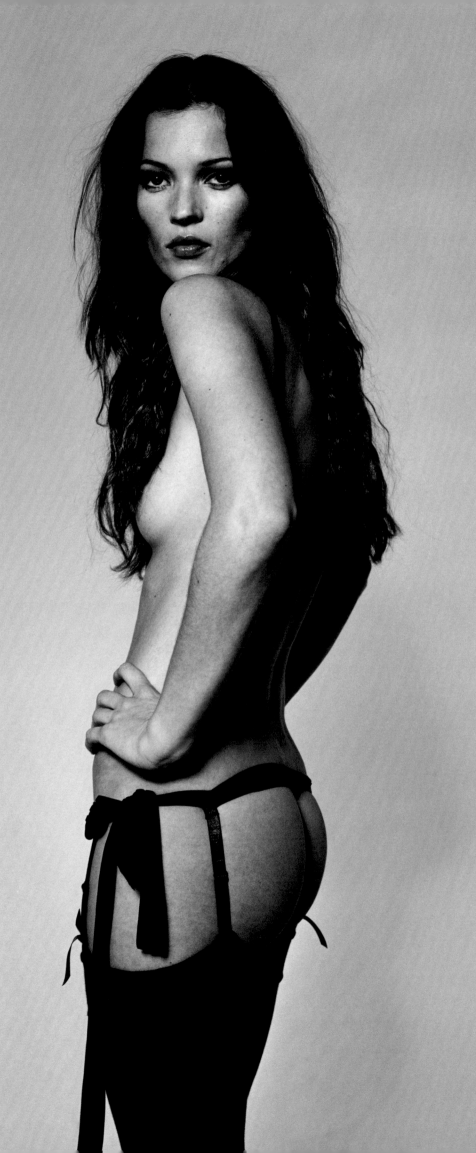

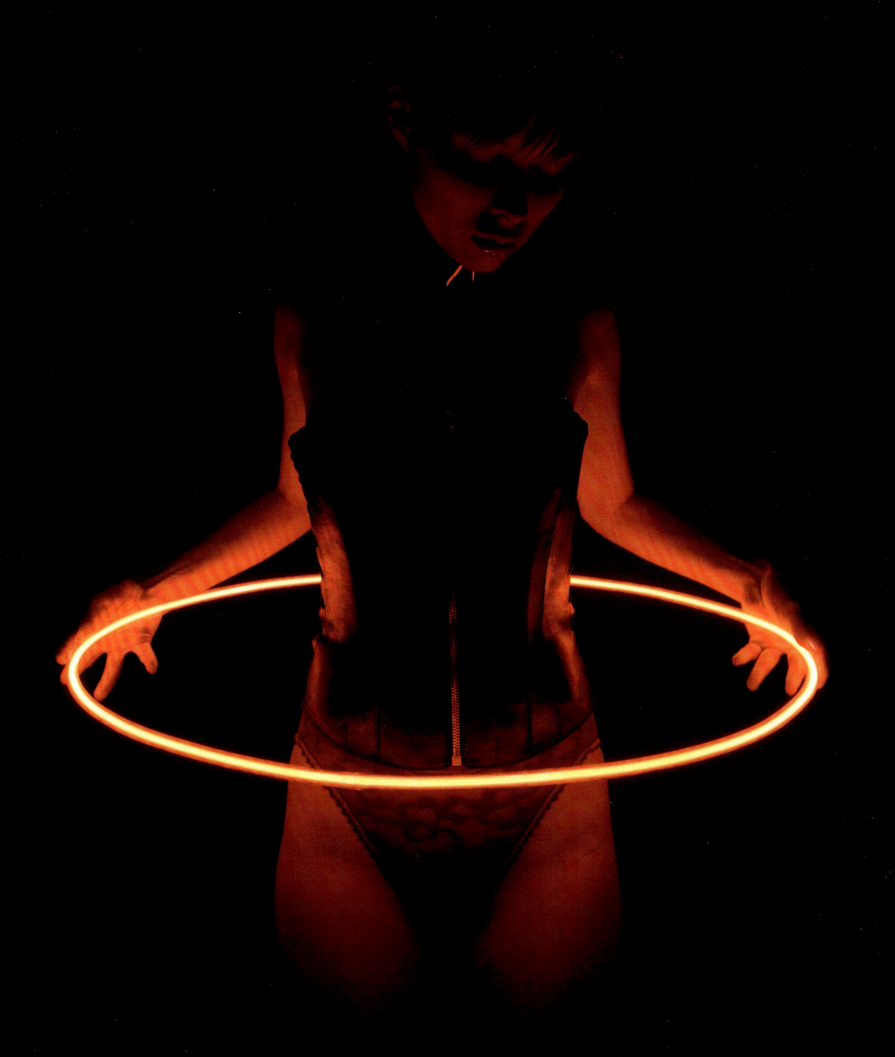

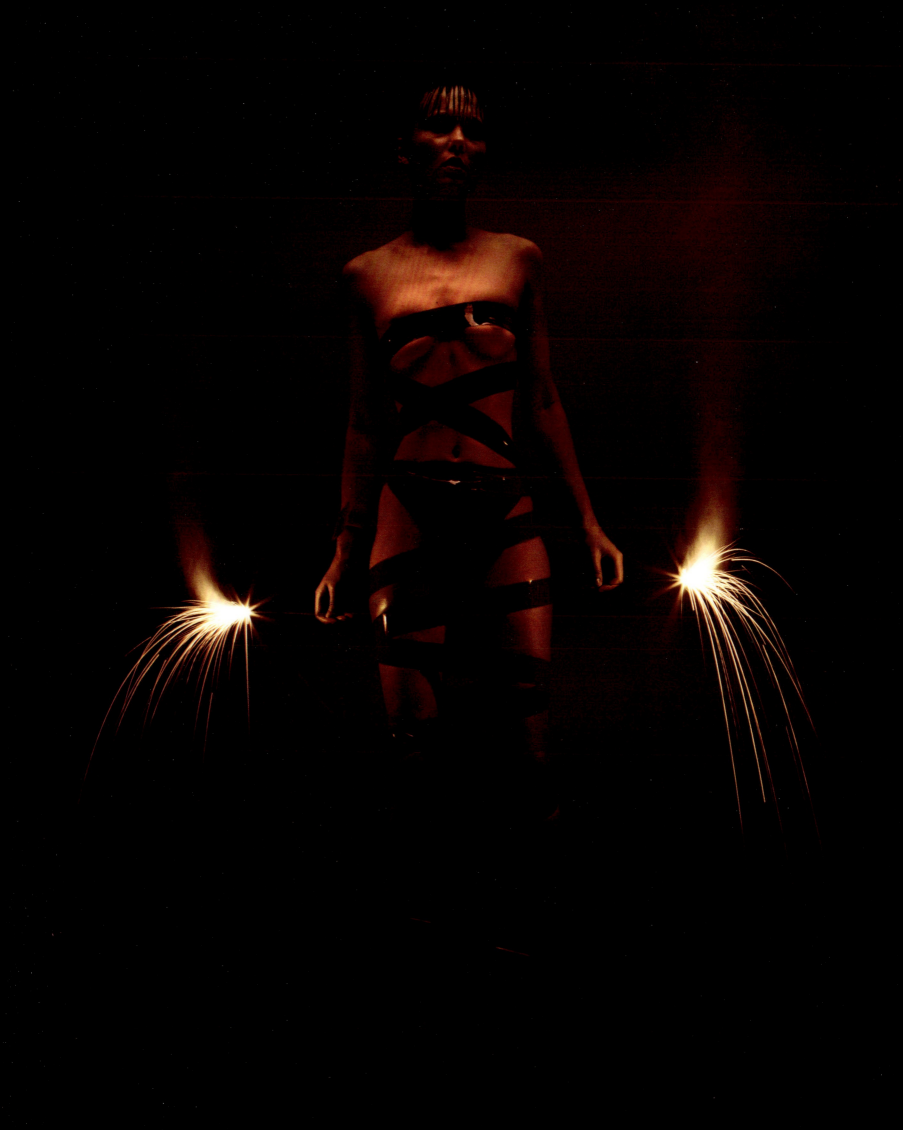

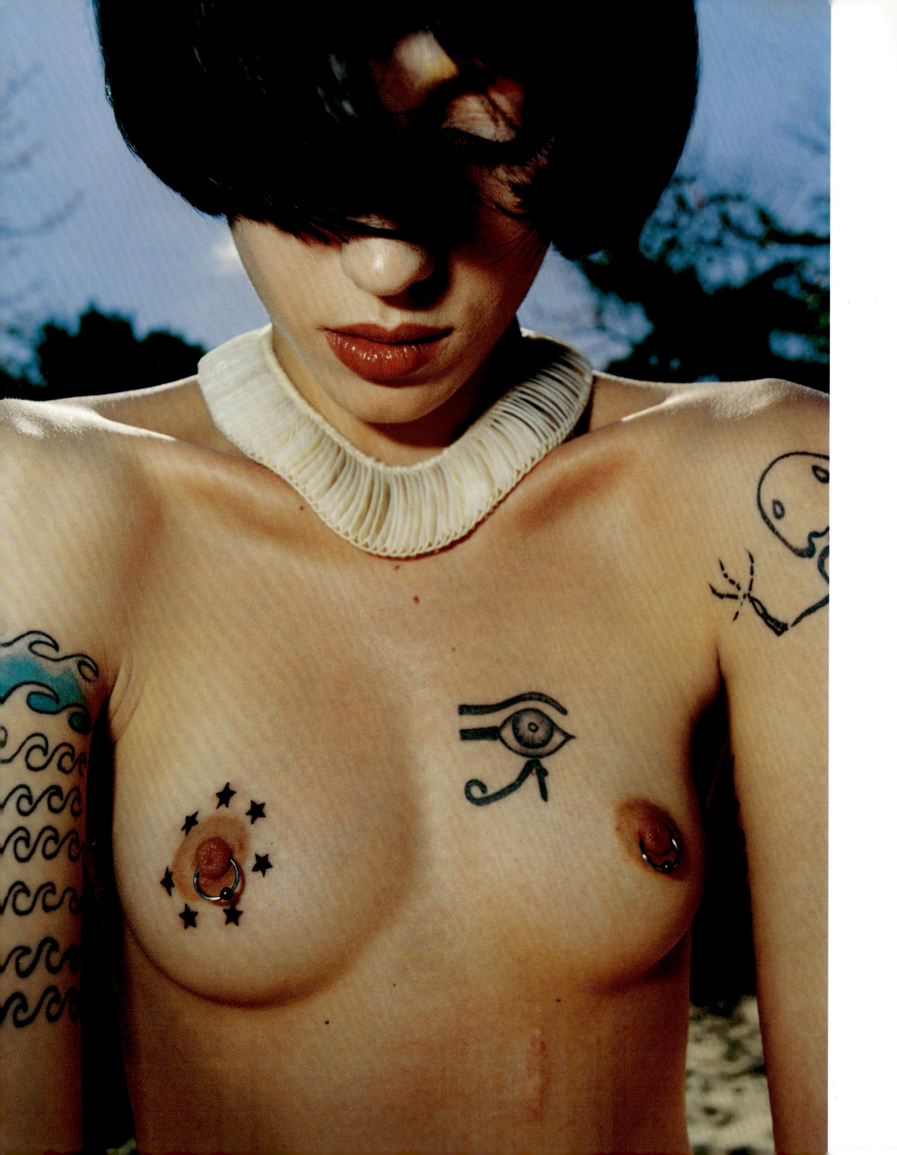

Bra Zilch | 1998

The story came out in my first season and I didn't have a book… but I had *Dazed*. And that was even better.

Rankin is a strong character, so I guess we all have to be that as well on set. He expects the new, so the formulas we models know don't work on him as well as they work on other photographers. We have to step out of our comfort zones, and I guess that is what makes me want to be part of projects like these.

We shot on the beach, so everything was a challenge: the sun, the water, the people who came to watch… We almost fell off that little wooden boat—me, Rankin, and the camera! I feel proud of what we accomplished, these images are timeless. We do what we do in order to be remembered; in this case, we got it.

MARINA DIAS

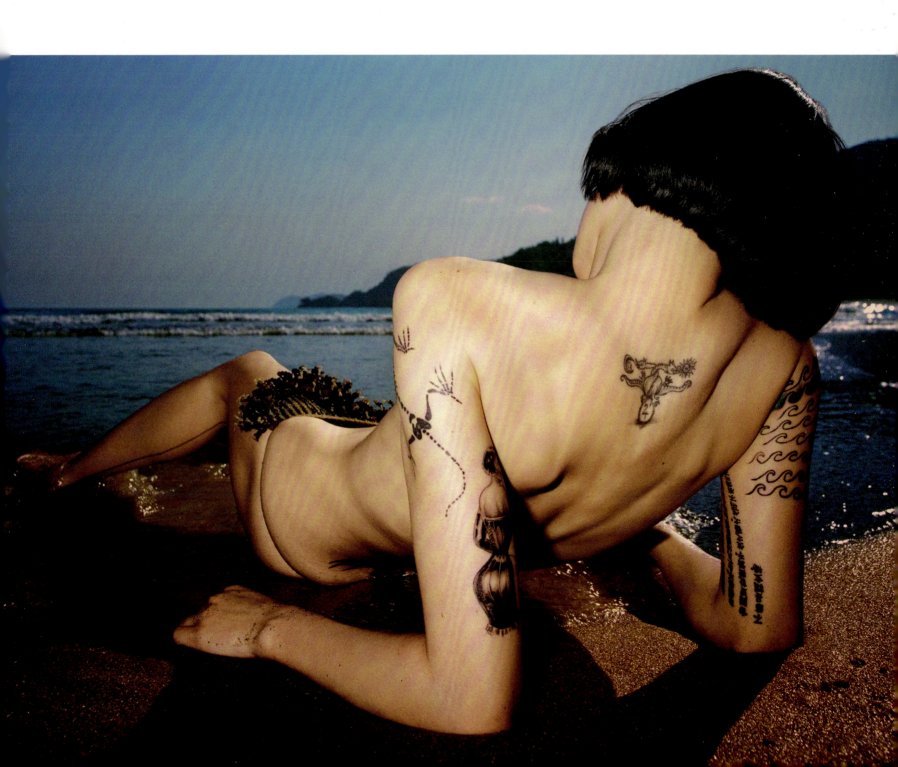

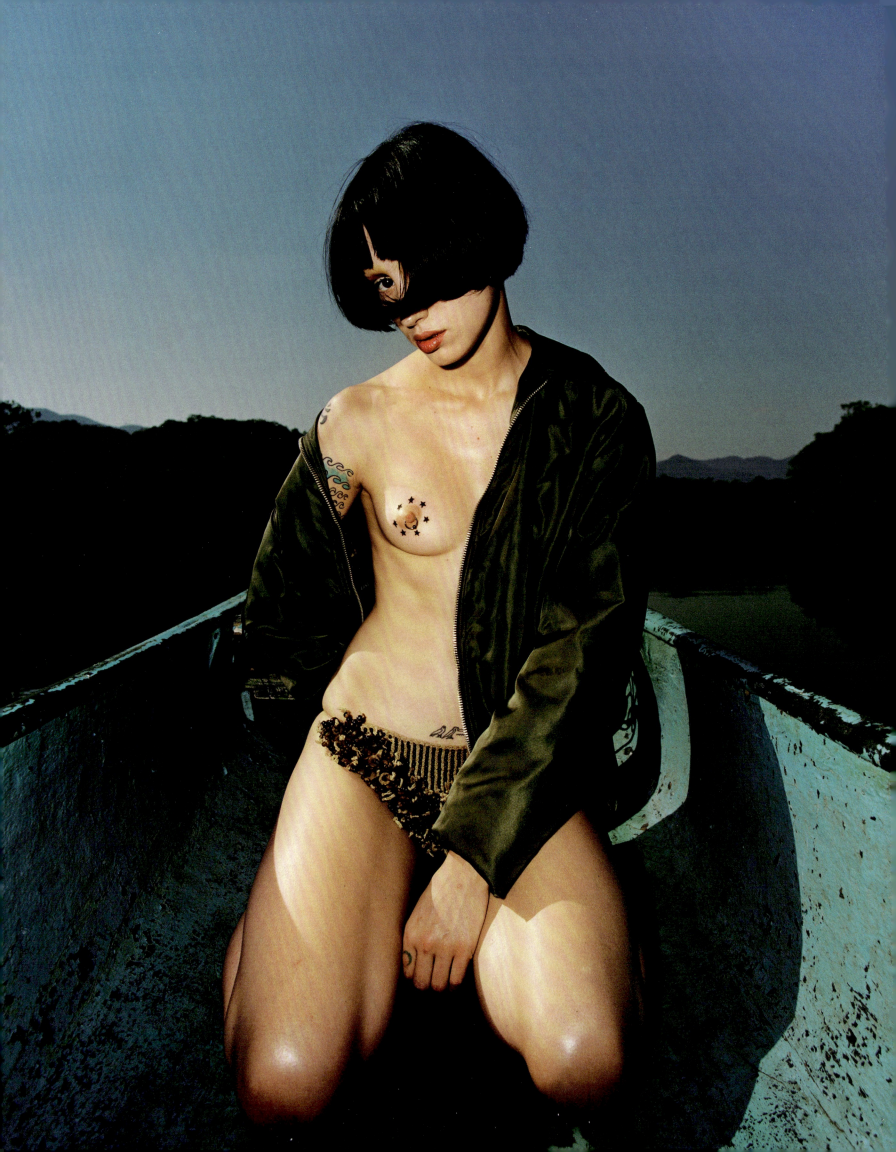

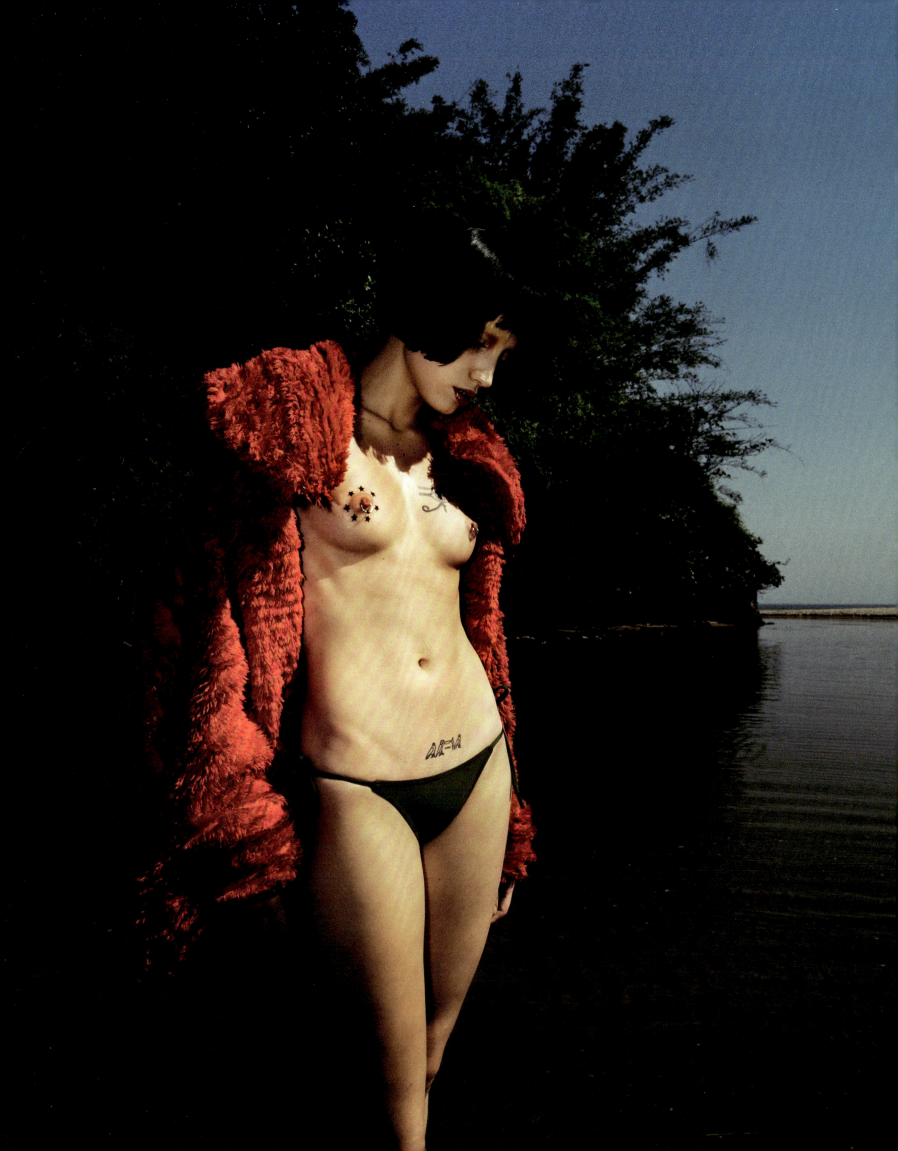

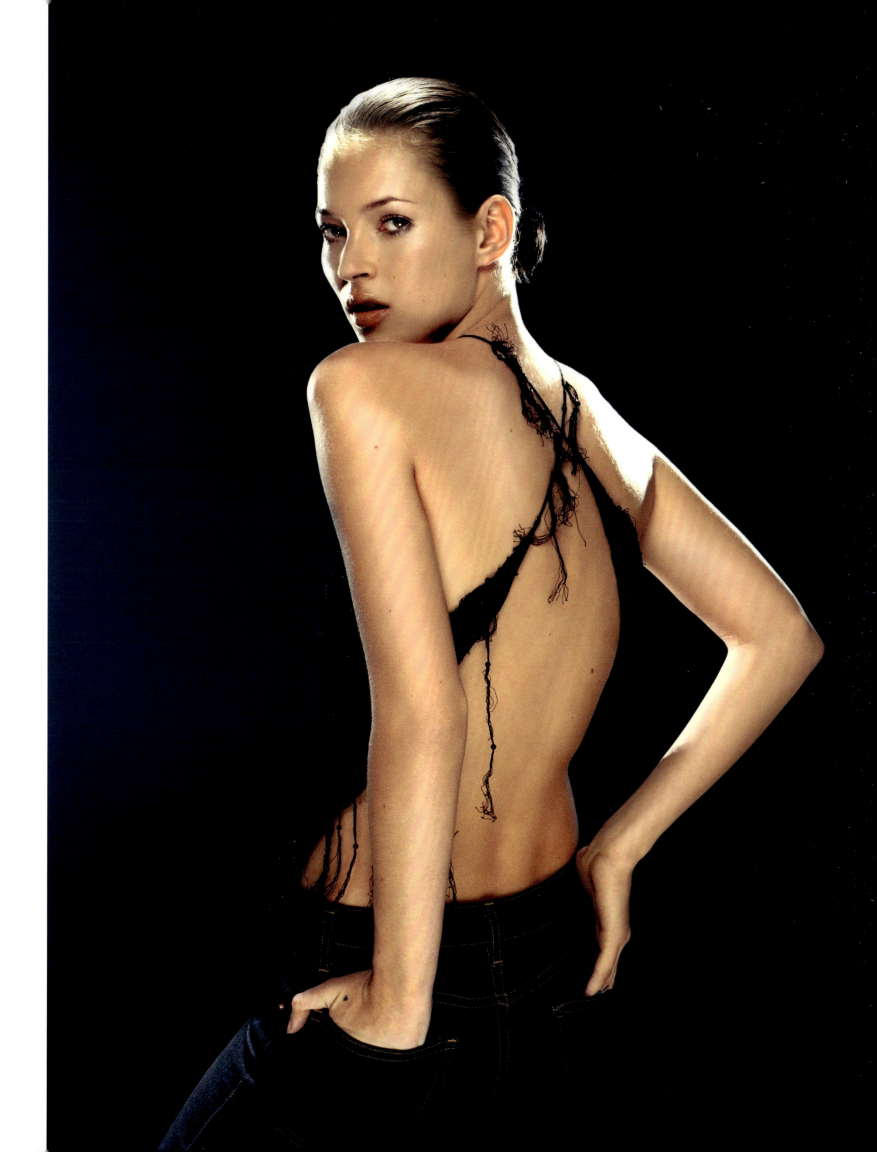

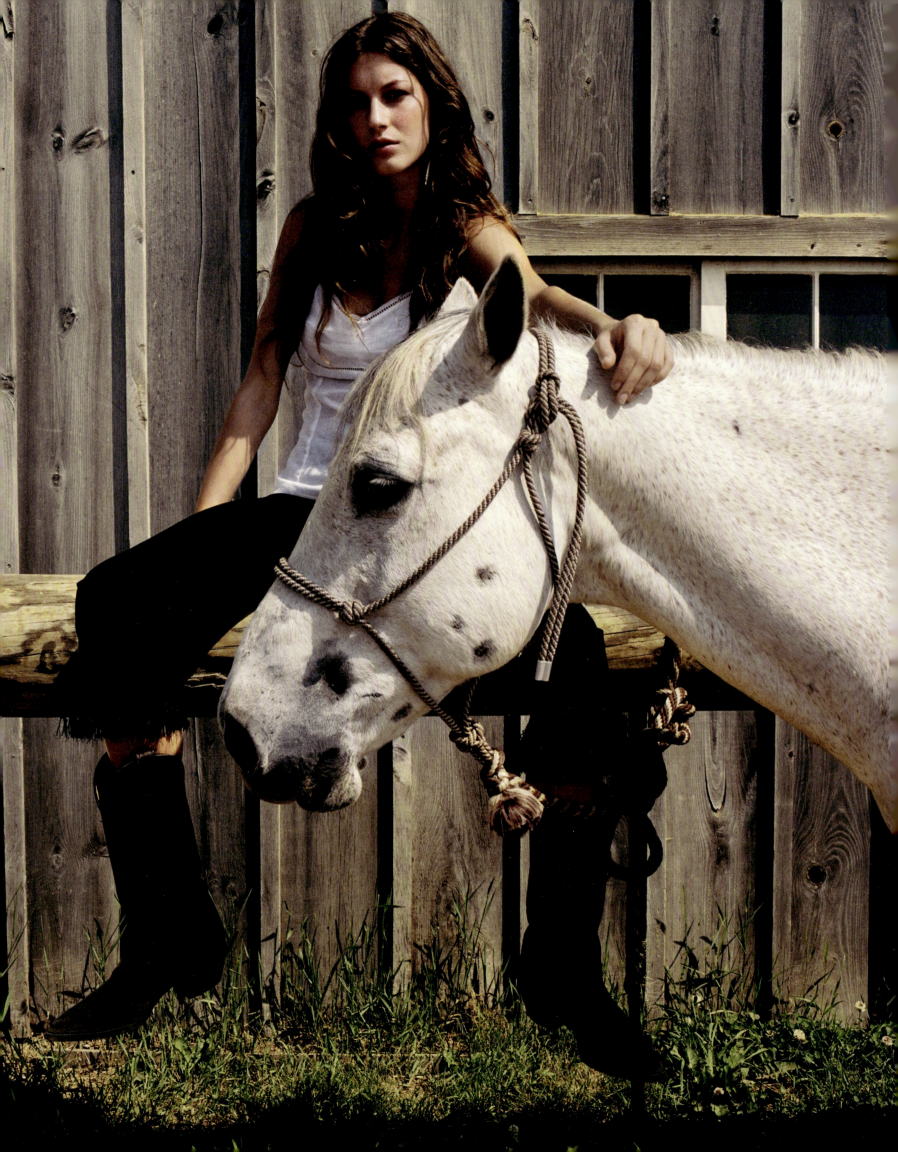

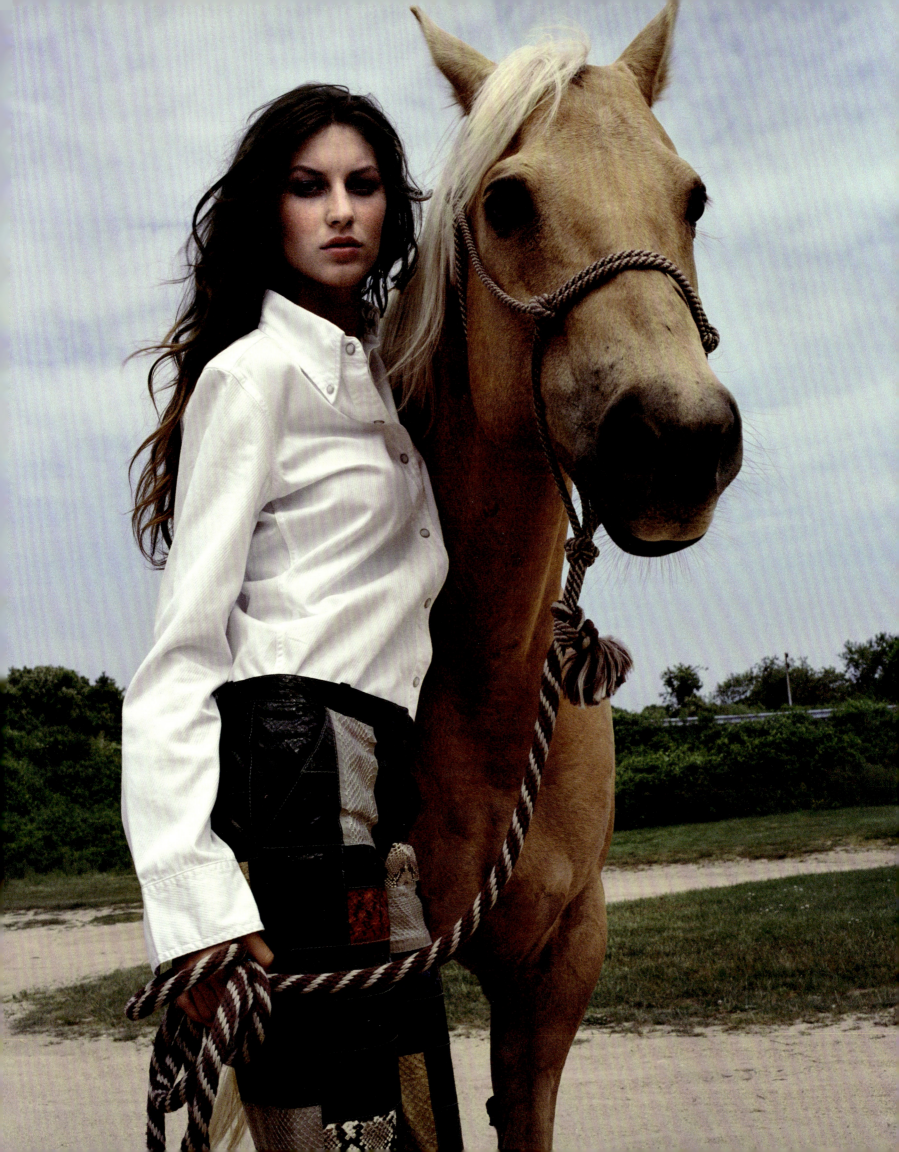

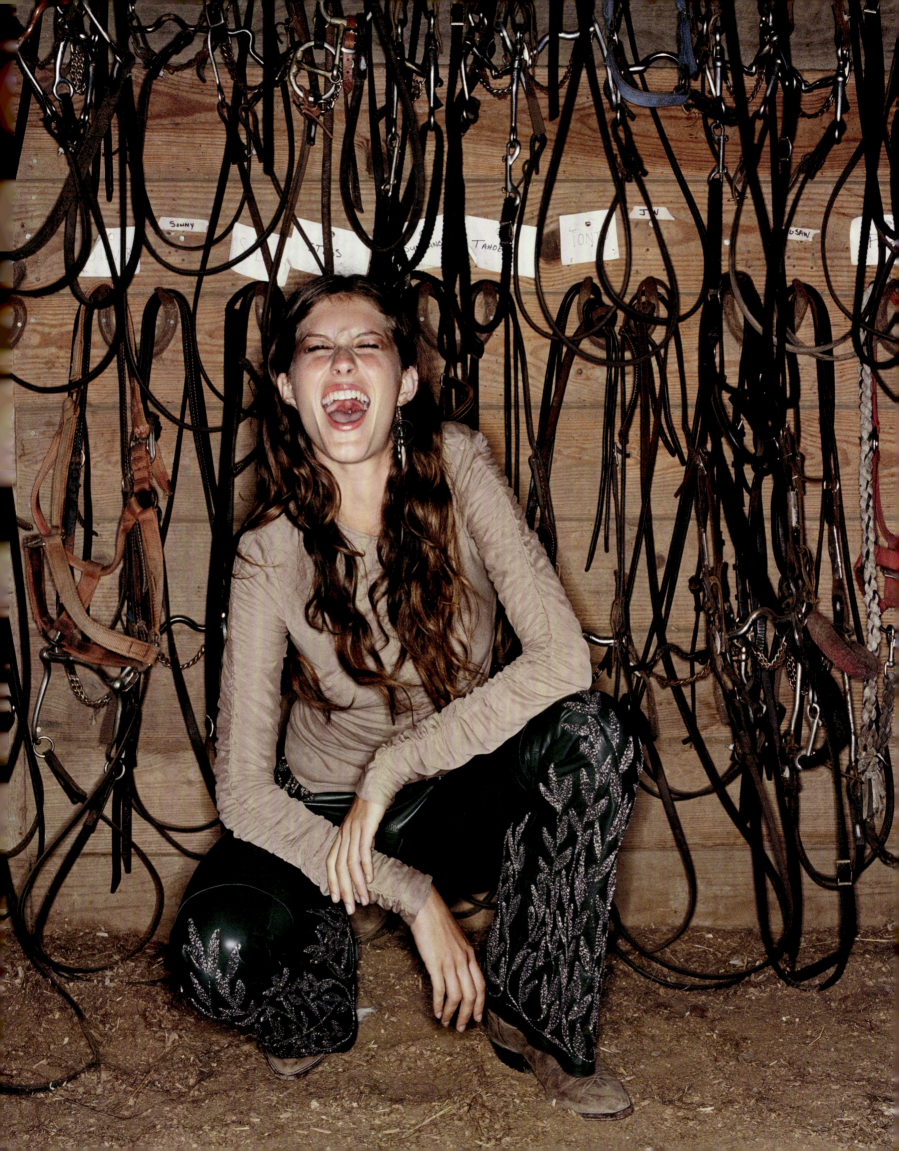

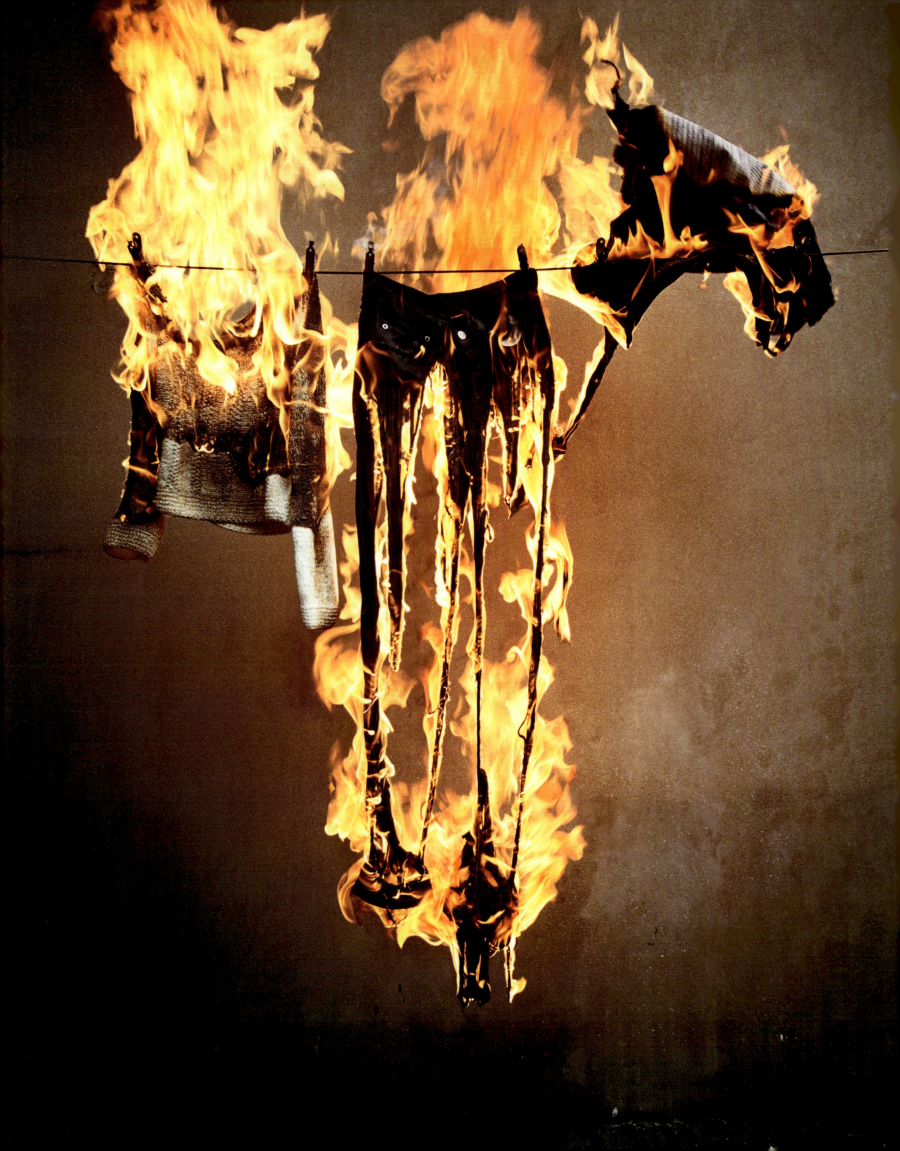

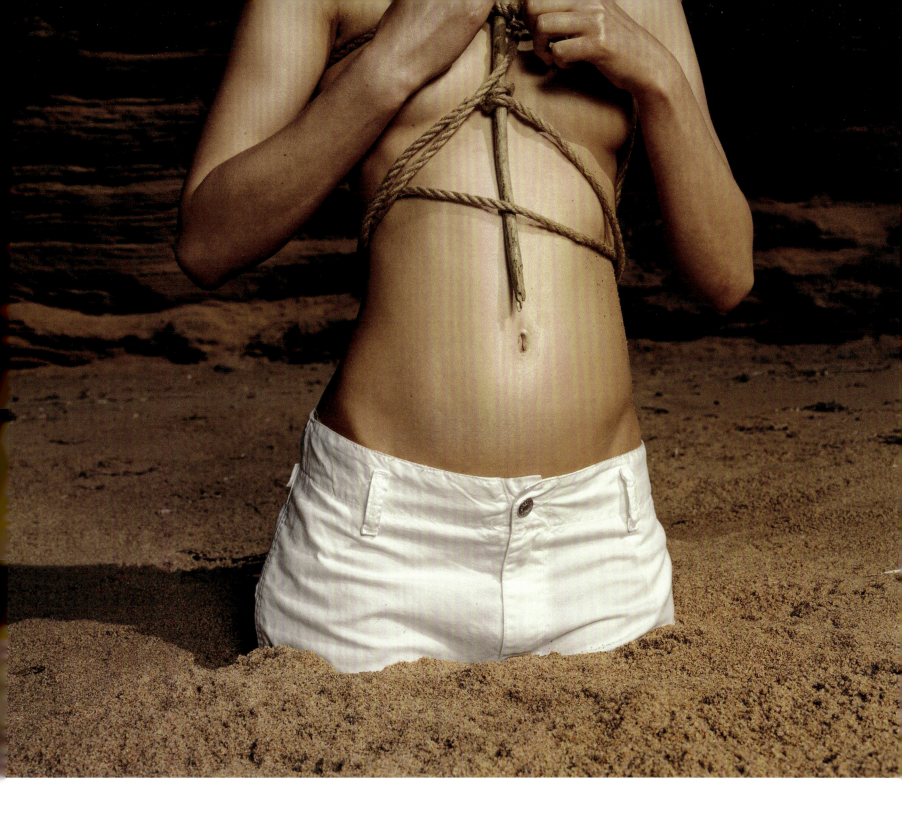

Baked Alaska | 1998 Stranded | 1999

There have always been companies that I have refused to work with. You look up the company, their ideology and visual world. Then you look up the photographer, the body of work…. but with Rankin we always shared this conversation of what he was looking for before going in front of the camera.

There was this thing of trust I always felt with Rankin—the outrageous jokes that are too funny, and sometimes heated conversations if we did not agree on the topic we were talking about. But then there was this lovely calm seriousness with respect once we got to work.

I feel that I was lucky to work in a time when creativity was really the highest aim—we said there are the "pay the rent" jobs and then the "real work" that you do because you love to create images. Images that sometimes obtain something beyond… that was the reward.

SANNA SAASTAMOINEN

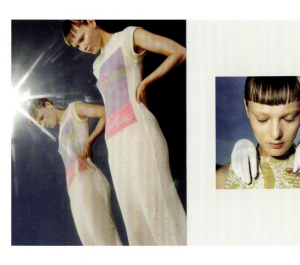
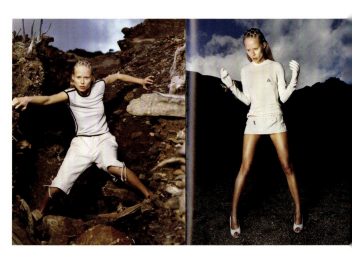

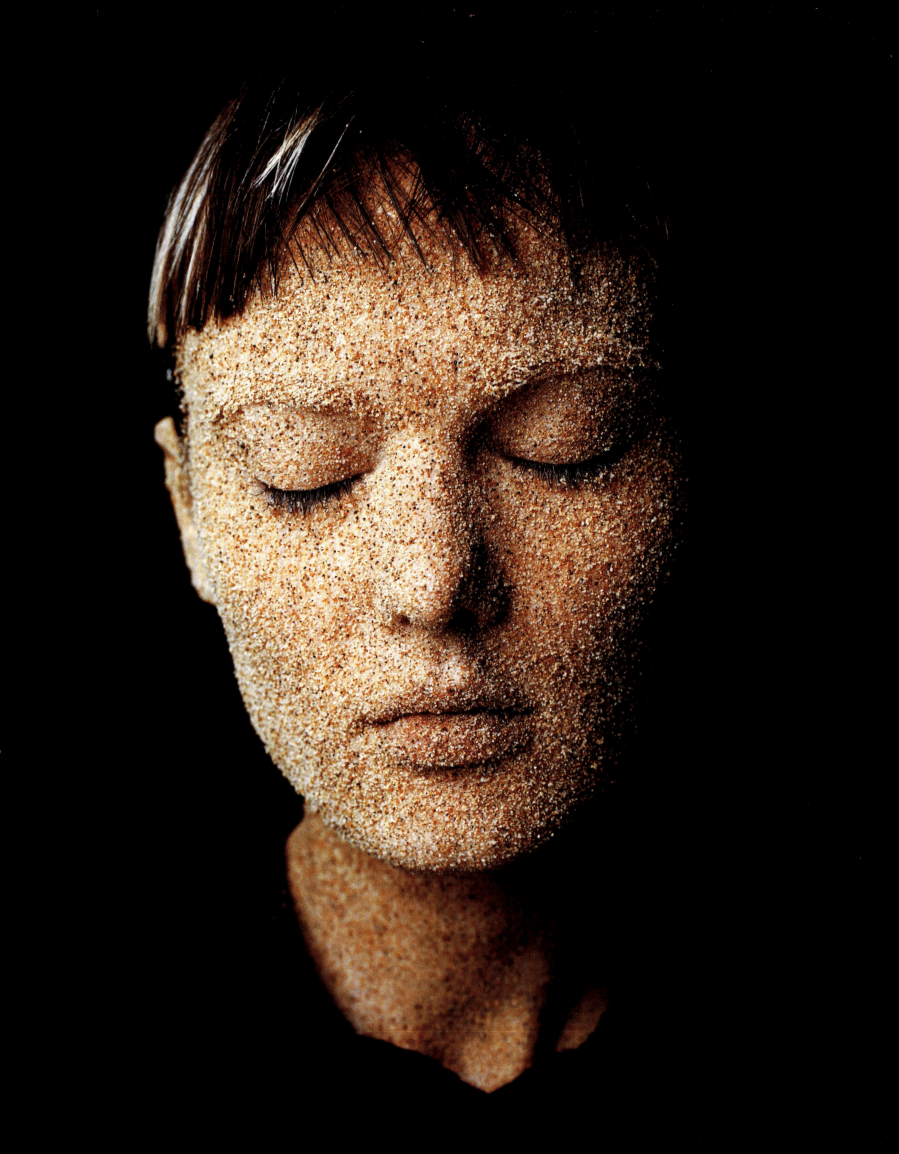

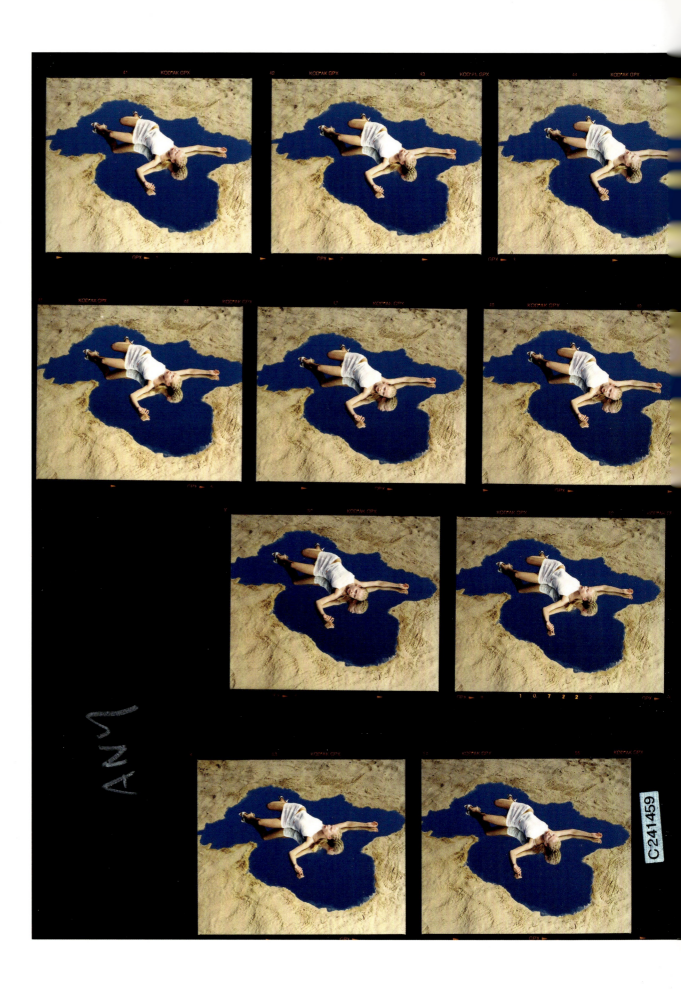

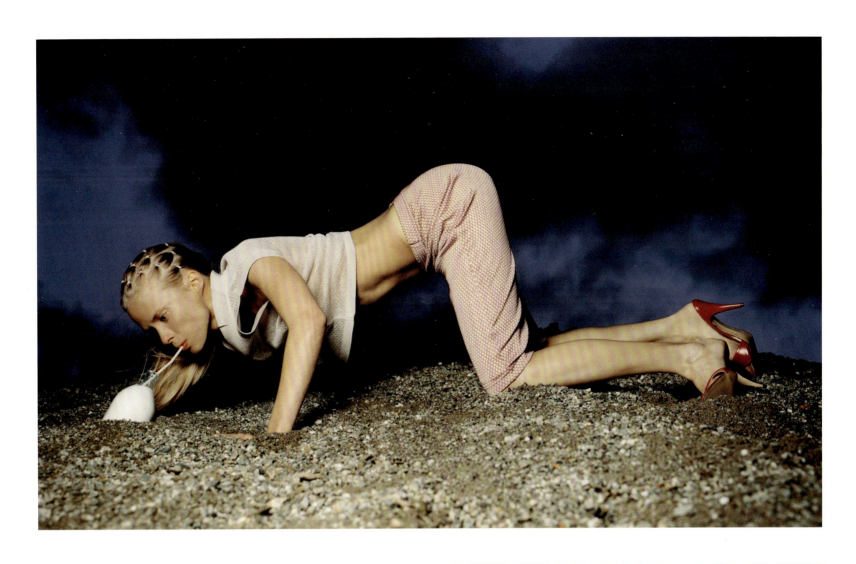
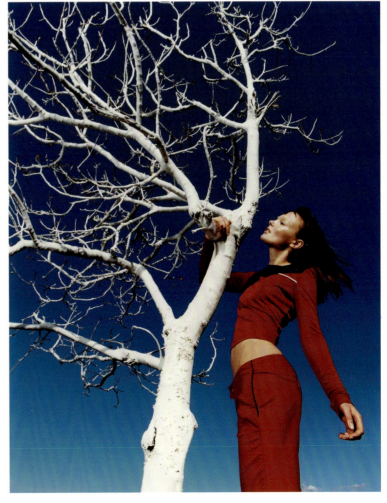

Next
Sparkly Gisele | 1998

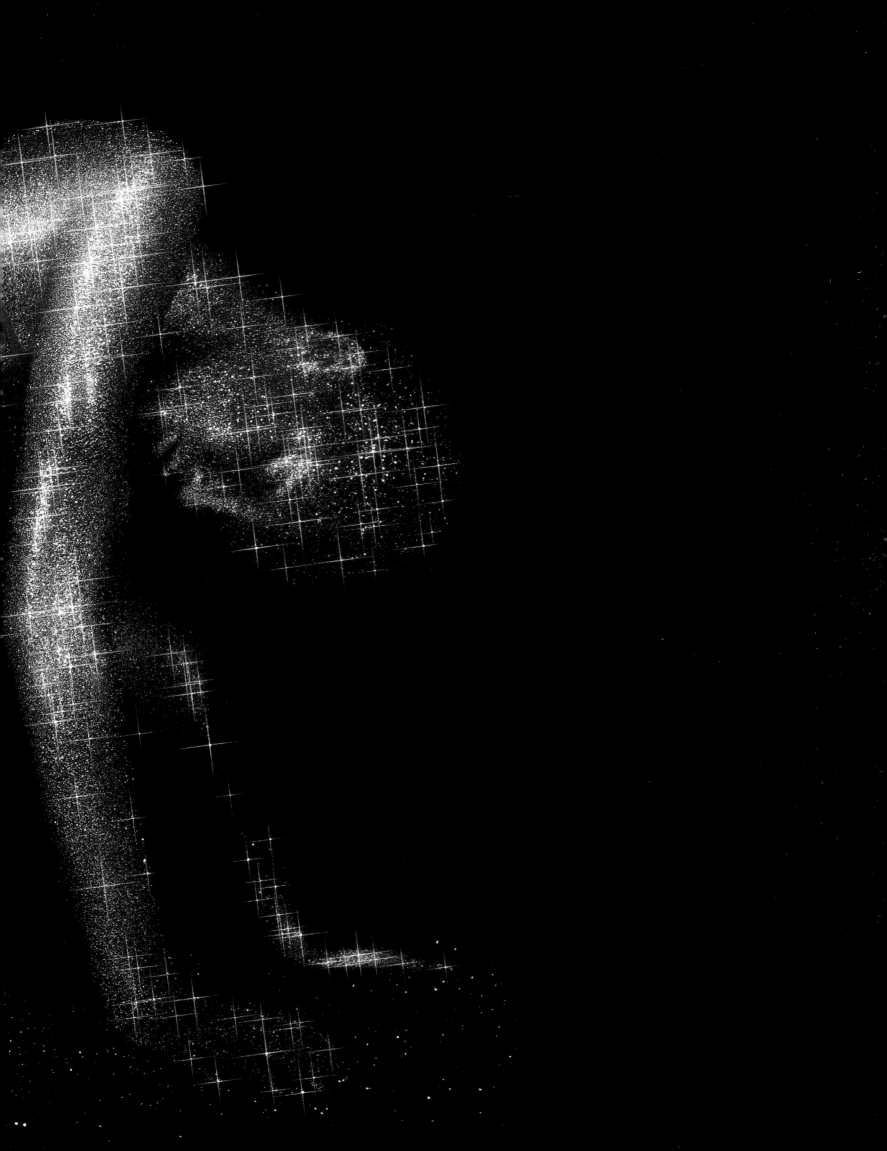

RANKIN | What do you remember about working with me?

KATE | I remember the *Dazed* offices—it doesn't seem that long ago, but it is, isn't it? Just shooting in the offices with everyone around, and it being fun. It was almost like a modeling test, it was like, "Yeah, do that, yeah, whatever, throw it together."

R | We were a second wave on the scene, weren't we? You were part of the first wave, with Corrine Day, David Sims, and Mario Sorrenti—to me you were part of that crowd. At *Dazed* we were like the second lot. And I always wondered if you ever thought, "Who do these guys think they think they are?"

K | No! No, I obviously liked it, as I ended up with Jefferson, so I thought it was quite cool!

R | What did you think of me and Jefferson back then when you met us?

K | The odd couple. You were cute, I really admired what you had done, and I thought it was really cool you had started this on your own. You had a magazine and it wasn't corporate, like everyone else was doing. I would go to *Vogue* and all those massive publishing houses for castings, but you guys were completely different and you did your own thing.

R | And do you remember our shoots?

K | Yeah… Those were the swinging 1990s! We were in full flight, literally.

R | That's true! I flew in on a helicopter to shoot you in Brazil.

K | And I flew in on a helicopter to meet you, because I was already in Brazil. There were two helicopters and we were all going down the Amazon, and then we flew round the head of Jesus Christ in Rio, didn't we? It was amazing!

R | Then we were shooting the next day, so we all just happened to go out for the night—and the next day you looked amazing in the pictures!

K | Fresh as a daisy! Those were the days. They don't happen like that anymore. Do you find that everything is very corporate now?

R | It's like everyone wants it to be like it was, but then they are also really politically correct.

K | Well, I find that with Snapchat and everything. When I was young, to think to pose in front of a camera for a selfie like that would have been the most embarrassing thing ever! You would never do that in our day—I mean, it's just so weird!

R | It's the opposite of what we were about. Going back, there are so few pictures of me. I didn't want to be photographed. You didn't even really want to be photographed either.

K | No!

R | You weren't like, "I love doing this," it was more like, "Okay, let's do it." It was about having fun.

K | I liked hanging out and having fun. Some models see it as work, where I just saw it as hanging out with my friends taking some pictures at the time.

R | And I think that's why you did really well. I do miss those days sometimes.

K | In those days you could make a shoot just out of a bag of clothes.

R | Out of nothing, yeah!

K | Out of nothing! A bag of clothes, a hairdresser, and a make-up artist. And you'd go off with a camera, and it wasn't a big production. It was just us, in a tiny office, with a backdrop, some knickers, and some spray paint.

R | We would just have an idea and go for it. Did you think at the time that any of the pictures we took back then would become so iconic to people?

K | No, no.

R | How does that make you feel when you look at them?

K | I don't know, really. I suppose it's because I have been around for so long—I mean I have been doing it for thirty years now—so there's a lot of pictures, and I suppose my face is just… a sign of the times or something? I mean, it's been seen!

R | But back then you didn't think we were making something iconic?

K | I didn't think, "Oh we're changing fashion history." I just thought, this is just what we're doing, this is just what I wear—mainly because it's all secondhand and that's all I could afford. I couldn't afford Chanel and all the things the supermodels were wearing, it was just secondhand stuff from the 1970s and it was just the way it was.

R | Did you think of yourself as a model?

K | No.

R | I read the other day you said that you're still surprised when you get a campaign.

K | Yeah!

R | Because I'm always still surprised when I get a campaign, too.

K | It's always still a bit of a blag. But obviously I don't feel like I am that old, I still think I'm seventeen in my head.

R | Yeah, I do as well.

K | That's why it's like just carrying on. I don't think, "Oh, I'm not seventeen now, and I can't do that any more."

R | Did you ever take time out?

K | I did once, a long time ago. I said, "I can't do this anymore." It was when I was shooting a lot. It was after I was going to yet another shoot at Notre Dame in Paris, there were all the steps going up to the bell and I was like, "I can't do this any more." It was the second shoot in the week where I had been up the bell. I just canceled the next day and I went home. I think I took a year off.

R | I always felt like an outsider to the fashion world in a way. I mean, even when I was in the "in crowd," I felt like an outsider.

K | There are a lot of fascists in fashion. You just have to get on with your own thing, don't you? I'm not up on who a new designer is, particularly, but I know who I like, and I love clothes and I love fashion and I love images, and I love being around people that create the images and the clothes and the hair and the make-up, you know. This world is my thing!

R | There are some people that are just great in this industry because they are really good at making you feel comfortable—for me, you've always been like that. How do you feel about getting old?

K | Ugh! How does anyone feel about getting old? It's a nightmare!

RANKIN IN COVERSATION WITH KATE MOSS

R | I quite like it…

K | Well, I mean I do feel better, being forty-ish, than when I was twenty-ish, for sure. I feel better in myself.

R | But you never really look at yourself anyway, you're not one of those models. You never go up to the screen and look at your shoots.

K | No! Remember when you projected images from a shoot live on the set for everyone to see? I hated it when you put that up. I really hate seeing outtakes.

R | I have stopped doing that, you know, because of you.

K | It was awful, every click was out there. I only want to see the good ones. I don't even look at the screen when you're going 'click.'

R | Are all us photographers different? Or is their anything that connects us all?

K | Ego! No, only joking…

R | That's okay—ego, really?

K | Yeah, it's almost like lead singer syndrome.

R | Lead singer without a microphone?

K | Well, the camera is the microphone, I think. I don't know if other models would say that. It's not a horrible thing, though; it's just the way it is. Really to work with different people all the time, you can't get ahead if you're an asshole. People just don't want to work with you. So all photographers have got to have some sort of personality traits that people like…

R | Do you feel more comfortable talking now than you used to?

K | No, I hate it. My opinions are my own and I don't really feel like I need to share them, though with my friends I do of course.

R | You are really opinionated.

K | But not on paper. I've had the education of life, definitely. To be in our game you've got to have common sense.

R | I think you are one of the most down-to-earth models I have ever worked with, and I think that is why everyone loves you, or at least why I do. Do you still feel that way?

K | Yeah—even though, you know, I don't usually get on the bus or on the tube…

R | Do you still like coming to shoots?

K | Yeah, more now I think than when we were young. Now it's not like, "Oh my god, another shoot," it's more spaced out and I can pick and choose.

R | And you don't have to do all the editorials you used to have to do.

K | No.

R | And also you're working for yourself now, as an agent?

K | Yeah, it's really good. Its nice knowing that the kids are good, and seeing them grow into people. You take them and they get to know that it is work and not just a game anymore. You see them finding the balance. You can go to these parties and you can do shows but you still have to turn up. You can't cancel, because you just won't last in the business.

R | Whereas we could—back in the 1990s we could wing it a bit.

K | Yeah, you can't get away with acting like that now. It is so businesslike.

R | And do you enjoy business?

K | Well not like you, I mean you're an amazing businessman. But I like it, I like being in control. I suppose I have been managing my own career forever. You've got to learn something along the way, and I definitely learned what I am worth. Some people helped me out. Iman said to me once, "Don't take less than this for a show." It was show season and this brand didn't want to pay me what I had asked for, so she was like, "Put your foot down!" You learn from other models and I've always been like a sponge.

R | For me, working with you really influenced my fashion photography career. Is there anyone that has really influenced what you have done as a model?

K | Corrine Day. Sometimes when I get dressed I still think of Corrine. It is always with me, I know I'll look good if I go back to what Corrine liked.

R | One of my favorite photos of you was when you were at some fashion party in 1993 and you were wearing a transparent slip dress by Liza Bruce, and it's so seethrough it's basically just you in your knickers. Images from that night really just capture the feeling of what the 1990s were all about.

K | Well it wasn't transparent when I went out, it was only the flash that made it transparent!

R | You can look at those those photos and Corrine is standing right behind you.

K | There's a picture of me and Naomi Campbell from that night, and Naomi looks about thirty-five and I look about twelve. I always looked really young and she looked much older because she was a proper supermodel.

R | How important is having a laugh to enjoying your work?

K | Very important, the most important thing.

R | You have been in the business thirty years. What do you still get excited about, and what bores you the most?

K | Interviews, I hate doing interviews. But I get excited to see people. I still get excited when I get booked for Saint Laurent, or nervous when I get booked for Vuitton. I don't really feel that different now from when it started.

R | I always get excited to work with great people. A lot of my shoots are all about collaboration, and working with models like you does feel special. It's this exciting thing where we see you and your personality but you also have this amazing ability to still be different for every shoot.

K | I will be whatever you want me to be.

R | Yes, but it's more than just being a character. You're still always you, do you know what I mean?

K | Yeah, definitely. But I am always willing to go with what the photographer or brand want it to be like.

R | So you're a blank canvas?

K | That is what I want, how I want to be. I don't like having my picture taken just as me. Modeling is much easier. When I put the clothes on I become somebody else.

R | One thing I find interesting is that there are so few pictures of you laughing and smiling. But on a shoot you spend most of your time laughing and smiling.

K | But that's just because I don't like my face. So I only really like the images when I'm focused and working.

R | But you still have that look in your eye, even thirty seconds later you still have that humor. I think that's why everyone still loves you, because you are you! When you're laughing on your shoots you make everyone feel comfortable. Well, you make me feel comfortable taking your picture.

K | Well, I don't understand the point in turning up and making people feel awkward!

R | Some people do…

K | Yeah, but that's just insecurities on their part. To make them feel better they have to make somebody feel worse.

R | Do you ever go on a shoot and think, "They don't want me here?" I've walked onto shoots before and there is a weird atmosphere, maybe that they wanted someone else for the job. Do you ever get that?

K | Yeah, I do too! I've been on a shoot before and the woman stared at me, horrified, and then I had my hair and make-up done and she was like, "Wow! How did glam turn her around?" Actually she was really funny, she's a really good friend of mine now because I loved that she was so blatant.

R | When you look around now it's all the same people who came up with us. You wouldn't have thought that back then. It felt as though it was fleeting, I always thought it was going to be over in a year or so.

K | And then everyone would go and get proper jobs.

R | It felt like it was so of the moment, but I can still look around and be like, "I know all of you guys."

K | That's what James Brown always says—we're going to be wheeling each other round in and out of shoots when we're seventy, eighty, even ninety! "You look great, wear that! Go for the pink wheelchair, not the blue one!"

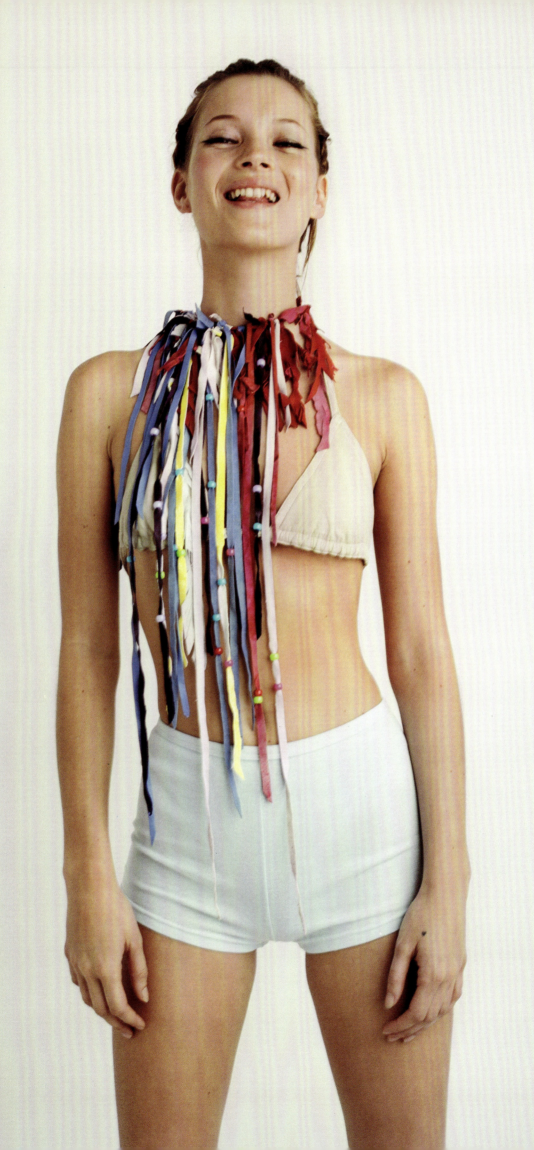

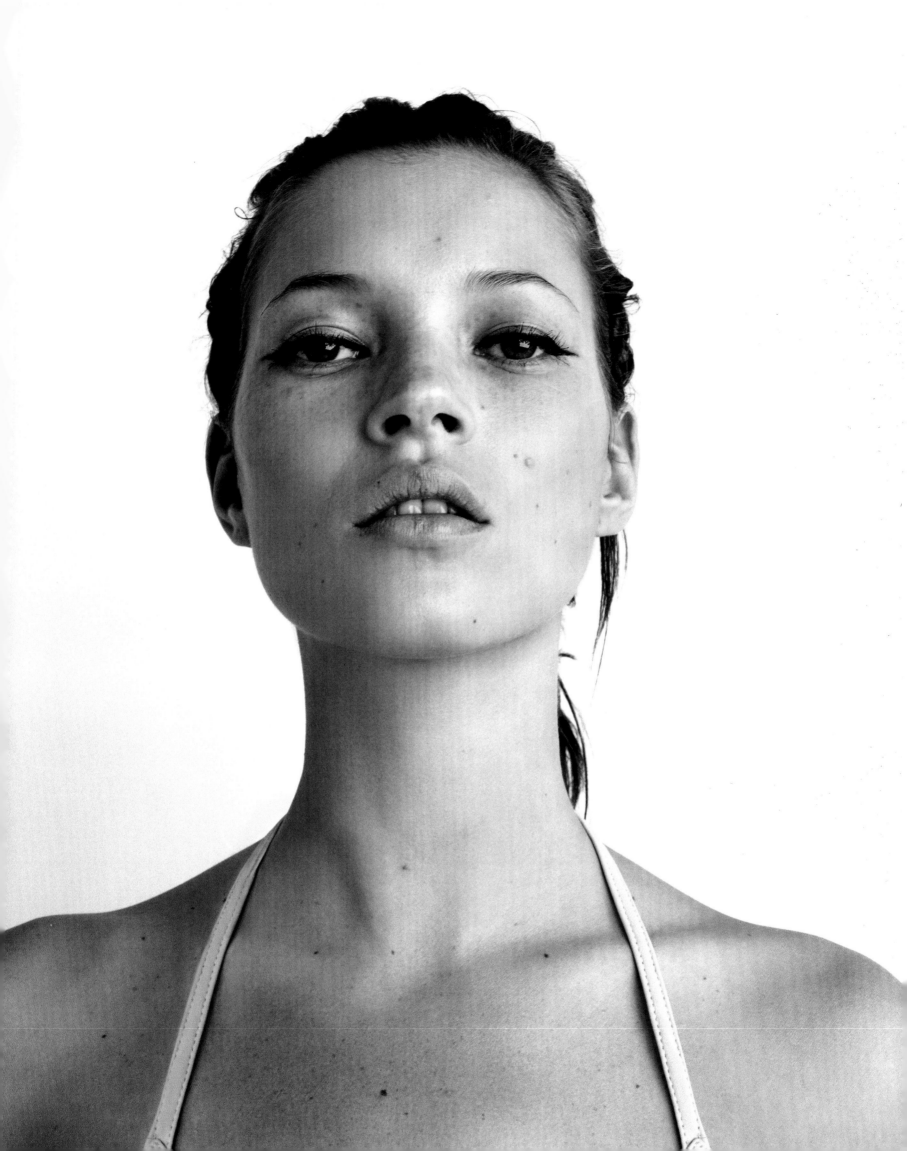

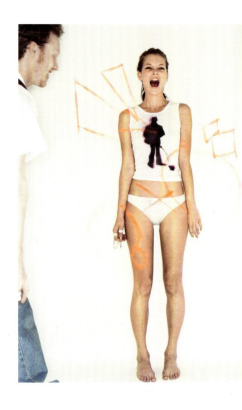

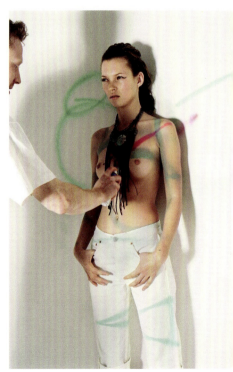

Spray Paint Kate | 1998

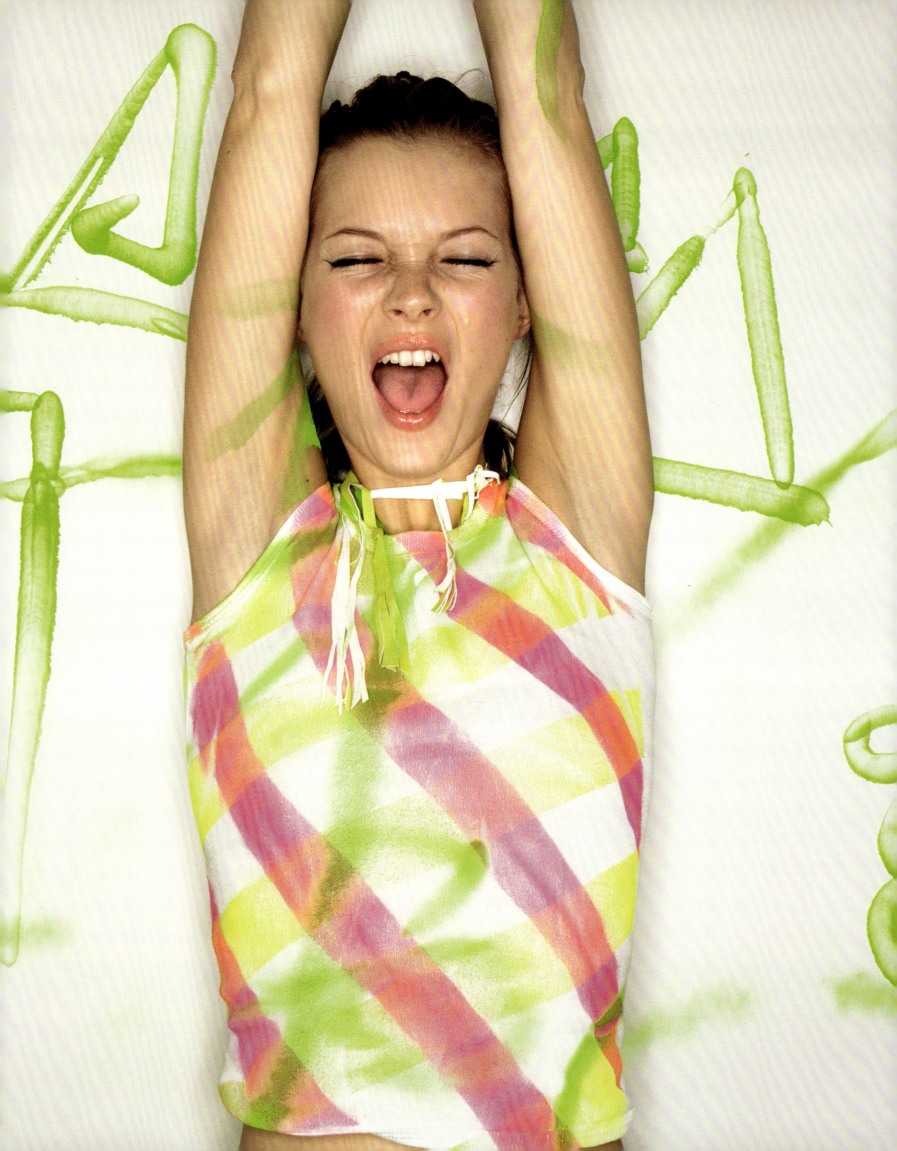

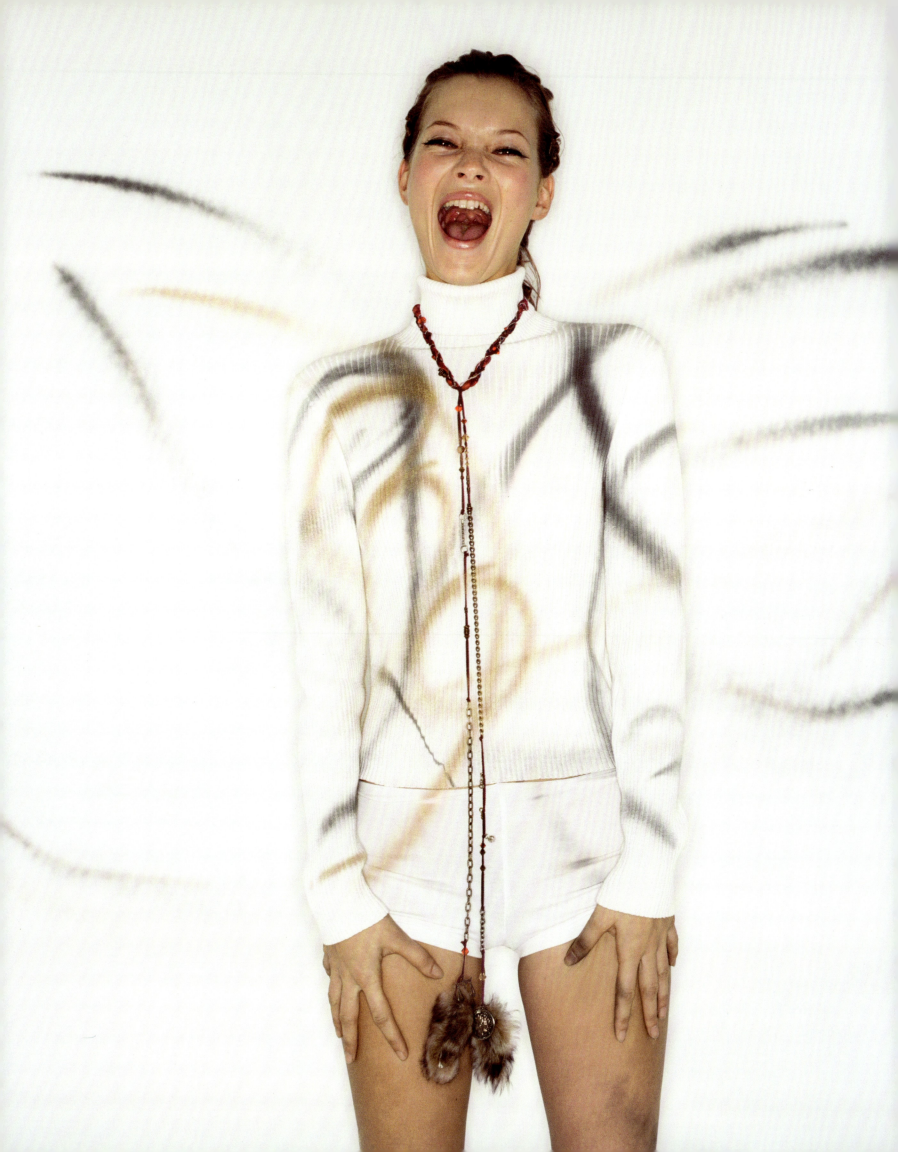

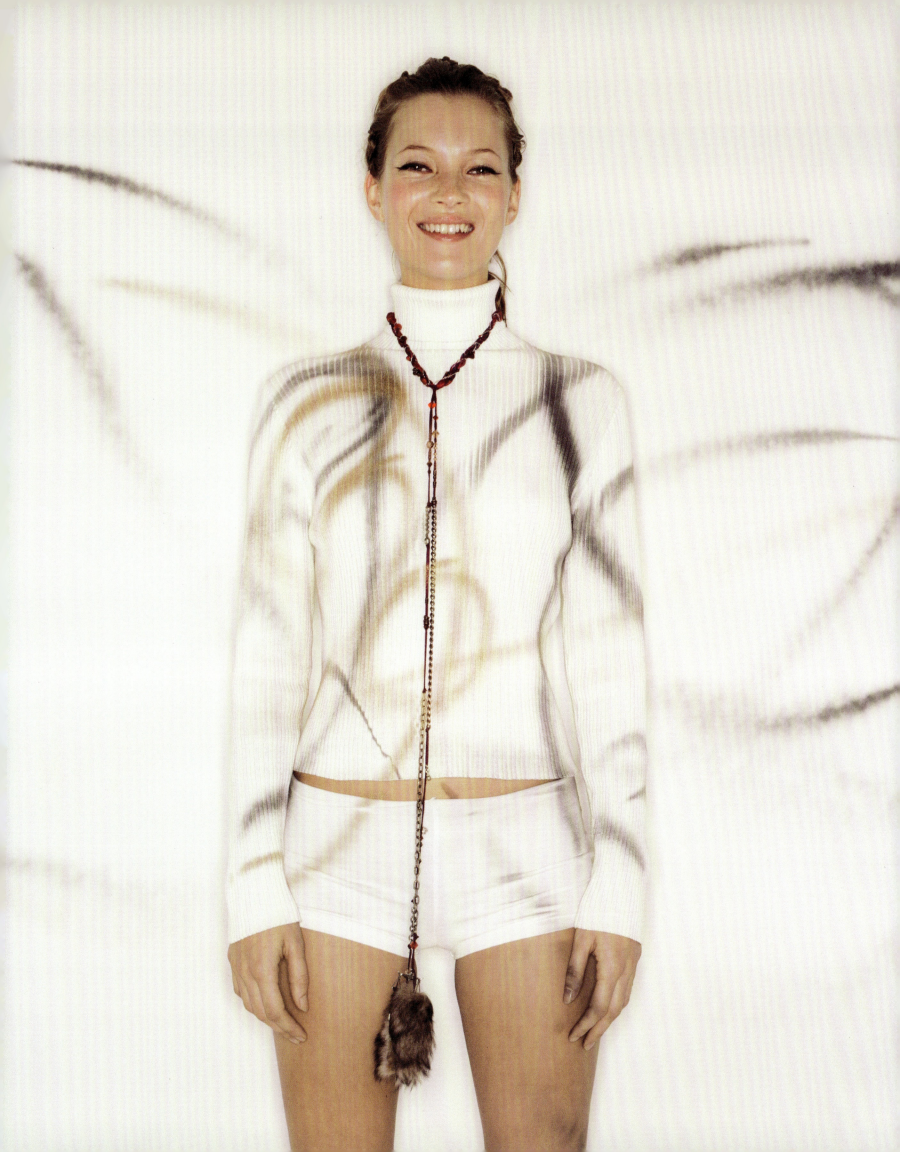

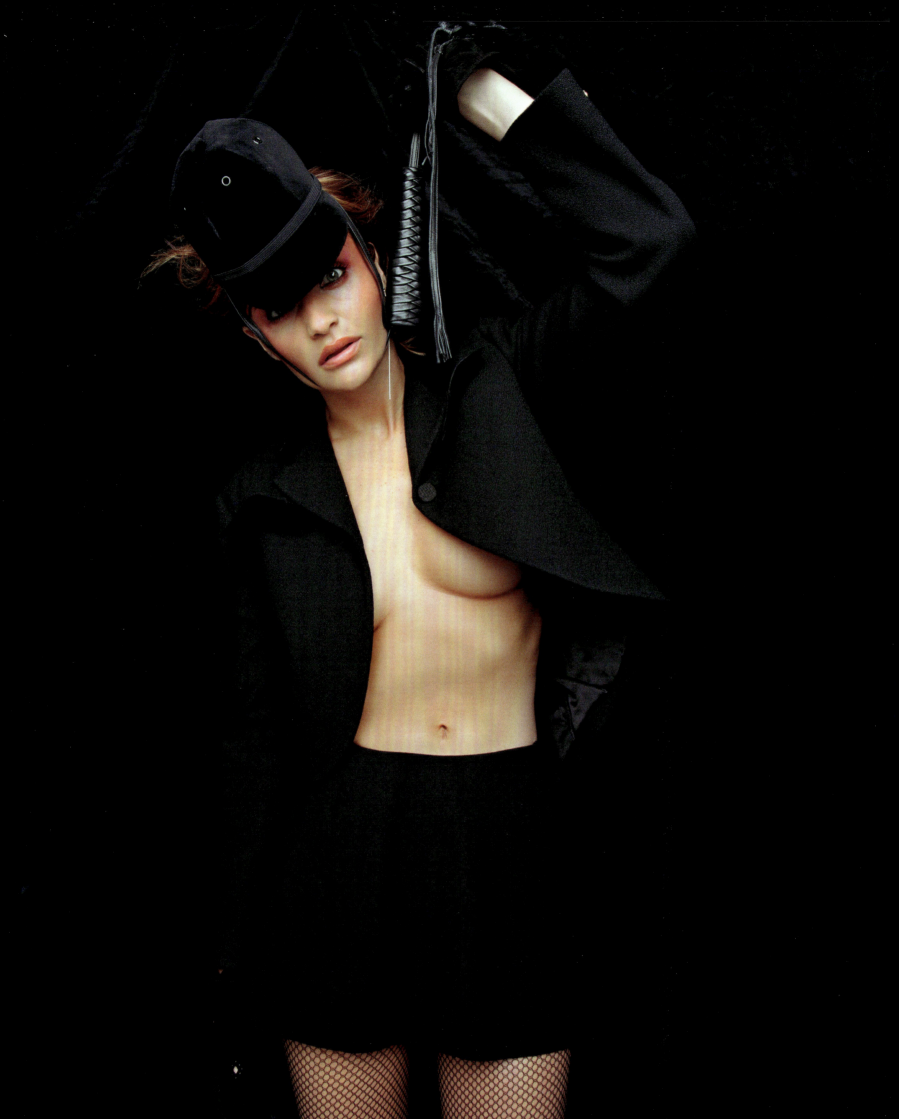

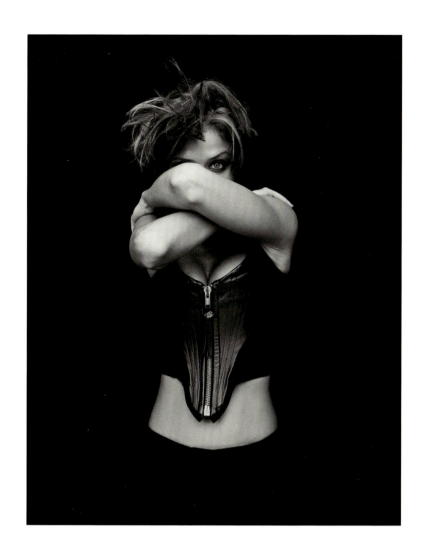
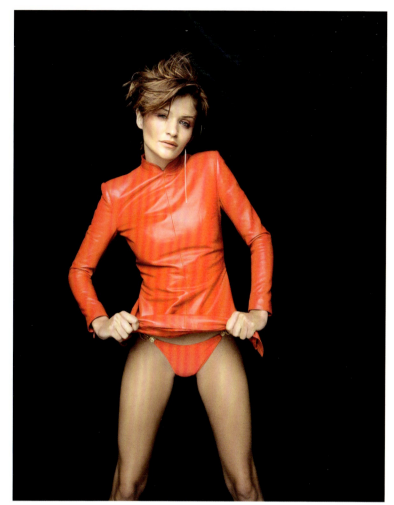
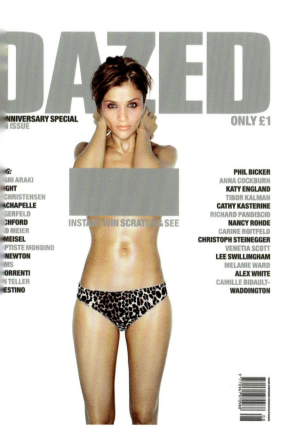

Flesh for Fantasy | 1997

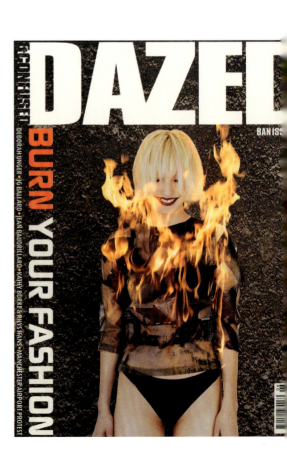

Highly Flammable | 1997

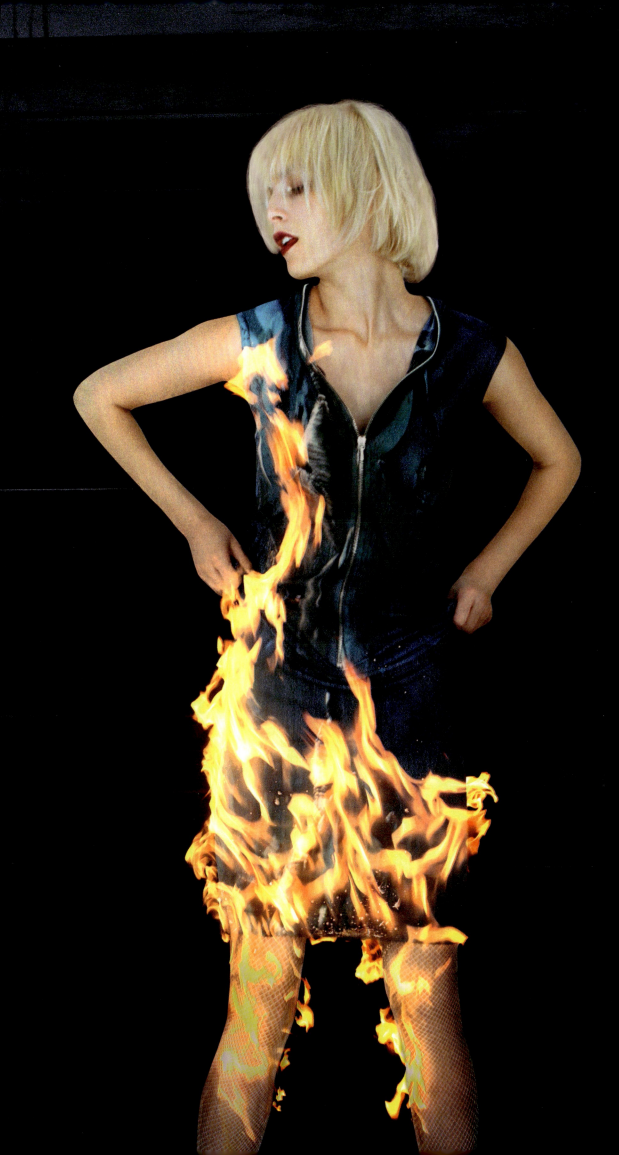

FIRE EXIT
KEEP CLEAR

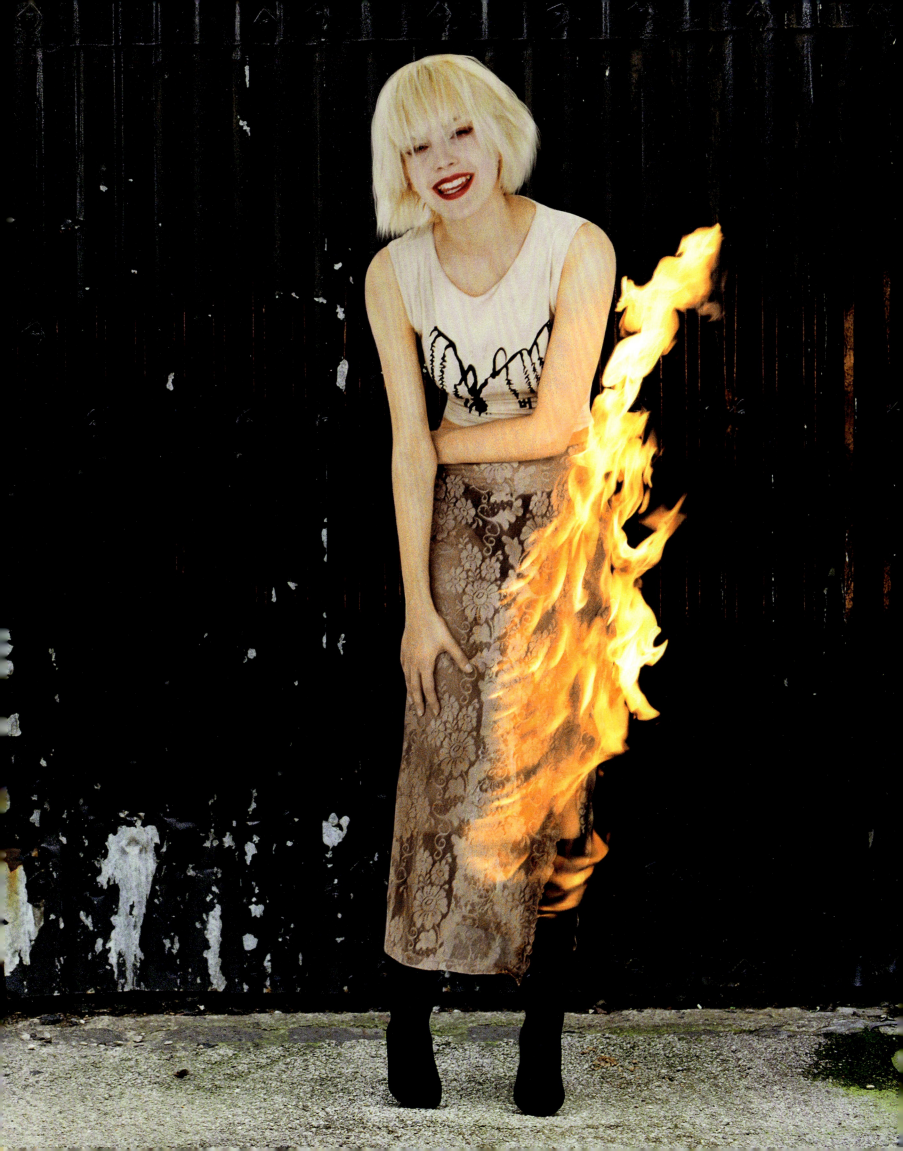

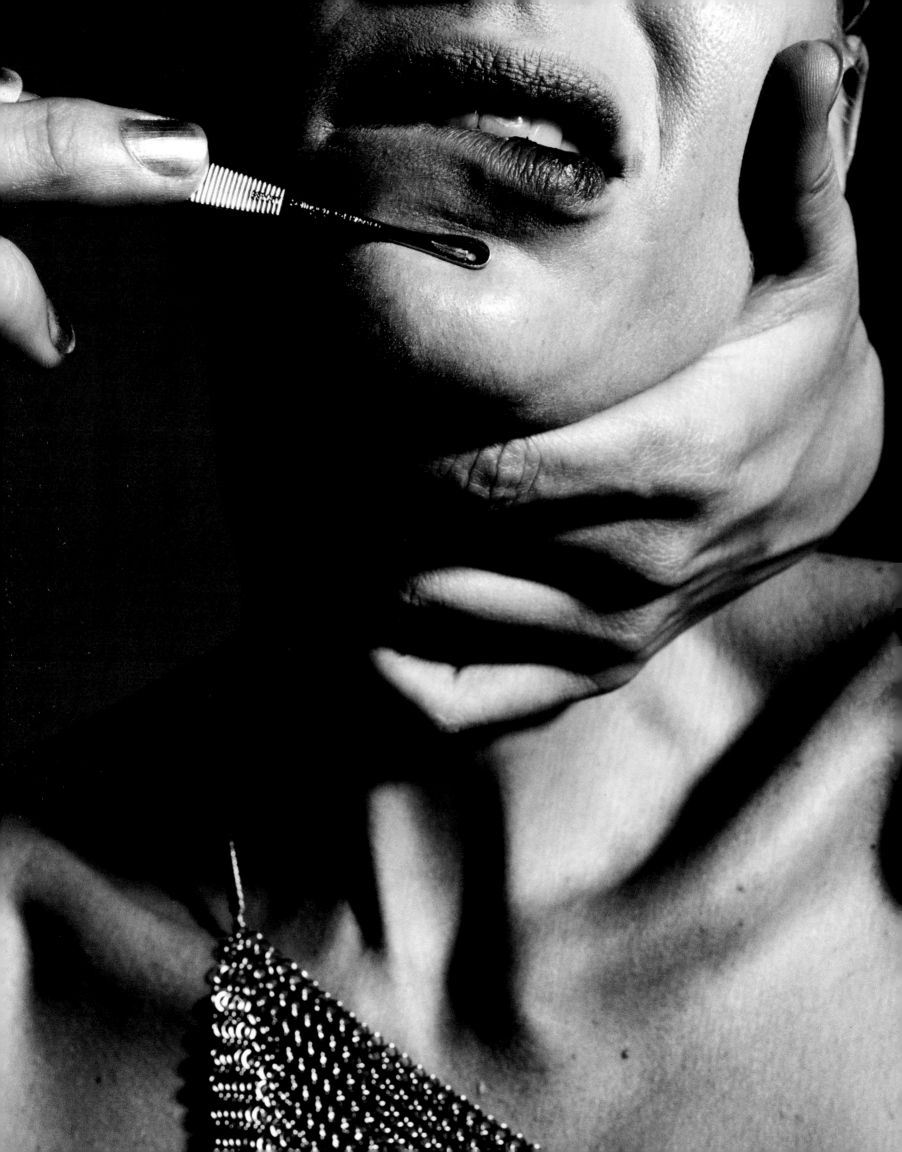

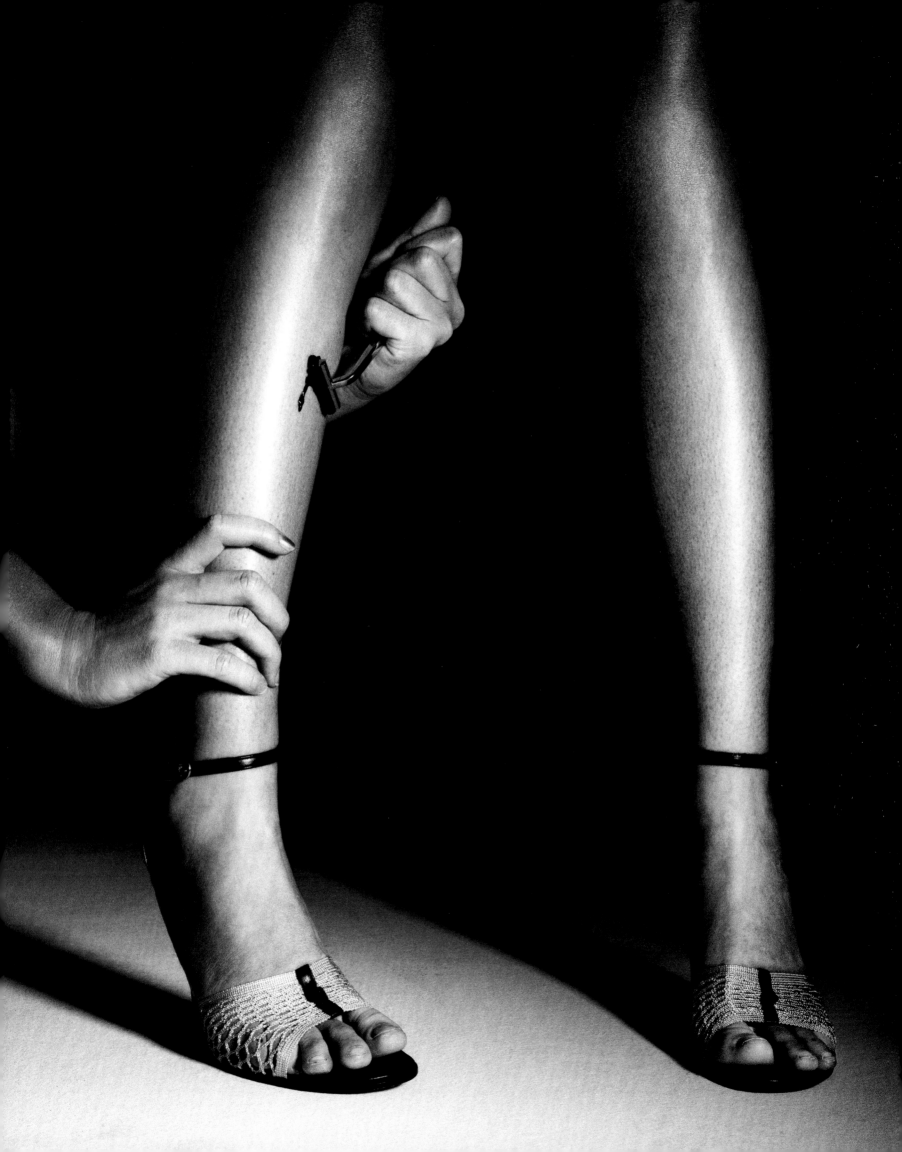

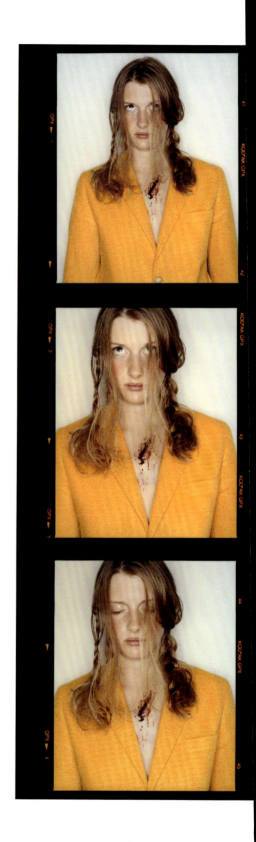

Previous
Plain | 1997

Dead Fashionable | 1997

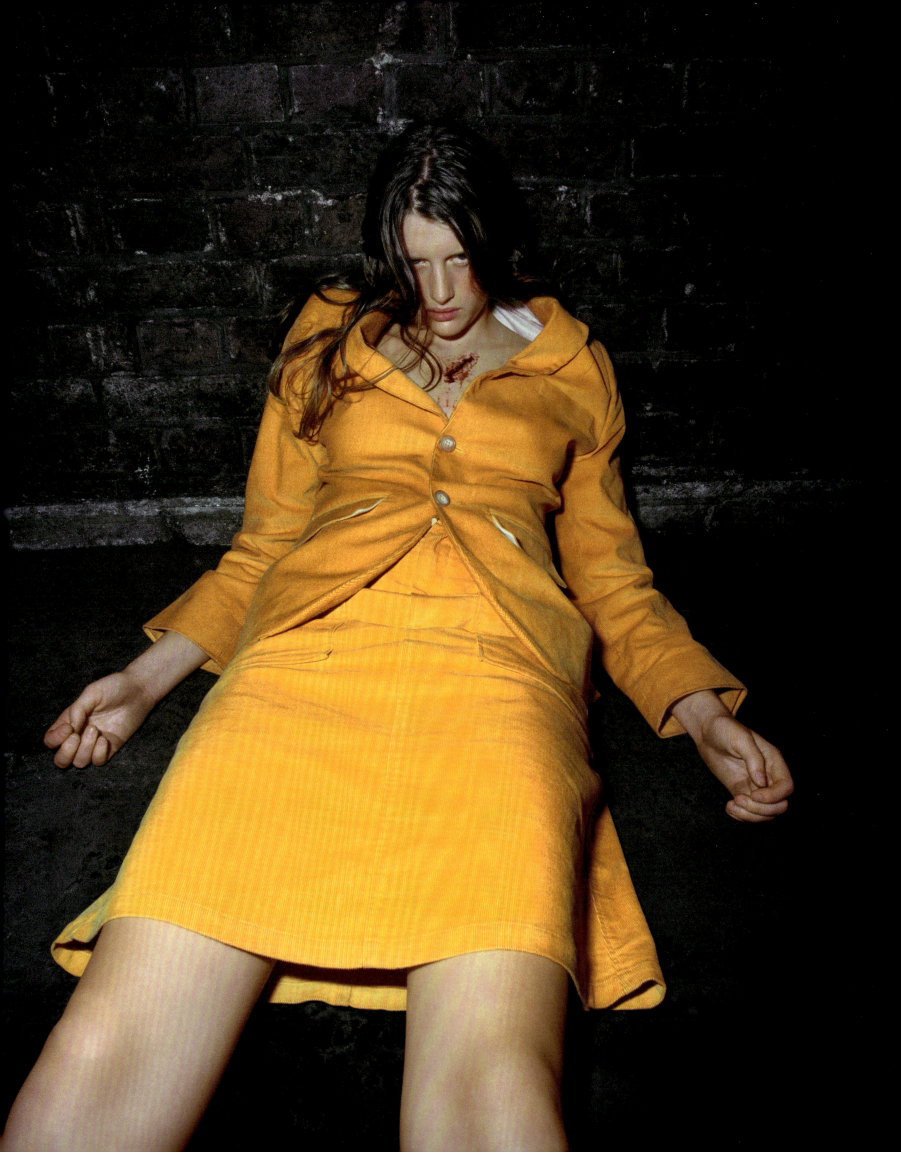

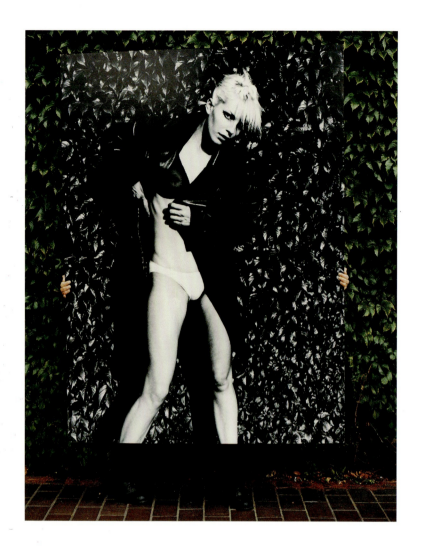
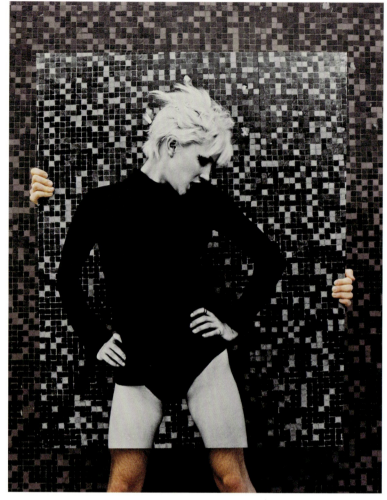
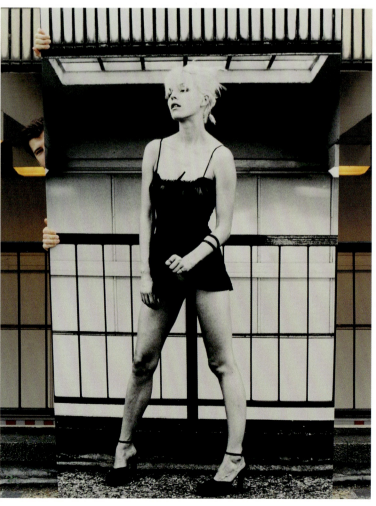
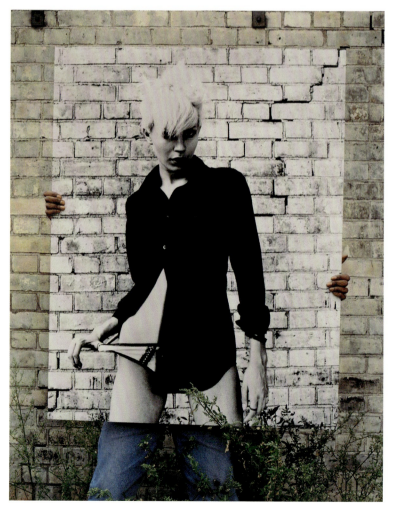

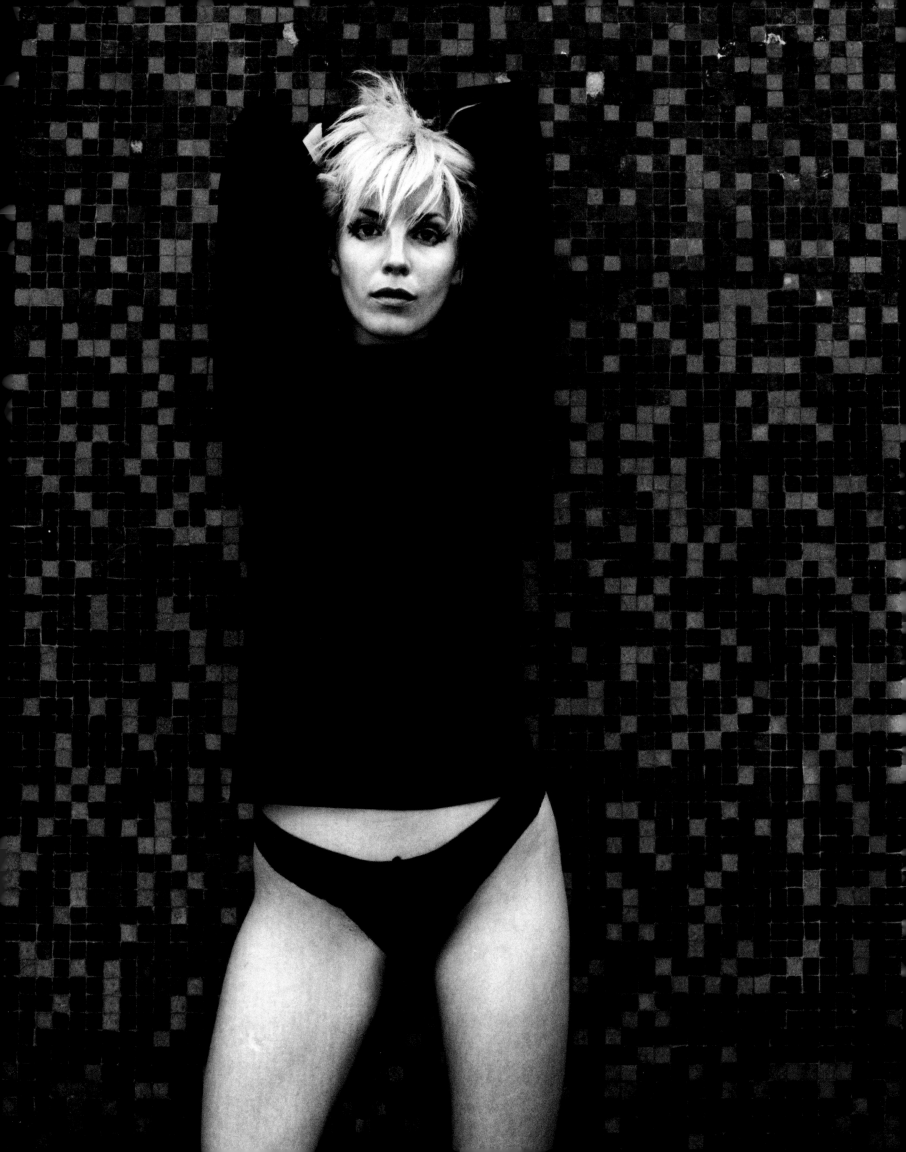

Well, Rankin has always been super, über-cool, working with super, über-cool publications, and I came from a boy band—and, you know, we were a few tiers down on the food chain of coolness… maybe more than a few tiers! So I thought that he was going to be standoffish and cool like other people I'd met in the fashion industry. But he wasn't like that at all.

I can remember the feeling that I got from Rankin, which is sort of like a kindred spirit.

ROBBIE WILLIAMS

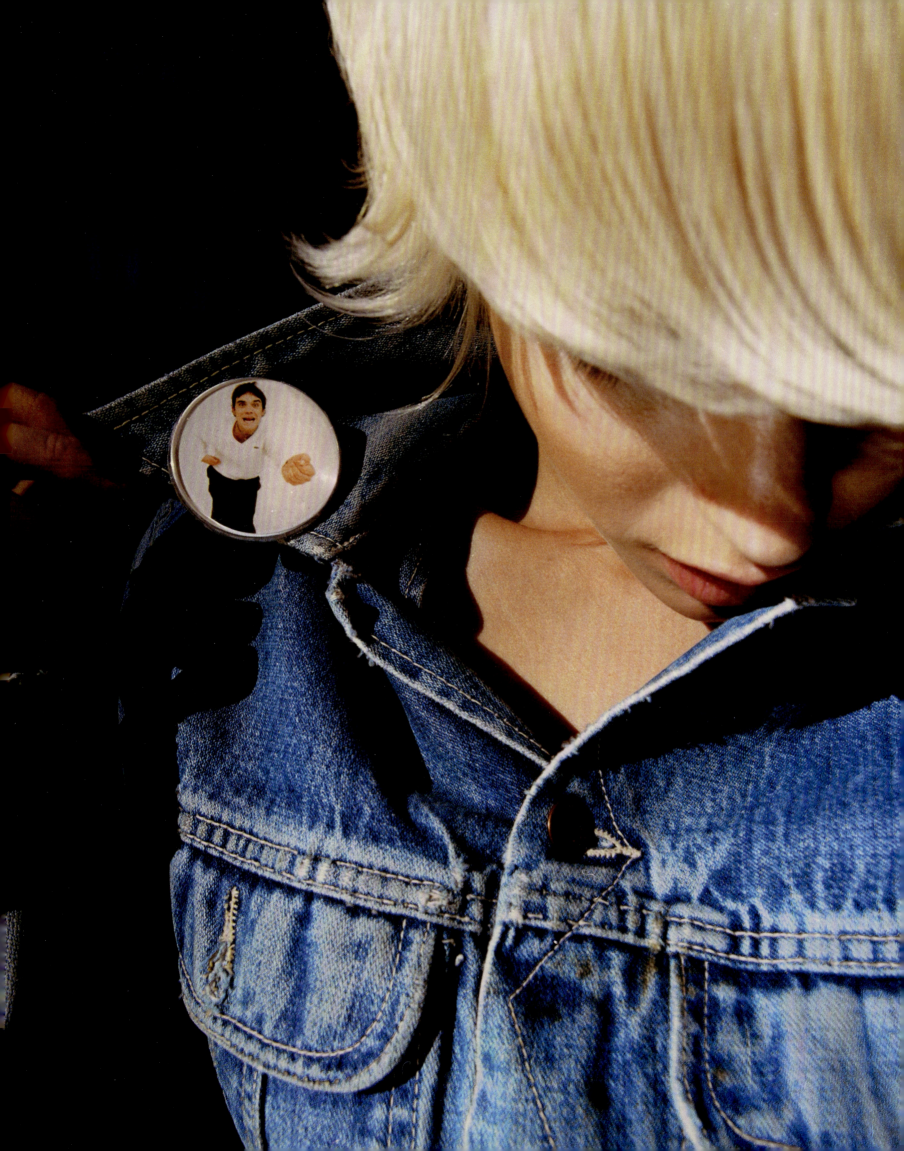

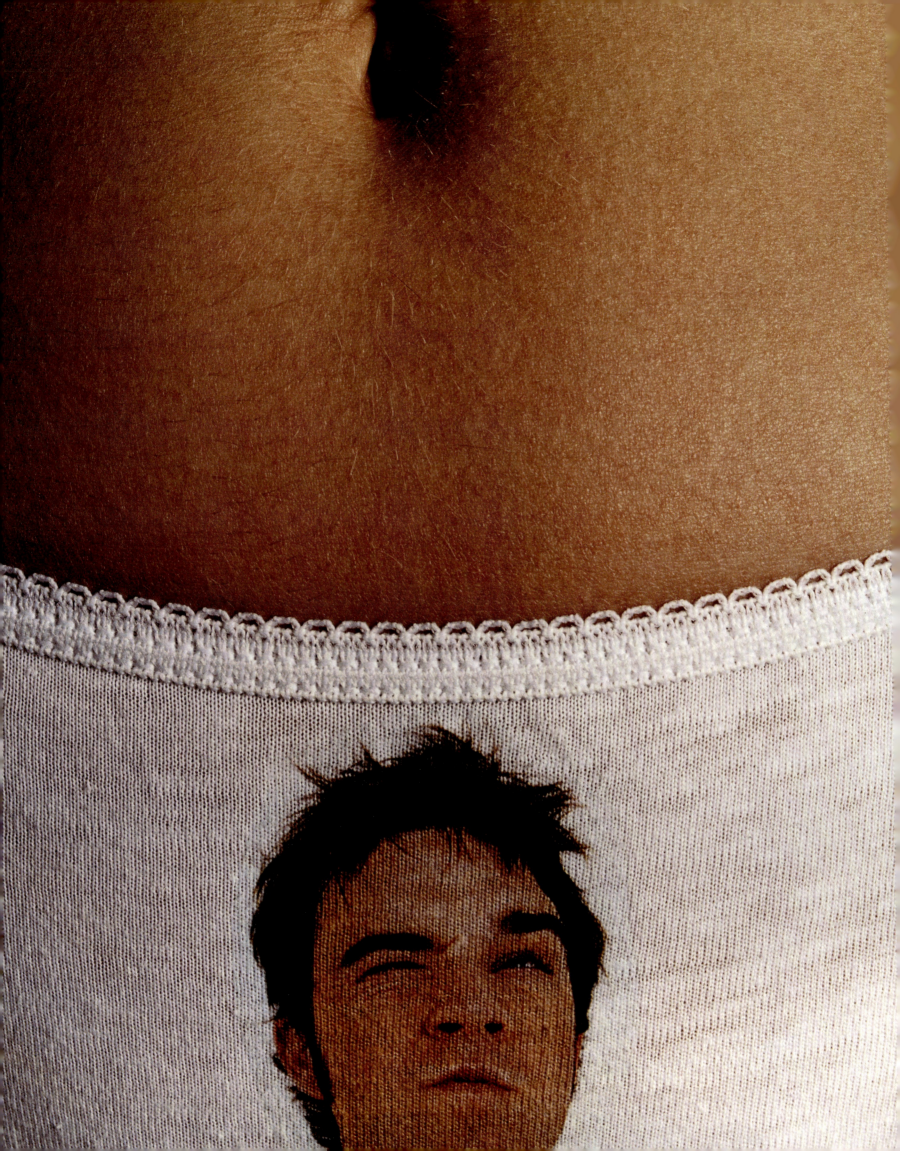

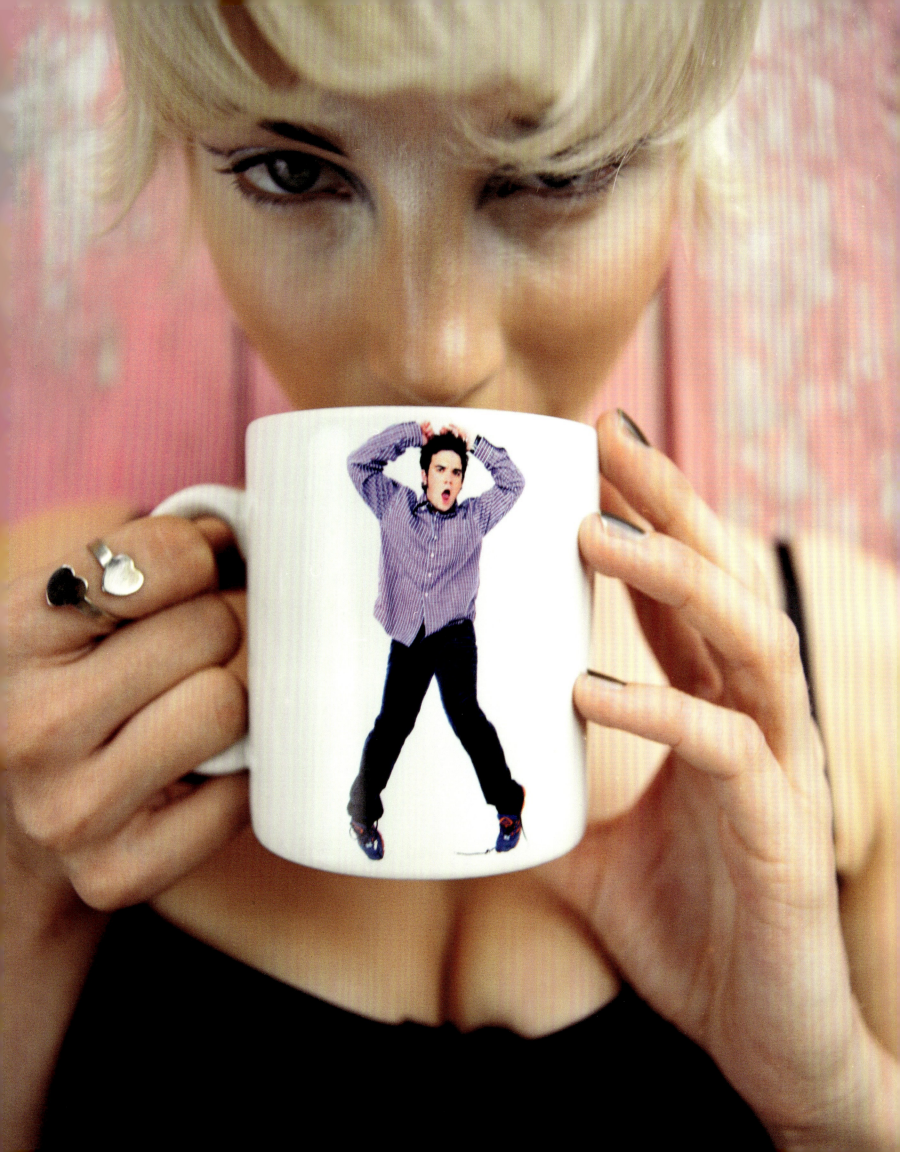

I remember my agency telling me I was shooting with Rankin. I wasn't really interested initially in what was involved, just that I was shooting with him.

He was quite abrupt, straight to the point, no mincing his words. The set was pretty fast-paced. It was good fun, so I knew the photos would be great. It was cheeky, sexy, and I enjoyed doing it alone. I had a unique look at the time and I'm probably quite gobby also, so can give as good as I get. I can imagine some models could have found him intimidating, as he was snappy at times.

At the same time I liked the strong, assertive sense of direction. Also a lot of pizza came—I was happy with that!

CLAIRE MERRY

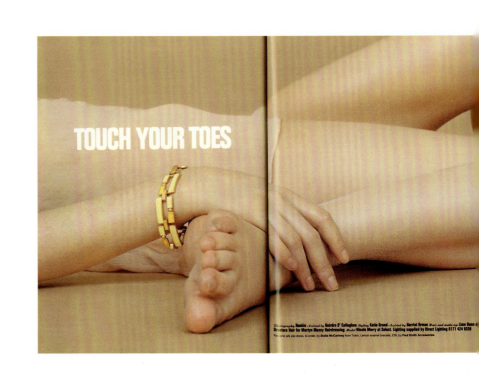

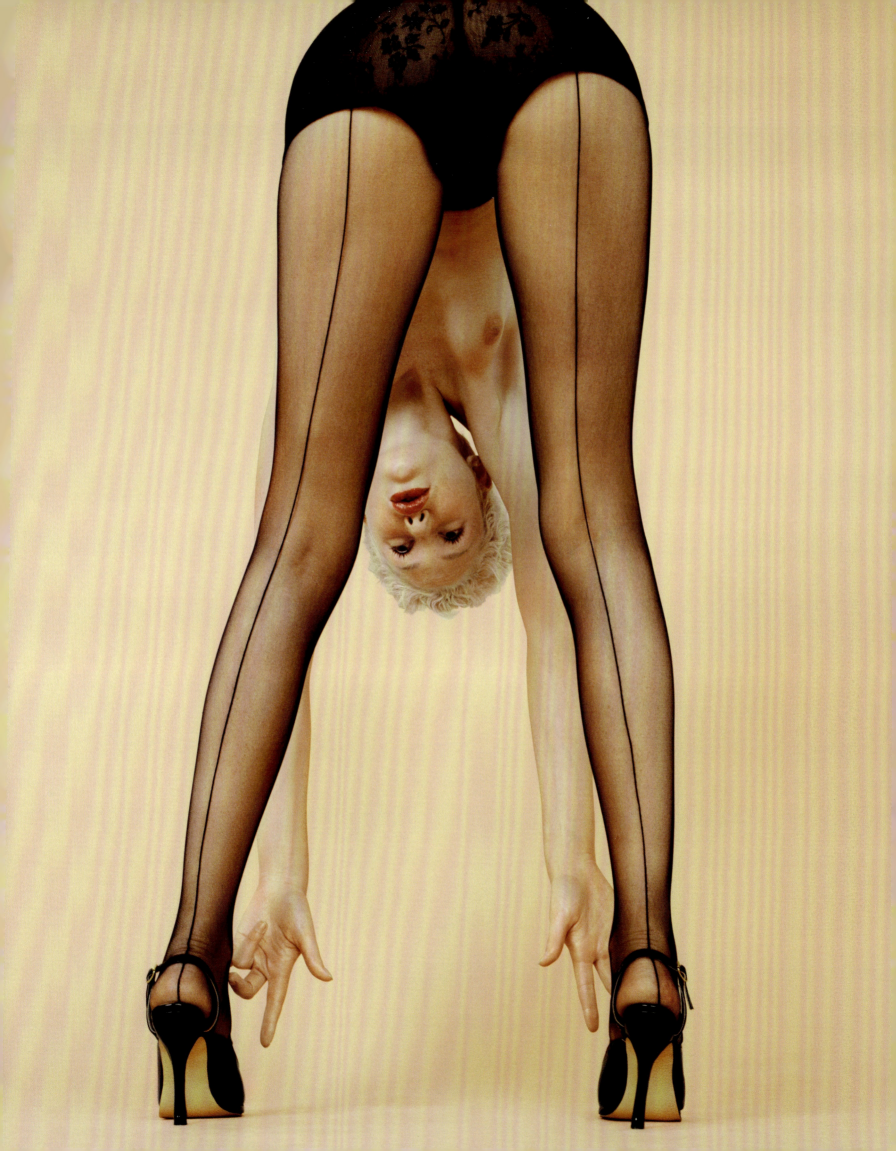

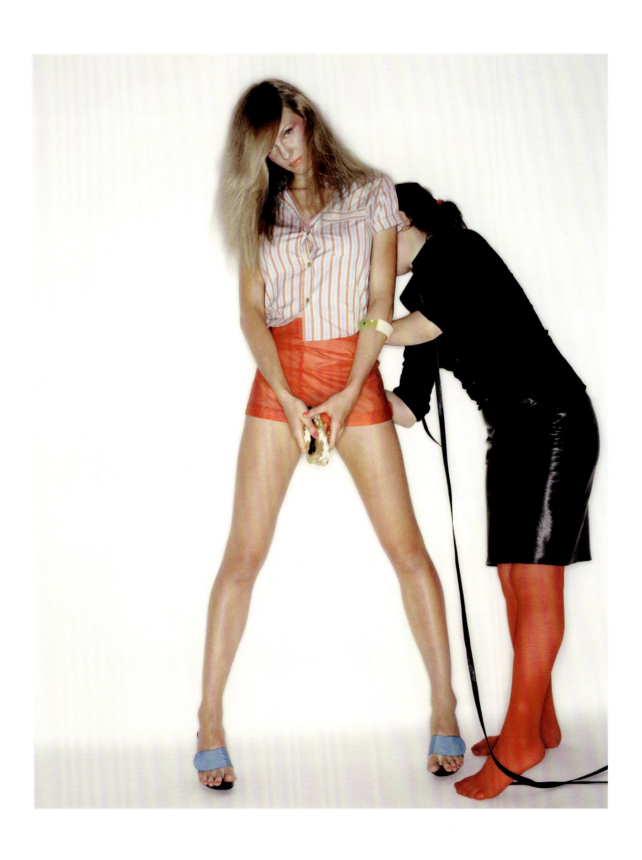

It's All a Veneer
Pack Your Trunks
Pop Fashion
Hungry?
Big Girl's Blouse
It's Not What You Wear, It's The Way That You Wear It
Sad Lad
Weep
Nancy Boy
Ghosts
Circle Line
Death Masks
Too Much Too Young
Livestock
Hip Chic
Blow Up
The Emperors' New Clothes
Mannequin Fashion
Dot
Melanie Williams
First Fashion
Jefferson
Me Me Me

1995–1988

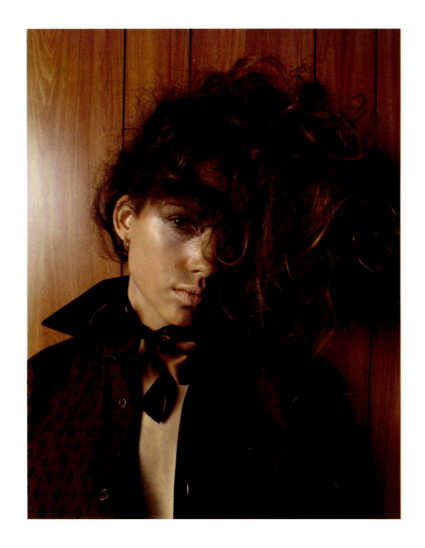
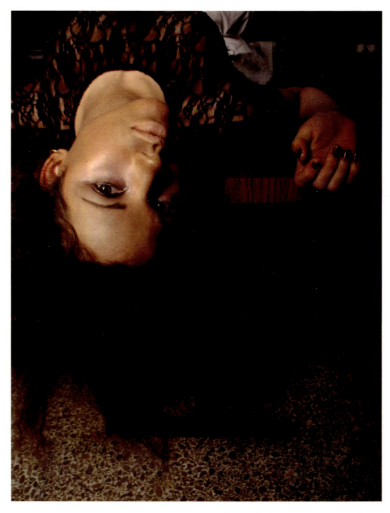
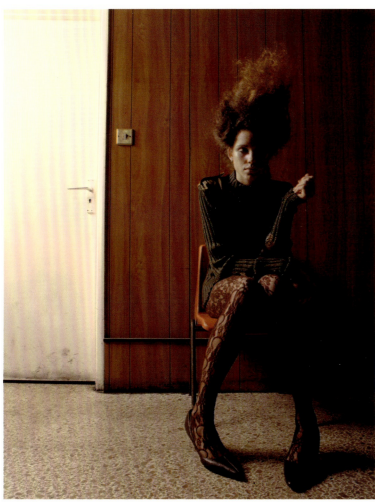
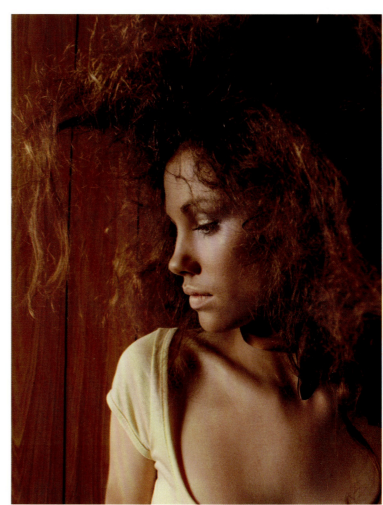

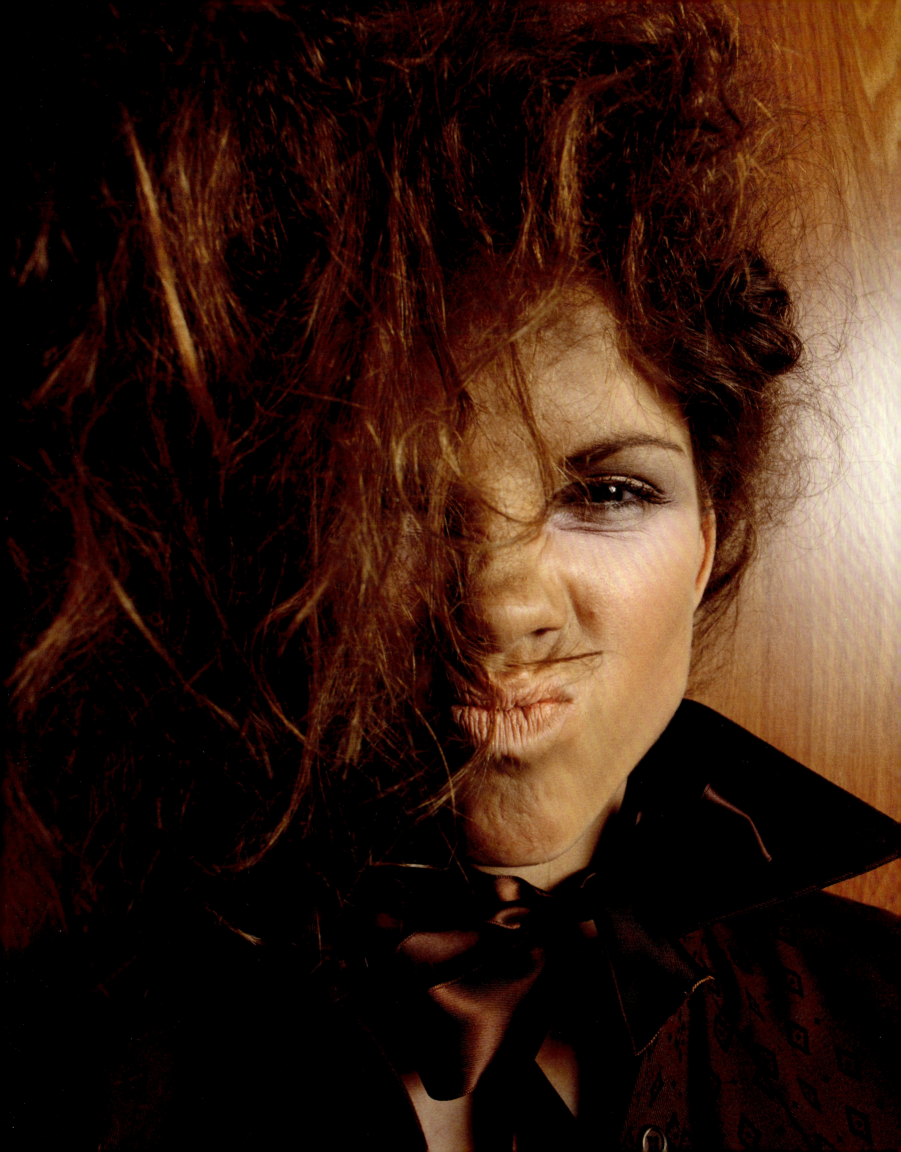

I had decided within the first five minutes of meeting him that I hated him.

KATE GROOMBRIDGE

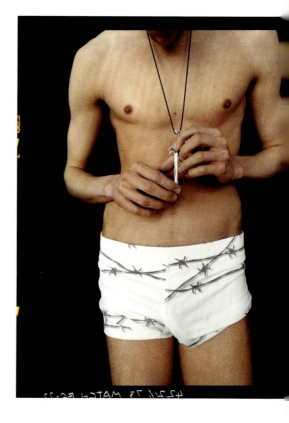

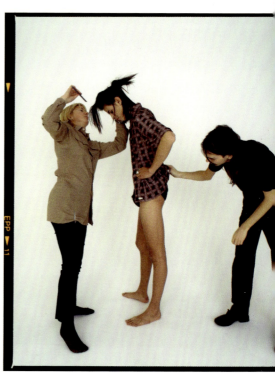

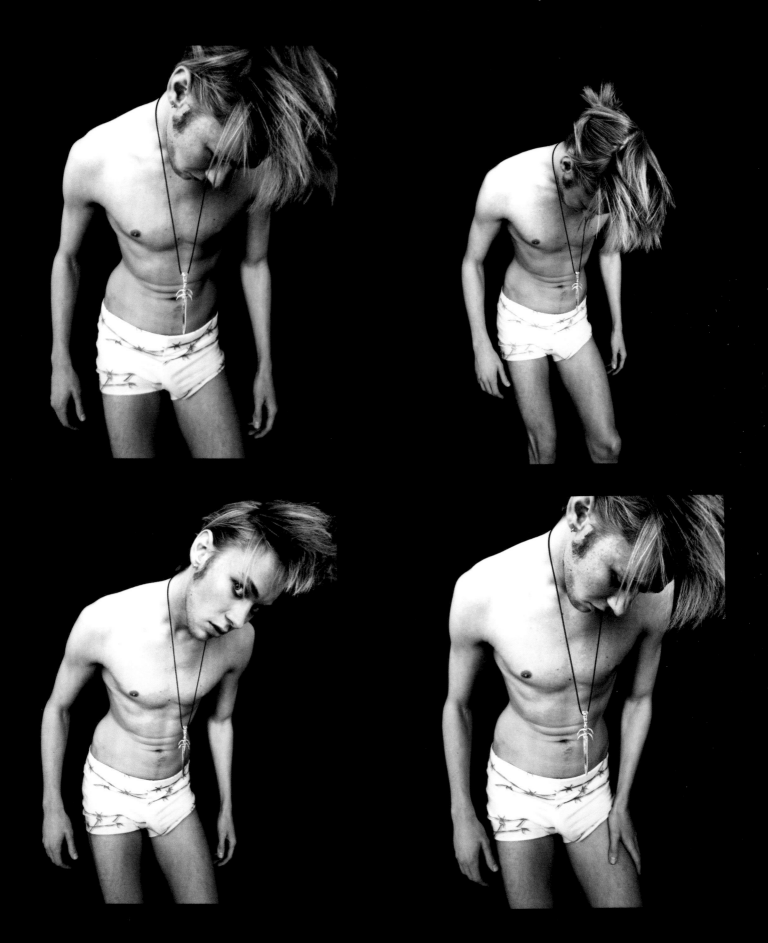

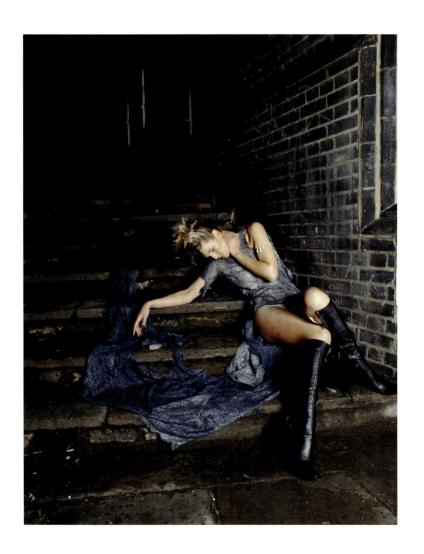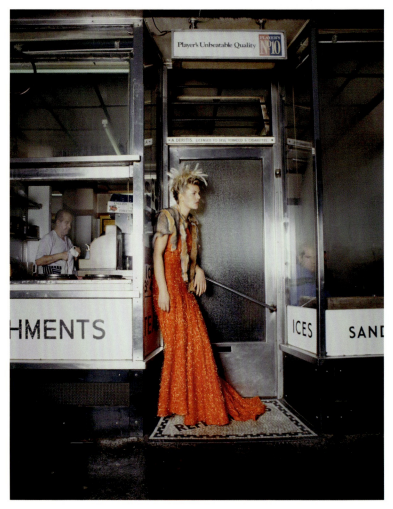

It was bloody freezing and we shot late into the evening, but I loved the styling and hair—I felt like this crazy chic nomad outside a greasy spoon in the East End of London. Looking back on it, it makes me miss this time we had back then—full of creativity and brilliance.

Being on set with him was always easy—it never really felt like work—he has a way of making it relaxed and always funny. I always remember being allowed to be free in front of Rankin as the subject—he does give direction when needed, but he allows the subject to evolve into character without intimidation. Therefore a sense of trust is built, and then the magic starts to happen.

I feel that Rankin was always a part of my life. I remember him as being a part of this great big gang we had. I also lived above the studios for *Dazed & Confused* on Clarkenwell Road, so we were always seeing each other. And I really remember Rankin's arses exhibition he did, with giant images of buttholes in the window, which always put a smile on my face.

PAULA THOMAS

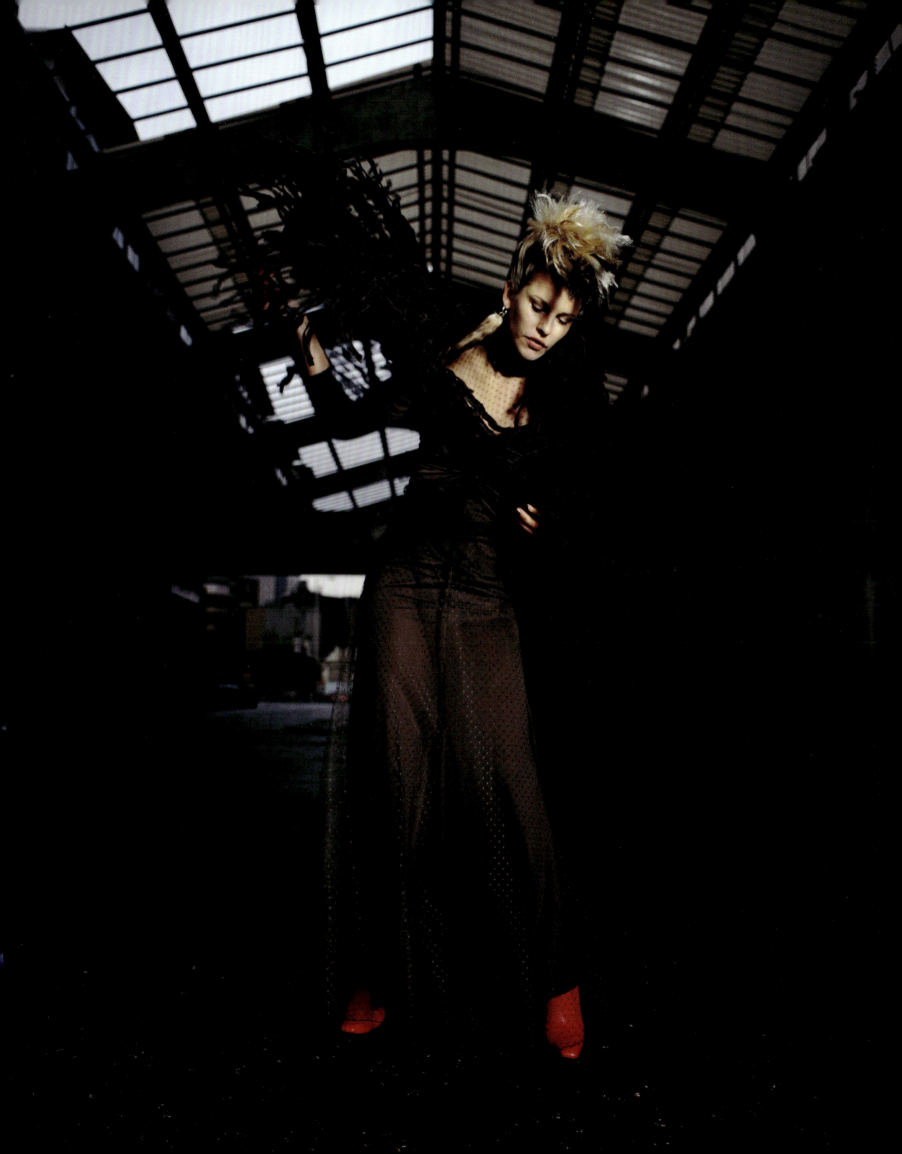

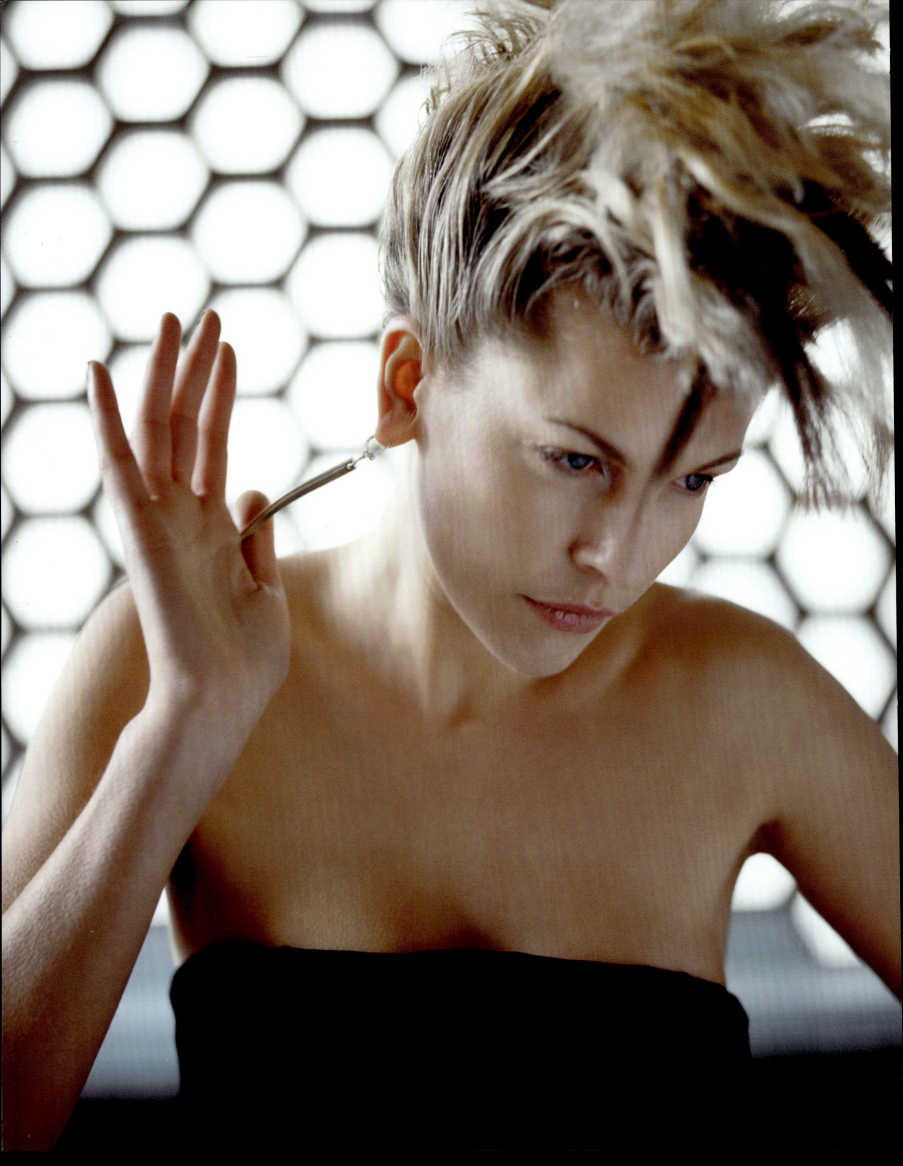

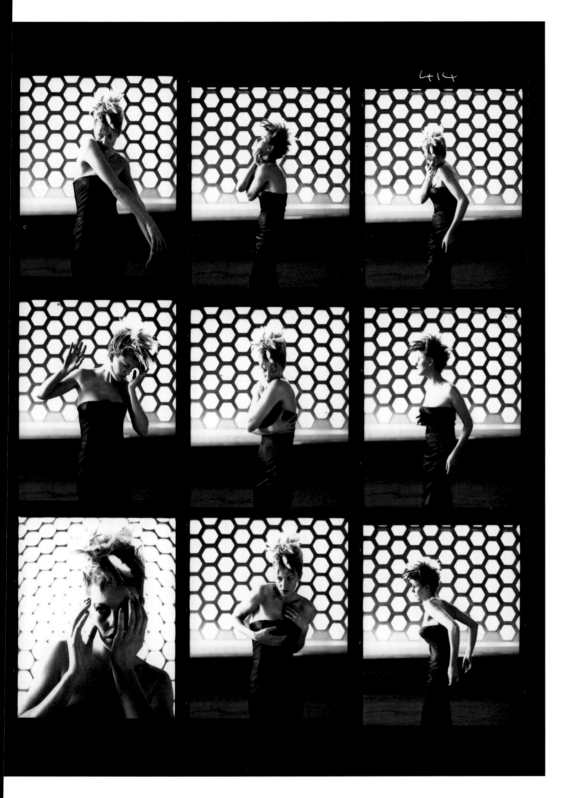

I had no preconceptions of what Rankin was like, as I had never heard of him. I was a very green teenager from Manchester and wasn't into the whole fashion scene. I liked chips and gravy and pints of beer with my mates. I hadn't been modeling very long at all, I was only a baby, and to be honest I didn't understand how things worked—and certainly didn't know how iconic Rankin, Katie Grand, and *Dazed & Confused* were.

I had never seen a ring flash until I started working with Rankin. I had polos in my eyes for days afterward! And I never really saw many people using them for years afterward—it's only recently people have become wise to how good they are and use them to get the perfect selfie. But they can never recreate what Rankin did with a ring flash.

With Rankin it definitely felt different from other shoots. I remember I couldn't believe it when Rankin and the team asked what I thought, as then, much more than nowadays, the model's opinion really never counted, and it was nice to feel part of the team, part of creating art.

ALEX LEIGH

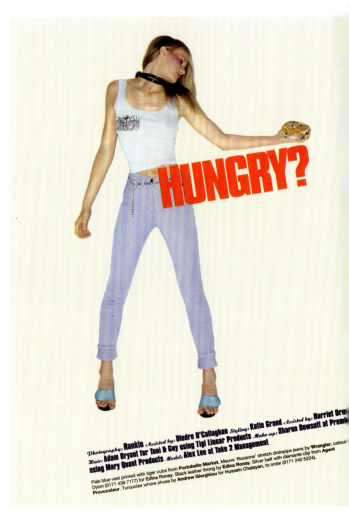

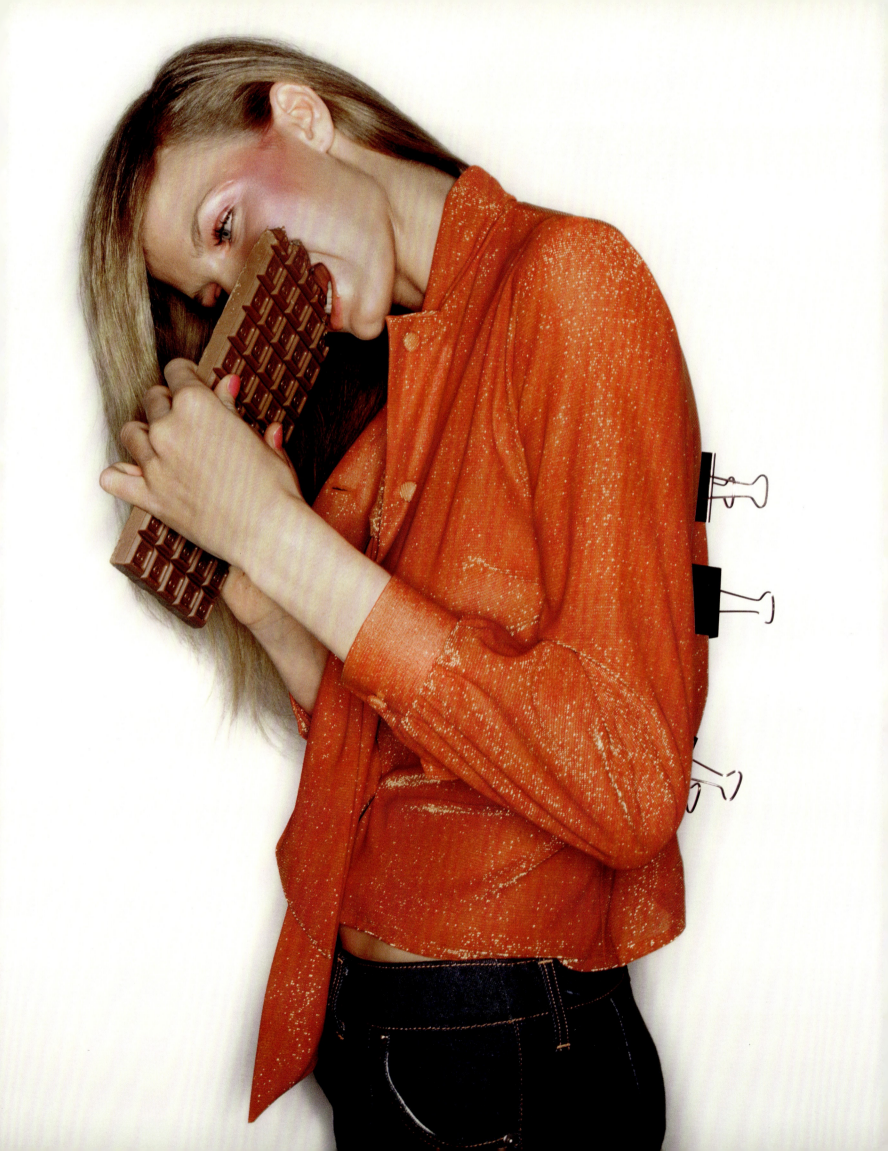

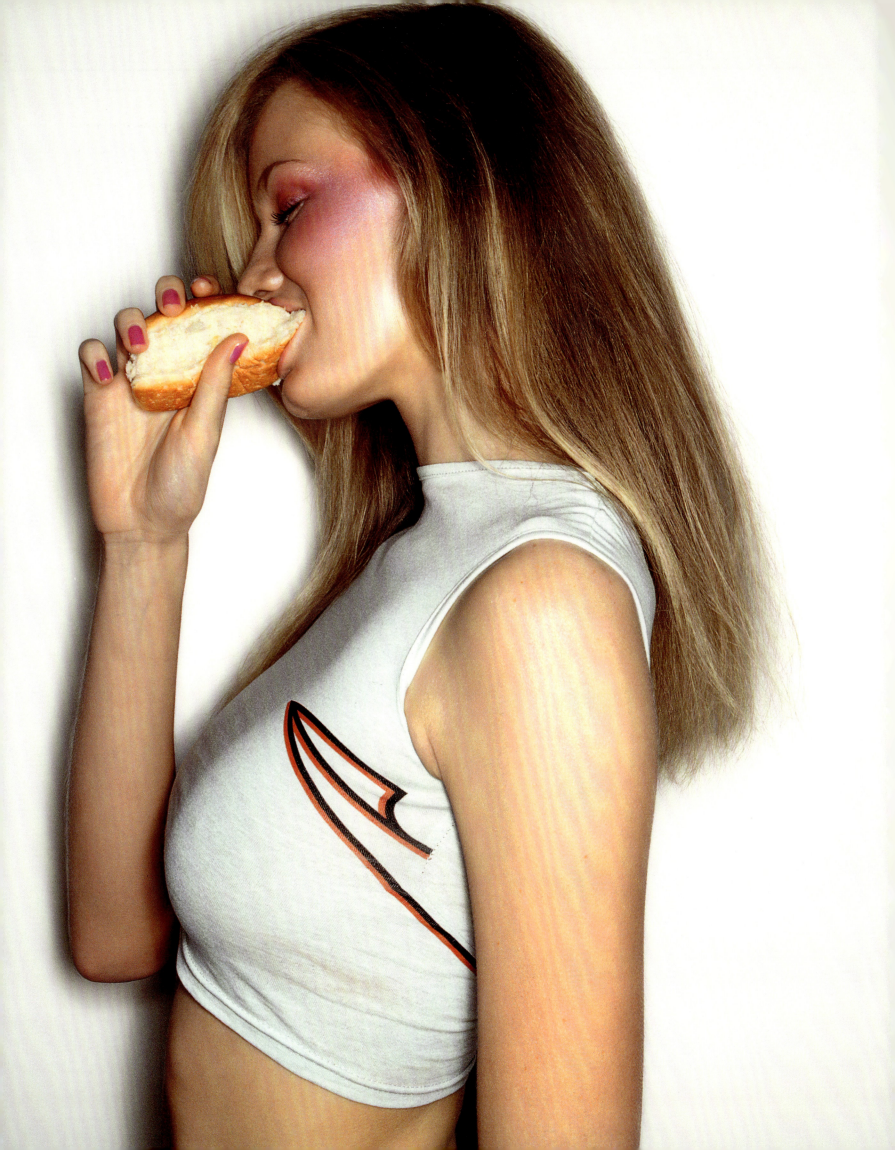

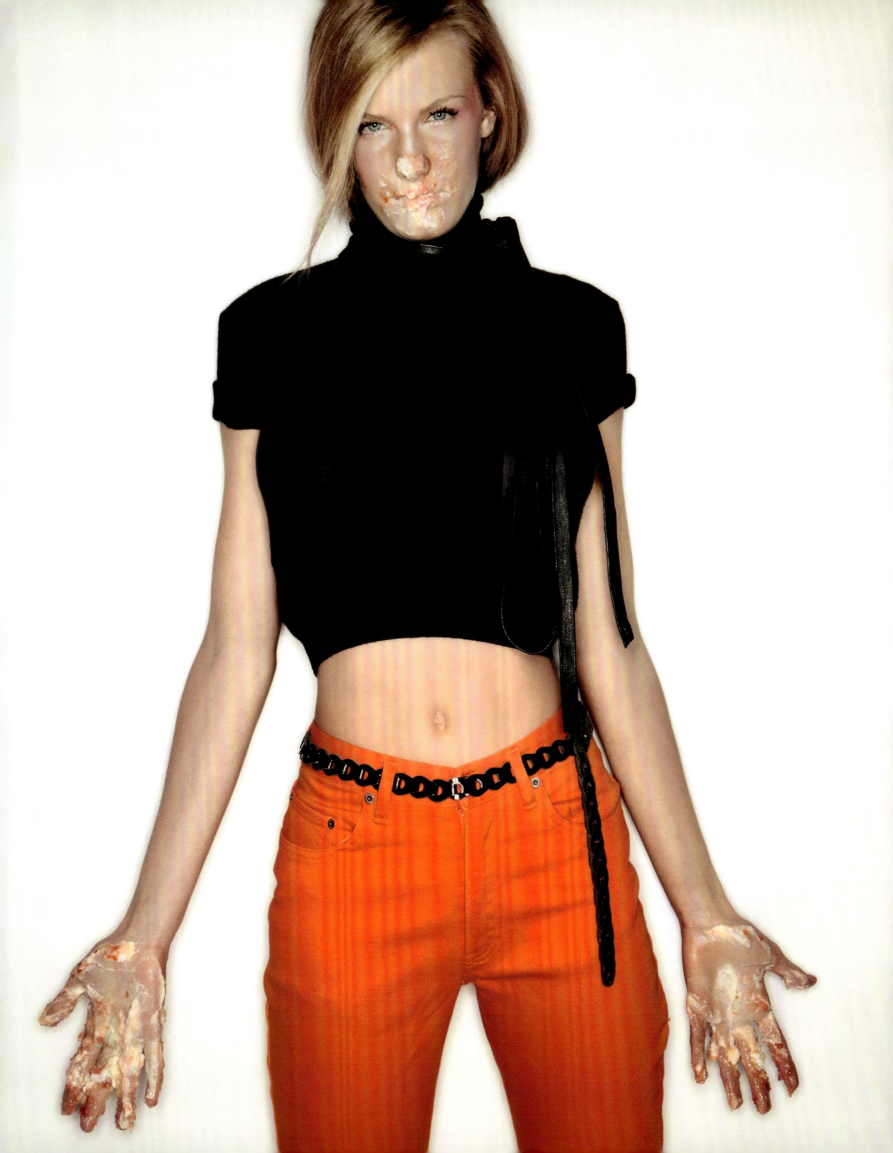

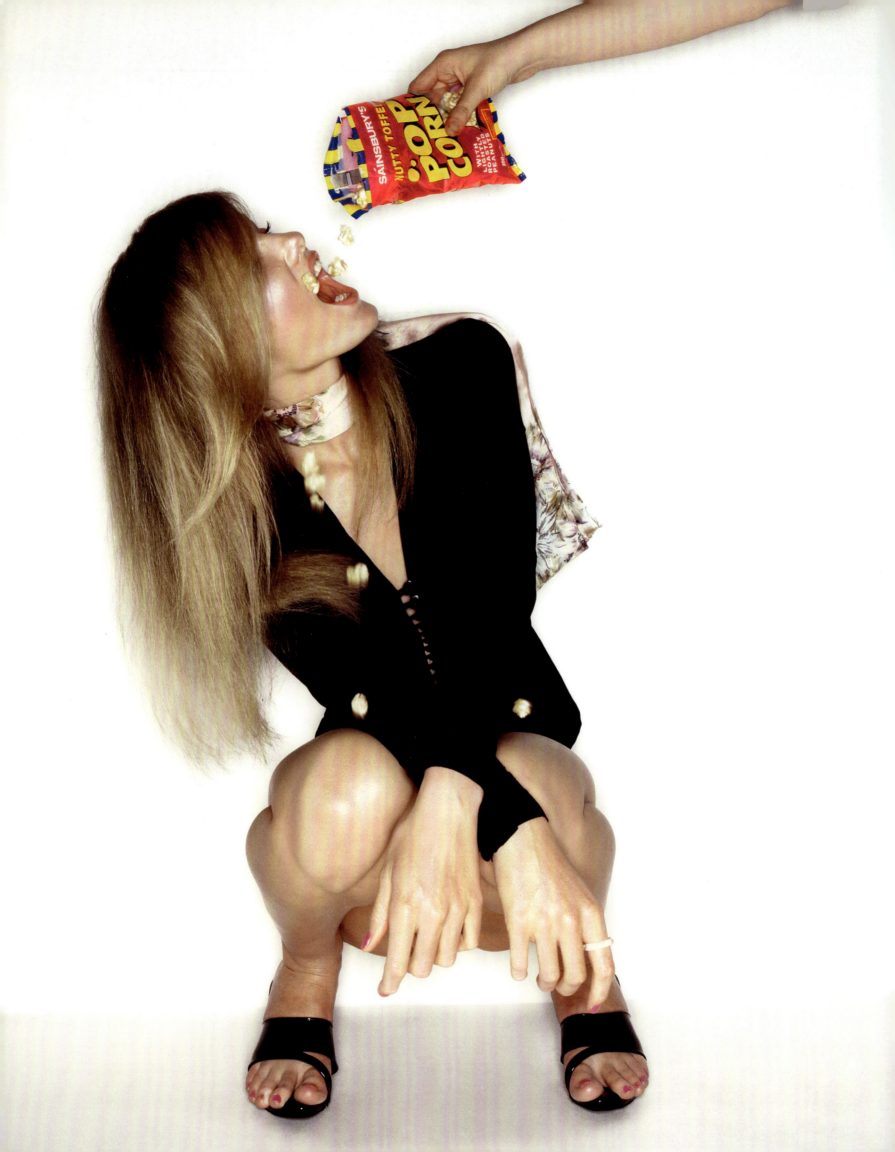

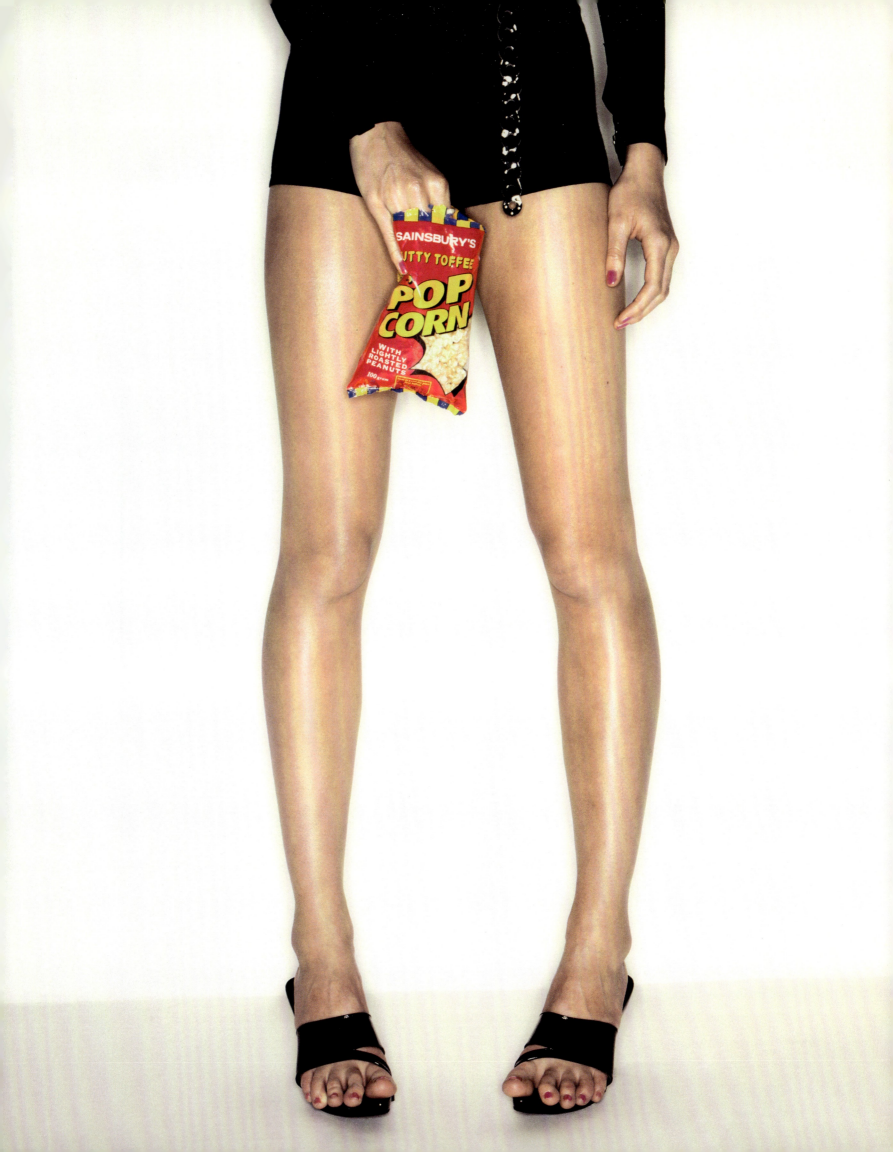

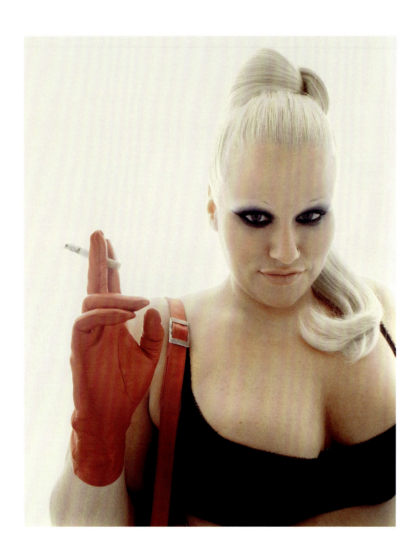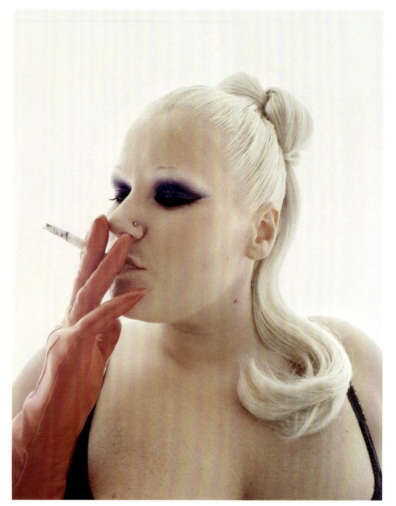

Big Girl's Blouse | 1995

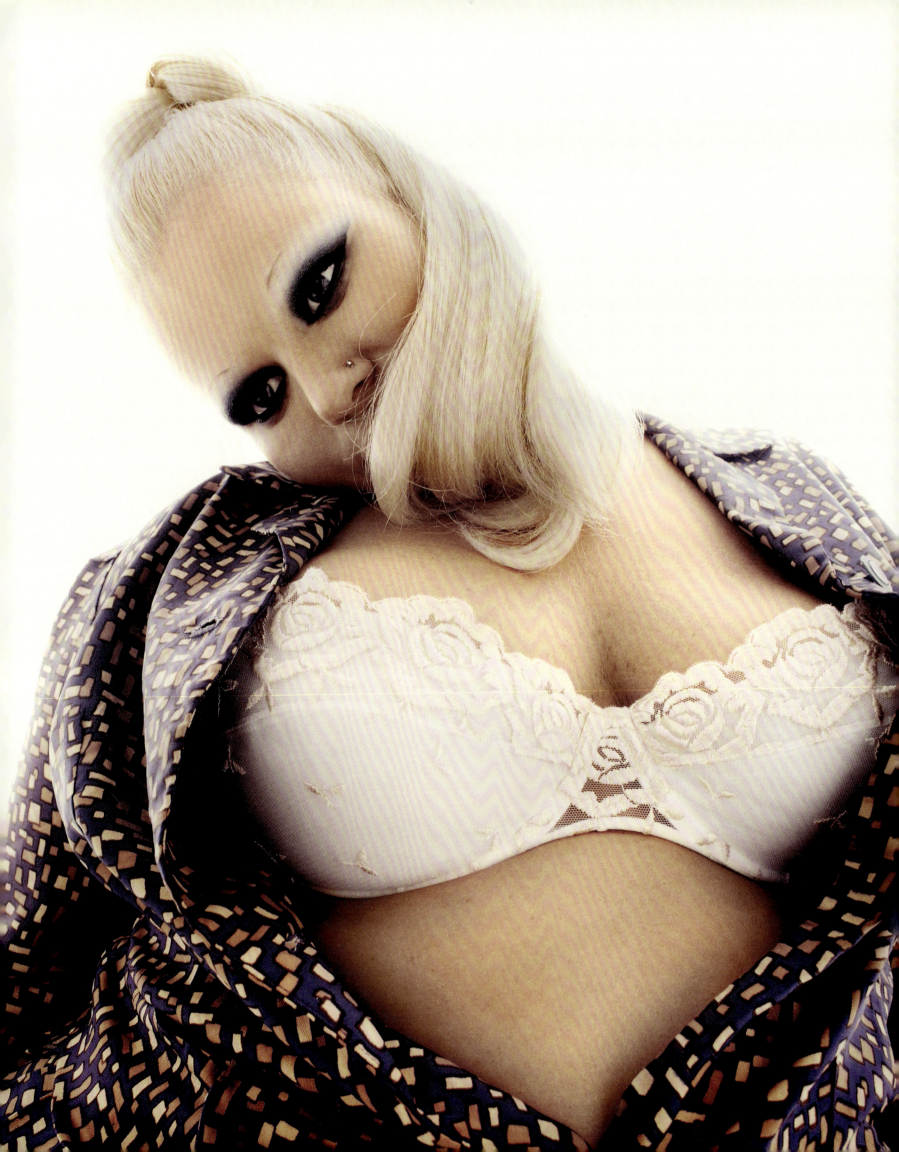

We were shooting at a studio in Old Street somewhere. I had recently arrived from New York, so was still finding my London legs. I wasn't sure if I was in the right place, but when I walked into Rankin's studio it felt electric. I have to say that in my career, it was the most fun I'd ever had in front of the camera.

The shoot was originally supposed to be a different theme, but for whatever reason it just wasn't happening, and then Rankin had this vision and 'It's Not What You Wear, It's The Way That You Wear It' was born. His enthusiasm was contagious.

KRISSY HAWKES

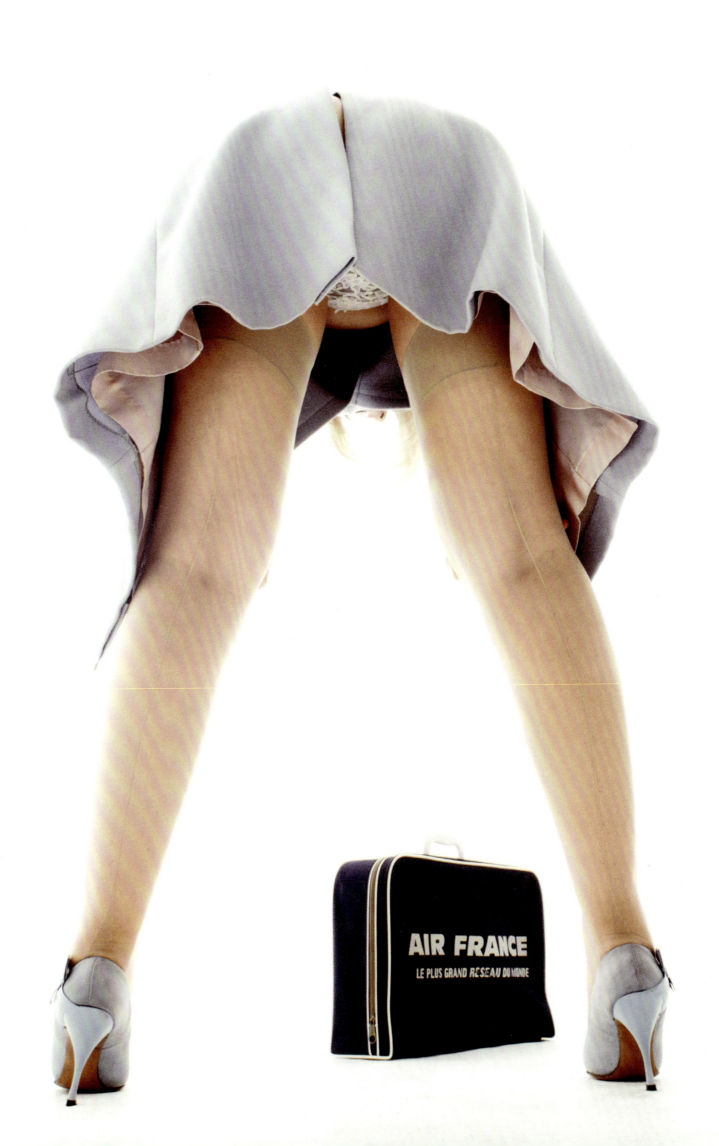

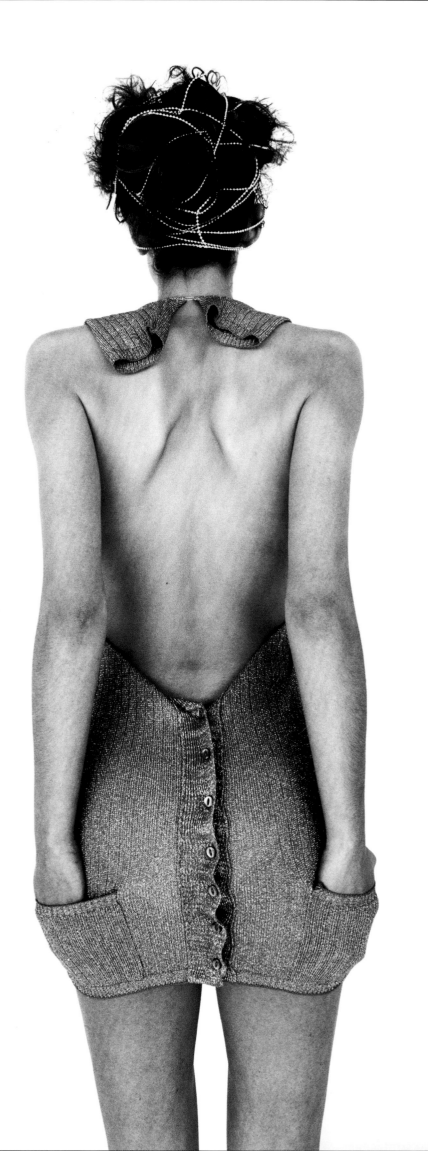
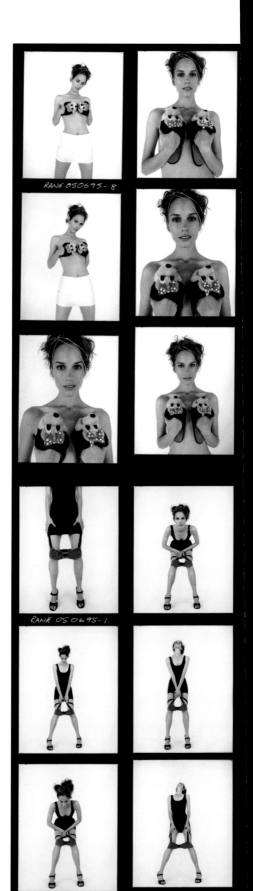

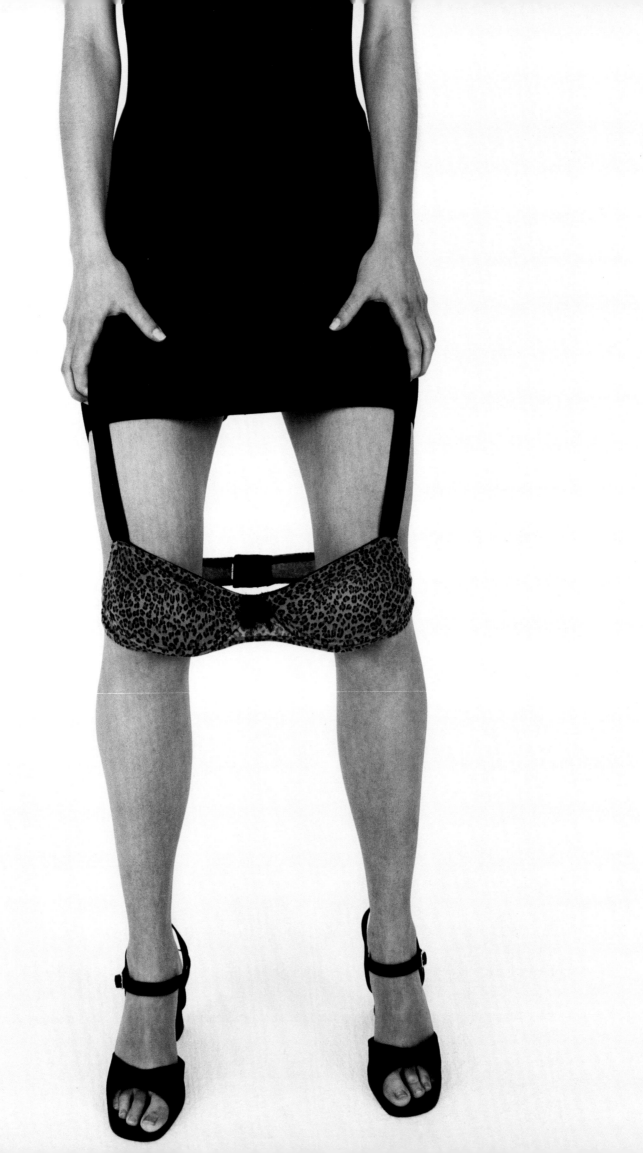

We shot it on a Saturday in and around Shoreditch for *Dazed*. I dread to think why I was cast, as the story is called 'Sad Lad'....

I wasn't really in to modeling, it felt a bit daft—I think at the time I was just getting swept along with the whole thing. It's only now looking back that I can see how definitive of that time everything was.

DAVID NEWBY

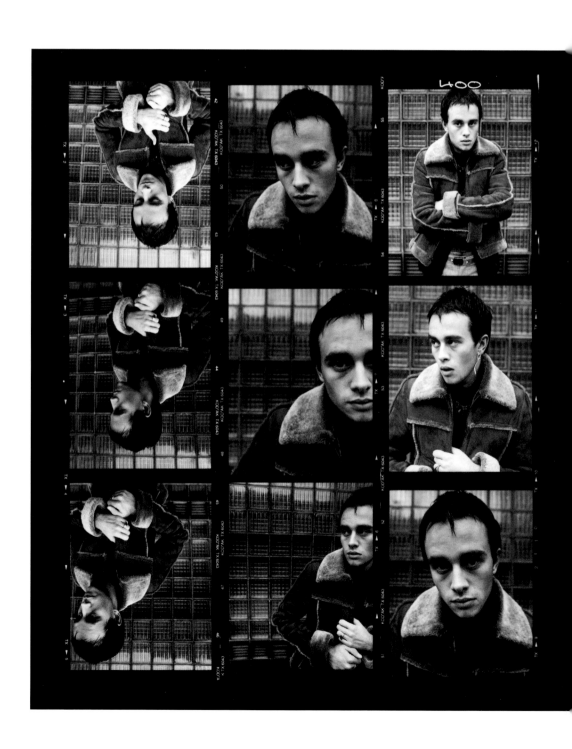

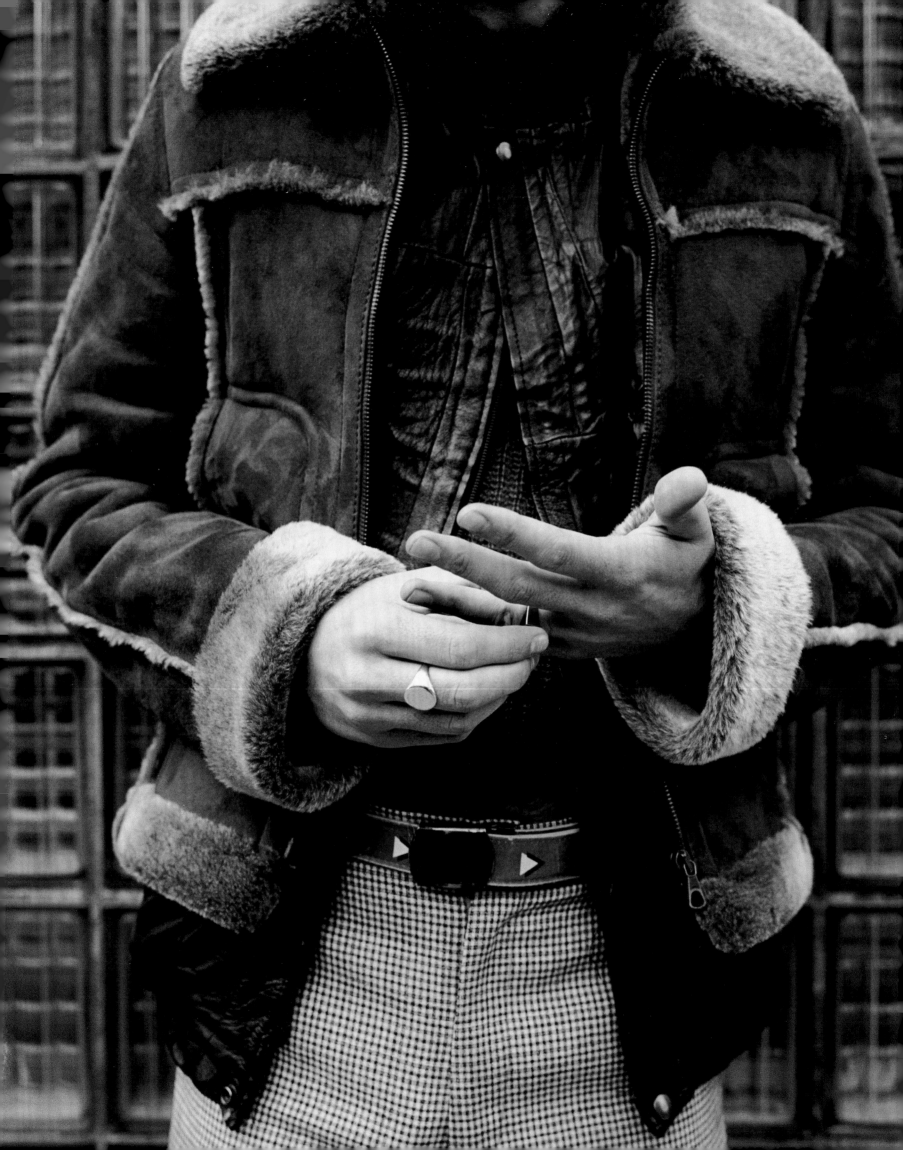

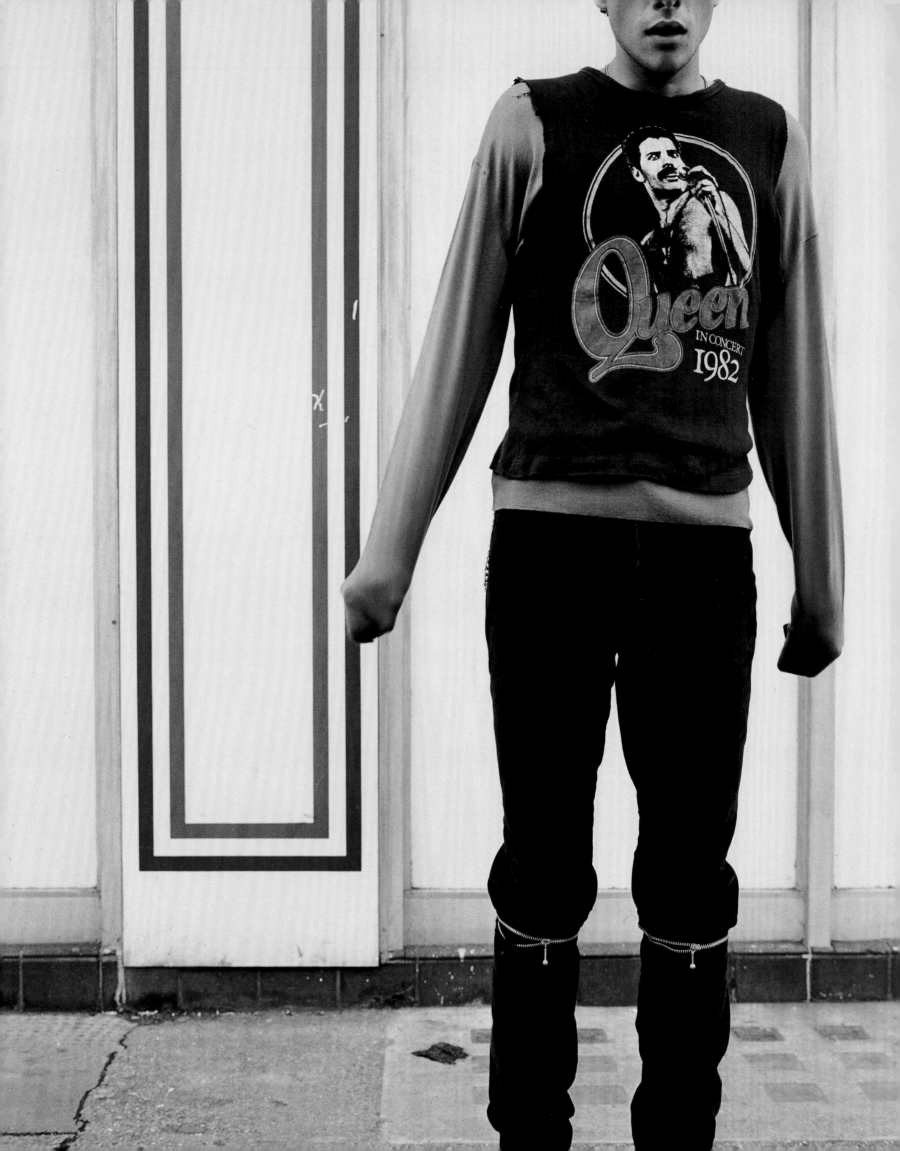

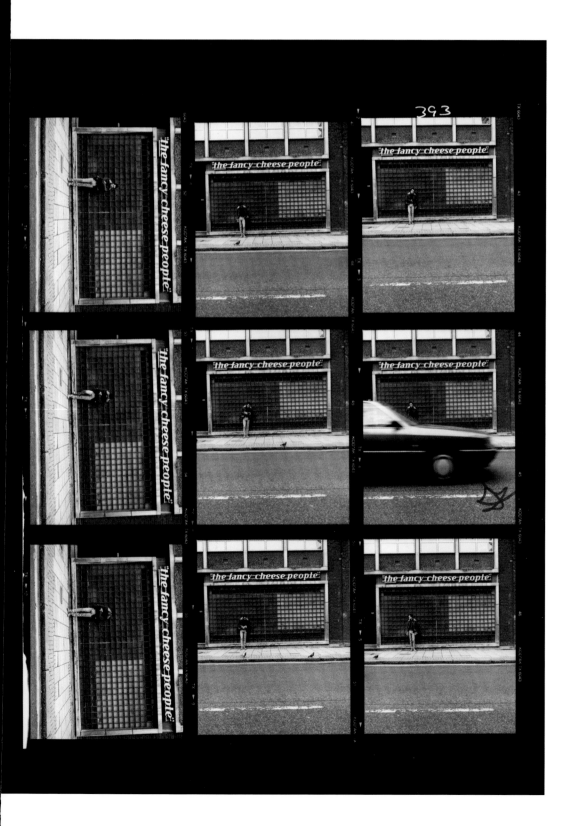

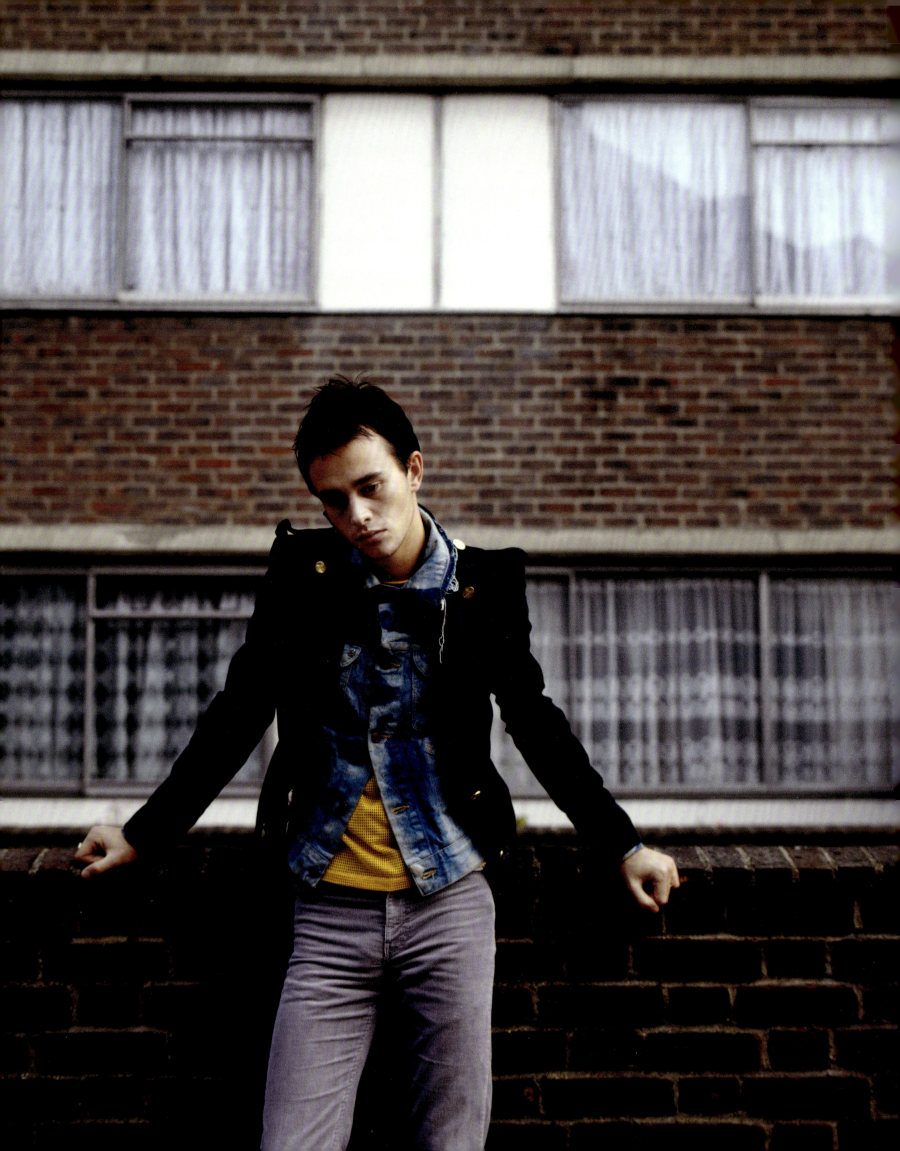

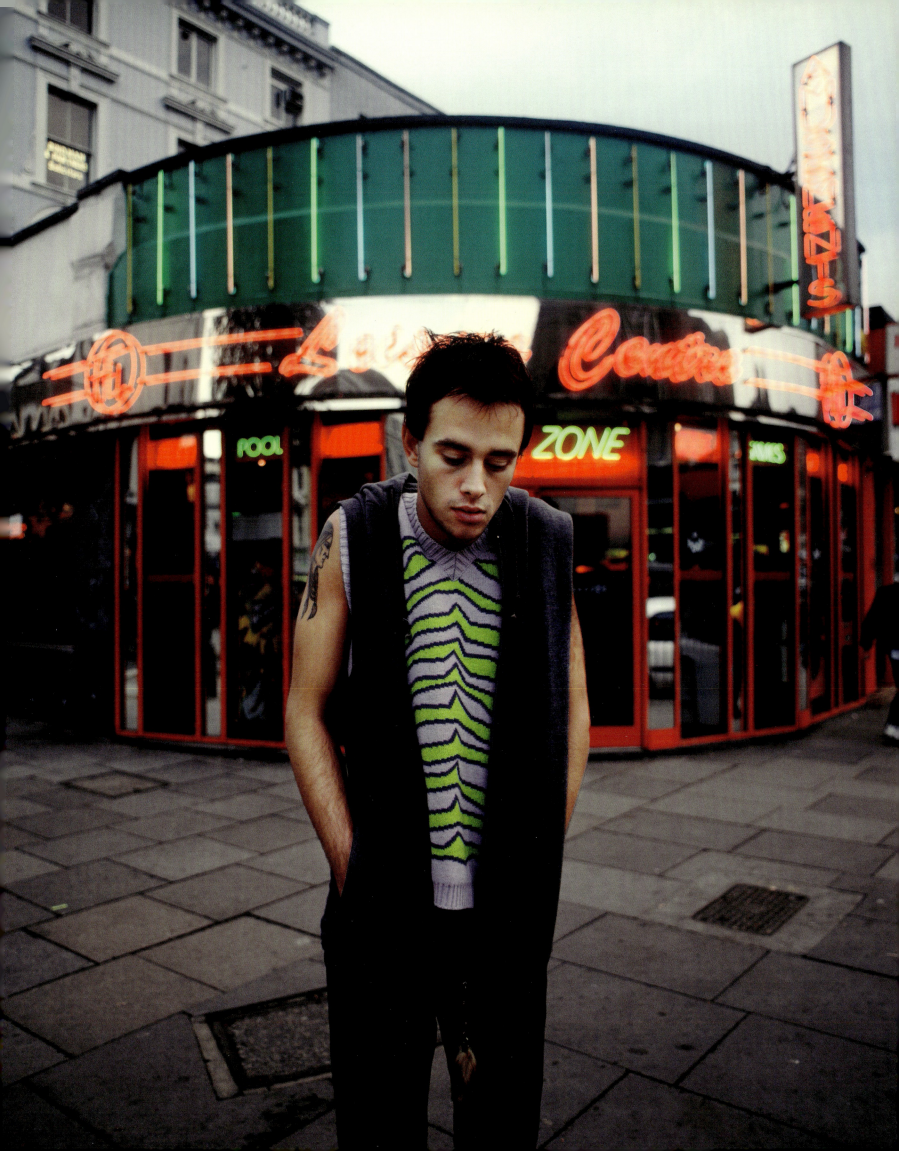

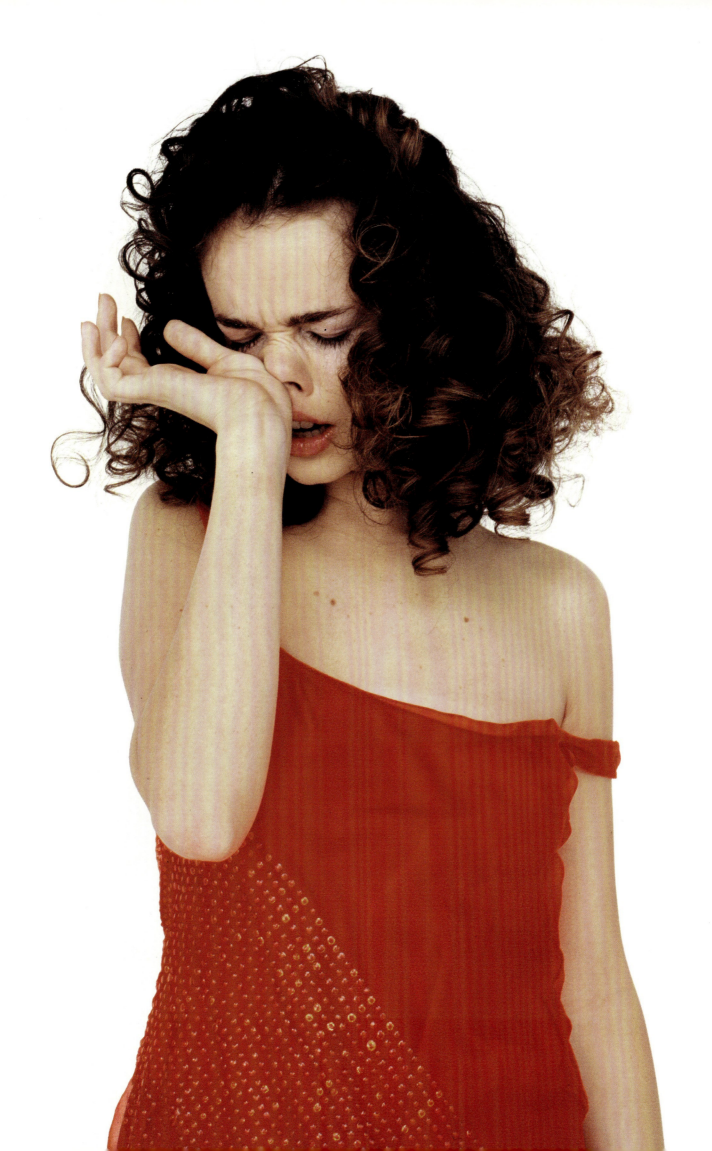

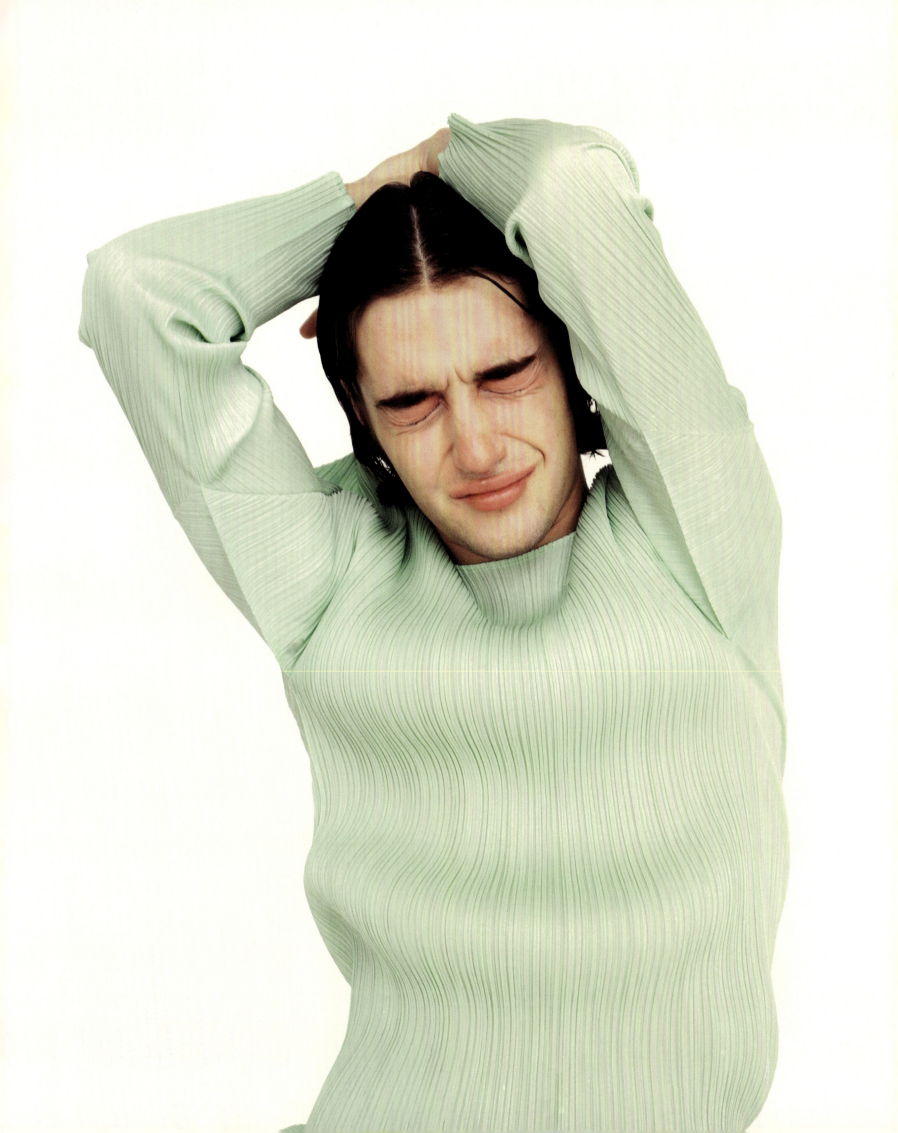

'Weep' was shot in the old *Dazed* studio in the offices of the magazine in Old Street. I thought I was just going to meet Rankin and Katie Grand for a general 'go see' and to see if we connected at all. I'd just done a Madonna video in LA, and some of my first campaigns as a model, so it was fitting that I go kiss the ring. I showed up and the shoot was in progress and he asked me to stay to do it. One of those great serendipitous moments in life.

All I knew when I was asked to go visit Rankin was whether I was OK crying for a shoot, and I was into it—I remember thinking on the tube on the way over, how on earth was I going to cry. There was something I came up with and wanted to personally dig into and explore for myself if it worked out, and then he gave me the space to do that. It was an exciting shoot to do when all the other shoots I was doing at that time were so controlled and were a picture of beauty and perfection—there was something special about being able to explore the beauty of imperfection and pain—or, you may say, reality.

The pictures are the complete opposite of how the shoot went. The pictures are raw and exposed, yet the shoot was intimate and kind. It was all about the moment and capturing that feeling right then. I don't think anyone would have thought we'd be talking about these images a quarter of a century later.

JAMES GOODING

Working on a Rankin set is fun, breaking the rules, pushing the boundaries, so very different from your usual highly pretentious fashion set.

KATIE COMER

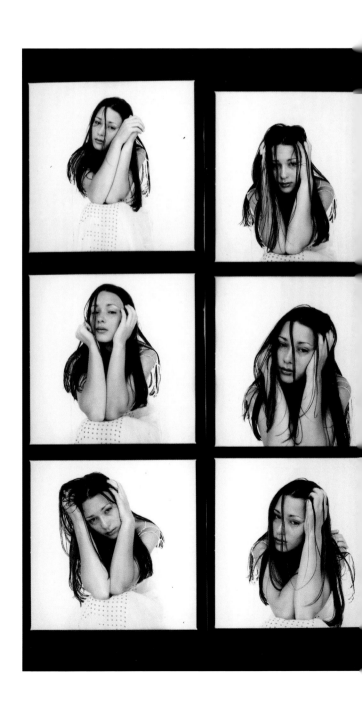

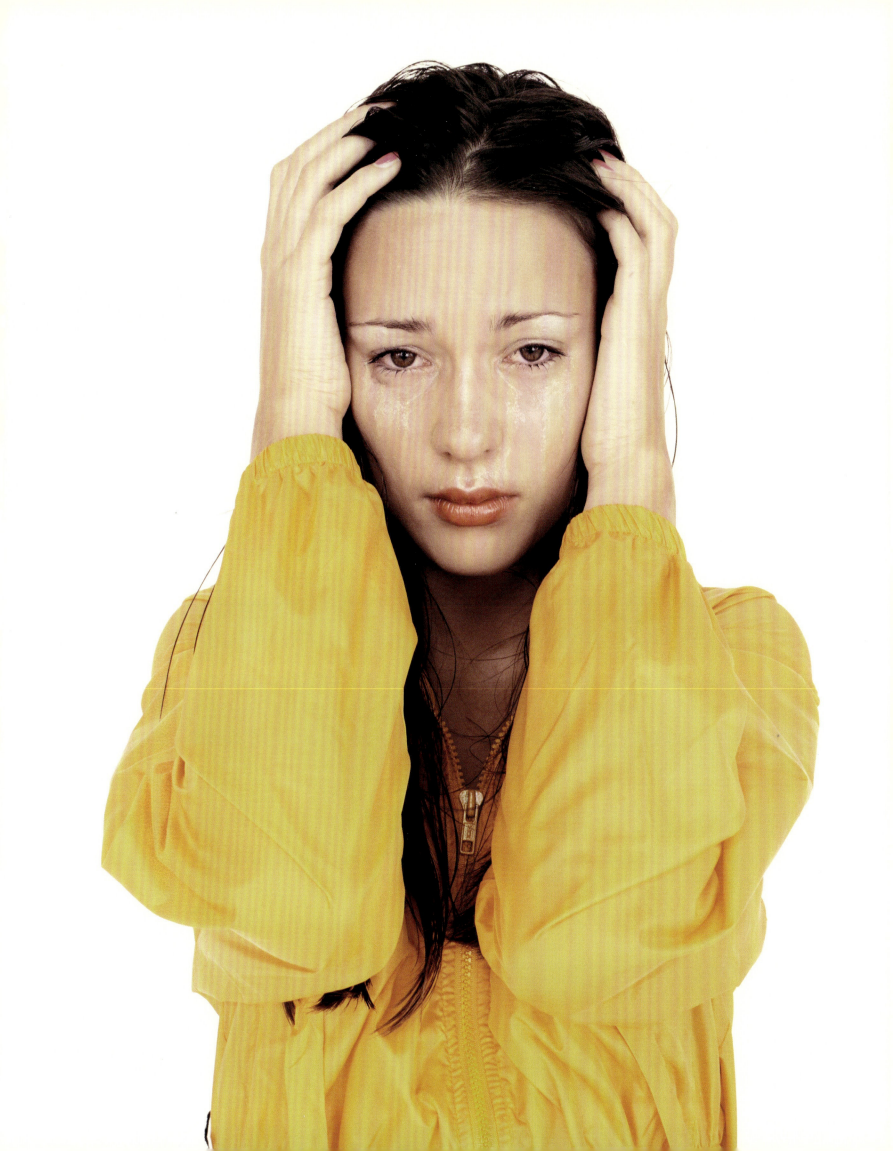

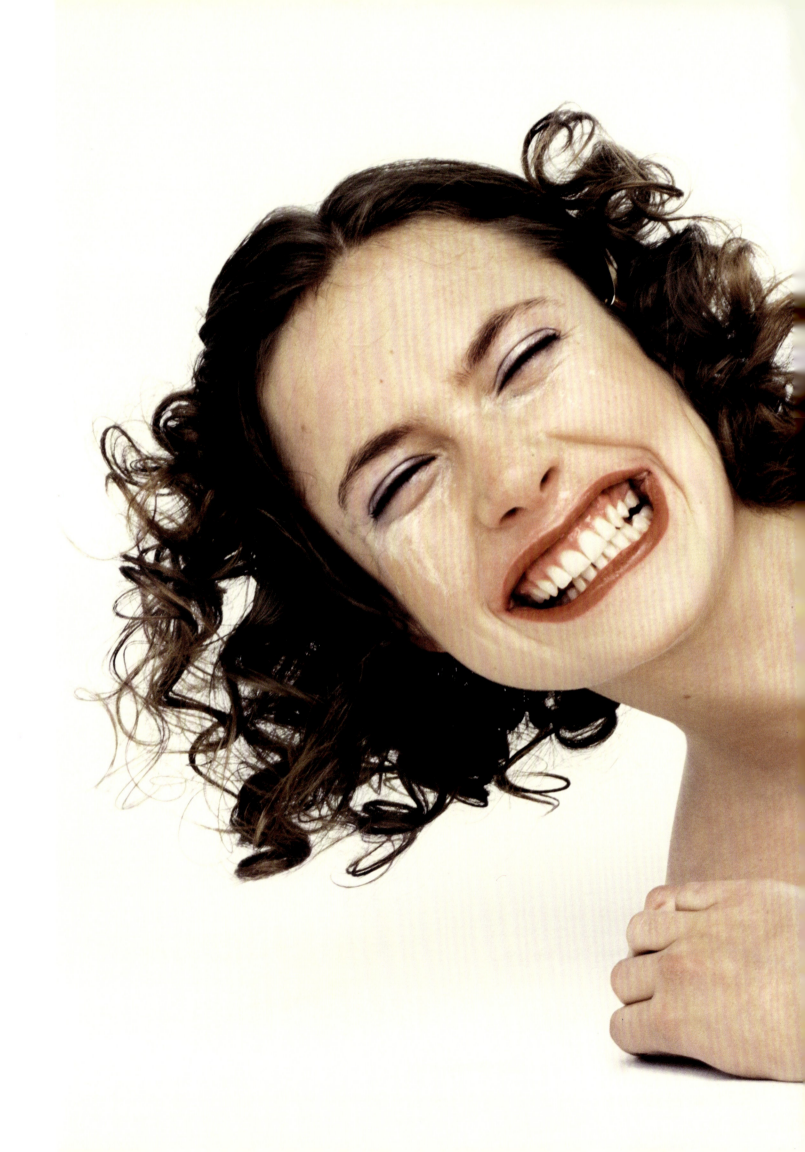

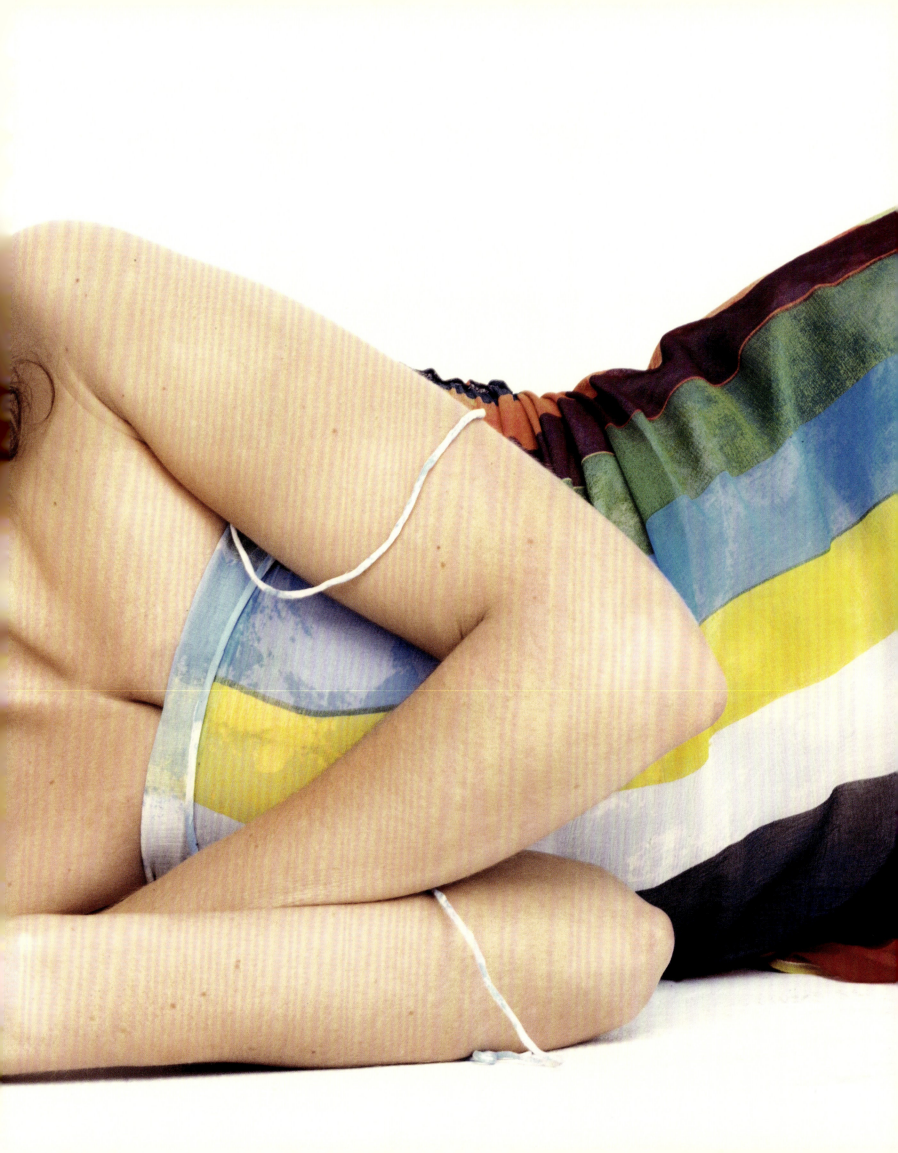

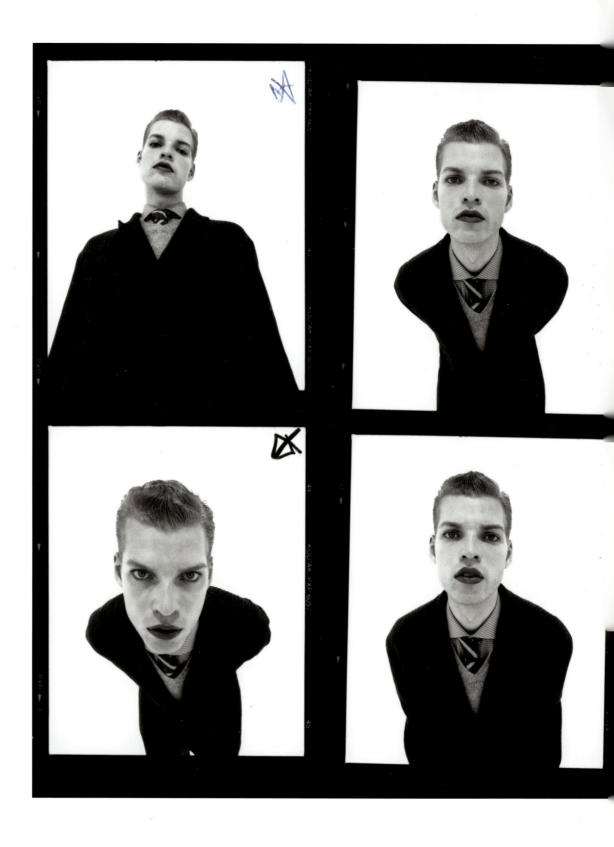

Nancy Boy | 1994

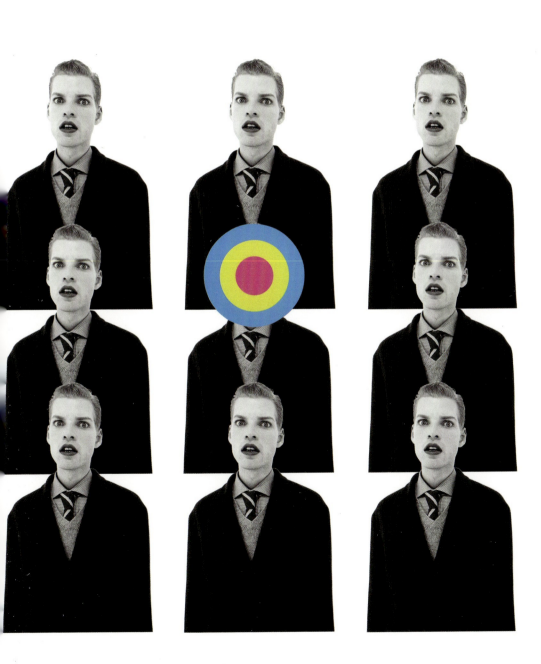

I was young and fresh off the plane from the States, and I remember thinking, why am I wearing trainers with a bikini?

The only thing I had heard about Rankin was from my agent. She said he had a fantastic new magazine called *Dazed & Confused*, and she was delighted that I had the chance to work with him. She saw something special in Rankin's photos and knew it was important for my career.

JACKIE VOLKNER

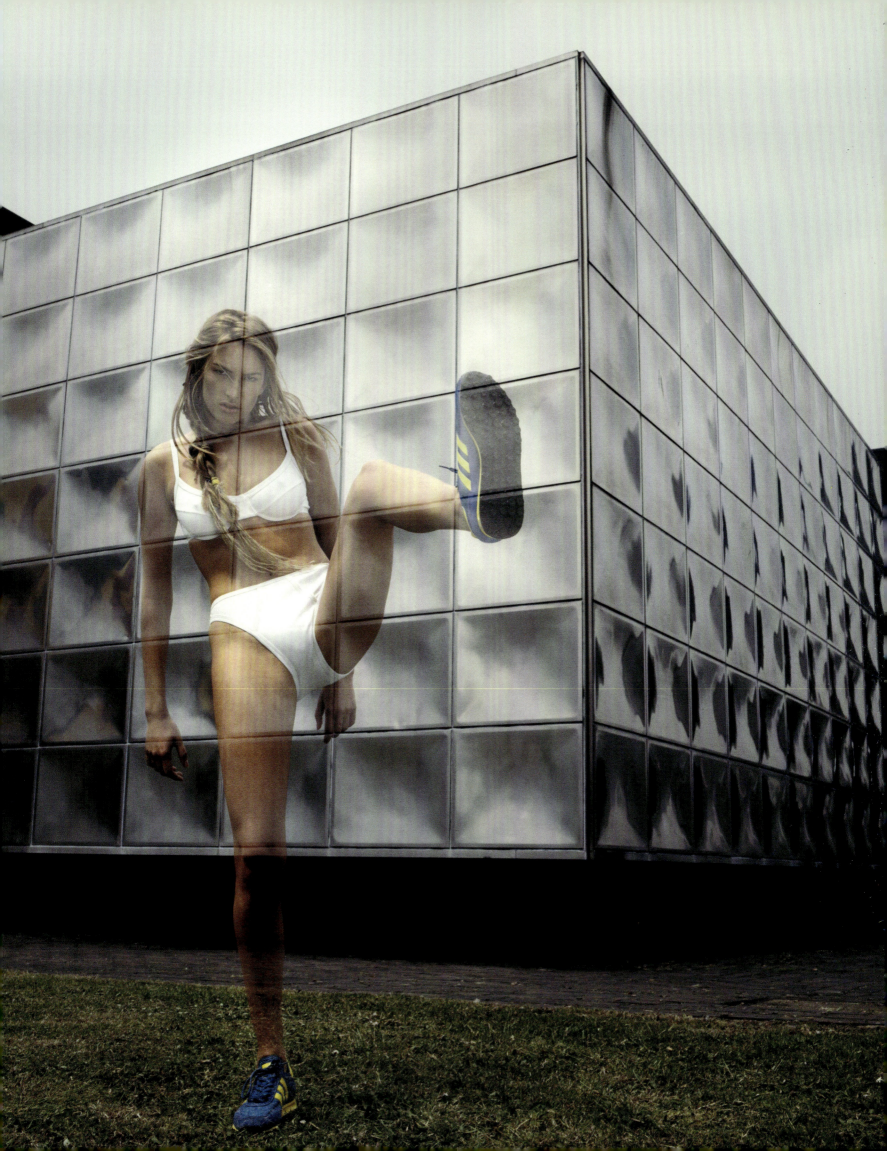

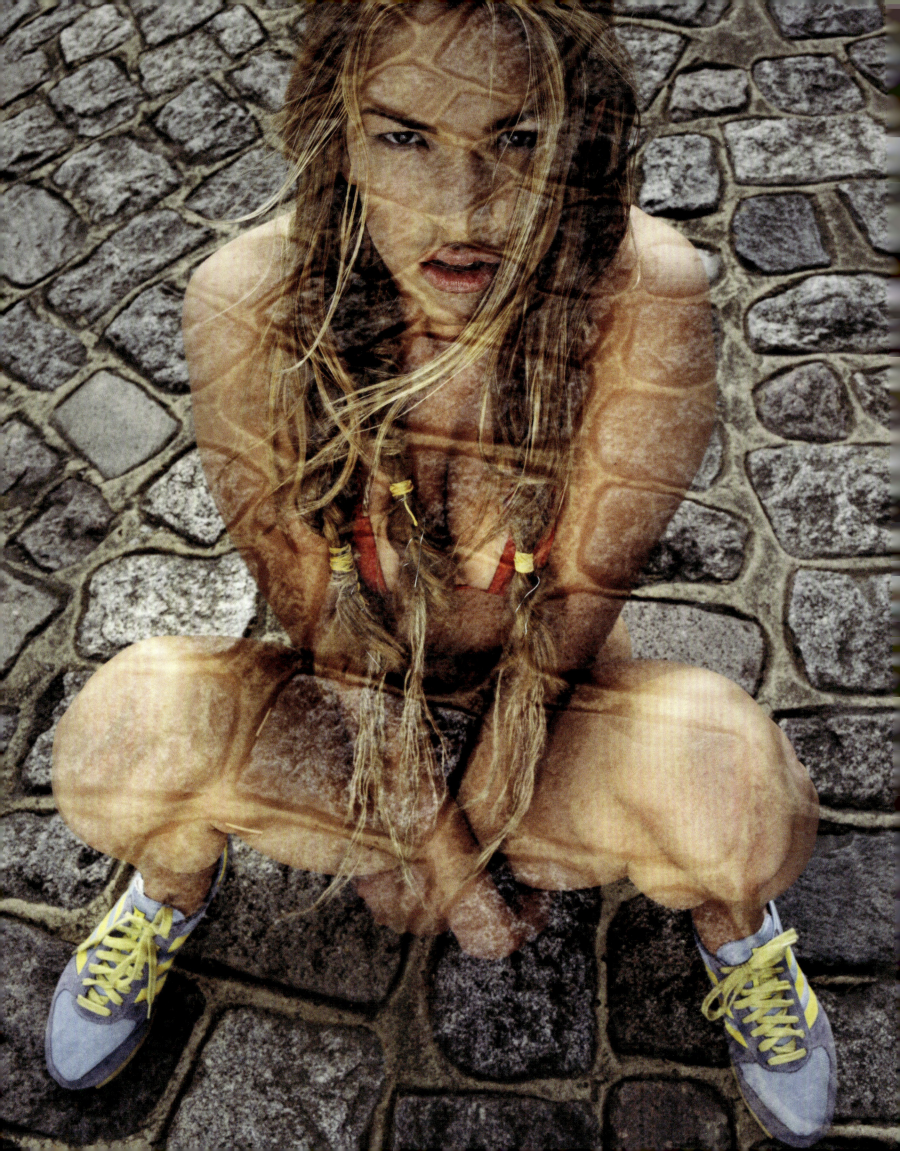

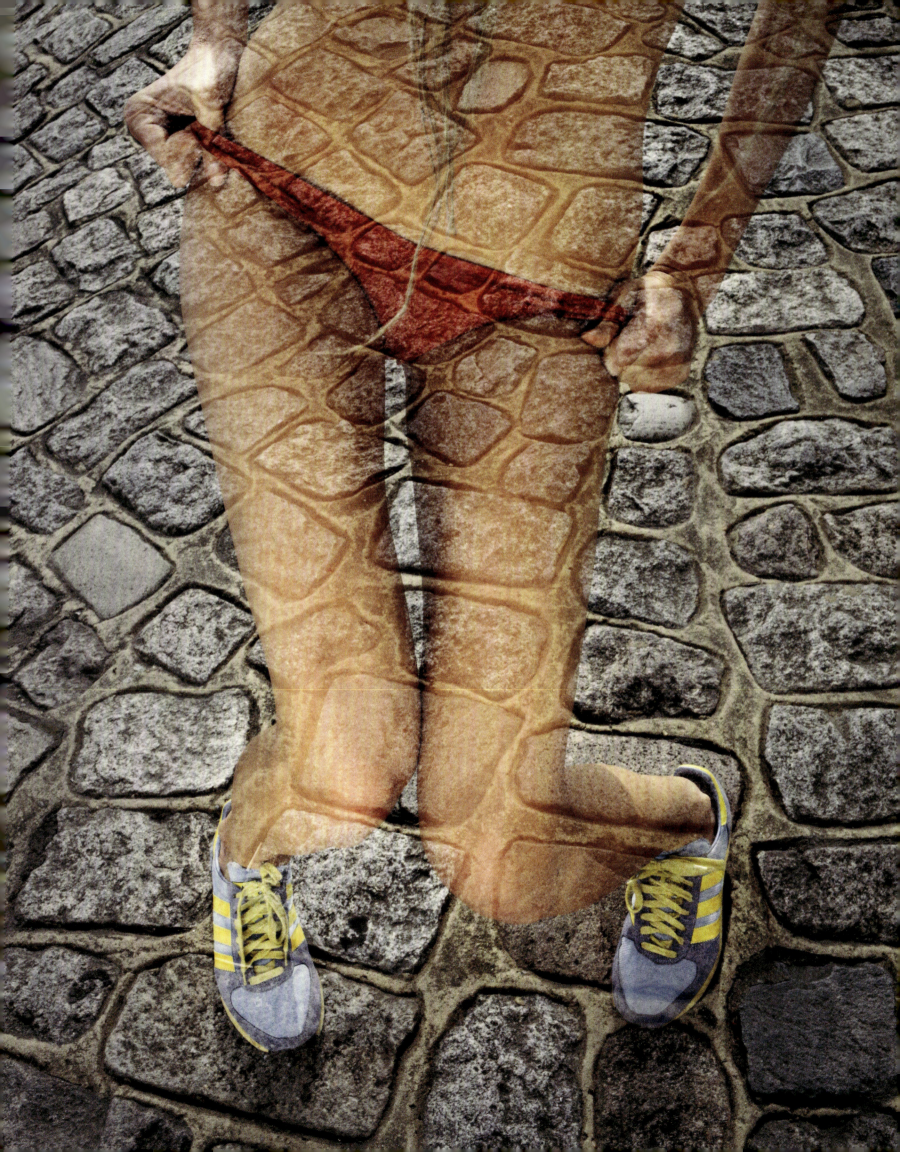

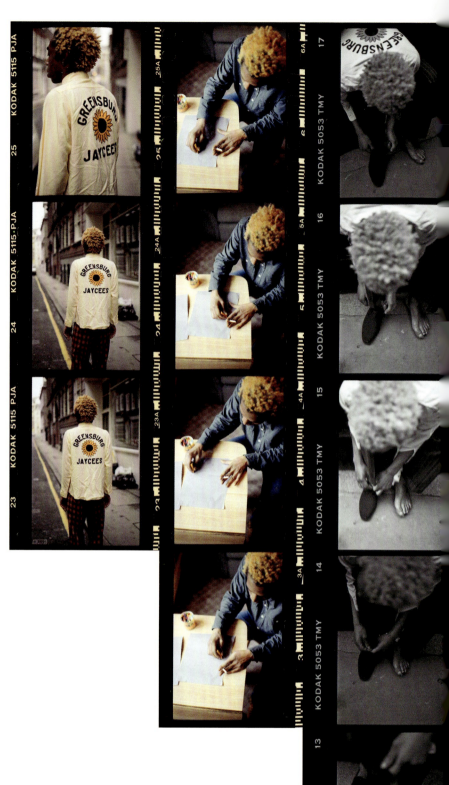

Circle Line | 1994

Next
Death Masks | 1994

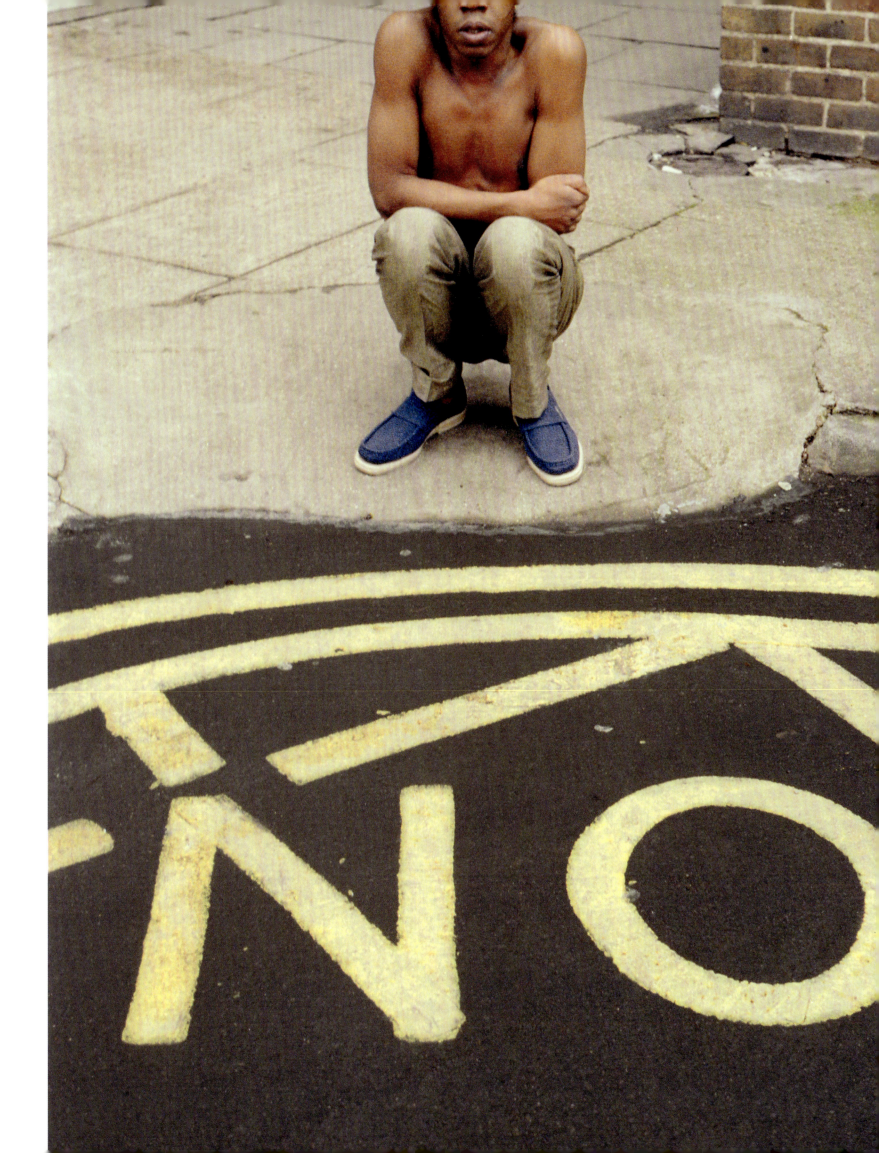

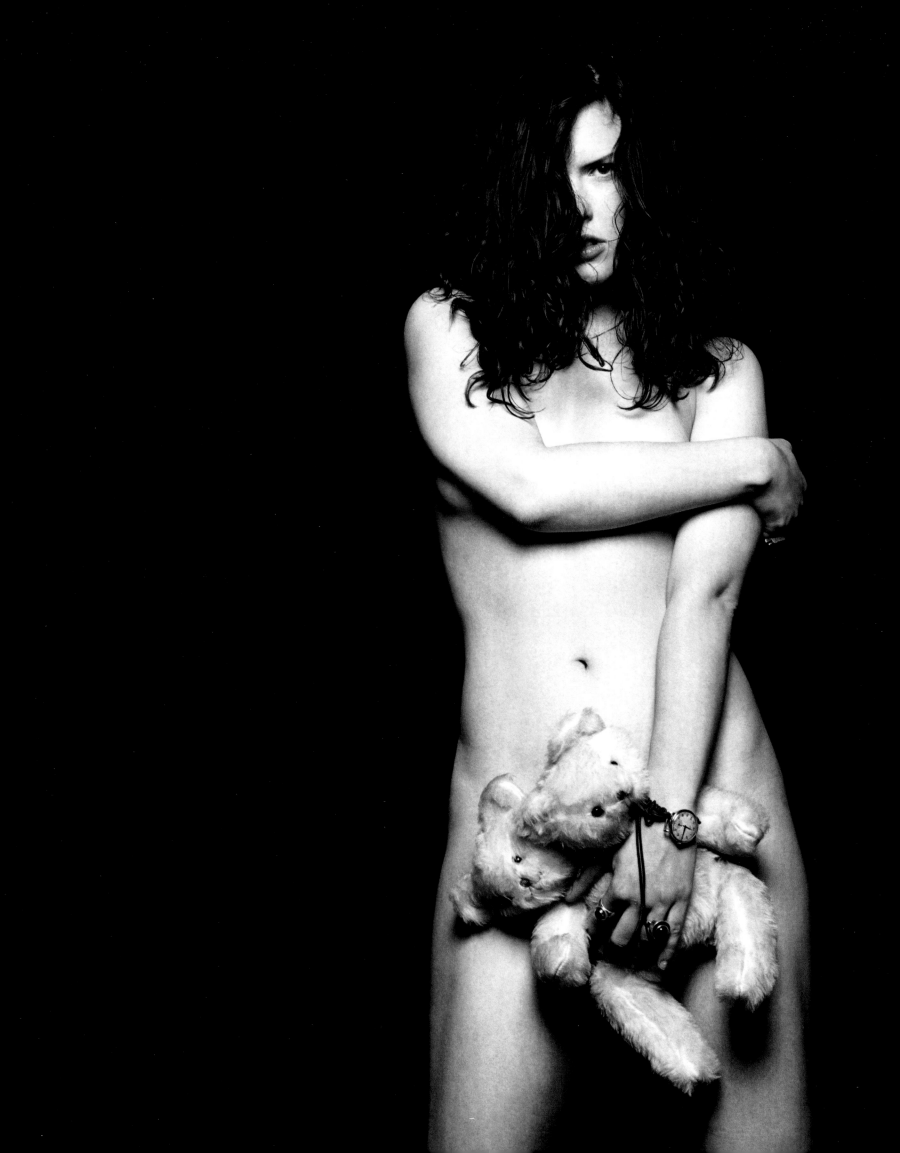

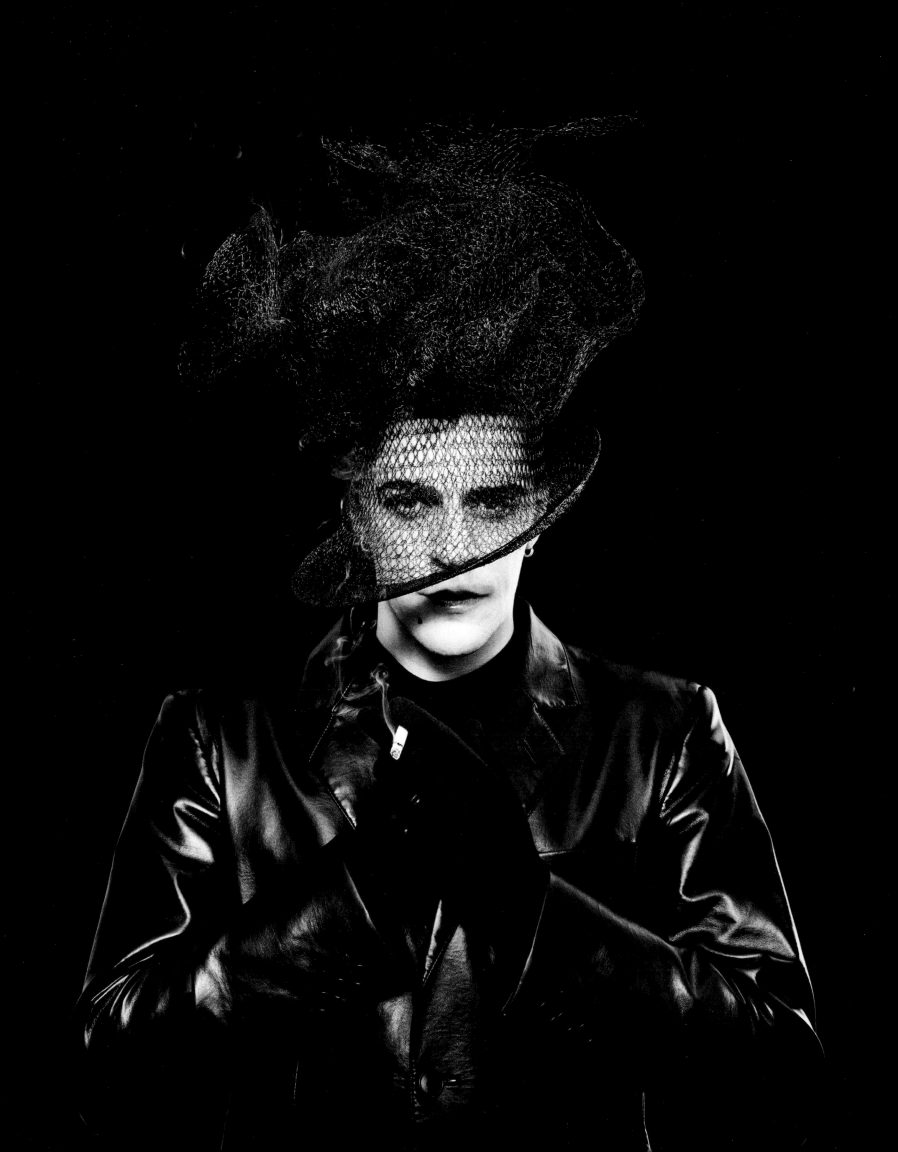

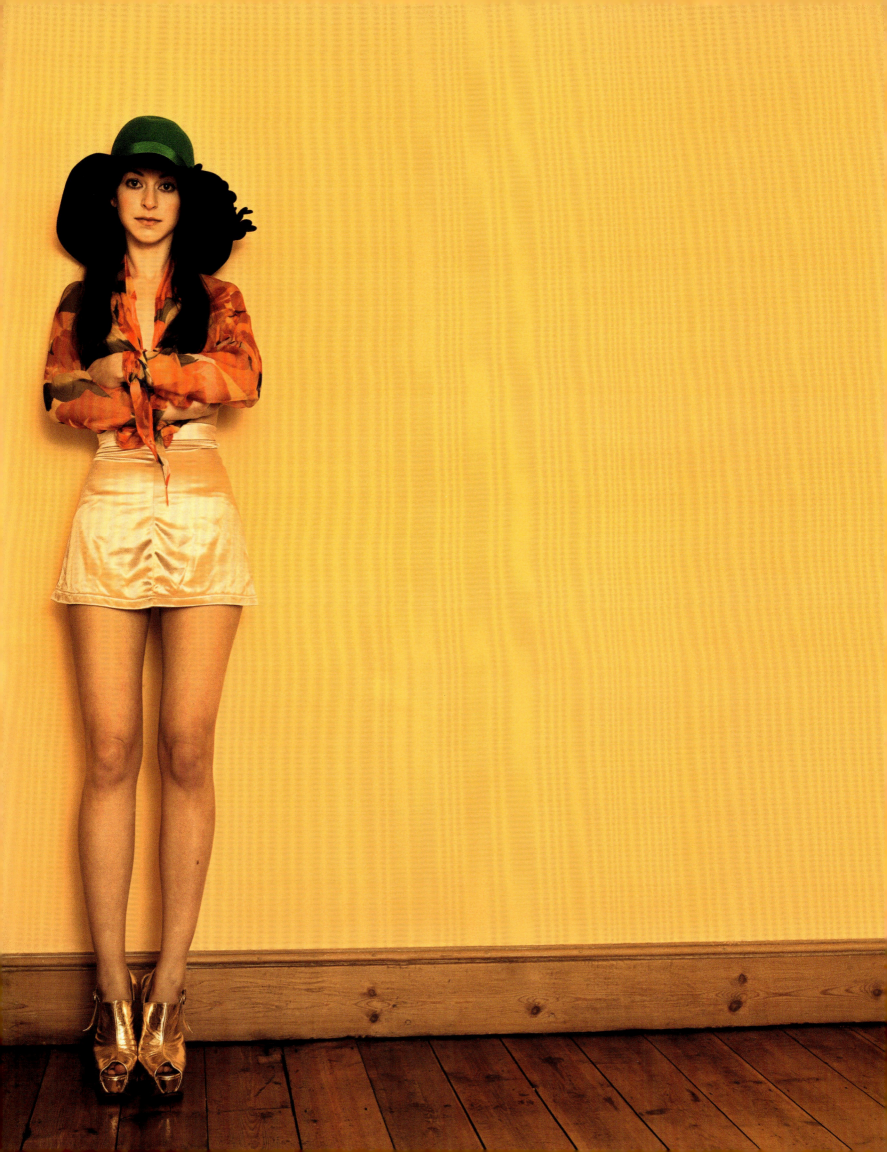

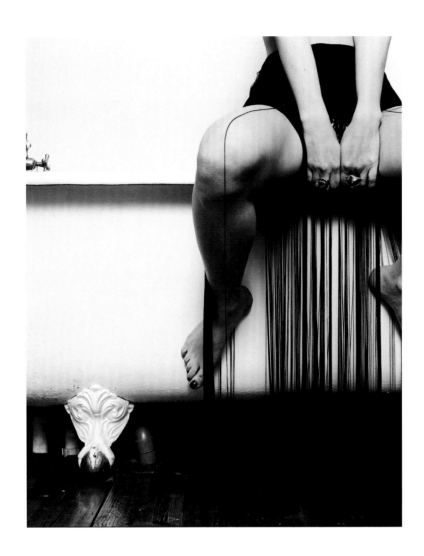
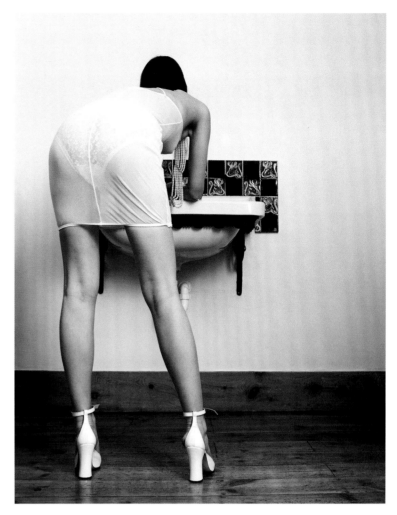

Too Much Too Young | 1994

I remember the 'Livestock' shoot—I had to stand amongst the pigs in a pen, and they stank, sniffing my legs, honking away, and it was bloody freezing, and I'm in these Vivienne Westwood super-high wedge shoes. I couldn't imagine it at the time, but I love those pictures.

I loved the excitement and passion Rankin had—and yes, sometimes that would come out as frustration if something wasn't working, but he was also equally silly and could laugh at himself. We were all doing this for free, trying to create something, so there was a sense of collaboration and camaraderie around it.

Even though at that time in my life I wasn't really confident at all, I felt comfortable and I trusted what he was doing—even if some of the ideas seemed crazy—because he seemed to appreciate and actually want to bring out my personality. Rankin's models have a sense of personality, strength, and quirkiness. I can see how that applies to me now—I wish I'd known it about myself back then.

I'm not surprised at Rankin's success at all—but at the time I had no idea, we were all just starting out, making it up as we went along.

KATIE CARR

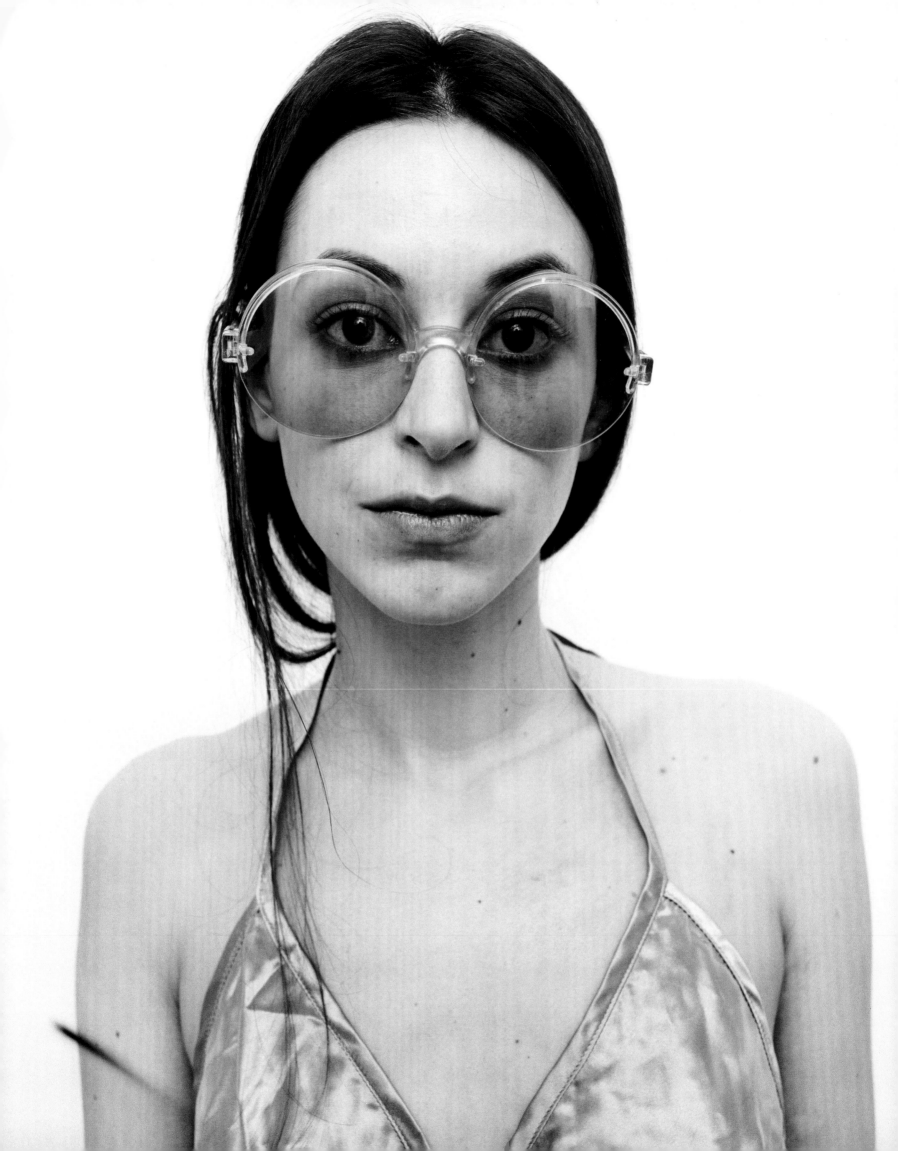

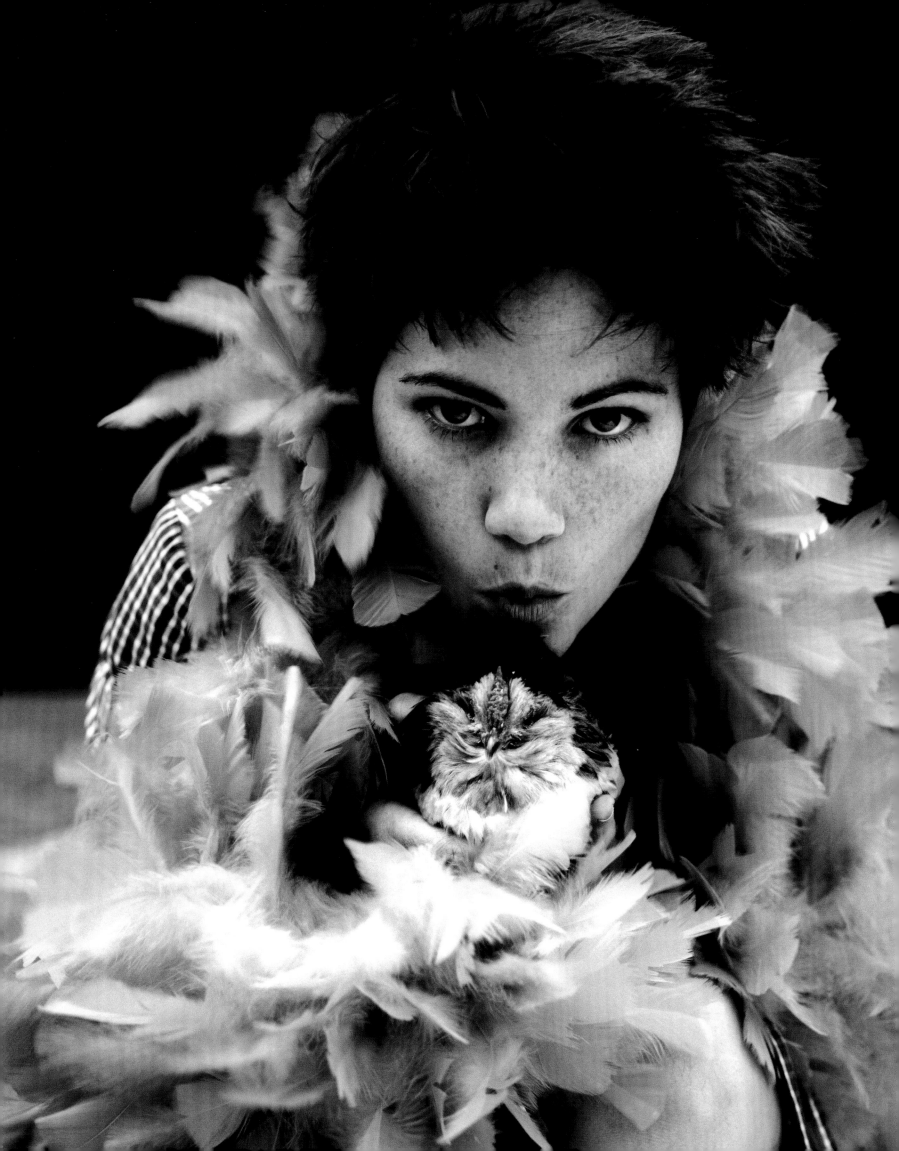

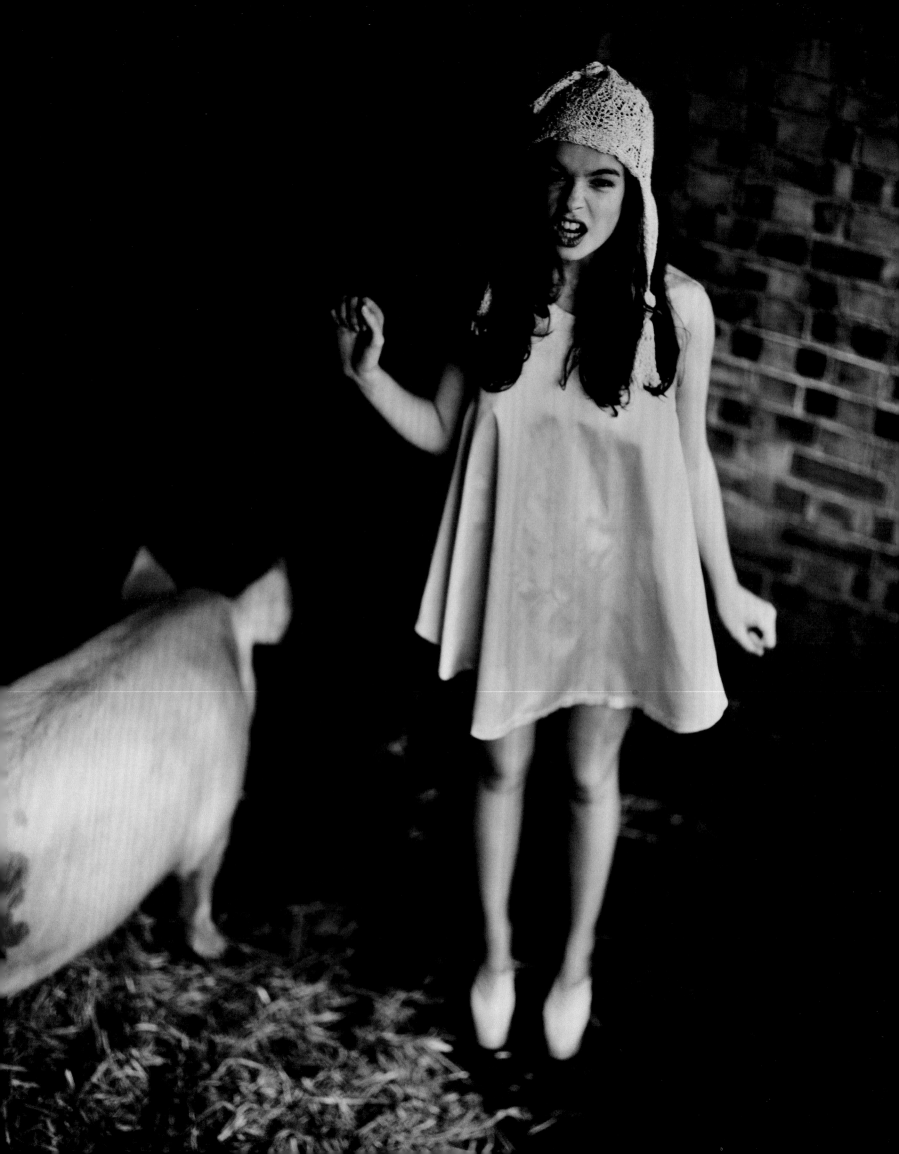

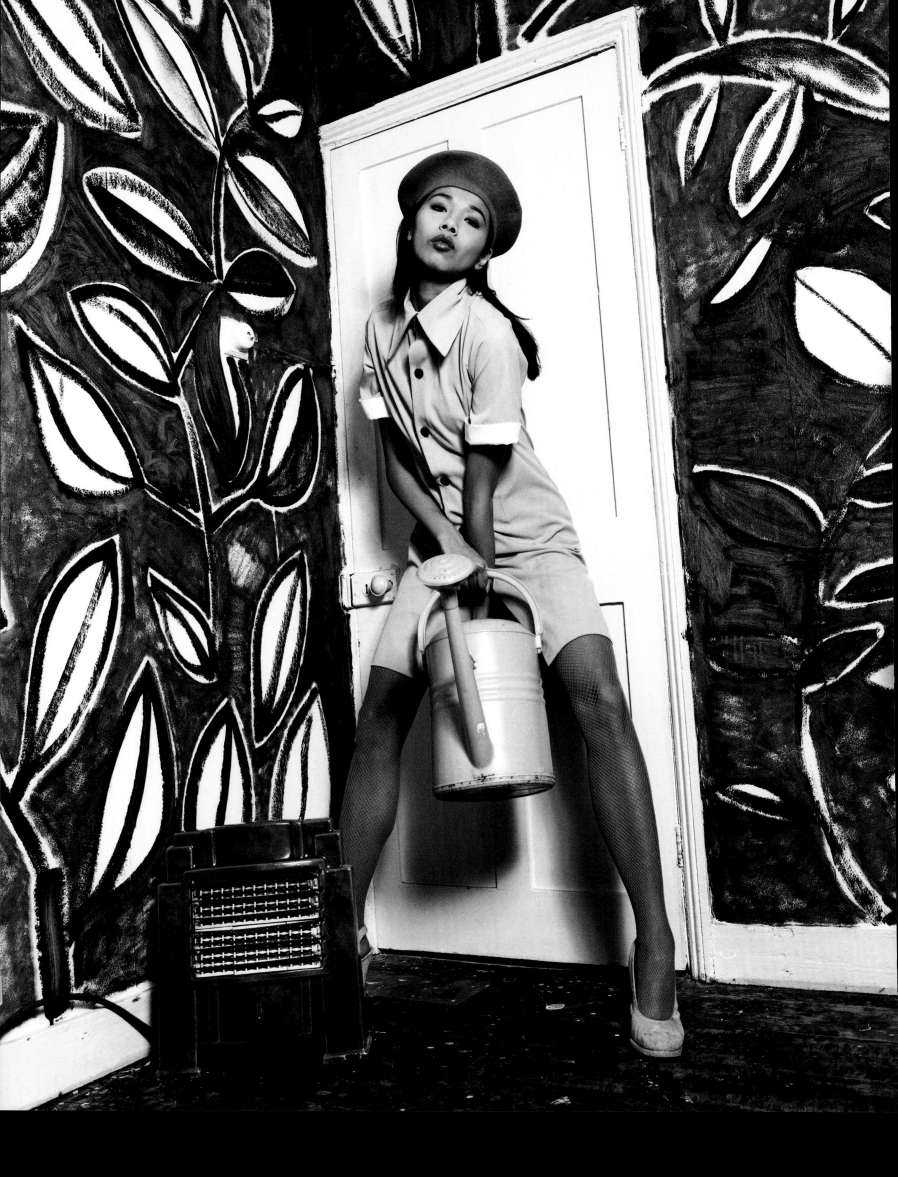

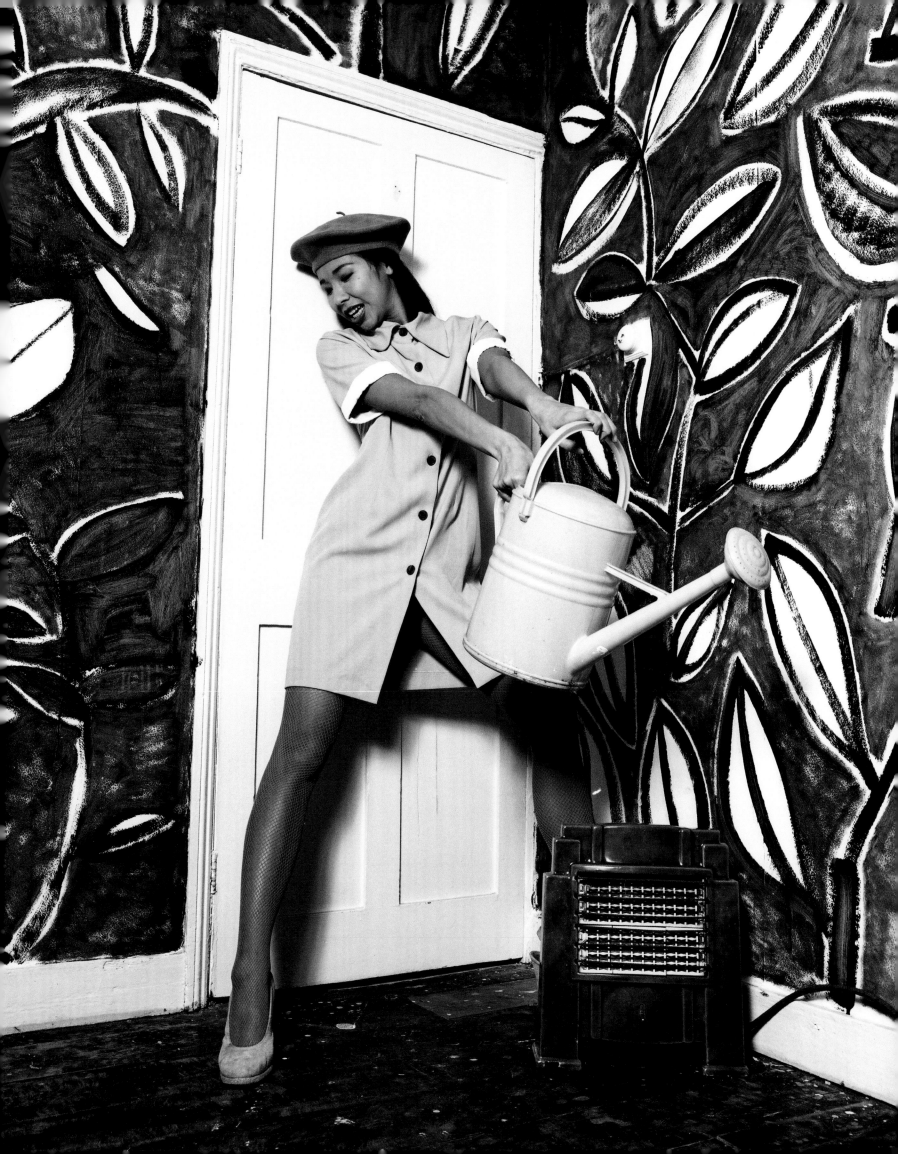

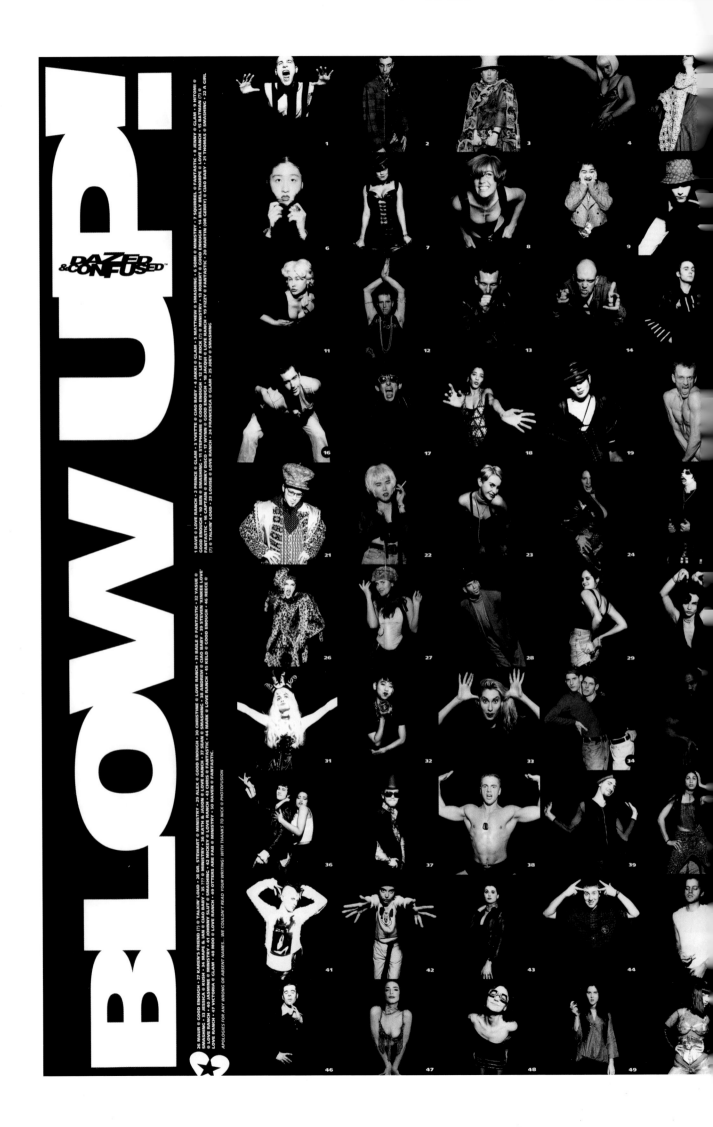

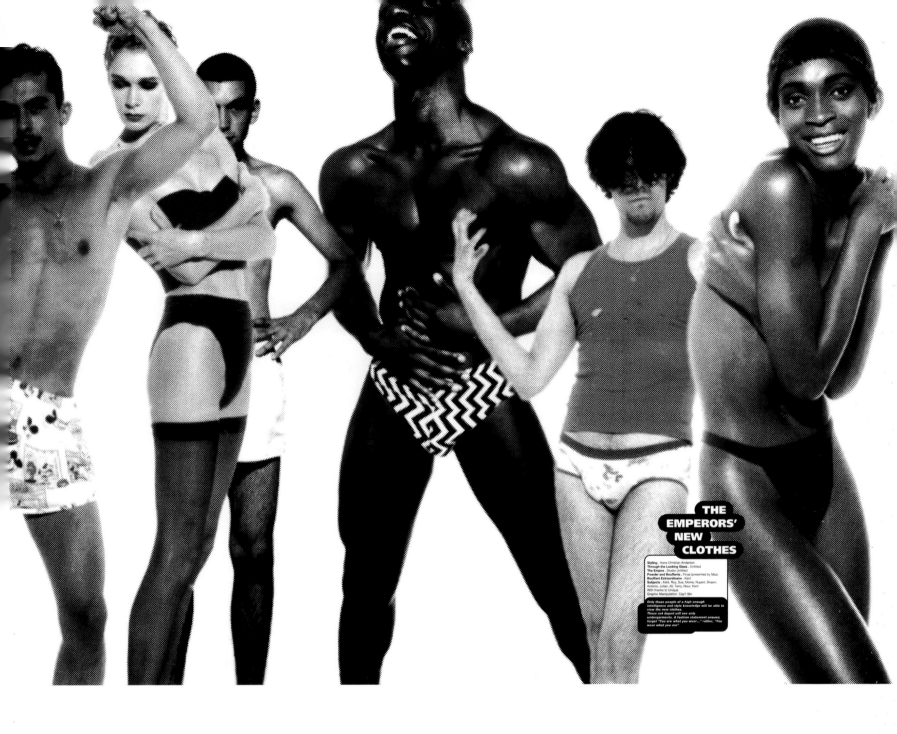

I can't say what a classic Rankin model is, but I guess one with an unusual quality?

MONI LEBON

It was a period where fashion and clubs were well-matched co-conspirators—I'm sure each generation says that, but it really was palpable. Rankin did his 'Blow Up' tour and I'd accompany him, and of course he was astute to choose the 'right' club nights; so it was Friday at the then newly-opened Ministry of Sound, Thursday at Gimme 5's Good Enough, Wednesday at the Milk Bar, and myself and Rankin went to some grim S&M night in Brixton on a Tuesday. I was bored, but Rankin thought it was great—not necessarily because of the risqué activity but because there were all these characters that he wanted to photograph.

STEPHANIE TALBOT

The Emperors' New Clothes | 1991

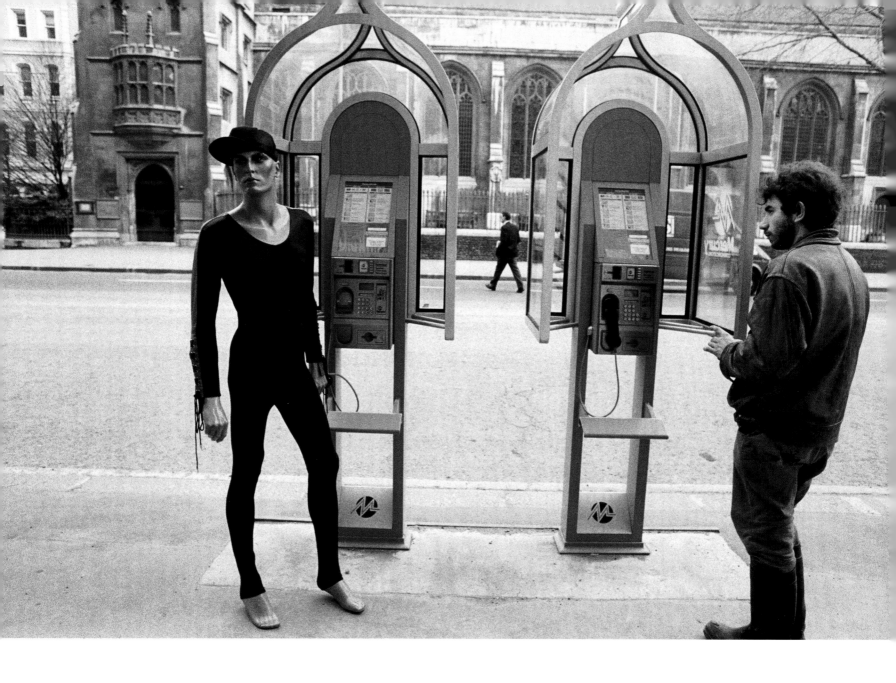

Mannequin Fashion | 1990

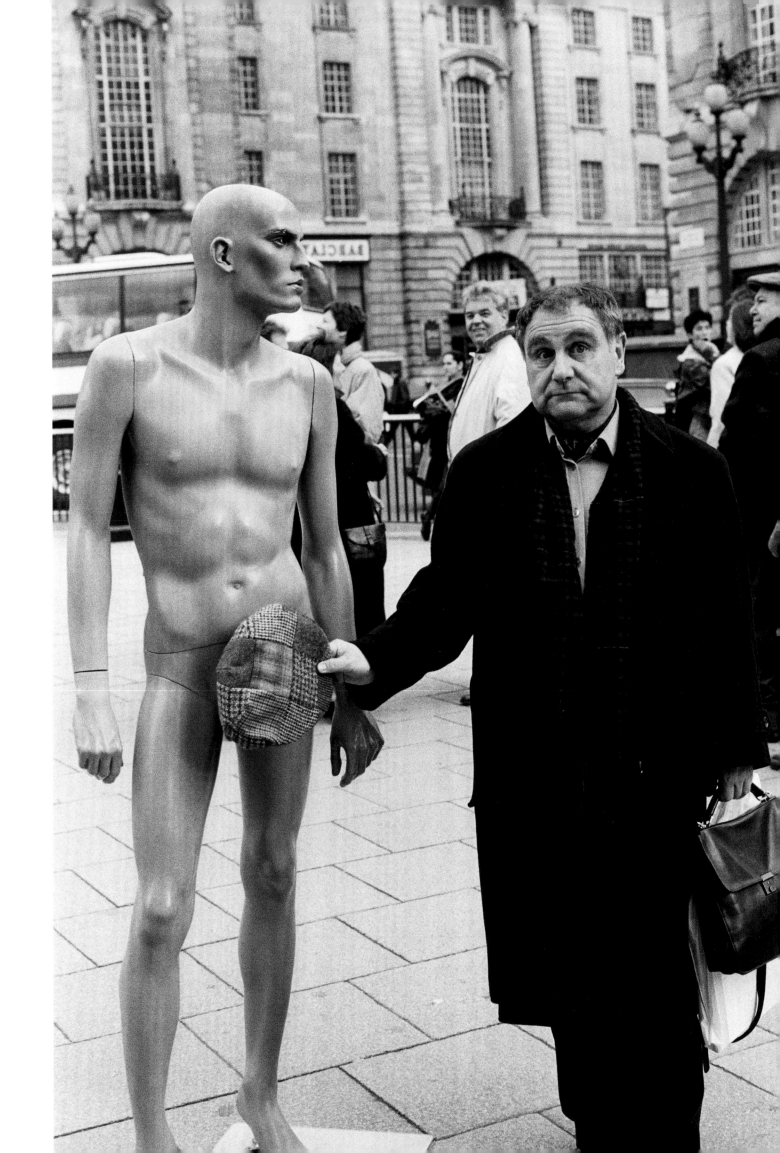

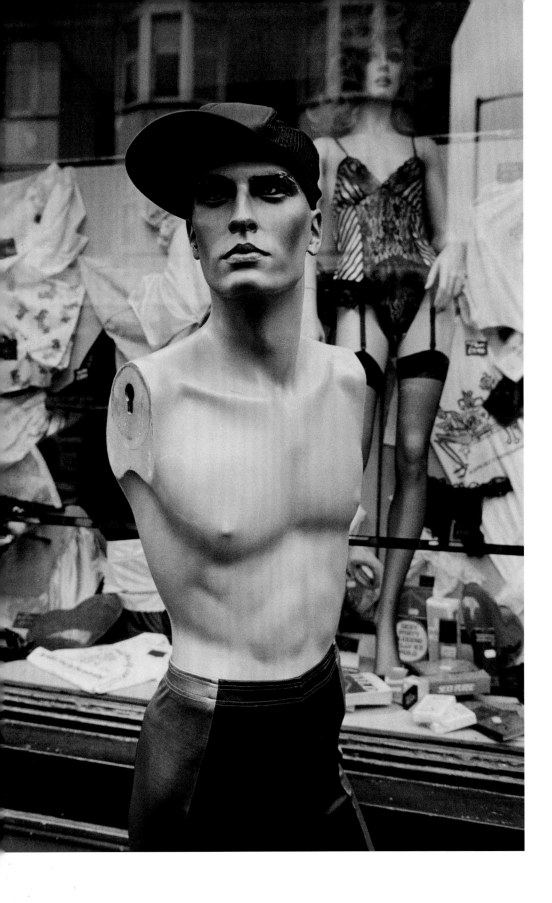
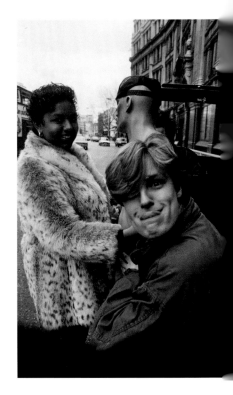
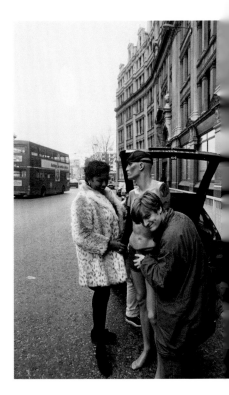

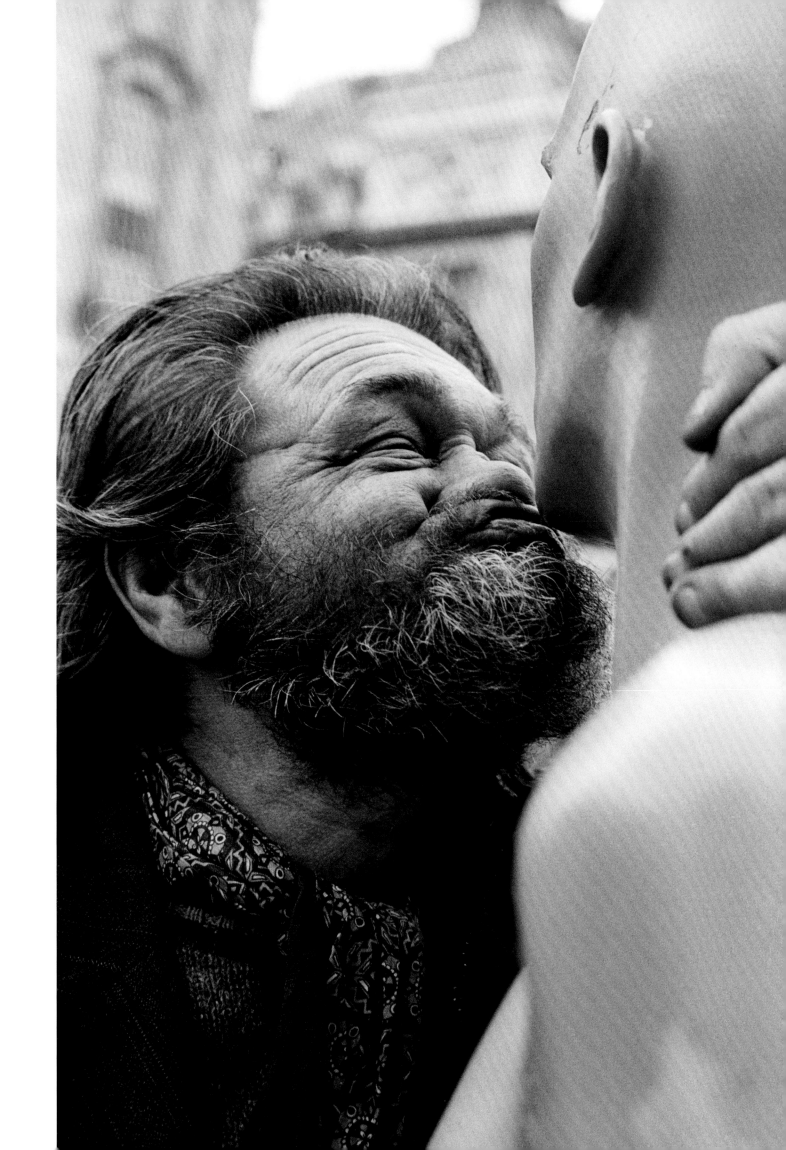

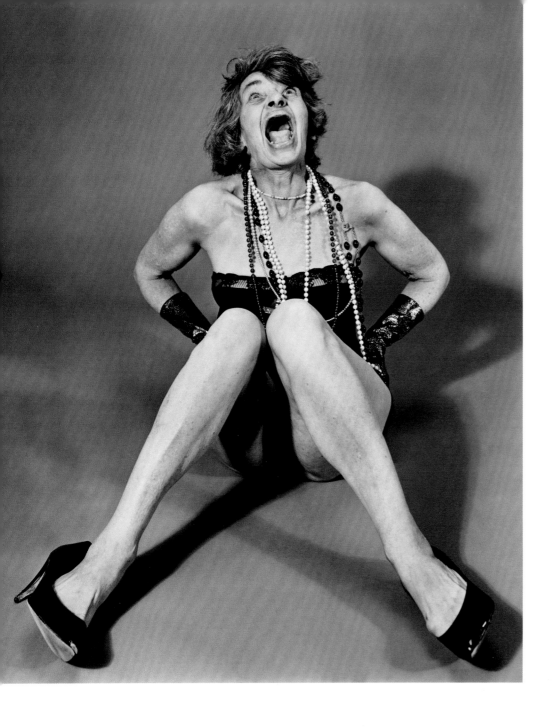

This project changed everything for me. It made me realize that photography could challenge preconceptions and make people change their minds. When I exhibited them at my end-of-year show, they really split the room. People either loved or hated them. The funniest (and best) part of the whole thing was that my dad, who up until then had been annoyed about my decision to go into photography (he was set on me becoming an accountant), sat by the work all night and listened to what people said. In the car on the way home, he said that people's reactions meant I was either going to be incredibly successful or fail miserably. It was a defining moment in our relationship, and after that he always supported my career choice. So, thanks to Dot, I am now the photographer I've become, and the rest of this book kind of rests metaphorically and literally on the shoulders of this shoot.

RANKIN

Dot | 1988

Next
Melanie Williams | 1988

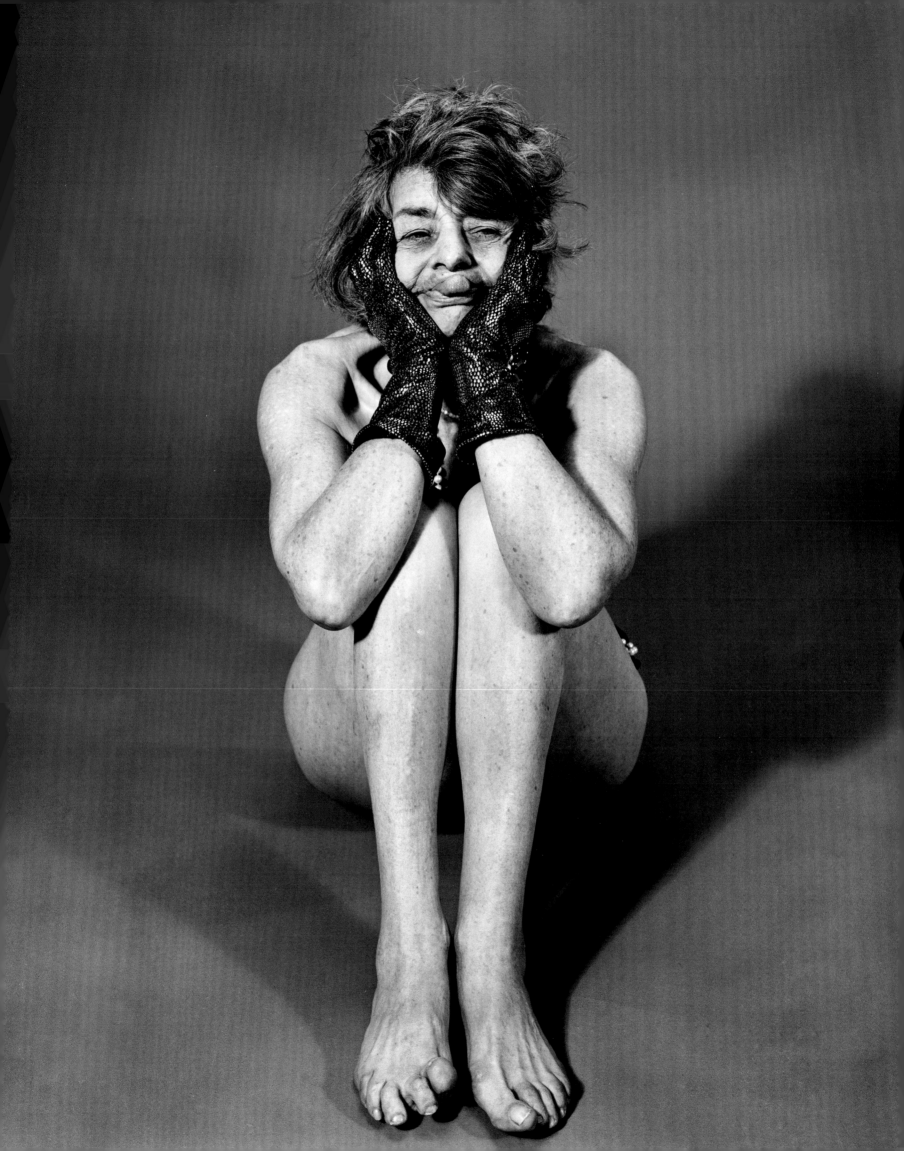

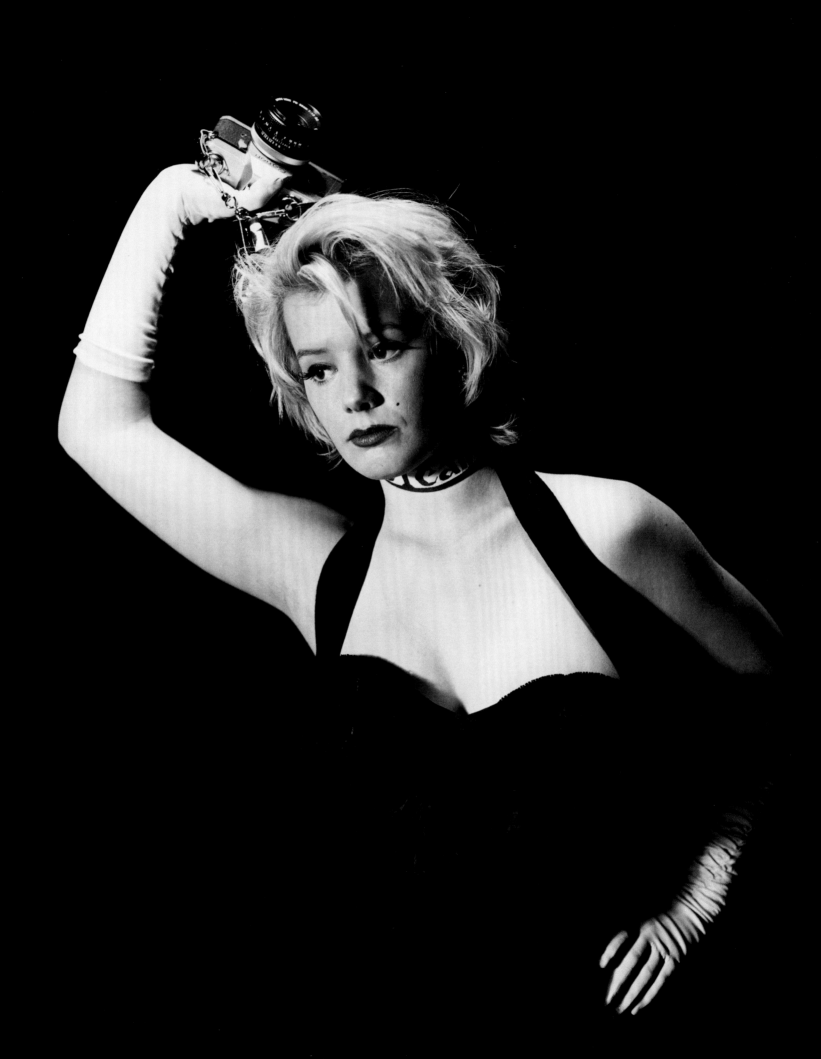

The shoot was at Barnfield College, Luton, in the late 1980s. I was a fashion design student. When I look at this picture, I feel the rebellious quality that obviously Rankin always brings to his images. I also feel the moodiness or sultriness in my expression, which he seems to have brought out in me during the shoot. Our days at Barnfield very much define the late 1980s for me, and this image captures that 'Brat Pack-Molly Ringwald-vintage-clad-moody-outsider' we were all emulating back then.

My favorite memories of Rankin were his controversial photo shoots at Barnfield… including glamour photography with a naturally crinkled septuagenarian complete with buttless chaps and feather boas! To my seventeen-year-old brain, rather shocking!

MELANIE WILLIAMS

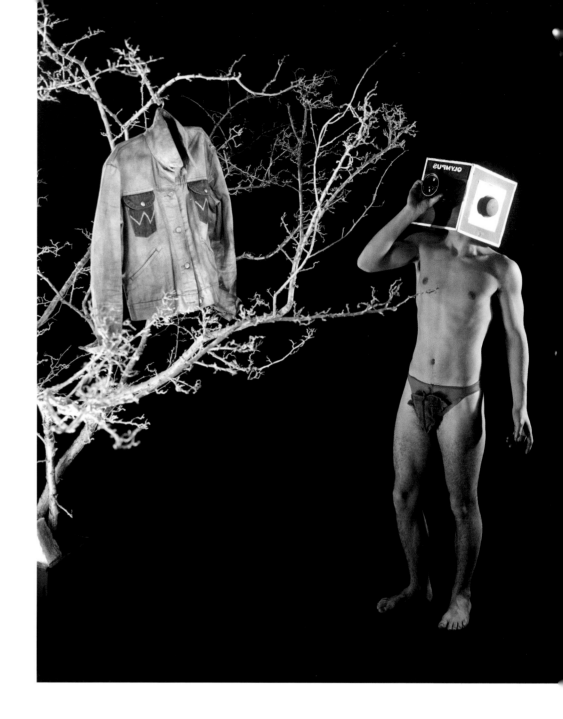

First Fashion | 1988

Next
Jefferson | 1988
Me Me Me | 1988

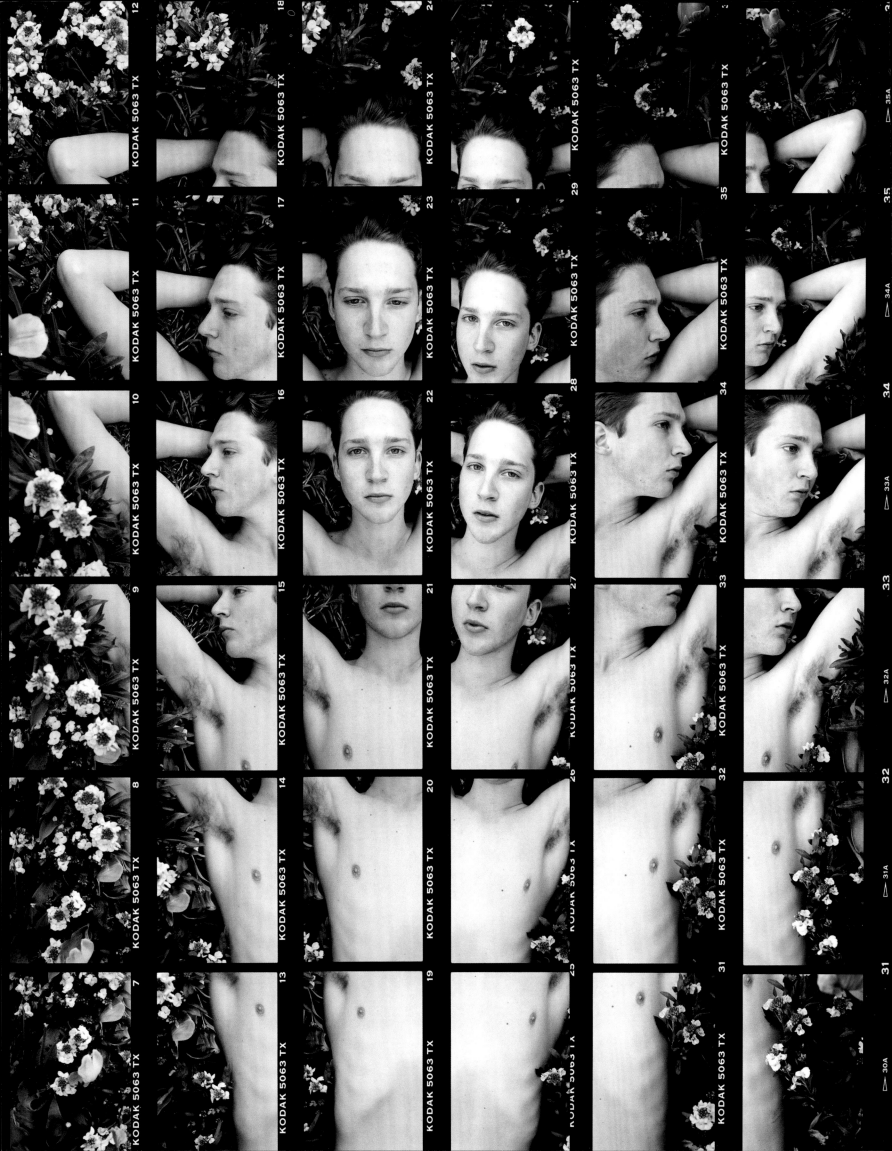

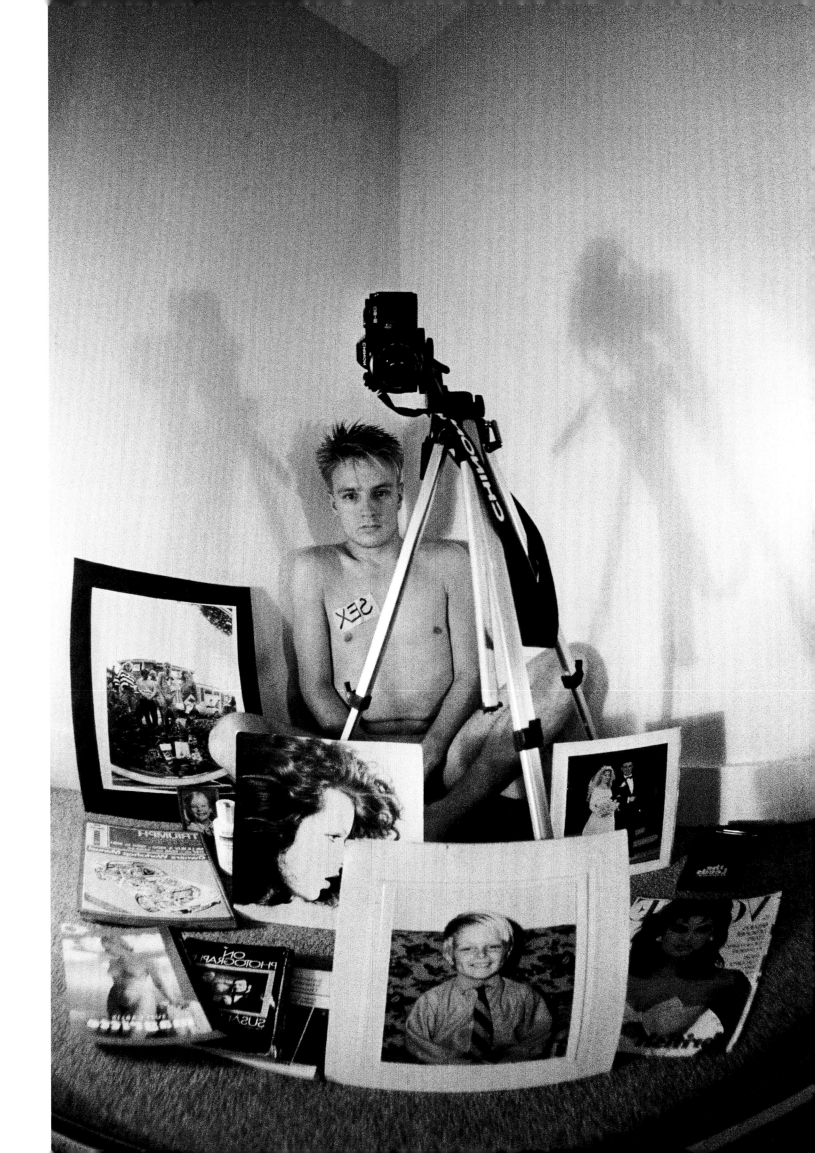

"If I was in the driving seat of my photography, then you were definitely in the passenger seat." That's how Rankin describes our journey together. It's an accurate metaphor for the *Confused* years, not least because Rankin did drive everywhere in a beat-up Ford Escort that regularly broke down (once quite spectacularly on the Elephant & Castle roundabout, when the passenger-side door fell off). I rode shotgun most of the 1990s with a close eye on the road and the tape cassette. He was a high-speed driver and he took no prisoners. When we were students together at the London College of Printing working on *Untitled*—the student magazine for which Rankin went on to win Student Photographer of the Year—the entire working issue had been left on the roof of his car (encased in floppy discs and bromide acetates) to become specks of dust somewhere in the grime and gristle of the Old Kent Road. That's just how focused Rankin was on driving full speed ahead into the future without once looking back in the rearview mirror.

Unfashionable—a title loaded with irony and double meaning—is Rankin's thirty-year monograph of image-making inspired by and related to fashion and beauty. In 'The Heroism of Vision,' the chapter of *On Photography* that discusses beauty, Susan Sontag describes the history of photography as "a struggle between two different imperatives… beautification… and truth-telling." As an artist, Rankin would forever be balancing the contradiction of creating artifice while simultaneously questioning reality in his photography. They say geniuses are those who can hold two opposing ideas in their head at the same time. When you enter into Rankin's photography, he transforms everyone else into the genius in the room. That is his gift, to transfer complex, often contradictory ideas into simple-to-understand, immediate pop iconography.

The first series of stories by Rankin and *Dazed & Confused*'s first fashion director, Katie Grand, present a remarkable legacy of intent. In the stories 'Weep,' 'Big Girl's Blouse,' and 'Hungry?,' Rankin was challenging every and any fashion convention, ripping it up, sending it up, spoofing and trashing beauty norms. He also looked to glamorize the hidden, by revealing and tackling taboo subjects like age and size in models. The mission was to humanize fashion—to bring his sense of reality to some of fashion photography's unattainable clichés. The images are at once sensational, seductive, politically charged, and questioning; this way of coming out into the world seemed so normal to us all at the time.

If Rankin was liable for speeding in the mid-1990s, Katie Grand was holding the map. She literally had her vision for fashion mapped out. Hers is an incredible story worthy of a book in its own right; Rankin and I had started *Dazed & Confused* and soon she became Rankin's partner and a founding partner, before graduating with a BA in textiles at Central Saint Martins. She had an effervescent energy and galvanized the spirit of the magazine into an exciting platform for emerging designers and photographers, introducing new ways of presenting fashion in magazines. They had a relationship that seared into his worldview Katie's fashion know-how and now, several decades later, the strength of those defining years of living and working together is still very much a part of their bond and their identities as visual artists.

Fashion photography is a team effort, and Rankin has always sought out collaborators who would inform him, push him, and add new dimensionality to his work. Most prominently featured in this book alongside Katie are Alister Mackie, Paula Thomas, Miranda Almond, Katie England, and the make-up artists Andrew Gallimore and Ayami Nishimura.

"For photographers there is, finally, no difference—no greater aesthetic advantage—between the effort to embellish the world and the counter-effort to rip off its mask," continues Sontag in 'The Heroism of Vision.' For Rankin's part, he would always talk about "holding a mirror to society," something that makes me think now of William Klein's experiments with mirrors in fashion in the 1960s: an attempt to circumnavigate the male gaze, to play tricks with perspective, and to undermine photography's pervasive privileging of the 'decisive moment.' Rankin was holding a mirror to society, but he was also steeped in the photographic histories of David Bailey, Arthur Elgort, Duane Michals, and Patrick DeMarelier, whom he heralds as some of his favorite fashion image-makers of all time.

As Katie's and Rankin's work continued to deepen, and in some places darken, stories such as 'Faking It,' 'Damage,' 'Dead Fashionable,' 'Plain,' and 'Highly Flammable' showed them poking even more fun at the fabrication of fashion, with Rankin becoming more elaborate in using photography as a tool to talk about the artifice of photography, and to bring a knowing self-criticism to fashion. Early on, to escape growing internal politics at *Dazed & Confused*—which was now being co-fashion directed by Katy England—they created *Another*, a supplement that lasted for four issues. This was many years before the official launch of *AnOther Magazine* (for which the name was repurposed), but its imagery is highly entertaining and illuminating even now: the livestock jokes (models mimicking farmyard animals) which became a recurring theme in both their careers started here, as well as much of the theatricality and surrealism of Rankin's visual gameplaying, where humor is an ever-present foil to fashion.

As Sontag describes, Rankin was simultaneously embellishing and ripping off masks in what was to become an echo of the reality being played out in the new vanguard of digital tabloid media—where images of fashion models off-duty, celebrities caught off-guard, and the extreme 24/7 documentation of reality was juxtaposed daily with red-carpet languor and retouched front covers. This new post-truth image of fashion and celebrity icons must have been to Rankin, as an artist, a contradiction that sat front and center of his view of the world.

'Spray Paint Kate' is a great example of this. Live-graffitiing the clothes and her body, the shoot was post-punk performance art as fashion photography. It's a great story and cover, but the most striking image is provided by its very counterpoint, via the simple black-and-white image of Kate. Here, Rankin's connection to Kate as a portraitist crackles through the page like electricity through a wire.

There couldn't be a wider contrast to that simple shot of Kate than 'Sparkly Gisele'—the glistening glamor and retouched fantasy personified in that image sizzles next to Kate's cool, unkempt stare. The glistening, sci-fi vision of Gisele and the portrait of Kate are like Rankin's yin and yang: the twin polar extremes of beautification and truth-telling that he will continue to explore throughout his work.

By the mid-1990s, Rankin was becoming a hot industry name, and excursions into glossy-magazine territory naturally followed. *Allure*, *Harper's Bazaar*, *Citizen K*, *Nylon*, *Geo*—the results are more conventional, perhaps, with Rankin ceding control, but taking him to interesting new locations with bigger budgets and bigger models. For Rankin, I'm sure there is no difference between personal work, editorial work, or advertising—"as long as it's good," as he would say—but for me the car was parked somewhere in East London, and Rankin was off on a jet plane exploring some other place.

It was only a matter of time before Rankin launched his own magazine, where he really could stick two fingers up at everything and

AFTERWORD
JEFFERSON HACK

anyone (I'm certain that also pertains to me!) and just do exactly as he pleased. *Hunger* (which comes in part from the movie *The Hunger*, featuring David Bowie and Catherine Deneuve, and in part from Rankin's exhibition title *Visually Hungry*) is the evolution of his debut title, *RANK*, and its images dominate the first part of this book. It's now Rankin's main focus for his fashion work, a world that really appeals to him because he's so easily bored. "I saw how instantaneous fashion was and I loved that," he explains. There's an incredible clarity and immediacy to his ideas for *Hunger*. You see the master photographer at work without inhibitions. The concentrated rush to connect with an idea is finely honed. Fashion photography does not sit in the service of selling clothing. For Rankin it's another form of narrative communication, with all the humor, roleplay, ritual, tease, and transformation of his early work for *Dazed & Confused*. If that was post-modern punk, this is post—Tate Modern, conceptual punk.

I remember when Rankin showed me the first set of contact sheets of his shoot with Kate Moss for 'Spray Paint Kate.' She was the first supermodel he'd photographed, and it absolutely blew him away. It was then he realized how a seriously experienced model can make such a difference to his fashion work. Through the book you see the icons—Helena, Eva, Heidi, and Milla—simultaneously fetishized and distorted as beauties; they bring a new collaborative energy to his representation of female beauty. The Gisele contact sheet, for *Citizen K*, is truly as entertaining and enlightening as looking at Bert Stern's contact sheets of Marilyn Monroe. Here is the crystallization of a fashion moment in time, when joy, optimism, the transference of youth, and sexual promise meet sexual empowerment.

But none is more celebrated or more reimagined in these pages than Tuuli, Rankin's wife and collaborator, and the most chameleon-like of all the models he has worked with. Like David Bailey's amazing, decades-long documentation of Catherine Bailey, Rankin's and Tuuli's collaboration is a phenomenal coming together of two artists who, as husband and wife, can legitimately express intimacy, play sexual roles, and push beauty ideals further than anyone. It makes me wonder if Rankin's feminine alter ego is actually Tuuli—and if, by way of some phantasmagorical roleplay, the power and transference is also reversed through the images they make together? The images featured here are just a fraction of Rankin's and Tuuli's canon, from which the book *Tuulitastic* has been published.

In the stories 'Less Is More Make-Up,' 'Head in the Clouds,' 'Crystal Amaze' (what looks to be a camp homage to Richard Avedon's 'Dovima With Elephants'), and 'It's Not That I'm So Smart; I Just Stay With Problems Longer,' we see narrative fashion editorial collapsing. It's as if, in today's editorial context, fashion photography is too long-winded, too self-indulgent for Rankin. These are images as fashion haikus; individually as powerful as they are as part of a set. Designed either for billboards or Instagram feeds, they are images whose power is their very detachment from the context of fashion itself. Fashion photography through the ages has in its own way prepared us for this moment, when the photograph as a digital entity, unbound by humans, bound only to algorithms, is artificially creating a new reality and a new fashion consciousness. A new generation is now making fashion photography, styling themselves and creating new beauty ideals, fashion labels, and style identities without magazines, without clients, without backers, without permission, just because they can.

As an artist and self-publisher, Rankin has pioneered self-reflection in fashion photography. This is his direct link to this new generation, their visual stream of consciousness representing an unlocking of photography and in many ways an unfashioning of fashion itself.

Yet at the same time, Rankin's lens is always anchored on moments of personal connection. This is why, when he tells me that he falls in love with the people he photographs in a really intimate way, I believe him. Rankin loves people. His humanism stands before his art, and in the images of models in *Unfashionable* we see it come across as their empowerment. They are not represented as accessories to an image; they are given the same power, the same authority as his celebrity portrait sitters. If there is one phrase I would use to describe the attitude inherent in a classic Rankin portrait, it would be 'positive defiance.'

If, for David Bailey, there is a definite interrelationship between portraiture and fashion, for Rankin there might be little if any distinction at all. Just looking at the images of this new generation of Insta-girls—Bella, Gigi—they are the only credit in the fashion photograph that really matters to Rankin.

Rankin is not only a mythologist of others; he is also a great self-mythologist. Most people don't know his birth name is John Rankin Waddell. Maybe the Queen called him John, or maybe she called him Rankin, we'll never know, but Rankin by its very intensity as a name, by its very Scottish medieval ancestry, comes with a portent of power, title, position, status. And while Rankin himself had none of these, he had the working-class defiance and the cocksure sense of his own skill as a photographer that he was always going to do exactly as he wanted.

We flip through history in reverse, and at the end of the book we find where it all started in the mid-1980s. We see Rankin in a nude self-portrait, sitting in a studio surrounded with the collected assemblage of his interests in fashion, sex, and magazine culture. A classic school portrait is front and center, just behind it his parents' wedding photograph, a copy of *Vogue* magazine alongside Susan Sontag's critical text *On Photography*. The word *sex* is hand-written on tape stuck to his bare chest. It represents the entire semiotics of what is to come, and it's through these twin images that we can see so much of what informed Rankin's approach to photography: the creation of persona and identity through mythmaking, his deconstruction/reconstruction of photography as a medium, and finally the deep humanism, shown through the inclusion in his work of friends, collaborators, and his parents (after whom he has named his current studio in Kentish Town, Annroy).

Rankin's portrait of me is one of my favorite documents of our relationship. Every photograph is a transference of energy and power, every person in the photographer's gaze a subject that he molds to his own reality. In that moment of beatitude he captured the tenderness of our love and trust—something unspoken, unacknowledged between us even today. *Unfashionable* to me reads as an essay on otherness, bringing to light what we don't see, what others invariably fail to see, but what Rankin sees. It's an emotional connection to people that is beyond language, but—thankfully, for us holding this book—not beyond photography.

 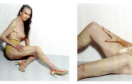 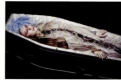

2018–2016
Pages 8–61

Slime of Passion
Hunger TV
Mar 28, 2018

Model	Vanessa Powell
Hair	Jonathan Connelly
Make-up	Andrew Gallimore
Stylist	Jessica Midwinter

F**k Facetune
The Impression
Issue 4, 2018

Models	Elizabeth Gibson, Frances Dunscombe, Susan Walker
Hair	Nick Irwin
Make-up	Andrew Gallimore
Stylist	Mike Adler

Casket Couture
Hunger TV
Oct 26, 2017

Models	Bethany Robbins-Bishopp, Leon Flint, Bonnie Bond, Junior Choi
Hair	Nick Irwin
Make-up	Marco Antonio
Stylist	Mike Adler

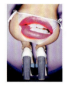 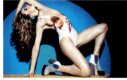 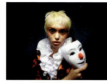 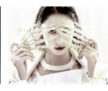 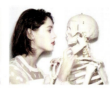 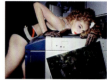

Love's a Bitch
Hunger
Issue 12, 2017

Model	Valeria Karaman
Hair	Jonathan Connelly
Make-up	Andrew Gallimore
Stylist	Mike Adler

The New Law
Paper Magazine
Mar 2017

Model	Iris Law
Hair	Sharmaine Cox
Make-up	Holly Silius
Stylist	Adele Cany

Life In a Dream
Dazed & Confused
25th Anniversary Issue, 2016

Model	Gigi Hadid
Hair	Luke Hersheson
Make-up	Lisa Eldridge
Stylist	Katie Grand

 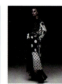 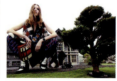 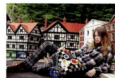 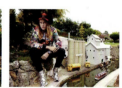

Scream
Hunger
Issue 11, 2016

Model	Alice Blomfeldt
Make-up	Holly Silius
Stylist	Anna Hughes-Chamberlain
Creative Director	Vicky Lawton

It's A Small World
Hunger
Issue 11, 2016

Models	Roxane Gliner, James Phillips
Hair	Adrien Clark
Make-up	Bea Sweet
Stylist	Anna Hughes-Chamberlain

 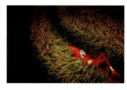 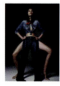 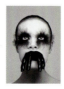 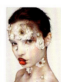 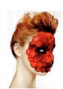

Red Hair Don't Care
Hunger
Issue 9, 2015

Model	Sally Jonsson
Hair	Nick Irwin
Make-up	Andrew Gallimore
Stylist	Kim Howells

Strip
Hunger TV
May 15, 2015

Model	Leaf Zhang
Hair	Nick Irwin
Make-up	Linda Hay
Stylist	Jessica Bobince

Less Is More Make-Up
Less is More, Kunsthalle Rostock
2015

Models	Madeleine White, Maisie Jane Daniels, Ellen Burton
Hair	Nick Irwin, Jay Doan
Make-up	Heidi North, Andrew Gallimore
Stylist	Kelly Shenton

INDEX

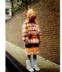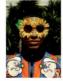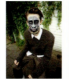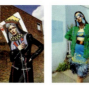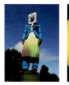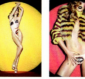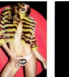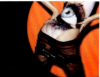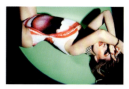

#NoFilter
Hunger
Issue 13, 2017

Models	Sibui San, Lola Parnell, Lulu Stone, Olivier Geraghty, Cheye Waith, Tom Watson
Hair	Nick Irwin
Make-up	Andrew Gallimore
Stylists	Kim Howells, Stevie Westgarth

Eye Eye Abbey Clancy
Hunger
Issue 12, 2017

Model	Abbey Clancy
Hair	Brady Lea
Make-up	Holly Silius

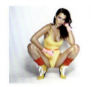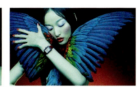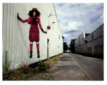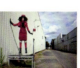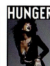

Bella in Love
Love Advent Calendar
Dec 24, 2016

Model	Bella Hadid
Hair	David Harborrow
Make-up	Ciara O'Shea
Stylist	Victoria Young

Bird Song
Hunger
Issue 11, 2016

Model	Xu Liu
Hair	Nick Irwin
Make-up	James O'Riley
Stylist	Victoria Bain
Creative Director	Vicky Lawton

Jump To It
Hunger
Issue 11, 2016

Model	Winnie Harlow
Hair	Brady Lea
Make-up	James O'Riley
Stylist	Anna Hughes-Chamberlain
Creative Director	Vicky Lawton

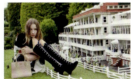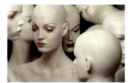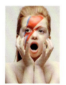

Uncovered
Hunger
Issue 10, 2016

Model	Yana Dobrolivbova
Make-up	Andrew Gallimore
Stylist	Kim Howells

2016–2011
Pages 62–127

All The Young Kooks
Hunger
Issue 10, 2016

Models	Millie Millburn, Rubee Irwin
Hair	Nick Irwin
Make-up	Andrew Gallimore
Stylist	Scott Robert Clark
Creative Director	Vicky Lawton

Chin Up
Hunger
Issue 9, 2015

Models	Georgie Hobday, Gwilym Pugh
Hair	Nick Irwin
Make-up	Andrew Gallimore

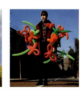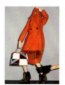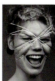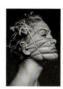

Head In The Clouds
Hunger
Issue 8, 2015

Models	Harry Uzoka, Harry Goodwins
Hair	Brady Lea
Make-up	Oonah Anderson
Stylist	Chris Benns

Right Way Up, Wrong Way Down
Hunger
Issue 9, 2015

Models	Rhiannon Laslet, Connor Askin, Minna Griffiths
Hair	Nick Irwin
Make-up	Andrew Gallimore
Stylist	Kim Howells
Creative Director	Vicky Lawton

Distorted
Hunger
Issue 8, 2015

Models	Leanne Maskell, Tessa A
Hair	Amiee Hershan
Make-up	Andrew Gallimore
Stylist	

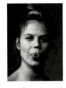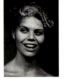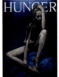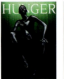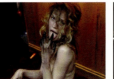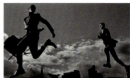

The Fearless
Hunger
Issue 7, 2014

Models	Camilla Christensen, Soo Joo Park, Grace Bol, Hollie-May Saker, Neelam Gill
Hair	Biance Tuovi
Make-up	Celia Burton
Stylist	Kim Howells
Creative Director	Vicky Lawton

The Drop
Hunger
Issue 7, 2014

Models	Allen Taylor, O'Shea Robertson, George Alsford
Grooming	Adam Walmsley
Stylist	Chris Benns
Creative Director	Vicky Lawton

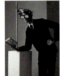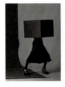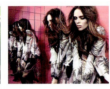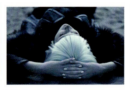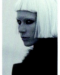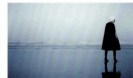

Coco Cavalli
Hunger
Issue 4, 2013

Model	Coco Rocha
Hair	Nick Irwin
Make-up	Caroline Saulnier
Stylist	Way Perry

Into the Mist
Hunger
Issue 3, 2012

Model	Tuuli Shipster
Hair	Nick Irwin
Make-up	Michelle Campbell
Stylist	Scott Robert Clark

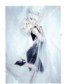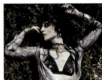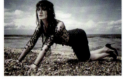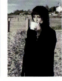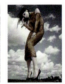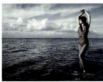

The Real Erin
Hunger
Issue 1, 2011

Model	Erin O'Connor
Hair	Keiichiro Hirano
Make-up	Terry Barber
Stylist	Anna Hughes-Chamberlain

No Yesterdays On The Road
Hunger
Issue 1, 2011

Model	Tuuli Shipster
Hair	Yiotis Panayiotou
Make-up	Kathy Jeung
Stylist	Laura Duncan
Illustration	Marcela Gutierrez

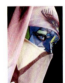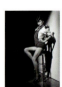

Painted Veils
Dazed & Confused
Vol 2, Issue 62, Jun 2008

Models	Momeena Yasmin, Stephanie Carta, Amira Ahmed
Hair	Gow Tanaka
Make-up	Ayami Nishimura
Stylist	Ayami Nishimura

International Woman
Longchamp
A/W 2004

Model	Jessica Miller

Interzone
AnOther Magazine
Issue 5, A/W 2003

Model	Heidi Klum
Hair	Paul Hanlon
Make-up	Lisa Houghton
Stylist	Hector Castro

Celluloid Closet
Dazed & Confused
Vol 2, Issue 3, Jul 2003

Model	Louise Pederson
Hair	Alain Pichon
Make-up	Val Garland
Stylist	Hector Castro

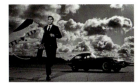 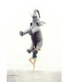 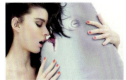 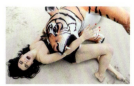 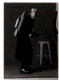

Crystal Amaze
Hunger
Issue 4, 2013

Model	Crystal Renn
Hair	Rob Talty
Make-up	Lisa Storey
Stylist	Way Perry

It's Not That I'm So Smart; I Just Stay With Problems Longer
Hunger
Issue 5, 2013

Models	Lucy Colquhoun, James Parr
Hair	Nick Irwin
Make-up	Linda Öhrström
Stylist	Way Perry

Creative Concept and Set Design
Lord Whitney

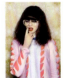 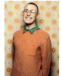 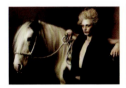 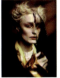 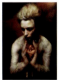 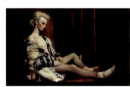 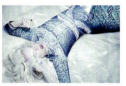 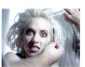

Welcome to Oddity Park
Hunger
Issue 2, 2012

Models	Katie Parnell, Luke Brennan
Hair	Jonathan Connelly
Make-up	Linda Öhrström
Stylist	Anna Trevelyan

Be Still, Beating Heart
Hunger
Issue 2, 2012

Model	Cooper Thompson
Hair	Jonathan Dadoun
Make-up	Caroline Saulnier
Stylist	Anna Hughes-Chamberlain

Wrapped in Lucid Dreams
Hunger
Issue 1, 2011

Model	Portia Freeman
Hair	Paul Donovan
Make-up	Andrew Gallimore
Stylist	Anna Hughes-Chamberlain

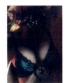 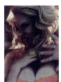 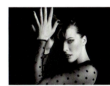 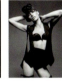 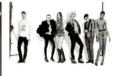 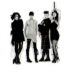 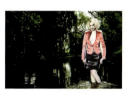

Carbon Copy
Hunger
Issue 1, 2011

Model	Tuuli Shipster
Hair	Jonathan Connelly
Make-up	Andrew Gallimore
Stylist	Anna Hughes-Chamberlain

2011–2001
Pages 128–177

Killa Milla
Hunger
Issue 1, 2011

Model	Milla Jovovich
Hair	Jenny Cho
Make-up	Melanie Inglessis
Stylist	Ryan Hastings

Jefferson x London Club
French Playboy
Issue 91, Jun 2008

Models	Jefferson Hack, Gareth Pugh, Gary Card, Jodie Harsh, Karley Sciortino, Matthew Stone, Theo Adams, Toula Adeyemi, Morwenna Lytton Cobbold, Matthew Josephs
Hair	Tracy Cahoon
Make-up	Ginni
Stylist	Alex Aikiu

Paper Doll
Vs. Magazine
2008

Model	Tuuli Shipster
Hair	Sascha Breuer
Make-up	Michelle Campbell
Stylist	Scott Robert Clark

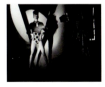 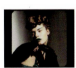 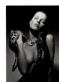 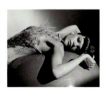 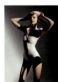

And God Created Eva
Citizen K
Issue 29, Dec 2003

Model	Eva Herzigova
Hair	Karim Mitha
Make-up	Maria Olsson
Stylist	Monica Pillosio

Paris Plage
Citizen K
Issue 30, Spring 2004

Model	Susan Eldridge
Hair	Seb Bascle
Make-up	Emma Lovell
Stylist	Monica Pillosio

 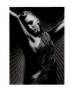 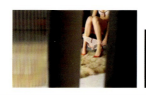

Lust & Luxury
German Vogue
Sep 2003

Model	Stella Tennant @ Viva London
Hair	Wendy Iles
Make-up	Charlotte Willer
Stylist	Claudia Engelmann

Haute Couture
German Vogue
Jul 2003

Model	Tetyana Brazhnyk
Hair	Wendy Iles
Make-up	Charlotte Willer
Stylist	Claudia Engelmann

Elle Macpherson
Intimates
2003

Model	Tuuli Shipster
Creative Director	Elle Macpherson

Glamorarma
Citizen K
Mar 2004

Model	Gisele Bündchen
Hair	Yannick D'Is
Make-up	Alice Ghrendrih
Stylist	Monica Pillosio

Touched Up
Dazed & Confused
Issue 85, Jan 2002

Models	Caitriona Balfe, Anne Vyalitsyna
Hair	Richard Scorer
Make-up	Wendy Rowe
Stylist	Miranda Almond

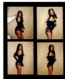 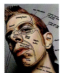 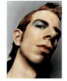 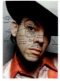 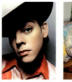 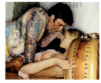 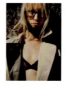 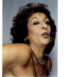 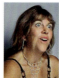

Beauty Queens
Rank
Issue 3, 2001

Model	Riccardo
Hair	Shinya Nakayama
Make-up	Emma Lovell
Stylist	Miranda Almond

Bootyfull
Rank
Issue 00, Dec 2000/Jan 2001

Models	Martin Meister, Rupert Meats
Hair	Bea Watson
Make-up	Emma Lovell
Stylist	Miranda Almond

Underwhere?
Rank
Issue 00, Dec 2000/Jan 2001

Models	Tua Fock, Paul John Sayce
Hair	Richard Scorer
Make-up	Lisa Houghton
Stylist	Miranda Almond

2001–1996 Pages 178–245

Big Night Out
Rank
Issue 00, Dec 2000/Jan 2001

Models	Yvonne Elwood, Jeni Ktori-Hooper

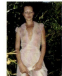 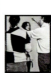 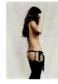 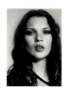 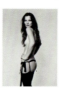

Cheeky
Dazed & Confused
Issue 56, Jul 1999

Make-up	Emma Lovell
Stylist	Miranda Almond

Viva La Revolution
Dazed & Confused
Issue 51, Feb 1999

Model	Kate Moss
Hair	James Brown
Make-up	Charlotte Tilbury
Stylist	Katie Grand

Turn The Dark On
Dazed & Confused
Issue 52, Mar 1999

Models	Laura Kay, Sanna Saastamoinen
Hair	Colin Gold
Make-up	Colin Gold
Stylist	Jo Phillips

 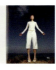 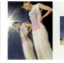 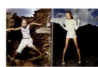 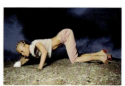 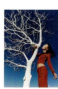

Stranded
Diesel Style Lab
S/S 1999

Models	Laura Kay, Sanna Saastamoinen
Hair	Peter Gray
Make-up	Charlotte Tilbury

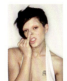 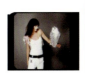 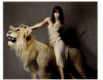 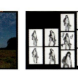 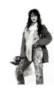

Bimba Bosé Rank Issue 2, Apr 2001	Animal Magnetism Jalouse Feb 2001	Livestock 2001	Bag Lady 2001	I'm only 13 Creative Review 2001
Model Eleonora Salvatore González Hair Shinya Nakayama Make-up Lesley McMenamin Stylist Miranda Almond	Model Greit Troch Make-up Emma Lovell Stylist Miranda Almond	Stylist Miranda Almond	Model Kate Moss	Model Jacqueline Mawby Hair Richard Scorer Make-up Lisa Houghton Stylist Miranda Almond

 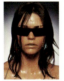 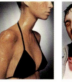 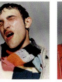 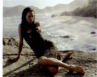 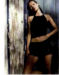

London Fashion Geo Magazine Feb 1998	Meltdown Dazed & Confused Issue 57, Aug 1999	Sweaters Nylon Nov/Dec 1999	Kate's Allure Allure Oct 1999
	Models Lauren Gold, Amanda Grace Johnson Hair Mark Anderson Make-up Charlotte Tilbury Stylist Miranda Almond	Models Adam Hindle, Amanda Johnson Hair Shinya Nakayama Make-up Emma Lovell Stylist Mat Ryalls	Model Kate Moss Hair Peter Gray Make-up Charlotte Tilbury Fashion Editor Ricky Vider Rivers

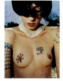 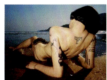 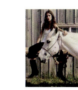 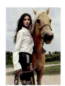 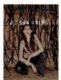

Bra Zilch Dazed & Confused Issue 38, Jan 1998	Big Issue The Big Issue Dec 1999	How The West is Worn Allure Aug 1999	Baked Alaska Diesel Style Lab A/W 1998
Model Marina Dias Hair Danilo Mazzuca Make-up Cesar Fassina Stylist Cesar Fassina	Model Kate Moss Hair Peter Gray Make-up Jackie Hamilton-Smith Stylist Miranda Almond	Model Gisele Bündchen Hair Peter Gray Make-up Teresa Pemberton Fashion Editor Ricky Vider	

 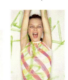

Sparkly Gisele 1998	Spray Paint Kate Dazed & Confused Issue 43, May 1998	Flesh for Fantasy Dazed & Confused Issue 33, Aug 1997
Model Gisele Bündchen Hair Malcolm Edwards Make-up Val Garland Stylist Katie Grand	Model Kate Moss Hair Malcolm Edwards Make-up Charlotte Tilbury Stylist Katie Grand	Model Helena Christensen Hair Malcolm Edwards Make-up Val Garland Stylist Katie Grand

 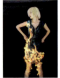 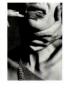 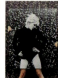 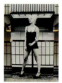

Highly Flammable Dazed & Confused Issue 31, Jun 1997	**Plain** Dazed & Confused Issue 29, Jun 1997	**Dead Fashionable** The Golette Gallery, Paris, 1997	**Faking It!** Dazed & Confused Issue 25, Oct 1996
Model — Natasha Elms Hair — Moose Make-up — Miranda Almond Stylist — Jackie Hamilton-Smith	Model — Laura Palmer Hair — Paul Lupes Make-up — Gina Crozier Stylist — Charlotte Stockdale	Model — Helen Cross-Fancy Stylist — Katie Grand	Model — Natasha Elms Hair — Moose Make-up — Sharon Dowsett Stylist — Katie Grand

 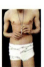 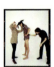 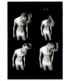 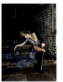 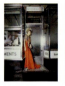 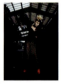 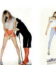 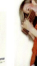 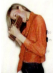

Pack Your Trunks
Dazed & Confused
Issue 17, 1995

Models — James Redmond, Greg Payne
Grooming — Val Garland
Stylist — Alistair Mackie

Pop Fashion
1995

Model — Paula Thomas
Stylist — Katie England

Hungry?
Dazed & Confused
Issue 15, 1995

Model — Alex Leigh
Hair — Adam Bryant
Make-up — Sharon Dowsett
Stylist — Katie Grand

 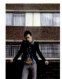 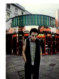 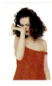 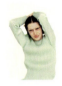 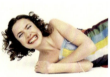

Weep
Dazed & Confused
Issue 10, 1994

Models — James Gooding, Caroline Taylor, Katie Carr, Kate Comer
Hair — Thomas Dunkin
Make-up — Sarah Coleman
Stylist — Sarah Coleman

Nancy Boy
Another Magazine
Issue 1, 1994

Model — Marc Massive
Hair — Robert Frampton
Make-up — Robert Frampton
Stylist — Katie Grand

 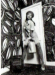 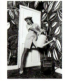 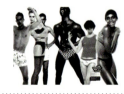 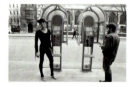 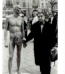

Livestock
Another Magazine
Pilot Issue 0, 1994

Models — Katie Carr, Lucy Wood Freeman
Hair — Spencer Gymer
Make-up — Sammy
Stylist — Katie Grand

Hip Chic
G-Spot Magazine
Issue 2, 1992

Model — Moni LeBon
Make-up — Firyal Arneil
Stylist — Stephanie Talbot

Blow Up
Dazed & Confused
The Fashion
Supplement, 1991

Hair — Model's Own

The Emperors' New Clothes
Dazed & Confused
Issue 1, 1991

Models — Keld, Roy Brown, Sue, Moni LeBon, Rupert, Shawn, Antonio, Julian, Ali, Terry, Nour, Kent
Hair — Kent & Firyal
Make-up — Firyal

Mannequin Fashion
1990

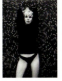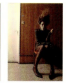

1995–1988
Pages 246–309

Obsessive Behaviour
Dazed & Confused
Issue 25, Oct 1996

Models	Natasha Elms, Robbie Williams
Hair	Moose
Make-up	Angie Parker
Stylist	Katie Grand

Touch Your Toes
Dazed & Confused
Issue 20, May 1996

Model	Claire Merry
Hair	Liam Dunn
Make-up	Liam Dunn
Stylist	Katie Grand

It's All a Veneer
Dazed & Confused
Issue 17, 1995

Model	Kate Groombridge
Hair	Colin Gold
Make-up	Vanessa Evelyn
Stylist	Katie Grand

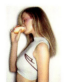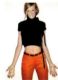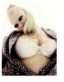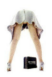

Big Girls Blouse
Dazed & Confused
Issue 14, 1995

Model	Jacqueline Wallace
Hair	Adam Bryant
Make-up	Julie Thomas
Stylist	Katy England

It's Not What You Wear, It's The Way That You Wear It
Dazed & Confused
Issue 13, 1995

Model	Kristina Hawkes
Hair	Esther Bihore
Make-up	Maria G2 Luigi
Stylist	John Spencer

Sad Lad
Dazed & Confused
Issue 16, 1995

Model	David Newby
Grooming	Emma Kotch
Stylist	Alistair Mackie

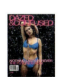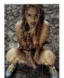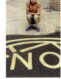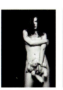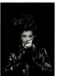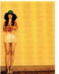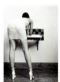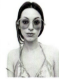

Ghosts
Dazed & Confused
Issue 8, 1994

Model	Jackie Volker Mallos
Hair	Alain Pichon
Make-up	Philip Baligan
Stylist	Katie Grand

Circle Line
Dazed & Confused
Issue 7, 1994

Model	Jimmy Dixon
Stylist	John Spencer

Death Masks
Dazed & Confused
Issue 8, 1994

Models	Katie Grand, Judy Blame
Hair	Hina Dohi, Liz Daxtaeur
Make-up	Hina Dohi, Liz Daxtaeur

Too Much Too Young
Another Magazine
Pilot Issue 0, 1994

Model	Vanessa Rubio
Hair	Spencer Gymer
Make-up	Charotte Tilbury
Stylist	Katie Grand

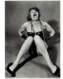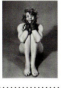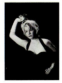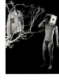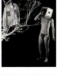

Dot
1988

Model	Dot

Melanie Williams
1988

Model	Melanie Williams
Hair	Helen Darlington
Stylist	Helen Darlington

First Fashion
1988

Model	Rankin

Jefferson
1988

Model	Jefferson Hack

Me Me Me
1988

Model	Rankin

Thanks to Rizzoli, Charles, and Jacob for believing in me enough to do this weird and wonderful book about my fashion work. As you can tell from the title, the fashion world has never been my happy place, and hopefully this book will help people understand where I'm coming from.

Thanks to Mark and Gary at Farrow Design for putting up with me. I think the design is ace and I think you're a genius, Mark—hopefully you'll speak to me again at some point in the future!

Thanks to all of my old teams and new; to everyone who has produced, art-directed, archived, edited, assisted, styled, glammed, made-up, hair-styled, modeled, agented, retouched, digi-teched, PR'ed, set designed, laughed, cried, and put up with me on set. Doing this for thirty years has left me with way too many people to mention everyone by name, but you all know who you are and you have all contributed so much in so many ways. I wouldn't be here without you. Thank you also to all of my current team, especially Ellen Stone, without whom this book would never have been finished, and Nicola, who just makes me laugh because she laughs at all my jokes.

Thank you to everyone involved in helping me in my parallel career as a business owner. That goes for all of the backroom people who have offered me lots of advice over the years.

Thanks to my friends who have told me when I was being a dick or encouraged me to go for it, when the consensus was to stop.

A special mention goes to Kate Moss and Katie Grand. It really has been a brilliant adventure to work with each of you along the way. Kate, photographing you is always a breath of fresh air. You are such a laugh and an amazing talent, I feel very privileged to have been able to be one of the photographers to get that opportunity. Katie, you are truly one in a zillion, helping so many people to find their way in this business. I think all of your 'crew' have a lot to thank you for, especially me. When I look back at our first shoots together, they are some of my favorites. Those first baby steps we took together, I'm so glad they were with you and that we're still friends.

A massive thank you to Jefferson, who was my partner in the madness of *Dazed* that set us on the path to who we have both become. I am so proud of what *Dazed* is, was, and is going to be.

On this note, I'd also like to thank my sister Susanne, not only for being my sister, which she is pretty wonderful as, but without you *Dazed* would not be here now. Not everyone knows that, but they should.

Finally, this book is dedicated to my best friend and partner in life, Tuuli. You have always been my favorite person to photograph since we met seventeen years ago. In this incredible bubble, it is you who keeps it real. Thank you.

One last thank you to my dogs—those morning walks have calmed me down a lot!

ACKNOWLEDGMENTS